# OUT OF T____

*The Reinvention of Art 1955 1975*

ter Ratcliff

School of
VISUAL ARTS

ALLW
NE

05   04   03   02   01   00      5   4   3   2   1

Published by Allworth Press
An imprint of Allworth Communications
10 East 23rd Street, New York, NY 10010

Copublished with the School of Visual Arts

Cover design by James Victore, New York, NY

Cover image courtesy of Barry Le Va

Page composition/typography by Sharp Des!gns, Lansing, MI

ISBN: 1-58115-073-3

LIBRARY OF CONGRESS CATALOGING-IN-PUBLICATION DATA
Ratcliff, Carter
    Out of the box: the reinvention of art, 1965–1975 / Carter Ratcliff.
      p. cm.
    Includes bibliographical references and index.
    ISBN 1-58115-073-3
      1. Minimal art—United States. 2. Conceptual art—United States. 3. Art, Modern—
    20th century—United States. I. Title.
N6512.5.M5 R38 2000
709'.73'09046—dc21
00-053589

AESTHETICS TODAY
Editorial Director: Bill Beckley
*Redeeming Art: Critical Reveries* by Donald Kuspit
*Dialectic of Decadence* by Donald Kuspit
*Beauty and the Contemporary Sublime* by Jeremy Gilbert Rolle
*Sculpture in the Age of Doubt* by Thomas McEviley
*The End of the Art World* by Robert C. Morgan
*Uncontrollable Beauty* edited by Bill Beckley with David Shapiro

Printed in Canada

# TABLE OF CONTENTS

# ACKNOWLEDGMENTS

This book is about many artists, and many artists helped me complete it. I should mention Bill Beckley first, for he not only provided invaluable assistance and encouragement at every step, but provoked me in the most tactful way to come up with the idea of the book in the first place. He also provided indispensable recollections of the late 1960s and early 1970s, as did a number other artists, among them Mac Adams, Richard Barry, Mel Bochner, Rosemarie Castoro, Stephen Kaltenbach, Barry Le Va, Will Insley, Patrick Ireland, Mary Miss, Dennis Oppenheim, Dorthea Rockburne, Allen Ruppersberg, and Fred Sandback.

Having traced the disintegration of the minimalist object, I noted its reappearance as the body of the performance artist, at which point I turned to Eleanor Antin, one of the inventors of performance art. In the course of a very helpful talk, she mentioned something I hadn't known when I conceived this book and named it *Out of the Box*. In 1972, *Art Gallery* magazine published a statement of hers with precisely the same title. For Antin, the box was an allotment of art-world space—"a small box (a gallery) or a big one (a museum)." As Antin noted, "The standard exhibition box conditioned the art put into it." Impatient with that conditioning, Antin realized that "the only space I really want to occupy is in somebody's head." Of course her postcard piece, *100 Boots* (1971–72), entered mailboxes, but only in transit. And when, as a performance artist, Antin stepped into various characters other than her own, she stepped beyond all box-like confinements whatsoever.

I mention Eleanor Antin's essay to acknowledge that the theme of this book is not a thesis imposed on works made in 1965–75. The theme emerged from the works themselves. My task was to show the power and variety of the strategies that liberated art from the box as exhibition space and, just as important, from the box as geometric object. I would like to acknowledge, as well, that this task had been performed already, even as art was making its escape from its minimalist confinement. I'm referring to the work of Willoughby Sharp and Liza

Béar, who launched the magazine *Avalanche* in 1971 and thus created the primary source of information about art in the aftermath of Minimalism. Their interviews with artists are models of the form. Sharp and Béar grasped not only particular tactics but also the sweeping strategies that led certain artists from one medium to the next, and deep into what was known, in those days, as real space and real time. If they had not published *Avalanche*, it is unlikely that I would have written this book. I would also like to thank Willoughby Sharp for all the help he provided while the book was in progress.

All the artists I discuss in *Out of the Box* were extremely generous in providing reproductions of their work. Though I have already thanked them for their illuminating conversation, I would like to note that Richard Barry, Patrick Ireland, Stephen Kaltenbach, and Barry Le Va went far out of their way to supply crucial images. To Darcy Huebler I owe a large debt of gratitude for her response to my request for Douglas Huebler reproductions. I am grateful as well to Elizabeth Childress, of the Walter de Maria studio; Elyse Goldberg, of the James Cohan Gallery; Rodney Hill, of Gorney, Gavin & Lee; Amy Plumb, of the Dennis Oppenheim studio; Daniela Silverman, of the Sonnaband Gallery; and Amy Young, of the Robert Miller Gallery. With remarkable generosity, Jon Hendricks gave me access to a rich store of archival material. Finally, in gathering the more elusive images, Bill Hayward gave me far more help than friendship could fairly demand.

For their assistance in retrieving texts and compiling lists, I would like to thank Liz Goodwin, Bradd Skubinna, Erica Honnus, Wade Savitt, and, especially, Jane Hur, who tied up an exceptional number of loose ends at the last moment. I would like to thank Allworth Press and its staff generally. In particular, I am thankful for the care and insight that Jamie Kijowski brought to copyediting the text, and for the energy and clarity of James Victore's design, which Charlie Sharp has implemented with such admirable skill. I am grateful to Nicole Potter, for keeping the book on track, even during moments of panic, technological and other; and to Tad Crawford, for his thoughtful introduction, his patience, and his belief in the project, which was unwavering from the outset.

# INTRODUCTION

## Smashing the Minimalist Enclosure

In "Anecdote of the Jar," Wallace Stevens writes of a jar placed in the Tennessee wilderness that "took dominion everywhere" and ordered what had been wild and untamed.

In the art world of the 1960s, Minimalism offered a structure not unlike that jar, an ordering principle, Platonic and powerful, that subdued all manner of opponents. Yet no sooner had Minimalism carried the day than the energy of the wilderness asserted itself with the hunger of maggots feasting on the rot of the vanquished dead until new, previously unimaginable forms rose unruly, polytropic, hydra-headed, and with the devouring-creating force of the many-armed Shiva wrapped in his garland of skulls.

The jar of Minimalism appeared to be a bell jar to a younger generation of artists, a suffocating enclosure threatening their artistic lives and futures. Living under such a threat, the younger artists reacted with a titanic outpouring of invention and energy. Against the impersonal, systematic, minimalist endgame, these younger artists redefined the possible in art. Emotion, mystery, wind, words, brilliant colors, violence, earth, flesh, holes, movement, voice, explosions, landscape, memory, burial, story, trees, masturbation, speculative thought, physical motion, the hand, subjectivity, and so much more emerged from repression with the sudden, elemental force of a tsunami.

I recall the shock of that forceful encounter with the new. Of experiencing earth on a gallery floor, hearing an artist sing a single word while performing a chin-up, listening to a man on a video monitor tell of his narrow escape from drowning as a child while a film showed the river which almost took his life, seeing photographic documentation for large-scale earth projects and speculative plans for projects too vast to exist except in the mind, encountering words on gallery walls, reading stories in galleries instead of books, and more and more, an upswelling and overflowing of energy that brought into the galleries what had been unwanted, forbidden, inconceivable.

That the late sixties and early seventies are a generation gone surprises. How could that outpouring of energy be overcome by the linearity of time and relegated to the box of history? What is admirable in Carter Ratcliff's incisive view of that decade is that he writes not only as a historian but as a participant who lived the events and knew the vitalizing intensity of that time. In *Out of the Box*, he joins his experience with his perspicacity to offer a living narrative of a decade when artists smashed through enclosures to rediscover the squalid wilderness in its recrudescence and splendor.

TAD CRAWFORD, *Publisher*
*August 30, 2000*
*New York City*

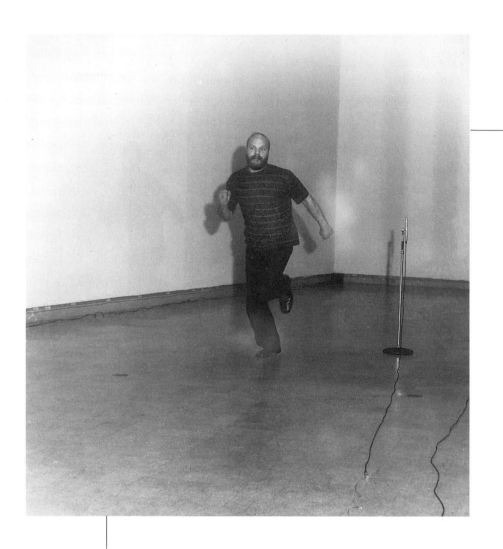

BARRY LE VA, still from film documenting trial runs to establish sound levels for the recording of *Velocity—Impact Run*. 1969. Ohio State University Art Gallery, Columbus.

# OUT OF THE BOX

"I was impressed by the rigorous structure of minimalist thinking without necessarily wanting to make a minimalist gestalt."

*Barry Le Va, 1971*[1]

One afternoon in October 1969, Barry Le Va stood against a wall of the art gallery at Ohio State University, Columbus. Then he ran as fast as he could toward the opposite wall, fifty-five feet away. Crashing hard, he waited for a moment and then retraced his steps, again at top speed, and again, he was halted by the gallery wall. After repeating this action for an hour and forty-three minutes, Le Va was done with the first stage of *Velocity Piece #1*. The work's subtitle is *Impact Run, Energy Drain*.[2]

Interviewing the artist in the summer of 1971, Liza Béar and Willoughby Sharp asked what those phrases meant. Le Va replied:

> I think *Impact Run* is self-explanatory. The *Energy Drain* is one of the main purposes of the piece, and that, of course, increased with time until I couldn't move at all. . . . I'd say the first few runs took about three seconds, then longer and longer up to about seven seconds. After a while I was in extreme physical pain, but I'd anticipated that because I'd made test runs in my studio beforehand.

Asked if he "hit the wall front on," Le Va replied:

> Yeah, with everything I could. Sometimes I would try to block, but every part of my body ended up being used. After a while my arms were bleeding. When I hit the wall, blood would fly onto the opposite wall. All these physical traces were left as part of the piece, skin from my elbows, sweat marks, blood. I wanted the record to be as complete and as clinical as possible.[3]

These traces recorded Le Va's determination to test an absurd thesis: If one tries hard enough, it is possible to run through walls. As he ran, Le Va recorded himself in stereo. *Velocity Piece #1* became public with the playback of the tape. As the artist described it,

> The sounds were of my footsteps and the impact of my body against the walls. While I was running, two microphones were set up at either end of the rectangular space so that there wouldn't be any dead spots, then, for the exhibition, the speakers were placed

in approximately the same positions. People would have an auditory experience of the footsteps going in a straight line from one end to the other, my body hitting the wall, bam, stop, then back again. What the sounds did was to articulate the changing location of the footsteps as they traveled across the floor, though they were in fact emanating from two speakers in fixed positions. I wanted people to visualize and experience the event from start to finish as they heard the tape.[4]

Usually, one visits an art gallery to see an object. Offering nothing to see, Le Va invited his audience to play detective by reconstructing an unlikely event from a sparse set of auditory clues. From this effort would follow a comparison, or so the artist hoped. "One of the most important points of the piece," he said,

was the dialogue set up during the exhibition between the activity inside the gallery and the activity in the surrounding environment, basically the hallway which was parallel to the gallery. Students would constantly travel up and down that hallway on their way to classes. So in terms of direction, the gallery and hallway were parallel; in terms of intention, density, configuration, and direction of the movement, they were diametrically opposed. In the hallway . . . there was a continuous flow of fairly aimless movement, the students were just in transit. The space was open-ended, there were no barriers. Inside the exhibition space . . . the activity was very concentrated.

In the "open-ended" corridor just outside the gallery, action is patterned casually if at all, as crowds of students pursue the familiar and, of course, sensible goals of education. This is the space of the ordinary world. Within the walls of the gallery is aesthetic space. Here, a solitary figure displays rigidly patterned behavior that makes no sense except as art. Le Va meant these contrasts to be sharp, yet lines were crossed. When the gallery door was open, *Velocity Piece #1* could be heard in the hallway. Traces of the aesthetic drifted into the realm of the ordinary.

Recently the artist said, "This was not a performance piece. I was not there, doing something in front of an audience. I was doing something, but I wasn't there. Or I was there as a ghost."[5] Only as a ghost could Le Va escape the space of the gallery. But how are we to make sense of this? If Le Va had wanted merely to leave the gallery, he'd have found literally no obstacle. Nothing would have been simpler than to walk out through the studio door, in the usual way. But he didn't want to do anything simply. More to the point, he didn't want to be literal, for literalism had become oppressive.

▸ On his first encounter with minimalist objects, their literalism had seemed redemptive: the one credible starting point that his times could offer. Soon, though, he saw that literalism could just as credibly be seen as an end point. Not only was minimalist form locked into its own

clarity, it was locked into the space of the stripped-down, white-walled gallery, for only here did its literalism look absolutely uncompromised. In no need of a future, the object had imprisoned itself in a static present.

Art had to get out of the box—but how? If art abandoned the boxy forms of Minimalism or kept those forms but left the box of gallery space, everything achieved by literalism would be lost. If art stayed in the box, what was there for younger artists to do? Le Va felt stymied by the clarity that, at first, had seemed to open the way forward. In *Velocity Piece # 1*, he enacted his dilemma with a literalist doggedness learned from the art that had created the dilemma in the first place.

To slam against the wall was to demonstrate an impossibility. By slamming against the wall with such violence, time after time, Le Va confessed the helplessness he felt in the face of an impossibility he understood as absolute and therefore cruel. To make sense of his art and the art of his generation, we need to feel the force of that absolutism for ourselves. We need to feel the allure of the minimalist box and the power of that allure, how oppressive it was and how urgent the need to escape it.

This is a book about artists who escaped, who would have been no more than practitioners of a style if they had accepted imprisonment. Le Va, too, escaped, despite the impossibility of running through walls.

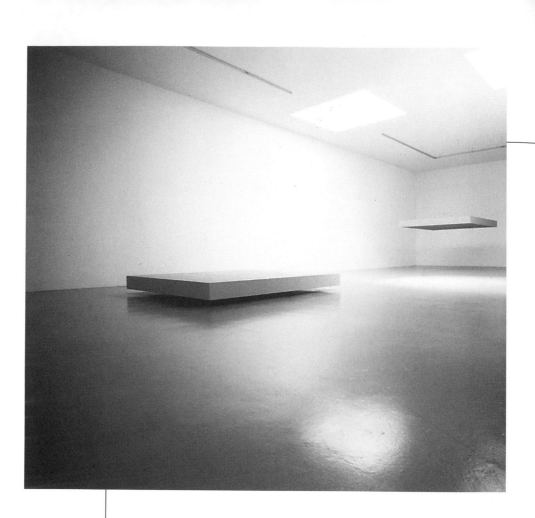

ROBERT MORRIS, left: *Untitled (Slab)*, 1962. Painted plywood, 12 x 96 x 96 inches.
Right: *Untitled (Cloud)*, 1962. Painted plywood, 12 x 96 x 96 inches.

# APODICTICITY

"Primary Structures" is a misnomer for an important exhi-
bition at the Jewish Museum. A qualifying addition to the
title is "Sculpture by Younger British and American Sculp-
tors." This subtitle reveals most strikingly the extent of
misunderstanding about New Art. The best work in this
exhibition is not sculpture. In this exhibition, the best
work is by Carl Andre, Dan Flavin, Sol LeWitt, Don Judd,
Robert Morris, Robert Smithson. The addition of "dilu-
tants" and mannerists to this exhibition (in the name, no
doubt, of a "good show") does not dissolve the issues the
best work raises. . .

•The work of the six artists named above demands a new
critical vocabulary. The common criticism of art is a
language without pertinence. Its only accomplishment is to
separate the viewer from the object of his sight. Such
words as "form-content," "tradition," "classic," "roman-
tic," "expressive," "experiment," "psychology," "analogy,"
"depth," "purity," "feeling," "space," "avant-garde,"
"lyric," "individual," "composition," "life and death,"
"sexuality," "biomorphic," "biographic". . . can now be
regarded as suspect.

*Mel Bochner, 1966*[1]

In 1969, Annette Michelson wrote of Robert Morris's *Slab* (1962) that it "seemed to declare, as it were, with John Cage, 'I have nothing to say and I am saying it.' 'Statements' of this sort, which brook neither denial nor debate, we term apodictic."[2] An apodictic artwork is self-evident, indubitable, in need of no analysis or justification. To be apodictic is to invite critics to be quiet. Of course, every object of vision eventually exhausts the resources of language. Nonetheless, commentary finds endless starting points in an artwork's subject or its play of symbols, and there is usually something to be said about the feelings a work of art expresses, the view of the world it offers, or its struggle to illuminate ultimate things. The trouble—or the shocking virtue—of *Slab* and other minimalist objects was their seeming refusal to have subjects, to make symbolic allusions, to convey feelings or attitudes about anything.

Critics faced this refusal for the first time in 1959. That year, the Museum of Modern Art in New York presented an exhibition called *Sixteen Americans*. Among the works on view were four large paintings by Frank Stella. In none of them was there anything to see but wide stripes of black paint laid on in symmetrical patterns. Three decades later, the critic and historian Irving Sandler recalled the dismay he and other veterans of the 1950s felt at the sight of these blank, light-absorbent canvases. Why drive painting to this "nihilist extreme"? To make matters worse, younger writers were finding reasons to praise Stella's blankness. Sandler found it "perverse, if not absurd," to hear it said that "Stella's painting was painting for its own sake *only*." Yet Carl Andre, later a minimalist sculptor, made just that claim in the catalog of *Sixteen Americans*:[3]

> Art excludes the unnecessary. Frank Stella has found it necessary to paint stripes. There is nothing else in his painting.
>
> Frank Stella is not interested in expression or sensitivity. He is interested in the necessities of painting.
>
> Symbols are counters passed among people. Frank Stella's painting is not symbolic. His stripes are the paths of brush on canvas. These paths lead only into painting.[4]

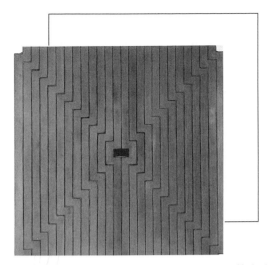

FRANK STELLA, *Avicenna*, 1962. Aluminum paint on canvas, 74¹/₂ x 72 inches. Menil Foundation (Janet Woodward, Houston).

A few years later, Stella recalled that, as a student,

> I had been badly affected by what would be called the romance of Abstract Expressionism . . . which was the idea of the artist as a terrifically sensitive, ever-changing, ever-ambitious person—particularly in magazines like *Artnews* and *Arts*, which I read religiously. It began to be kind of obvious and . . . and you began to see through it. . . . I began to feel very strongly about finding a way of working that wasn't so wrapped up in the hullabaloo . . . something that was stable in a sense, something that wasn't constantly a record of your sensitivity, a record of flux."[5]

Writers who want to include the early Frank Stella among the Minimalists usually quote him on his stripe paintings: "What you see is what you see."[6] When Donald Judd looked at these canvases, what he saw were "slabs"—wall sculptures unmarred by any illusion of space, any composition, any hint that their formal order is intended to reflect the underlying order of the universe.[7] Thus Judd approved.

Though Judd is known as a founder of Minimalism, he made his first appearance in the art world as a doggedly perceptive reviewer for *Arts Magazine*. His sympathies were narrow, yet he seemed to see everything worth seeing and raise the points that needed to be raised. In his review of Roy Lichtenstein's show at Castelli, in 1963, he praises only an effect of abstraction: "The Ben Day patterns and their various juxtapositions I like a lot." Judd sees the sophistication in Lichtenstein's tactic of recycling comic book panels, and his account of representation represented has not been much improved by nearly four decades of subsequent theorizing. Yet pop art can't hold his attention. The trouble, says Judd, is that Lichtenstein's "paintings are dealing with an idea of some-

thing, rather than something itself." One might say, that is what art does and has always done. But those who came to be known as Minimalists wanted to change all of art's dealings with everything.

In his review of a show at the Wadsworth Atheneum in Hartford, Connecticut, Judd notes with approval "boxes on the floor" by Robert Morris, Tony Smith, Anne Truitt, and James Lee Byars. He wonders why Robert Rauschenberg gave his white paintings from the early 1950s such a tenuous presence. Then he pauses to wonder if merely existing is enough for an artwork to do. Perhaps it is, for .

> Things that exist exist, and everything is on their side. They're here, which is pretty puzzling. Nothing can be said of things that don't exist. Things exist in the same way if that is all that is considered—which may be because we feel that or because that is what the world means or both. Everything is equal, just existing, and the values and interests they have are only adventitious.[8] .

That is, nothing is essentially more valuable than anything else. With his comments on existence and equality, Judd rejects essences and the metaphysical traditions that encourage us to believe in them—in some transcendent essence of truth, for example, or beauty or historical necessity. Art, in his view, delivers nothing of that sort. Nonetheless, he acknowledges that certain artworks are better than others, if only for "adventitious" reasons. ·

· In 1965, a year after his Hartford review, Judd praised certain "new work" for being "intense, clear and powerful." He was talking of objects by Minimalists, himself included, though he never accepted the label nor did he ever mention himself by name. Clarity, intensity, and power are the products of drastic omissions. One must learn to leave out all the familiar compositional devices. One must dispense with visual harmonies and textural nuance. As for order, if an object is sufficiently unified, it needs almost none. And if, like a stripe painting by Frank Stella, it has many parts, the work can succeed only if "the order is not rationalistic and underlying but is simply order, like that of continuity, one thing after another."[9] With this unemphatic dismissal of hierarchy, Judd dismissed as well the yearning for transcendence built into the hierarchical structures of traditional composition.

This is a yearning for exalted meaning, which a work of art satisfies by seeming to be more than mere matter: at the hands of an artist, pigment and metal are somehow linked to the spirit and its concerns. Carl Andre denied these concerns in an aptly flat-footed manner, explaining that "the art of association is when the image is associated with things other than what the work itself is. Art of isolation has its own focus with a minimum association with things not itself. My art is the

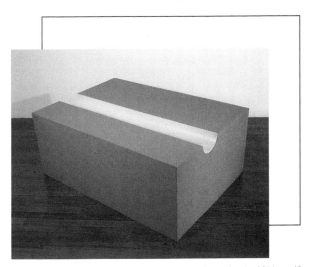

DONALD JUDD, *Untitled*, 1964. Oil paint on wood, enamel on iron, 19¹/₂ x 48 x 34 inches.

exact opposite of the art of association." Having convinced himself of that, Andre could say without qualms that "there is no symbolic content to my work."[10] For Robert Morris, it wasn't enough for the art object to be apodictically clear in form and self-sufficient in meaning. Its relationship to its setting had to be equally clear, and thus entirely controllable.[11]

Minimalist object and minimalist gallery—container and contained—made such a tight formal fit, and the tightness of the fit was so literal, hence so obvious, that many overlooked it, or saw it and felt no need to remark upon it. This solidification was not a flourish of wit, not the product of a subtle and coherent argument. It was a display of power, of formal elements brought under the relentless control of a will singular to the point of solipsism. In the minutely adjusted relationship between minimalist objects and their pristine sites, sympathetic viewers saw the triumphant clarity of an apocalyptic revelation. For a few seasons in the mid-1960s, certain New York galleries seemed to be putting the culmination of modernist history on display. Not everyone saw Minimalism that way. The most articulate exception was taken by critics dedicated to color-field painting.

Michael Fried wanted art to inspire transcendence, an upward ascension to what he called a state of "grace." To his eye, grace is the benefice of the color-field painters' purely "optical" images. Even more generous, in Fried's account, is the "concentration on syntax" that allows certain sculptures by Anthony Caro to "essentialize meaningfulness *as such.*" When we are granted the perception of such essences, says Fried, we enter "a continuous and perpetual *present.*"[12] No longer immersed in ordinary time and space, we intuit ultimate things—as promised not only

by other critics of Fried's formalist bent but by a long line of writers on art. In the third century, the neo-Platonist Plotinus described art as a window onto ultimate Realities.[13]

"The True Artist Helps the World by Revealing Mystic Truths." In 1967, Bruce Nauman commissioned a fabricator to write these words in spiraling neon, for display on a wall or in a window. Fitted to the format of a logo, the statement takes on a sarcastic edge. For nearly two millennia, this statement and its variants were uttered with reverence. We who live and die in a world of mere appearances rely on true artists to give us a glimpse beyond the veil of shifting, contingent phenomena. They redeem us with "Mystic Truths," not in a logical form intelligible to the mind, but in a visual form that inspires our intuitive faculties. When great art brings intuition to life, we transcend the world of mere appearances and death. We see, if only for an instant, what is absolutely and eternally Real. So the Minimalists appalled Michael Fried.

Drawing the attention to objects stranded in real time and real space, they distract us from the Real. They try, it appears, to convince us that there is no Reality with a capital "R," no elevated zone of Truth for art to illuminate.[14] Minimalist flatness, blankness, and literal-mindedness generated an atmosphere of skepticism, a bleak but powerful light of factuality. That power gave comfort of sorts to those who had abandoned their faith in art as the vehicle of redemption. And it may be that the minimalist object prompted some who had clung to that faith to cast it aside, to say, here and now, in this space bereft of all but a few rectilinear forms, that the here-and-now is suddenly sufficient. Minimalism charged the flow of secular experience with a new kind of glamor.

Old kinds of glamor and beauty and redemptive grace had been sought in far-off, unreachable distances—in the heaven of transcendent art or the less refined paradise of celebrity and fashion. Minimalism taught the mind to join perception in a trance of attentiveness to simple physical fact. Michael Fried and many others rejected this lesson indignantly. No one merely learned it. Perhaps it is not in any ordinary sense learnable. One can only give in to the didactic presence of the minimalist object, allowing it to change the very texture of one's thought and vision.

With their talk of painting struggling to reveal its "purely optical" essence, the formalists wore their Platonic yearnings for the Real on their sleeves.[15] Annette Michelson is not quite so simple a case. She rejects the Real as defined by Fried and the other formalists, and she talks a good antimetaphysical, prophenomenological game. Yet she never engages with Morris's sculptures as the odd, aggressively distinctive objects that they are. She shows no feel for, no interest in, the contingencies of her own experience. Rather, she faces the blankness of Morris's

geometries and reenacts an episode from Platonic myth—that moment in the *Phaedrus* when the charioteer, allegorical figure of the aspiring soul, drives the horses upward through the clouds of deluding appearances and catches a glimpse of the eternally Real.[16]

·The Platonic Forms are external. To apprehend them, the mind reaches outside itself, so to speak. To do this, it need not be any mind in particular. It need only be the generic mind of the philosopher, the seeker after Truth. As Michelson rushes to be the first to announce the appearance of apodicticity, she displays the generic mind of a bureaucratic functionary: an art historian seeking—and finding—the authentically new. Playing this depersonalized role, she feels a suprapersonal awe. Michelson saw the apodictic object as being there all at once, in its entirety, and imperturbably resistant to anything one say might about it. Consider it from whatever angle one might, the object's apodicticity was untouched because it was untouchable, In Michelson's eyes, Morris's objects had the aura of Plato's Forms. Marcia Tucker, a curator at the Whitney Museum of American Art, saw them with more secular eyes.

In 1970 Tucker organized a survey of Morris's career, which had begun less than a decade earlier. At the outset were objects that tweak the scientific mind's faith in objective measurement, as works by Marcel Duchamp and Jasper Johns had already done. In an untitled lead piece from 1963, Morris juxtaposed casts of two footprints with two two-foot-long rulers. As each footprint is distinct, so the rulers are of different lengths. Noting this, we question science's power to regulate every last nuance of our experience—anyway, this is what Tucker expects us to do. Arriving at Morris's minimalist period, she says that *Corner Piece* (1964) ·"is of interest because it examines an object in relation to the physical context."[17] This may seem an odd way to put it. Wouldn't it make more sense to say something along these lines: "With *Corner Piece*, the artist examines the matter of an art object's relation to its physical context"?

But before dismissing Tucker's phrasing as another instance of a catalog writer stumbling over her words, we should consider the possibility that she meant what she said. In the mid-1960s it seemed to many in New York that art was driving itself forward inexorably, into an ever-fresher aesthetic territory. So great was the force of historical necessity that works were posing and solving their own problems, thus making themselves. Artists had been reduced to the studio equivalent of mid-wives. By 1970, the new felt so very novel that novelty seen as serious, as genuinely new, had acquired an aura of the uncanny. Autonomy was the goal, and important works had attained it, so there was a kind of plausibility in talk of an object examining itself "in relation to its physical context."

ROBERT MORRIS, *Corner Piece*, 1964. Painted plywood, 78 x 108 inches. Photograph: Rudolph Burckhardt.

Several years earlier, Morris had written, "Some of the new work has expanded the terms of sculpture by a more emphatic focusing on the very conditions under which certain kinds of objects are seen."[18] Following Morris's lead, Tucker wrote that his

> single, unitary forms are perceived and experienced in relation to the structuring factor of the room, which is not simply accepted by the artist, but actively utilized. The object acquires meaning or completes itself in relation to a human activity, to the behavior of the spectator as he physically participates in the work by walking around it. Here, however, there is no aesthetic distance between the viewer and the piece, no mystery in comprehending the making of the work, no special skill required to "understand" it. . . .
> The *L-Beams* . . . suggest a child's manipulation of forms, as though they were huge building blocks. The urge to alter, to see many possibilities inherent in a single shape, is typical of a child synchretistic vision, whereby learning of one specific form can be transferred to any variations of that form.[19]

Tucker's ideal viewer circles Morris's cubes and slabs and *L-Beams*, taking stock of their various aspects. Restless and alert to particulars, this viewer is never overcome by the Platonic awe that stopped Michelson in her tracks. Yet Tucker expects the inventory of "possibilities inherent in a single shape" to deliver a clear idea of that shape—not a Platonic Form, but a stable concept, clear and distinct. At some point, particulars are absorbed by the universal they have revealed. The contingencies stirred up by shifting points of view become incidental. Yet Barry Le Va and others of his generation found nothing incidental in their points of view.

As these younger artists could see without much difficulty, the

minimalist object revealed new aspects as vantage points shifted, physically or conceptually. This was notable, it was revelatory, only because the object had seemed so unified, so self-enclosed, so independent of the viewer. It had looked not real but Real, to Michelson and many others. Her account of apodicticity was driven by a longing for the absolute, a metaphysical need she claimed to have quenched with a phenomenologist's matter-of-factness. Praising Morris's *Slab*, she was a metaphysician in denial, entranced by the Real despite her doctrinal certainty that the days of entrancement were over.

• Impressed but not overwhelmed by the authority of the minimalist object, younger artists wanted to claim that authority for themselves without merely personalizing the object, rendering it expressive or beautiful in some too-familiar way. Each tried to impose a viewpoint on a presence that had seemed to resist all points of view. They wanted it to confess its manifold nature. Yet none wanted to sacrifice the power generated by the self-evident form, the immediately intelligible concept, the thing that so obviously and literally is what it is. ·

See a minimalist box as a form, and line becomes the salient property of art. In the late 1960s, lines reached through the space of the gallery and beyond, and lines drawn across the Western deserts made the surface of the earth equivalent to a sheet of drawing paper. Artists who saw the object as a surrogate for the body put their own bodies in its place. These were the inventors of performance art. Artists who understood the object as a function of concepts took Minimalism as the first step toward language as the medium of art. Other views of the object revealed other aspects, and still other inventions followed, as artists tried to see the minimalist object for themselves without sacrificing the power of literalism, simplicity, and blankness. The difficulty was to find personal variants on minimalist impersonality. To finesse that contradiction was to effect a transfer of power, from the static, self-sufficient object to one's view of the object and thus to oneself.

• Artists who were young in the mid-1960s and impressed by the minimalist object departed in every direction from that aesthetic landmark. Much of their work is well documented. Commentary is ample yet fragmented by the habit of grouping artists by medium: performance artists are surveyed in one book, hard-line conceptualists in another. The notion of discrete, self-enclosed mediums persists, understandably so. Earth art, for instance, is obviously different from body art. Artists who use photographs in a documentary manner can nearly always be distinguished from artists whose photographs of real things launch their art into realms of narrative fiction. Yet Minimalism taught artists to believe that they could simply make art, in whatever medium seemed suitable.

⸁The minimalist object did not, after all, develop directly from the traditions of sculpture. One could see a box by Donald Judd or Robert Morris as a monochrome painting displaced from the wall to the floor, having acquired in the process a third dimension. As Judd said in 1965, "The new work obviously resembles sculpture more than it does painting, but it is nearer to painting."[20] The minimalist object destabilized both mediums and opened the way to the invention of new ones—or to the idea that art advances by further displacement, further alienation from the traditional mediums and even from the idea that mediums can be given coherent definitions.⸱ ⸱

Still, the idea persists, and so we try to enclose the wide-ranging artists of the late 1960s and early 1970s in single categories. The work of Walter De Maria, for instance, is usually seen in books and exhibitions devoted to earthworks. Yet he follows no one line of development from a single point *A* to an easily charted point *B*. During the 1960s, he takes his place in several constellations of artists—here an earthworker, there a conceptualist, elsewhere a maker of video tapes or simply a sculptor.

⸱ As the 1960s ended, curators in the United States and Europe scrambled to keep up with artists who had taken the minimalist object as a starting point, then departed for distant points.⸀Group shows proliferated, hectic attempts to round up these younger artists and herd them into the art corral of the museum interior.⸱For an exhibition called *Live in Your Head: When Attitudes Become Form—Works—Concepts—Processes—Situations—Information*, Harald Szeemann crowded the work of nearly seventy artists into the Kunsthalle in Berne, Switzerland. The show was to open late in March 1969. Among those invited to send work was ⸱Walter De Maria. Busy drawing lines on the Nevada desert, De Maria supplied the catalog with a picture of mile-long, parallel lines he had drawn in the Mojave Desert the year before. He included, as well, plans for a work he had installed in 1968 at another of these roundups—*Art by Telephone*, at the Museum of Contemporary Art in Chicago.

De Maria's piece for that show converted the minimalist object to a telephone "placed directly on the floor—no pedestal—in or near the center of the exhibition area. The cord is stretched tight and held down with the fewest number of staples deemed necessary for safety." The phone had no number, nor could one call out on it. A nearby notice read: "If this telephone rings, you may answer it. Walter De Maria is on the line and would like to talk to you." In a letter to Szeemann, the artist wrote: ⸱"Harald . . . I feel that this is the best work I can submit to you. I believe it does span the entire range of all five categories: works, processes, concepts, situations, information." Much of the work I discuss in this book spans these sprawling categories and more: performance,

political action, narrative. As I trace three hundred and sixty degrees of development from the point occupied by the minimalist object, my path often doubles back on itself, and we meet some artists at several points in their careers. Like many others, De Maria appears more than once in my narrative, the same artist each time but not always the same character.

• Complex situations inspire a search for methods of simplification. • The traditions of art history and curatorial expertise offer all too many of these: the study of a solitary artist wrenched out of context; the distribution of careers into the readymade categories called genres; genealogies of stylistic influence. An account of stylistic development helps us see Florentine painting of the fifteenth century. It helps us make sense of the twentieth-century avant-garde. But in the aftermath of Minimalism it obscures more than it reveals. The line, the plane, and the grid of the minimalist object preceded Minimalism, obviously. These are demotic forms, and so a grid by Mel Bochner cannot be seen as a variation on a grid by a minimalist predecessor—as a brushstroke made by Alfred Leslie in 1959 can be seen as a variant on a brushstroke made by Willem de Kooning in 1954. Nor does it help to place a Bochner grid on paper in one genre and a three-dimensional grid by Sol LeWitt in another, for the traditional idea of sculpture does not encompass LeWitt's gridded objects. As John Elderfield points out, a quirk of their construction derives their beams of sculptural mass, giving them the look of drawings extended from the flatness of paper to the fullness of space.[21]

If familiar notions of genre and style are useless, there's no point in trying to write the sort of narrative those notions inspire. This book is not a sequential history of a period. It is more like a film, the product of montage, with slow pans and tracking shots, two-shots and close-ups, crosscuts and flashbacks, dissolves and the occasional fade to black.

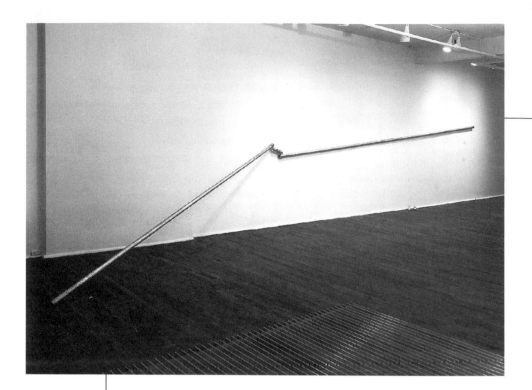

BILL BOLLINGER, *Untitled*, 1967. 2-inch aluminum pipes with universal join, 34 feet long. Bykert Gallery, New York.

# FROM BOX TO PLANE AND LINE

"Boxes are fairly complicated things. You've got eight edges."

*Donald Judd, 1967*[1]

Seen as a set of right-angled symmetries, the minimalist object looks absolutely immobile: a conclusion at one with its premises. A young sculptor named Bill Bollinger sensed the cogency of minimalist logic, yet he saw no need to make variants on a Judd box or a LeWitt lattice. To Bollinger's eye, the outlines of their objects were leading edges, captive to the task of defining planes and angles. Feeling their energy, wanting to set it free, he exchanged rectangular volumes for lengths of pipe.

Now the boxy object was all leading edge, a thick line surging into space and, with the help of a universal joint, surging off on a new tangent. Bollinger made the first of his aluminum-pipe pieces in 1967. The same year, he made a *Rope Piece*, which he described as

> a rope stretched between two terminals (eye bolts) located in floor at variable distances apart, or in floor and ceiling making the rope vertical. I regarded the content of this piece as the state of tension of the rope line and the manner of anchoring the piece into the space. I was not interested in composition and the vertical-horizontal placement was chosen for its neutrality. I realized from this piece that I am not interested in form but in the fact of form.[1] I have considered my work since then as not primarily expressive through form but declarative through state.[2]

Gravity did the tautening in *Droplight* (1969), a light fixture connected to a ceiling outlet by a standard cord. Here, cord is line and the role of plane is played not only by ceiling, walls, and floor—the inner surfaces of the gallery-as-box—but by the surface of any object the light illuminates. Once he had freed line from the stasis of the minimalist box, Bollinger saw it as a generative force with the power to reshape the very idea of plane. In 1967, he had stretched a length of multistrand wire across the floor, drawn it very tight, then sprayed it—and the floorboards—with a swath of white paint. Next, he cut the wire and it

> exploded. The uniform paint covering was thought of as an extended surface. The wire, very assertive by itself, became a

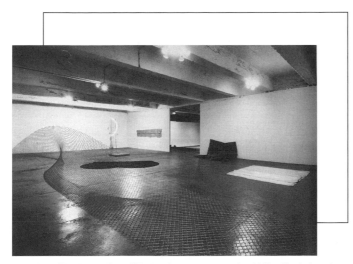

"Nine at Leo Castelli," Leo Castelli Warehouse, New York, 1968. Clockwise from left, on floor: BILL BOLLINGER, UNTITLED, chain link fence, 40 feet long; STEPHEN KALTENBACH, *Untitled*, folded felt; BRUCE NAUMAN, *John Coltrane Piece*, aluminum with mirror-finish bottom face; GILBERTO ZORIO, *Untitled*, material unknown; EVA HESSE, *Augment*, latex. On wall, left to right: KEITH SONNIER, *Untitled*, neon and rubber latex; *Mustee*, rubber latex, flock, and string.

structural prop carrying paint lines from the floor through space. This piece explicitly carried itself into and became a part of surrounding surfaces. I came to understand surface as a continuous foreground existing independently of objects.[3]

Toward the end of 1968, Robert Morris invited nine young artists to show new work in the large, slightly decrepit spaces of a warehouse on the Upper West Side of Manhattan. Sponsored by Leo Castelli, Morris's dealer, the exhibition included a floor piece of folded felt by Stephen Kaltenbach; more floor pieces, these made of latex by Eva Hess; and Alan Saret's springy, light-catching tangles of chicken wire. Along the line where wall met ceiling, Richard Serra splashed dipperfuls of molten lead. Morris was on the verge of publishing his essay on "Anti-Form," and the Castelli Warehouse show served to illustrate the doctrine in advance. Of course, Serra, Sonnier, and the rest were pursuing their own interests, which did not put them at odds with the idea of form. They wanted only to redefine it. Bollinger's contribution to the Warehouse show was a length of chain-link fencing. It ran the full length of an immense room and, halfway through its flight, made an elegant flip.

The joints in Bollinger's pipe pieces gave their lunges a syncopated limberness. Chain-link fencing is, in effect, all joints: a web of hyper-flexible connecting devices, which Bollinger deployed with a grace both astonishing and not in the least balletic. Its leap through space had the exuberance of a utilitarian material freed from its usual chores, and as it turned on its axis, this length of ordinary fencing supplied an image of

Bollinger's elusive idea about "surface as a continuous foreground existing independently of objects."

Bollinger died in 1988. By the mid-1970s, he had already drifted away from the scene where he had once been so promising a figure. Recently, the sculptor and writer Wade Saunders reassembled the scattered documents of Bollinger's career for an essay in *Art in America*. Among the illustrations of his works is a sequence of ten photographs of Bollinger on a motorcycle as he passes a truck, then disappears over a rise in an urban highway. These photographs were taken by Robert Fiore for the catalog of *Anti-Illusion: Procedures/Materials* (1969), the Whitney Museum's rerun of the Warehouse show. Other sequences show artists at work: Keith Sonnier fiddling with a curtain of latex, Rafael Ferrer mixing straw and automotive grease. For *Anti-Illusion*, Bollinger had a two-ton rock placed near the elevators on the ground floor of the Whitney. His second piece was a length of chain-link fencing laid flat on the floor with some links cut, to permit overlapping—a surface doubling itself here and there. Neither of these works has any obvious link to the pictures of Bollinger on a motorcycle.

Saunders quotes the artist's description of "surface as a continuous foreground existing independently of objects," then adds, "This is the kind of understanding that riding a fast motorcycle may both prompt and reinforce. Bollinger was 'working' in these pictures, but not in the manner of the other artists Fiore depicted."[4] Simply to perceive himself in motion was to continue his work as an artist, Saunders suggests. This makes sense if Bollinger identified himself not merely with line but with line-as-direction, as vector, and felt it come alive as he advanced through space. The minimal object found self-sufficiency by enclosing itself within regular planes. Liberating the line that shaped those planes, Bollinger broke out of the box and found that planes are indistinguishable from space itself, if one moves through it with the determination of a high-speed vector.

\* \* \*

Richard Tuttle drew lines with thin wire instead of thick pipe. Rather than zoom through space, Tuttle's lines meandered, quirkily, from a point on a gallery wall to another point in space, never far away. Like Bollinger, Tuttle was among the young New York artists regularly included in such curatorial round-ups as the Whitney's *Anti-Illusion* show. James Monte, who organized the exhibition with Marcia Tucker, called Tuttle's work "discreet," even "recessive."[5] There were terms of praise in the late 1960s, when the brash and the monumental were associated

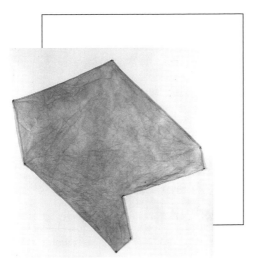

RICHARD TUTTLE, *Grey Extended Seven*, 1967. Dyed canvas, 48¹/₂ x 59¹/₂ inches.
Collection: Whitney Museum of American Art, New York.

with the heroics of Abstract Expressionism and the militarism of
America's adventure in Vietnam. So discreet were Tuttle's lengths of wire
that they sometimes let themselves be upstaged by the shadows they
cast. .

. From large sheets of white paper the artist would cut irregular
polygons. Then he'd attach them to the white of the gallery wall: white
on white, plane on plane, a layering that alluded to the minimalist geom-
etry of object and room but drew attention to planarity itself, not as an
ideal, but as a quality specific to a particular occasion. Likewise, each of
his wire pieces gave the general idea of linearity an irreducible particular-
ity—a personality, even, for the shadow it cast looked like a self-portrait
made in collaboration with the source of light, and skewed by the light's
point of view. These portraits, as I'm calling them, were of the artist's
materials, not of the artist himself. Rather than picture Tuttle, they put a
distinctively Tuttle-esque sense of line on display.

· Sometimes he worked with canvas, but never in the manner of a
painter. Rather than mount a piece of canvas on stretchers, he would
attach it directly to the wall, loosely enough to preserve its wrinkles.
Rather than paint it, he would dye it with Tintex, a product found not in
an art store but at the supermarket. Instead of four corners, his canvases
pieces would have seven or eight—or nine. The outlines of these flat,
flexible objects seemed to have been improvised, but not under pressure
from expressionist heat. Tuttle's improvisations have a meandering, con-
templative ease. Some of the cloth pieces suggest letters of an alphabet
forgotten or not yet fully evolved. Others allude to such forms as a regu-
lar octagon or septagon, but only in the most willfully casual way. These
pieces suggest geometry done by eye, without a ruler.

In the introduction to an exhibition called *Live in Your Head: When Attitudes Become Form*, Scott Burton wrote:

> The most fundamental law of nature is that everything that exists in space also exists in time; artists today work with that knowledge in unforeseen ways. A Bill Bollinger rope piece does not change from day to day; indeed, its fixedness, its tension as it stretches between two anchoring bolts, it is very point. But what happens to it when it is disassembled? Does it still exist? If so, does it exist as rope, as potential art, as art? . . . The ontological instability of the Bollinger piece introduces, on the psychological plane, an experience of anxiety about being. . . .
>
> What we are witnessing is a new realism or naturalism born of extended collaborations between the artists and nature, chance, material, even the viewer. The nineteenth-century manifestation of realism (especially in Europe, which was not under the Arcadian illusions of contemporaneous America) was not only a style but also a preference for a certain kind of subject matter—the raw, unpleasant, ordinary, ugly, proletarian. A similar preference is felt again and again in the torn, flopping, "anxious objects" in this exhibition. But the humbleness of Richard Tuttle's wrinkled, dyed, nailed-up pieces of cloth is rivaled only by their grandeur of conception—they have no back, no front, no up or down, they may be attached to the wall or spread out on the floor. Imagine making an object which will maintain its integrity in all circumstances yet which exerts absolutely no demands on its situation.[6] •

Sometimes it seemed as if Tuttle wanted demands to run the other way, from situation to work. In 1972, Ellen Lubell described his execution of five wall pieces. One was called *Pencil Line:*

> With deliberate, peaceful whole-arm movements, each line is completed in one attempt; they always seem to be personally proportioned, fitting the limits of his hands or arms. . . . Small bumps in the lines reflect Tuttle's pulse, and on that particular day the rhythms of the street-drilling machinery on Eleventh Avenue below.[7]

In the role of mechanical draftsman, a minimalist would draw the line that defines the plane that defines the object that enters into a definitive relationship with its environment. Thus the object's surroundings are included in its definition. Tuttle, by contrast, plays the part of a seismograph, and his line doesn't define his environment so much as register its various pulsations, which include the beating of his heart and the rapid thump of jackhammers. What his line doesn't register is any qualitative difference between the two rhythms. •

\* \* \*

In the late 1960s critics compared Alan Saret's chicken wire sculptures to clouds, and of course they were described as Jackson

Pollock drip paintings in three dimensions. A more austere reading begins by noting that chicken wire is a plane established by a pattern of lines. In that respect, it resembles a floor sculpture by Carl Andre. Of course, the units of an Andre carpet are detachable. Its lines are functions of planes juxtaposed. In chicken wire, lines are interwoven to form a plane, and when Saret crumpled lengths of the material into bristly masses, line and plane became difficult to distinguish—or to care about very much. Airy traps for whatever light reveals them, these works dissolve their minimalist premises into luminous obscurity.

. John Baldessari gave one of those premises a charming transience in a series of five photographs called *Throwing Four Balls in the Air to Get a Straight Line (Best of 36 Tries)* (1972–73). Against the bright blue sky the balls are a shiny red, and the lines they mark seem to strain for ruler-straightness. In 1969, Tom Marioni bent a metal tape measure into a taut curve, then released it into the air. In the artist's account, "The object leaves the hand as a circle, makes a drawing in space and falls to the ground."[8] With this *One-Second Sculpture*, Marioni sent line through a full gamut of physical conditions: from motion to rest, from circularity to random curviness to simple linearity. In *The Creation, a Seven-Day Performance* (1972), he spent a week in the Reese Palley Gallery in San Francisco and hung meanings on his lines.

On the third day, the artist attached a sheet of brown wrapping paper on a wall. Seated before it in the lotus position, he reached up as far as he could, pencil in hand, and drew a line. For many hours, he repeated this action. The result was a thin strip of graphite generated by countless small lines, marks made in oblique imitation of cellular plant growth. For Marioni intended his drawing to evoke Genesis 1.11, the passage where God commands the earth to "bring forth grass, the herb yielding seed after his kind, and the tree yielding fruit, whose seed was in itself."

Genesis 1.20 tells of the fourth day, when fish are created "and fowl that may fly above the earth in the open firmament of heaven." To celebrate this verse, Marioni placed his sheet of paper high on the wall, out of reach.

> I had to jump to get to it. I would circle the gallery and then run parallel to the wall, and while I was in flight, like a hurdle jumper with a pencil, I'd make that mark. I kept doing that all day long. . . . The marks were a record of my attempted flight, and the end result looks like a wing, this arced bunch of lines.[9]

Marioni began as a sculptor working in the manner of West Coast Minimalism, which is just as severely geometric as the New York variety but less gritty—or, as a Californian might say, less puritanical. For

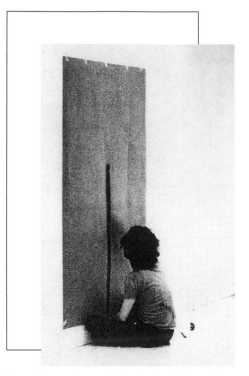

TOM MARIONI, *Drawing a Line as Far as I Can Reach*, 1972. Performance piece. Reese Palley Gallery, San Francisco.

Robert Morris, it was enough to build a cube or slab of plywood and finish it with a coat of flat gray paint. John McCracken, who worked in Venice, California, during the 1960s, produced flawlessly finished slabs of polyester resin in gorgeous reds, yellows, and aquamarines. Larry Bell made prismatic cubes of glass. Whether they evoke gems or customized cars or both at once, the works of the West Coast Minimalists are frankly, almost nonchalantly sensual.

Marioni followed their example until he underwent something like a conversion experience. Having read of ritualized performances by Yves Klein, the French painter, he began to think of Pollock's dripping less as a way to make a painting than as an action valuable in itself. He became interested in Asian calligraphy and its sources in meditation. By the late sixties he had stopped making objects, or made them only as records of repetitive performances. Yet he didn't entirely abandon his origins.

Barry Le Va's *Velocity Piece #1* was violent. There are reminders of autism in the repetitious structures of Vito Acconci's performance pieces. Marioni's rituals were serene. Working in San Francisco, he felt no need to find a performer's equivalent to the blank symmetries and permutations of New York Minimalism. When he wasn't evoking creation

myths, he was organizing performances with a communal flavor. The first of these took place at the Oakland Museum in 1970. Entitled *The Act of Drinking Beer with Friends Is the Highest Form of Art*, it inaugurated a series of similar events—evenings of talking and drinking—which continues to this day. In the social and religious tone of Marioni's art one sees the seductive sensuality of the West Coast Minimalists transformed.

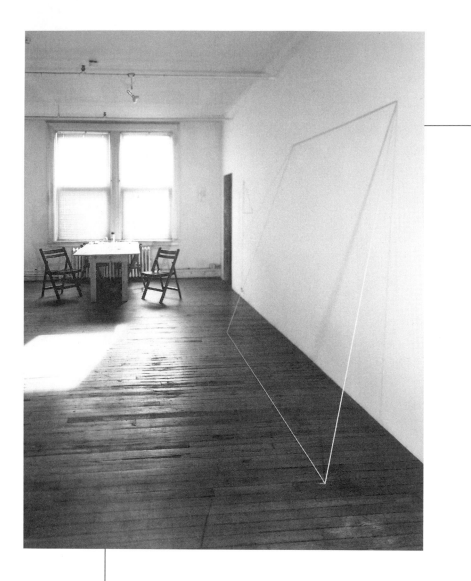

FRED SANDBACK, *Untitled*, 1970. Orange elastic cord. Installed at
the artist's studio, New York.

# LINE CONTINUED

"There is more than one way to draw a line."
*Fred Sandback*[1]

The palette of New York Minimalism was not confined to Robert Morris gray and the scrap-metal hues of Carl Andre's floor pieces. Donald Judd used delectably tinted Plexiglas, and, painted or polished, the metal surfaces of his objects were often sumptuous. Dan Flavin's pink and orange fluorescent tubes bathed their surroundings in auras at once luscious and ethereal. Even the works he assembled from stark white light gave off an undeniably lovely glow. Yet neither Flavin's nor Judd's works were ever grouped with McCracken's and Bell's, and condemned as merely beautiful. It is difficult to say what rendered the New Yorkers immune from this charge, though Judd's sober way of talking about others' art may have protected his own. In the vicinity of Minimalism, artists' statements had remarkable weight.

· It's not that the initiated audience simply heard and obeyed. Rather, there was an implicit agreement that statements of intention and meaning were to be respected: one must look at art in light of whatever the artist says about it. Having looked, one was free to reject what one saw, but statement and object had to be understood as inextricably joined. The artist's emphases and omissions were to become one's own. Of a work by Flavin, Judd wrote:

> A single daylight-white tube has been placed at the end of a short corridor. . . . It makes an intelligible area of the whole wall. There is some relation to the diagonals of Morris Louis. The tube is a very different white, in color and nature, from the painted white of the box that supports it. The box casts a definite shadow along its length. The light is cast widely on the wall. The light is an industrial object, and familiar; it is a new means to art. Art could be made of any number of new objects, materials, and techniques.[2]

Judd speaks of "intelligibility." He compares Flavin's diagonally placed object with diagonal flows of paint in the works of Morris Louis. He notes the difference between the white emitted by the fluorescent tube and the white painted onto the fixture holding the tube. He

remarks on the familiarity of the fixture as hardware and its newness as art, and looks ahead to further innovations. Judd says nothing of sensuous allure, here or in his other comments on Flavin's art. Mel Bochner remembers Judd acknowledging, in conversation, his liking for "snazzy materials."[3] Yet snazziness never found a place among "intelligibility," "credibility," and the other themes of his art criticism.[4] •

Like the prose of his *Notes on Sculpture*, Robert Morris's minimalist objects were ostentatiously unsnazzy. He and Judd led sympathetic sensibilities far from any delight in form or color—or far from the admission of any delight, for who is to say that the appeal of a work by Flavin or Judd or even Morris during his gray period is not, in its way, as sensuous as the appeal of a canvas by Willem de Kooning? Nonetheless, no one confessed to pleasure within the gravitational field of the minimalist object. The elaboration of line and plane proceeded in an atmosphere of stern sobriety.

With his fluorescent tubes, Flavin showed that line could be readymade. Moreover, it could be luminous. His precedent authorized the hot green lines of laser light that Rockne Krebs sent zipping through darkened galleries. Keith Sonnier often included lengths of green or red neon in his wall pieces of the late 1960s. Sometimes he would let a line of color curve nakedly into space, sometimes he'd diffuse its glow with a scrim of cheesecloth.

Bruce Nauman's *Green-Light Corridor* (1970–71) is forty feet long and just wide enough to accommodate the line of fluorescent fixtures that fill it with a ghastly glow—a claustrophobic allusion to the spacious radiance of Flavin's installations. *My Last Name Exaggerated Fourteen Times Vertically* (1967) turns "Nauman" into an eerie and nearly illegible line of dark blue neon. *My Name As Though It Were Written on the Surface of the Moon* (1968) is subtitled: *Bbbbbbbbbbrrrrrrrrrruuuuuuuuuuuuccccccccccceeeeeeeeee*. Rendered in light blue neon, these letters reach more than sixteen feet across the wall. Directional instead of diffused, neon light is linearity made luminous—never entirely ordinary no matter how common it becomes. Nauman found both the strangeness and the commonness of neon useful as he worked out variations on the minimalist virtue of impersonality.

• *My Name Exaggerated Fourteen Times Vertically* turns a signature into the product—and the emblem—of a bizarre procedure that has nothing to do with an artist's identity, as such identities are usually understood. Following the Minimalists' cue, and that of Sol LeWitt in particular, Nauman was defining an artist as one who follows arbitrary processes wherever they lead.[5] Unlike the Minimalists, Nauman acknowledged that an endpoint might be strange—out of this world, as he sug-

gests by showing how his name might look if he wrote it on the moon, his hand set adrift by lunar gravity. *Neon Templates of the Left Half of My Body Taken at Ten-Inch Intervals* (1966) is an array of seven curved lengths of bright green neon tubing. Suspended on the wall in a vertical row, they do not suggest the human figure. To see the link with Nauman's form, one needs the title. Together, work and title argue that the artist has learned from the minimalist object to see his body, too, as an object—irregular in comparison to a cube but no less definable as a set of lines.

\* \* \*

In 1973, Patrick Ireland made the first of the installations he called *Rope Drawings*. His materials were lengths of clothesline, afloat in gallery space. Some were straight, some angled. Their placement looked random from certain viewpoints. From others, a degree of order appeared. Two or three of these levitating lines would echo a portion of the gallery space—an upper corner of the gallery, the meeting of ceiling and wall. Shift one's vantage point slightly, and this visual convergence would be lost. Randomness would reappear. One could see Ireland's lines as all that remained of a vaporized minimalist object. Just as plausibly, the lines were the gallery's reflection on its own geometric form. However one understood the elements of the *Rope Drawings*, the endless, subtle reshuffling of their patterns would have been unimaginable only a few seasons earlier.

"Space is a kind of jungle," Ireland has said. "A complete chaos with no rhyme or reason at all."[6] The artist's ropes insinuated formal rhyme, even the effect of reason, but only contingently. Always, chaos impended, the sign of contingencies more powerful than the occasional burst of reason. Not long before, when the minimalist object seemed firmly ensconced in gallery space, reason—or at least rhyme—had seemed not only desirable but unavoidable. History had brought art to a point of clarity self-evident to all in precisely the same way. To this minimalist triumphalism, Ireland's play of lines replied that art is what emerges from something unclear, idiosyncratic, and fugitive: a viewer's immersion in the game.

Fred Sandback's lines of yarn are more orderly than Ireland's ropes, more willing to align themselves with the lines and planes of the rooms where they appear. In fact, they often run parallel to wall or floor, or answer the ninety-degree angle of a corner with a forty-five degree slant through space. Yet these reflections on the simple structures of interior space generate no simplicities. Sandback's most distinctive form is a wide, empty plane marked off by squared-away "U" of yarn. Reaching

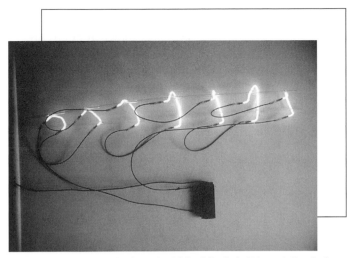

BRUCE NAUMAN, *Neon Templates of the Left Half of My Body Taken at Ten-Inch Intervals*, 1966. Neon tubing with clear glass tubing suspension frame. Collection: Philip Johnson.

from ceiling to floor, these planes function as virtual walls. One is reluctant to step through them, but only on first encounter. As the artist notes, the "'wall-of-glass' response is fairly short-lived."[7] The illusions generated by these works fade quickly under pressure from the direct, soberminded looking they invite.

As a student in the late 1960s, Sandback made refined variations on the minimalist object. One was a Plexiglas box, eighteen inches cubed. Painted silver, it stood on a clear Plexiglas pedestal of identical size. Next he welded thin metal rods into outlines of boxlike forms. He had dispensed with volume, but the memory of it lingered too insistently. Attenuated as they were, these metal lines were still objects. String stretched tight felt more like a line drawn on paper, and that became Sandback's medium. He first employed it to outline a length of wood, a two-by-four lying on the floor of his studio. "It was," he has said,

> a casual act, but it seemed to open up a lot of possibilities for me. I could assert a certain place or volume in its full materiality without occupying and obscuring it. I think my first attraction to this situation was the way it allowed me to play with something both existing and not existing at the same time. The thing itself—the 2½ × 4½—was just as material as it could be—a volume of air and light above the surface of the floor. Yet the forming of it, the shape and dimension of that figure, had an ambiguous and transient quality.[8]

From this form others followed: the squared "U," solitary lines stretched from ceiling to floor; trapezoids tilted against a wall; lines that reach from wall to wall, joining with a corner to mark off a triangle.

There are only a few others. Sandback's is not an art of invention but of response. Each of his works is a gesture pointing to the shape and feel of a particular setting. Though he learned clarity from the Minimalists, he feels none of their fascination with serial systems—nor with the control gained when systems are imposed. He does not, as he has said, "have an idea first and then find a way to express it."[9] Ideas emerge as the artist stretches strings through space in ways that illuminate it, not for vision but for the faculty we might call spatial intuition.

Offering no certainties, Sandback's works lead to no firm conclusions. However vivid, one's intuition of the artist's point is always tenuous, always impossible to detach from the form that prompts it. One can trace his lines back to the minimalist object, of course—if there had been no box, Sandback would not have devised his distinctive manner of doing without it. Yet his works never invoke the authority of their origin. His lines are not distillations of the box's generalities. They are not abstractions. In their responsiveness, they are contingencies—improvisations with no need to pretend that they have revealed the essence of linearity.

The "real space" of the Minimalists was easily theorized, easily converted from real to Real and brought under tight conceptual control. Sandback says that his works appear in "pedestrian space," which is

> literal, flat-footed, everyday. The idea was to have the work right there along with everything else in the world, not up on a spatial pedestal. The term also involved the idea of utility—that a sculpture was there to be engaged actively.[10]

We engage these works after they have engaged their settings. Sandback calls them sculptures, though they are "less dense" than most, "with an ambivalence between exterior and interior." As "habitable" drawings,[11] they sketch ways for the eye—and more to the point, for the body—to take the measure of a space, as the artist has already done.

"Sometimes," he has said, "I don't see various sculptures as being discrete objects, but rather more as instances of a generalized need to be in some sort of constituting material relationship with my environment."[12] Sandback is alive to the power of places to shape him, provisionally. His equally provisional works reciprocate, reshaping places with a few thin lines—concise summaries of responses too complex to articulate any other way. With lines that are taut but not rigid, Sandback charts particular ways of being in particular places. More generally, he makes points about ways to be, with arguments that are not didactic but austerely persuasive.

Ireland suspended his lengths of clothesline with threads of transparent nylon. Though not invisible, these filaments were intended

Lower left: FRED SANDBACK, *Untitled*, 1967. Elastic cord, string, and steel wire painted gray. Upper left: FRED SANDBACK, *Untitled*, 1968. Gray lacquer on 1/8" diameter steel rod. Six parts. Right: FRED SANDBACK, *Untitled*, 1967. Silver gray elastic cord. Installation view. Konrad Fischer Gallery, Düsseldorf, 1968.

to go unseen, like the clear tubing that supports the green neon of Nauman's *Templates*—or the thin marble props that ancient sculptors left in place, to support their figures' extended limbs. In art, invisibility is sometimes a fiction. Early in 1969, Robert Barry explained how his art arrived at the threshold of literally invisible form, and then crossed it. Over the years, he had noticed the way his paintings—severe abstractions—were affected by their surroundings. One speaks of "the gallery," as if all galleries are the same, but every cube of white art-space has a full complement of quirks. To acknowledge these local circumstances, Barry made his paintings very small and mounted them in patterns that

incorporated as part of their design the wall on which they hung. I finally gave up painting for the wire installations. . . . Each wire installation was made to suit the place in which it was installed. They cannot be moved without being destroyed.

Color becomes arbitrary. I started using thin transparent nylon monofilament. Eventually the wire became so thin that it was virtually invisible. This led to my use of a material which is invisible, or at least not perceivable in a traditional way.[13]

Barry used several imperceptible materials: radio waves of various frequencies, microwaves, ultrasonic sound waves. Emitting rays neither harmful nor detectable by the unaided senses, *Radiation Piece, Cesium* (1969) made itself known only as a plaque stating the name of the piece and the physical characteristics of its material. In works like these, line and plane were residual, just the too-familiar forms of the gallery one visited to discover that the visible world had been relieved of everything

crucial to art. Why bother to stop by? To announce his show at the Art & Project Gallery in Amsterdam, Barry sent announcements that read: "For the exhibition the gallery will be closed." As, in fact, it was.[14]

\* \* \*

♥ Group shows usually look cluttered. In the spring of 1969, the critic Lucy Lippard invited a crowd of more than three dozen artists to do their best to leave the Paula Cooper Gallery looking empty. Douglas Huebler, Stephen Kaltenbach, Dan Graham, and many others placed books on a table that stood near the dealer's office. Hans Haacke's work was a current of air from a small oscillating fan. With one shot of an air rifle at a gallery wall, Lawrence Weiner made a nearly imperceptible antiobject. When works took the form of objects, they tended to be discreetly linear. Rosemarie Castoro sent a long strip of tape meandering over the gallery floor. Carl Andre bisected it with short lengths of cable arranged in an irregular line. Bill Bollinger's lines were branches in a casual heap. Mel Bochner executed a measurement piece—lines on a wall, with their length in inches noted. And Sol LeWitt made his first wall drawing, a dense pattern of pencil lines.

At first, LeWitt's drawings seemed peripheral to his works in three dimensions. Slowly, they moved to the center of his oeuvre—if his oeuvre can be said to have a center. After all, he maintains no order of precedence between ideas, sketches, objects, drawings on walls, drawings on paper, prints in traditional mediums, photographic prints, books of photography. The market draws hierarchical distinctions here, but LeWitt's aesthetic does not. Nor does he claim any privilege for the artist's hand. In fact, he keeps his hand out of it. His wall drawings are made by others following brief instructions about the kind and quantity of lines to be drawn. Early on, Barbara Reise noted LeWitt's success in transmitting his ideas through the medium of others. "From his first wall drawing," she wrote in 1969,

> the relation between graphite line and interval was controlled to be as neutrally nonhierarchical as possible. Fine, hard pencil, close-as-possible juxtaposition, and evenness of pressure and width were stipulated; special aids like masking tape and supports for right angles and much human time and dexterity helped compensate for surface and manual irregularities to achieve an almost "machine-made" clarity to the ideas' expression. Against the usual white walls, the sharp silvery tone of the graphite held tautly without a dominating "figure" or "ground."[15]

Over the decades, every element of these drawings has been varied, again and again. Graphite became colored pencil, which became

SOL LEWITT, *Wall Drawing #146*, 1972. Blue crayon. Solomon R. Guggenheim Museum, New York, Panza Collection.

acrylic paint. Long ruled lines gave way to short lines rendered free-hand, straight lines became wavy, waves were replaced by spirals—not that LeWitt has ever abandoned any of his options, or closed off new ones. Even the figure-ground effect has appeared, in drawings of cubical shapes on fields of parallel lines. Why not, despite the implication of hierarchy? His sculptures are figures seen against the background of the gallery. Yet their gridded forms don't try to dominate their settings. Rather, their griddedness encourages the eye to see all form as equally patterned, hence as equal. Because it is not hierarchical, LeWitt's style of linearity reaches no end points, no conclusions transcending what went before. Endlessly resourceful, his line can transpose anything visible into one equalizing system or another—as in his *Photogrids* (1976), which, in principle, have a place for everything the camera can record—though, of course, he began with snapshots of windows and grates and other objects that show an affinity for minimalist form.

\* \* \*

• The younger artists who felt the authority of minimalist form the most powerfully felt it as an irritant. None was more irritated than Mary Miss, who, in 1971, described Minimalism as the ponderous effort of "putting the most theoretical weight on the least complicated physical object."[16] Yet the box supplied her with all the forms she considered legitimate—line in particular, though she bent chicken wire into an array of boxy forms in 1971. Obviously hand-made, these airy objects displayed formal quirks that no Minimalist would have tolerated.\Likewise, *Grate* (1966) is a squared-away form, too distinctively inflected to make it

SOL LEWITT, *Photogrids*, 1977. Artist's book. Detail.

welcome among neatly the fabricated works of Robert Morris and Donald Judd. In place of minimalist theory's generalizations, *Grate* puts the textural particulars of its weathered materials: old wooden beams, arranged in a rectangular pattern, and the old-fashioned metal grate that covers its central opening.

In 1973 Miss made her own gratelike structure from wooden slats, which filled a shallow, seven-by-seven-foot hole with an irregular grid. By then, she could no longer be considered a maker of objects. As the 1960s ended, she had already dismantled the minimalist box and deployed its elements in the landscape—or, in keeping with her insistence on specificity, one might say that she had found ways to use lines and planes to engage particular landscapes. During 1968–69, she used wooden stakes and lengths of rope to mark off stretches of terrain. This was a sort of drawing on the earth and sometimes in the air above the earth, though Miss never imposed a motif on a setting. Rather, her patterns of rope always responded to the shape of the site. *Ropes/Shore* (1969) reached along the edge of Ward's Island, New York, for over a mile, echoing its contour.

 That year, Miss installed a series of V-shaped forms at seventy-five-foot intervals in a sloping field. Viewed from one direction, each seemed to stand one directly above the next, in a compressed space. From the other direction, they zoomed at surprising speed toward a vanishing point. Either way, an immense, amorphous space was given a startlingly precise definition. As Miss has said, "I try to turn a vague situation into something definite. . . . I am dealing with individual experiences of reality rather than grids or formulas, and the resulting works are traces of those experiences."[17] *Untitled* (1973) was a series of five fence-like forms, each twelve feet wide and just over five feet high. Miss

placed them fifteen feet apart on a flat stretch of landfill in lower Manhattan, along the Hudson River. Because each was pierced by a large circular opening, viewers could look through the entire series. The first opening appeared at the top of its fence. The others were progressively lower—they descended like a setting sun. So one's view was of a columnar space growing steadily narrower, or somehow sinking into the earth, and cleaving this work to its site. In Minimalism, the lines that define regular objects also regulate vision, teaching it to conform to geometric generalities. In Miss's art, those lines became sight lines, vectors of the viewer's vision, focused on the particularity of particular landscapes.

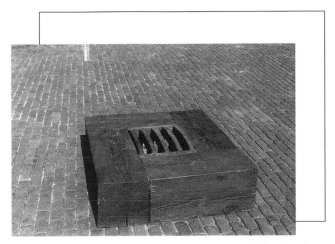

MARY MISS, *Grate*, 1966. Wood and Steel, 12 x 9 x 4 inches. Collection: Brown University Department of Art, Providence, Rhode Island.

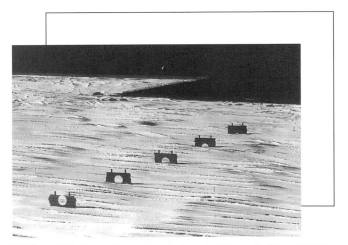

MARY MISS, *Untitled*, 1973. Wood, five parts. Each part 5¹/₂ by 12 feet. Battery Park, New York, landfill installation. Courtesy of the artist.

ROSEMARIE CASTORO, *Cold Sake*, 1971. Gesso and graphite on board, 14 feet wide x 14 feet deep, 84 to 74 inches high. Courtesy of the artist.

# LINE ENLARGED

"Five, six, pick up sticks
Seven, eight, lay them straight."
*Richard Long, 1980*[1]

One night in the spring of 1968, Rosemarie Castoro rode a bicycle along a circuit encompassing twenty square blocks of midtown Manhattan. "I had a gallon of paint attached to my bike, with a hole in the bottom," she recently recalled. "As long as I kept moving, there was a line of drips. Once, when I had to stop at a red light, a man in a car pointed out that the paint had begun to puddle. Actually, I used quite a lot—four gallons—and it took me three hours. Afterwards, I went to Max's, which was the artists' bar in those days. Also, St. Adrian's, which was farther downtown. Anyway, I went back the next day to photograph the drips. It was part of a series of pieces called *Streetworks*, organized by Scott Burton and John Perreault. We would just do them and run away."

Usually, Castoro's lines were solid: long strips of aluminum tape applied to a floor or the city pavement. "These were my *Cracking* pieces," Castoro says. "The idea was that the line would crack open the floor or the city, and things would emerge. I even stuck a length of tape to my own face." Of these works, she says, "When you break something open, you see what's inside. You bring the inside out." When Castoro used line to break open the box of gallery space, what came out was a new possibility for line itself. The Minimalists had used it to structure matter. With the sheer perspicuity of their objects, they declared that emotions, the human form, and the ordinary world were beside the point of art. Castoro found that the minimalist line was flexible. Its authority was versatile. It could be used to structure all the feelings, forms, and drifts of daily incident that Minimalism had dismissed.

On her canvases of the late 1960s, pencil lines crisscrossed in seemingly random patterns, and they look random even after the artists explains their rationale. "When I was outside the studio, I would make lists of everything I did. I wanted to know what I was doing. Back in the studio, these lists became patterns that I plotted on my canvases, and the lines show how the points in the pattern are linked." Thus, a hermetic system turns the flow of ordinary activity into elegant but impenetrable

ROSEMARIE CASTORO, *High Tunnel*, 1974. Epoxy, steel, Styrofoam, 27 x 48 x 48 inches. Courtesy of the artist.

drawings on canvas. With these works, Castoro made line the trajectory of intuition, a device for mapping her sense that all the elements of experience are interconnected. •

As the 1960s ended, Castoro turned the canvas into a freestanding panel: a wall of sorts, where interior and exterior meet. Joined in right-angled configurations, these planes allude to foyers, corners, corridors. Brushing a mixture of gesso and graphite onto their surfaces, Castoro persuaded her line to give up its rigidity. Though her patterns still defied interpretation, their textures made immediate sense as the traces of an activity. She was insinuating the improvisations of her hand onto flat surfaces shaped by straight edges: formal simplicities learned from Minimalism. As her layers of gesso grew thicker, Castoro's gesture grew more sinuous. Wide forms like brushstrokes detached themselves from the panels to become planes in their own right. Mounted on walls, they invited an expressionist reading and then deflected it. Clear about the process that generated them, these objects were emotionally opaque. •

• Shortening her sculptures, slimming them down, Castoro gave her three-dimensional works the look of two-dimensional lines. The wall was their page, where their wriggly contortions suggested the human form. Yet the schematism of her minimalist heritage persisted, preventing her art from becoming figurative in any reassuring sense of the word. If one insists, her skinny wall pieces of the early 1970s are images of the body. They are more believable as a calligraphic inventory of notionally human postures: a set of permutations comparable to Sol LeWitt's. Thickening again, her line left the wall to form a variety of shapes—tunnels, ladders, poles. The tunnels can be seen as rib cages, the poles as trees, yet these works guide the imagination to no familiar landscape.

They offer no targets for our empathy. For all their handmade idiosyncrasy, Castoro's lines are as impersonal as the edges that define a minimalist box. ✍

<p style="text-align:center">* * *</p>

Invited in the spring of 1968 to construct a work on the campus of Windham College in Vermont, Carl Andre laid one hundred and eighty-three bales of hay end to end. This was an enlarged version of the line of one hundred and thirty-seven bricks he had lined up on the floor of the Jewish Museum for the *Primary Structures* exhibition of 1966. "I'm putting Brancusi's Endless Column on the ground instead of in the sky," he explained. "Most sculpture is priapic, with the male organ in the air. In my work, Priapus is down on the floor. The engaged position is to run along the earth."[2] At Windham College, Robert Barry sent his line through the air, twenty-five feet above the earth—over twelve hundred feet of nylon cord, stretched between two buildings. Peter Hutchinson stretched his from one point to another on a coral reef.

On a trip to the island of Tobago in 1969, Hutchinson gathered five calabashes and strung them on a twelve-foot length of rope. Then he swam out to a reef, dove, and attached both ends of the rope to the coral surface. Because calabashes are lighter than water, they rose toward the surface, shaping the rope into a parabolic line. To another rope, this one fifty feet long, Hutchinson attached a dozen plastic bags filled with pieces of chopped-up calabash. When he attached it to the reef, nothing much happened at first. When the calabash began to decompose, its carbohydrates turned to gas. Only then did the rope draw a long arcing line underwater. Nearby, he found a line readymade—"a small underwater canyon," which he marked by damming one end of it with a wall of sandbags.[3]

Lawrence Weiner's contribution to linearity at Windham College in 1968 began with a rectangle, seventy by one hundred feet, staked out on a campus lawn. By stringing twine from stake to stake, the artist suspended a geometric drawing six inches off the ground. That year, Weiner incised a line in Mamaroneck, New York, from one side of a driveway to the other. The following year, he dug a trench on a rock beach. It reached from the low water mark to the high water mark. Incised line became incised plane when he removed a thirty-six-inch square of plaster from the wall of a midtown office rented by Seth Siegelaub, who had emerged as dealer in nonobjects—in this case, a reminder of monochrome painting, at once ghostly and brutally literal. Weiner's implements were a chisel and hammer. Five years later, in 1974, Gordon

PETER HUTCHINSON, *Threaded Calabash Underwater*, 1970. Tobago.

Matta-Clark used a chain saw to bisect a house scheduled for demolition in Englewood, New Jersey.

At the dawn of a day early in March 1969, Bill Beckley began to paint a line across a wheat field in Pennsylvania, aiming at the point on the horizon where the sun would set. In the morning, when sun was orange, he used orange paint. During the afternoon, beneath the blue sky, his paint was blue. Then, as the sun began its descent, he switched back to orange paint. When it set, he stopped. The line he had painted was three feet wide and half a mile long. The same year, Robert Morris rode a quarter horse between two posts set two hundred yards apart on a ranch near Edmonton, Canada. Exchanging horses occasionally, he planned to keep riding until he or one of the horses was exhausted. The piece, *Pace and Progress*, was Morris's contribution to an exhibition at the Edmonton Art Gallery. When the rancher saw that a path was being worn in the turf, he called the process to a stop. Inadvertently, Morris had inscribed the earth with a long, straight line. The line Richard Long wore into an English meadow, by walking back and forth through the uncut grass, was entirely deliberate.

About the same time, in 1967, Long made what might be called a landscape sculpture. In the middle ground stood a wooden frame. Painted black, it displayed the proportions of a tallish painting. In the background, a white ring of plywood lay on a stretch of ground which sloped upward to fill the frame. Members of the audience were required to establish the foreground by finding the point that delivered a view of the circle within the frame. Still a student at St. Martin's College of Art in London, Long had learned of the minimalist object, disassembled its constituent lines and planes, and then reassembled them in a space far

GORDON MATTA-CLARK, *Splitting*, 1974. Englewood, New Jersey.

beyond the world of art. With one remarkably elegant tactic, he had broken free of the object and of its container. In 1968 he walked an "X" into a field of daisies. The following year, he made an "X" of rocks in the shallow of a river in the Smoky Mountains of Tennessee.

,Though Long was working at a considerable remove from New York, the capital city of the aesthetic he had claimed for himself, dealers and curators quickly took note. He had his first solo show in 1968. Others followed yearly, in New York and Europe. In 1969, Long was invited to participate in Harald Szeemann's exhibition at the Berne Kunsthalle, *Live in Your Head: When Attitudes Become Form*. His contribution to the catalog was an outline of the Cornish peninsula, blank except for a short line, running due north, marking the ten miles he walked in December 1968.

Sometimes Long constructs a simple geometric figure of wood or stone on a gallery floor. Sometimes he arranges objects in the landscapes he traverses. Chiefly, though, he walks, taking photographs as he goes. He may walk for a certain time—twenty-four hours or as long as there is daylight. He may walk a certain distance—a mile, say, or, in the summer of 1974, a thousand miles in a squared spiral though the countryside of England. Since then, he has walked in less and less hospitable places—Lapland, the uplands of Peru—always following the premises he laid down in the late 1960s. Long has said that he "is interested in walking on original routes: riverbeds, circles cut by lakes." More often he follows a straight line, the shortest distance between two points, or a line found readymade in a cartographer's grid. No less than a Minimalist, Long is obsessed by linearity. He yearns to perfect it, to draw the impeccable line, and to throw his whole body into the task. Thus he draws his lines on the surface of the earth, by traversing it, endlessly, on foot.

43

Boots—one hundred of them—represent the act of walking in Eleanor Antin's photographs. In a long straight line, the boots face the sea. In a curving line, they traverse a deep gully. In concentric circles they surround a circular bed of flowers and in gridded ranks they occupy a supermarket aisle. There are fifty-one pictures in all. The boots appear indoors and out, in the city and the countryside. They take rides in a car and on a boat. Now and then they rest. Printing the records of their activities as postcards, Antin sent them to a thousand denizens of the art world. Art by mail was her response to severe perplexity. •

As the 1960s ended, all the familiar routines of art making and exhibition were in disarray. Antin, who had left New York for southern California in 1968, felt stymied. In those days, she has said, "my work was just too unlike other people's. I was making sculptural portraits of people out of brand-new consumer goods, or classifying people as books, according to the Library of Congress Classification System." A new SoHo gallery planned to show a selection of recent pieces in the fall of 1970. When the gallery failed to open, Antin improvised an exhibition at the Chelsea Hotel on West 23rd Street. At the conclusion of this far from adequate expedient, Antin returned to California, convinced that "there had to be a way to get art in front of people other than sticking it between the blank white walls of New York galleries." So she stuck her images of *100 Boots* (1971) in the mail, and their linear images spread through the networks of the postal system. •

Antin sees her boots not as an array of one hundred identical units but as a singular presence, the hero of an "epic."[4] Nonetheless, the boots look like a crowd, and flocks of people, assembled on successive nights, are brought to mind by the rows upon rows of beer bottles

ELEANOR ANTIN, *100 Boots Move On*, 1971-73. Detail. Photographic postcard.

arranged on shelves by Tom Marioni. The shelves are at the Museum of Conceptual Art in San Francisco, which the artist founded in 1970, after a curatorial stint at a small museum in Richmond, California. At first, he recalled,

> • I thought of sculpture in terms of, at most, an environment, a single room; but after working as a curator, I thought on a much larger scale. I was concerned with all elements of an exhibition, with the publicity, with the arrangements, with the catalog—even with aspects that reached outside the space.[5]

All the elements of an exhibition would count as art only if they were overseen by an artist, so Marioni quit his job at the Richmond Art Center, and opened the Museum of Conceptual Art at 75 Third Street in San Francisco. Every Wednesday night during 1973–74, he served free beer to friends and showed videotapes by other artists. The stacked rows of empty beer bottles, with their labels precisely aligned, are reminders of those evenings and of the linear form at the source of Marioni's aesthetic. In the aftermath of Minimalism, the possibility of a grid lurks in every straight line. So the labels of Marioni's beer bottles can be seen in two ways: as marking off a series of horizontal lines or as constituting the units of a grid that covers an entire wall of his Museum.

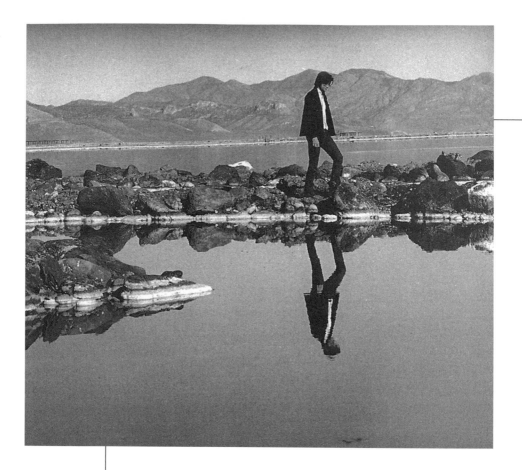

ROBERT SMITHSON, *Spiral Jetty*, 1970. Rocks, mud, precipitated salt crystals,
water; 1500 feet long and 15 feet wide. Rozel Point, Great Salt Lake, Utah.
View of the site, with the artist. Photograph by Gianfranco Giorgoni.

# LINE ERASED

"This is a map that will take you somewhere, but when you get there you won't really know where you are."
*Robert Smithson, 1970*[1]

Snow gives the earth its closest resemblance to a sheet of paper. Dennis Oppenheim liked to draw on it with a chain saw. In the winter of 1968, he cut a fifty-foot trench in the snow and ice near St. Francis, Maine, close to the Canadian border. In the ice of the Moose River, in upstate New York, he opened a channel one hundred feet long and four feet wide. Within twenty-four hours, it had frozen over. Into a static landscape, he introduced change. Then stasis returned, as he hoped it would. Soon afterward, Oppenheim made *Time Line* by incising the St. John River, frozen to a depth of four inches, with a three-mile-long replica of the International Date Line. The St. John separates Maine from Quebec, which meant that Oppenheim had aligned two boundaries, one temporal and the other geographical. On another stretch of the same frozen river, he drew a pattern of concentric but irregular circles that suggest the rings of a tree. This work, *Annual Rings* (1968), resembled a "traditional drawing," the artist has said, but "it was in the dead of winter and snowing constantly, so that this work was invisible in a day or two."

Line became plane in Oppenheim's *Salt Flat* (1969), an immense rectangle of salt spread on the black asphalt of a New York parking lot. *Cancelled Crop* (1969) was a still larger rectangle: a field of wheat, approximately seven hundred feet long by three hundred feet wide, planted in the flatlands of the Netherlands. Line appeared at harvest time. Normally, a mechanical harvester runs parallel to one side of the field. Here, the machine cut an X through the wheat to signify nullification: this crop would not go to market. Its value would be aesthetic, not commercial. The same year, off the shore of Tobago, Oppenheim tossed a blanket into the sea and photographed it as it sank—another plane, this one slowly curling with the grace of a manta ray.

These works survive only in memory, assisted by documentary photographs. Oppenheim's labor on the land and sea produced no objects, even though, as he has said, his outdoor works claim a place in the traditions of painting and sculpture.[2] Yet, he believed, those traditions could

DENNIS OPPENHEIM, ANNUAL RING, 1968. Lines cut in ice, 150 x 200 feet. Boundary
between Canada and the United States at Fort Kent, Maine, and Clair, New Brunswick.
Courtesy of the artist.

survive only by leaving themselves behind. For Oppenheim, the authority
of the minimalist object lay in that paradox. In 1969 he declared, "The
more successful work from the minimal syndrome rejected itself, allowing
the viewer a one-to-one confrontation with pure limits or bounds. This
displacement from object to place will prove to be the major contribution
of minimalist art."[3] Here Oppenheim speaks in the voice of an art histo-
rian intent on establishing the crucial point about a stylistic advance.
Behind this ventriloquism lurks the artist's understanding that no more
crucial points about stylistic advances were to be made.

In the field opened up by the minimalist object, there was no
development, only change: "one thing after another," to use Judd's
phrase. Theoretically, at least, Minimalism had ushered art into real time
and real space, to borrow a pair of phrases from the art talk of the late
sixties. All the old hierarchies had collapsed. In real time, no work of art
is timeless. In real space, the art object is no more privileged than any
other physical thing. Viewed in the long term, even Carl Andre's metal
plates are ephemeral, as he willingly understood. Inviting audiences to
walk on his "carpets," he seemed almost eager for signs that these, after
all, quite durable objects had entered into entropic decline.

The aura of the traditional art object—whether an ancient statue
or a late Picasso—was in such disrepute that documents of outdoor
pieces seemed almost more worthy than the artworks they documented.
In 1968, Oppenheim built *Model*, an object three feet wide by six feet
long. Covered with cocoa mat to simulate a Kansas wheat field, it is
incised with concentric curves borrowed from the contours of a volcano
in Mexico. A summer variant on the wintry *Annual Rings*, the work was

DENNIS OPPENHEIM, *Cancelled Crop*, 1969. Finisterwolde, The Netherlands. Courtesy of the artist.

never built at full scale. Nor was there any compelling need to enlarge it, especially after Oppenheim had documented his ability to execute works of "land art" under extreme conditions.

Lines on a model were as significant as lines on the surface of Kansas. And lines on a map meant no less. *Migratory Alteration of Time Zones* shows the United States with the boundaries of its four time zones redrawn to coincide with the flyways followed by migratory birds. Thus lines fixed by bureaucratic fiat acquired a certain limberness and a new affinity for the habitats they traversed. Oppenheim had no hope of realizing his proposal, of course, but this impossibility drained no power from his line of speculation.

\* \* \*

Water froze, snow fell, and the lines Oppenheim drew in the ice were obliterated. Wind and the baking sun had the same effect on the two lines Walter De Maria drew across the floor of the Mojave Desert in 1968. These lines were parallel. His next lines of chalk, drawn the following year, formed a cross on the bed of a dry lake in Nevada. One arm of the cross was five hundred feet long, the other a thousand. Later, in 1969, he directed bulldozers to scrape four trenches from the scrubby desert north of Las Vegas. Two of the lines were a mile long. The others were half that length. Oriented north-south and east-west, these trenches formed a strictly rectilinear pattern—the mapmaker's grid lines literalized.

As these works were being executed, De Maria planned yet another: two mile–long bulldozer cuts, one in Africa, another in India,

and a mile-square cut in the United States. The elements of this *Three Continent Project* were to be oriented so that, when photographed by satellite, their juxtaposed images would form a cross within a square. Only the African cut was made, in the Sahara Desert. *Three Continent Project* has yet to be seen. De Maria's other works from 1969, *Desert Cross* and *Las Vegas Piece*, are worn away and thus visible only in the photographs that, from the start, supplied nearly all the members of the artist's audience with their view of his desert drawings.

To put bulldozers to work in the desert is a cumbersome task. It's difficult, as well, to find a stretch of land where it can be done. De Maria's guide was his friend Michael Heizer, an artist whose father had learned the ins and outs of desert excavation as an anthropologist specializing in the ancient cultures of the Southwest. During school vacations, Heizer had sometimes accompanied his father on expeditions into the wilds of California and Nevada, and that is where he fled when, as a young painter, he found the New York art world too exasperating. In 1969, he borrowed the tone of political protest to announce in the pages of *Artforum*, "The position of art as malleable barter exchange item falters as the cumulative economic structure gluts. The museums and collections are stuffed, the floors are sagging, but the real space still exists."[4] In real space, he believed, an artist's actions could have a credibility unattainable in the studio. Heizer began drawing lines on the desert floor.

At first he was discrete. *Compression Line* (1968) is a triangular tunnel of wood running sixteen and half feet beneath the surface of the Mojave Desert. Over the next few years he made long, shallow indentations in the desert floor. He excavated trenches, some of them over two thousand feet long. *Circumflex I* (1968) begins as a sinuous line and then makes an exuberant loop. *Rift* (1968) reached over a dry lakebed like a jagged hieroglyph. In 1970, he hired motorcycle racers to inscribe vast, interlocking circles in the earth. Back in New York, Heizer etched a curving line into the plate glass window of Max's Kansas City, then the favorite artists' bar. During a fistfight, the window was broken. Heizer remade the piece, bigger this time. Another fight again destroyed it, and again the artist remade it, bigger still. Having noted Heizer's knack for immensity, one might assume that his etchings got better simply by getting bigger. In the aftermath of Minimalism, however, bigness was not obviously a virtue, even for Heizer. ❙

• A late sculpture by David Smith reminds us of a human figure, so we approach it with a certain sympathy. Because it is taller than we are, it impresses us as monumental, no less so than Michelangelo's *David*. We say of sculptures like these that they attain a grand scale, meaning

not merely that they are large but that they occupy elevated places in a hierarchy that reaches from the lowly to the transcendent. Questions of scale are questions of virtue. Because we feel no bodily affinity with a Judd box or a LeWitt lattice, these objects find no place in the traditional hierarchies of scale. Thus there is no reason to call them monumental or miniature, whatever their measurements might be.[5] The object is the size it is, literally, and this literalism was the Minimalists' chief legacy to younger artists.

Around 1968, Heizer dropped a few matches on the ground, noted their configuration, and transposed it to a sheet of paper. Then he transposed the same pattern to the floor of Black Rock Desert, in the form of immense troughs.[6] There's no reason to consider the desert piece an improvement on the drawing, especially when the artist has said, on site:

> Basically, this is invisible art. . . . It will survive only as memory. Memory will supplant abstraction as an alternative to life. I make books called photomemories, pictures of my things. I don't like feeling burdened by objects. I like to rent everything. All this equipment is rented. I make art that blows away, then it's only a memory. I can go on to something else.[7]

After Minimalism, big was not inherently better, more impressive, than small, nor was small any better than big. They were interchangeable, at least for artists who had been impressed by the minimalist object—the configuration of line and plane that can be seen as a form, as the embodiment of a concept, or as the upshot of a process. No view of the object could ever take precedence over any other, and so it was impossible to claim superiority for any extrapolation of line or plane. Carl Andre claimed an admirable modesty for the line of hay bales he sent along the ground, yet the work's ground-hugging policy made it no better or worse than the line Robert Barry sent through the air. No size or scale, no form or material, could claim an innate superiority.

What counted was the perspicuity of the evidence that one had worked one's will. Evidence of that sort can appear at any scale and in any number of ways, not all of them requiring a line to be drawn or a plane to be constructed. By the end of the 1960s a fog of contingency had enveloped the very idea of the object. In 1969, Lawrence Weiner found it possible—or, in some sense, necessary—to publish these declarations about all his works:

> 1. The artist may build the piece.
> 2. The piece may be fabricated.
> 3. The piece need not be built.
> Each being equal and consistent with the intention of the artist, the decision as condition rests with the received upon the occasion of receivership.

A year later, Weiner added a clause:

As to construction, please remember that, as stated above, there is
no correct way to construct the piece, as there is no incorrect way
to construct it. If the piece is built, it constitutes not how the
piece looks but only how it could look.[8]

In *Statements* (1968) Weiner described eighteen pieces, among
them:

A field cratered by structured simultaneous TNT explosions . . .
One sheet of plywood secured to floor or wall . . .
One sheet of transparent plastic secured to the wall or floor . . .
One sheet of clear Plexiglas of arbitrary size and thickness secured
at the four corners and exact center by screws to the floor . . .
One hole in the ground approximately one foot by one foot by
one foot; one gallon of water-based paint poured into this hole . . .
A two-inch wide, one-inch deep trench cut across a standard one-
car driveway . . .

Weiner executed some of these works, including the last. Of
course someone else could have cut the "trench" or it could have
remained uncut. Or Weiner could have incised some other driveway with
a method other than the one he used. No artist who learned of line from
the minimalist object ever tried to draw precisely the *right* line. The
point of moving on from Minimalism—the point of escaping from the
box—was to free art from the illusion of rightness the box acquired soon
after it came into focus. Weiner and others of his generation gave their
lines, planes, and grids an air of contingency, a look of being intended
fully but not inevitably. In the aftermath of Minimalism, there was a feel-
ing that one needn't realize one's intentions to justify them.

*       *       *

Robert Smithson's 1969 show at the Dwan Gallery featured
Nonsites, bins filled with material collected in the places mapped by
documents mounted on the gallery walls. The five metal compartments
of *A Nonsite, Francine, New Jersey* (1968) contained rocks gathered from
the terrain pictured in the five strips of aerial photography that accompa-
nied the piece. For each bin on the floor there was a photographic image
of the same trapezoidal shape on the wall. A wall label noted that "Tours
to the site possible. The five outdoor sites are not contained by any lim-
iting parts—therefore they are chaotic sites, regions of dispersal, places
without a Room—elusive order prevails."[9] *Mono Lake Nonsite* (1968) has
two parts: on the floor, a narrow metal trough, forty inches square, filled
with cinders from the shores of Mono Lake in Nevada; on the wall, a

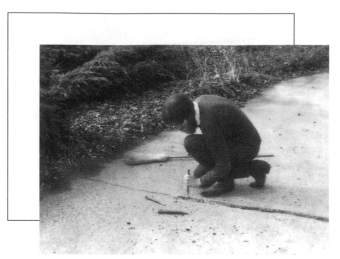

LAWRENCE WEINER, *A 2" Wide 1" Deep Trench Across a Standard One-Car Driveway,* 1968. Mamaroneck, Long Island, New York.

map of Mono Lake and environs. Mostly blank, its legible zone is confined to a strip around the edges that corresponds to the thin form on the floor.

A line links site and nonsite. For his show at Dwan, Smithson designed a linear announcement: a strip of paper about thirty inches long, folded like a ruler for dispersal through the mail and imprinted with a portion of the Mono Lake map. All lines are directional, yet Smithson was eager to disabuse his audience of the hope that any of the lines in his art, visible or imaginary, led anywhere. In a chat with Dennis Oppenheim and Michael Heizer, Smithson said of the Mono Lake piece, "The interesting thing about the site is that, unlike the nonsite, it throws you out to the fringes. In other words, there's nothing to grasp onto except the cinders and there's no way of focusing on a particular place. One might even say that the place has absconded or been lost."[10] Smithson used line to make bafflement perspicuous.

Yet, one might say, nothing could be clearer than *Spiral Jetty* (1970), Smithson's major earthwork and, as pictured in aerial photographs, an icon of postwar American art. Extending from Rozel Point on the shore of the Great Salt Lake, it is as wide as a one-lane road and fifteen-hundred feet long: a line of dark rubble encrusted with white salt, turning in on itself, as it stretches over the plane of water tinged a bright pink. But this spectacle is visible only from above. Those who have walked out on the jetty say that it feels like an open-air labyrinth.[11] And it isn't always easy to see it from any vantage point.

One day in 1981, Mary Livingston Beebe, a curator from Portland, Oregon, set out to see *Spiral Jetty.* Yet "even with precise directions," it "proved elusive."

ROBERT SMITHSON, *Mono Lake Non-Site*, 1968. Painted steel container, cinders, and map photostat. Map, 20½ x 40¼ inches; container, 7 x 39½ x 39½ inches. Collection: Museum of Contemporary Art, San Diego.

After an entire day on miserable roads, frustrated and angry, I sought the assistance of a rancher. He confirmed that I had followed the directions exactly but was able to suggest another possible route. I drove another forty miles, saw a wonderful pelican, an abandoned structure of some kind, and some horses—but no jetty. The water was pink with brine shrimp; the salt built up eerily on the shores. I knew the territory was right and I had to be close, but the great picture was in my mind and not in my camera. I shall return one day with a tougher car and a foolproof map.[12]

In the land of earthworks, "the great picture" may have nowhere to be but in the mind, even if a site proves to be findable and the work is in good repair.

In 1965, Robert Morris began sketching plans for a sculpture too big to fit inside a gallery. His model was Stonehenge, a structure keyed to the yearly cycles of the sun. From the form of that Neolithic monument he would take only circularity, though its example wasn't crucial: circles had already appeared in Morris's outsized *Wheels* (1963). In 1966, he completed *Untitled (Ring of Light)*. Two feet high, an inch over eight feet in diameter, it is divided into two precisely symmetrical parts. The linear opening between them is filled with fluorescent light. Five years later, Morris had the chance to build a circle of earth, stone, wood, and steel in the Netherlands, close to the sea. Called *Observatory*, it was two

ROBERT SMITHSON, stills from *Spiral Jetty*, 1970. 16 mm film.

hundred and thirty-three feet in diameter. Funds for its construction had come from *Sonsbeek '71*, an international sculpture exhibition. There was no money for its upkeep, and *Observatory* quickly disintegrated.

In 1977, the citizens of Oostelijk, Feveloand, an island east of Amsterdam, sponsored a second version of the piece. This one was even larger—nearly three hundred feet across. Both versions of *Observatory* are pierced by openings aligned with the summer and winter solstices and the equinoxes of spring and fall. Four times a year, the sculpture draws a line between the properly positioned viewer and the point where a major event in the solar calendar is occurring. The rest of the year, these lines—imaginary even as one looks along them—can only be imagined. Nancy Holt's *Sun Tunnels* (1973–76) are also focused on the movements of the sun—its rising and setting on the summer and winter solstices. There are four of them, massive objects cast from concrete and placed in the form of an X on the floor of Utah's Great Basin Desert. Nine feet in diameter and eighteen feet long, they invite one out of the sunlight, into their shade.

Holt has explained that

> the configuration of holes in the upper half of each tunnel corresponds with a constellation, either Capricorn, Columbia, Draco, or Perseus. The four diameters of the holes vary from seven to ten inches, relative to the magnitude of the stars to which they correspond. During the day, the sun, a star among stars, shines through

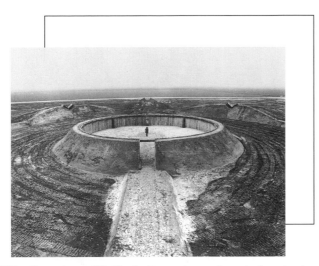

ROBERT MORRIS, *Observatory*, 1971-77. Earth, wood, granite, steel, and water, 298 feet, seven inches in diameter. Oostelijk, Flevoland, The Netherlands.

the holes, casting a changing pattern of pointed ellipses and circles of light on the bottom half of each tunnel. The shapes and positions of the areas of light differ from hour to hour, day to day, and season to season, relative to the position of the sun. The spots of warm light in the cool shady tunnels are like stars cast down to earth, inverting the sky, turning day into night. And on many desert nights, moonlight shines through the holes, castings its own paler pattern.[13]

Only rarely does the sun appear at the far end of a tunnel. More frequent but still rare are the occasions when lines reach through the holes in a tunnel's roof, connecting the eyes with a pattern of stars. Then, slowly, the objects that comprise the universe shift their positions and the lines of connection are lost.

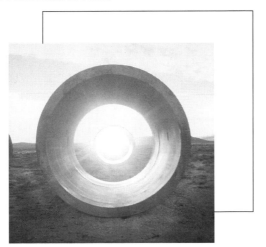

NANCY HOLT, *Sun Tunnels*, 1973-76. Four concrete tunnels, each 18 feet long and 9 feet in diameter. Great Basin Desert, Utah.

WILLIAM ANASTASI, *Nine Polaroid Photographs of a Mirror*, 1967. Nine black and white instant prints mounted to a mirror. The Metropolitan Museum of Art, New York. Barbara and Eugene Schwartz and The Horace W. Goldsmith Foundation Gift, 1994.

# FROM LINE TO GRID

"Compositions breed involvement, intimacy, and references to the self. Grids generate a greater emotional distance—a sense of the presence of objective, pervasive law."
*Amy Goldin, 1975*[1]

Usually, to extend a line is to lengthen it. Yet a line can be extended laterally, to produce a plane. Mark this lateral extension—this flat surface—at regular intervals, and a pattern of parallel lines appears. Rotate the surface ninety degrees, carry out the same procedure, and the parallel lines become a grid. Sol LeWitt's grids imply drafting-table procedures like these. Carl Andre's follow from a procedure he has formulated only in the most general terms. First he finds "sets of particles." Then he lets their salient traits dictate "rules for combining them in the simplest way." If the particle is a block of plastic too small to handle easily, he might drop a batch of them on the floor. A "scatter piece" results. If the particle is a square plate of metal, he squares them away in rows.[2] Then, perhaps, he abuts the rows, and a grid appears. Always, Andre prefers to speak not of grids but of his program for generating them. Dan Flavin, who sometimes arranged fluorescent tubes in a grid, had nothing to say of this device. LeWitt mentions it now and then, but only as "a convenience."[3] For Wassily Kandinsky and other painters on the geometric front of the modernist advance, the grid was far more than that. It was the foundation of painting and an emblem of the cosmos.

With the title of a book he published in 1926, Kandinsky marks a path we have already taken: from *Point and Line to Plane*. This primer of geometric abstraction proceeds step by step, from points alone and in clusters to straight lines and curves, and onward to lines that form into planes of various sorts. Along the way, Kandinsky talks of color and meanings the mind associates with the eye's discoveries. Not until he is well into the final chapter of his book does Kandinsky show a plane divided into a grid, which he fills with arrows indicating the "tensions" inhabiting each quadrant. Some are "lyric," others are "dramatic."[4]

Painters alive to these tensions give life to the lines they send across the canvas. We come alive as viewers when we sense the vitality in the contour of a form or a mark floating free across the canvas. "For," as Kandinsky says, "there can and do exist cheerful lines, gloomy and seri-

ous lines, tragic and mischievous, stubborn lines, weak lines, forceful lines, etc., etc."[5] Liberated from the task of recording the look of familiar things, line attains purity. In concert with pure color, it inflects the static simplicities of the rectangular surface, charging this merely physical object with "painterly-spiritual essences."[6] Only the vaguest residue of a grid is to be glimpsed in a fully realized composition, the painter's invocation of the transcendent Reality that resides somewhere beyond the veil of ordinary appearances.[7]

The visionary modernists—Kandinsky, Piet Mondrian, Kasimir Malevich, and dozens more—obscured the grid by complicating it with thrusts and counterthrusts of shape and color. In each of their compositions, a hierarchy emerges, with small forms happily subordinate to large. The goal was a harmony that would dignify the very idea of hierarchy and guide the audience to invidious distinctions of the most exalted sort: mind over matter, Reality over appearances, pure art over any practical concern. A grid in its uninflected state encourages no such patterns of subordination, and therefore held little interest for Kandinsky and his colleagues. Or for most artists, of whatever stylistic inclination. In the light of Western ideals, aesthetic and even moral, the minimalist preoccupation with the grid is, at best, peculiar. •

• To explain the static, repetitious forms of minimalist objects, Barbara Rose suggested in 1969 that we see its "use of standard units, 'self-sufficient' nonrelational forms and nonhierarchical arrangements of equal members, as a metaphor for relationships in an ideally leveled, unstratified anti-elitist democratic society."[8] Asked if one ought to read that sort of meaning into his gridded sculptures, Andre said, "That strikes me as the kind of idea that comes to a critic because a critic tries to impose upon an artwork linguistically intellectual propositions. . . . But I don't think artists think that way at all, at least, I don't. I think in terms of a physical reality."[9] •

Physical reality is an aggregate of atoms, which Andre celebrated on the occasion of his exhibition at the Dwan Gallery in May 1969. Advertisements for the show reproduced the periodic table of the elements, a grid with one hundred and three compartments arranged rather more erratically than the artist arranges his plates of metal—but a grid, nonetheless, and an emblem of his devotion to matter unencumbered by meaning.[10] LeWitt, too, sees the grid as a form without meaning, though he has spoken of its use: "It stabilizes the measurements and neutralizes the space by treating it equally. . . . This eliminates the arbitrary, the capricious, and the subjective as much as possible. . . . The form itself is of very little importance."[11]

In LeWitt's gridded sculptures, adjacent cubes of space share

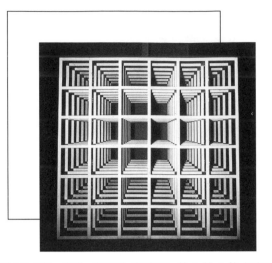

SOL LEWITT, *Modular Cube*, 1969. Painted aluminum, 60 x 60 x 60 inches. The Art Gallery of Ontario, Toronto.

the structural elements that define them. So these elements function in the manner of lines drawn on a sheet of paper, not as analogues to an architect's beams.[12] Though LeWitt's objects are obviously products of the fabrication shop, they have the look of drawings: products of the engineer's drawing board. The passage from LeWitt's drawing-like sculptures to his wall drawings is clear. Of course, the drawings are not for the most part gridded, but they are always the products of instructions as simple as the ones that generate grids. Because these drawings are executed by functionaries following the artist's instructions, the hand that generates these works remains impersonal: the anonymous agent of an intention not its own. The disengaged clarity of the grid illuminates LeWitt's art even when no grid is visible.

\* \* \*

Ed Ruscha is a Los Angeles painter. During the latter half of the 1960s, he worked as the designer-in-chief at *Artforum* under the pseudonym "Eddie Russia." Far from awed by the minimalist aesthetic, he nonetheless employed a modular scheme—in Judd's phrase, "one thing after another"—to generate books full of photographs, one image to a page, one subject to a book: palm trees, Los Angeles apartment buildings, swimming pools, gasoline stations. *Thirtyfour Parking Lots in Los Angeles* (1967)[13] is a sequence of aerial views. Each shows what might be called a pavement drawing, not made but found. Most are clusters of grid fragments, usually skewed and always neatly aligned. However, the lines that mark off the asphalt at *7101 Sepulveda Blvd., Van Nuys* form a grid as

EDWARD RUSCHA, "7101 Sepulveda Blvd., Van Nuys," from *Thirtyfour Parking Lots*, 1967. Artist's book.

rectilinear and, at its center, as neatly enclosed as any by Sol LeWitt. At one end of the lot stands a cubical office building with gridded façades. Seen from the air, this building becomes minimalist box—or unintended parody of the box, the work of an anonymous builder. ·

·Once the minimalist object had established its authority, grids became ubiquitous. John Baldessari imposed them on photographs of *Palm Trees in the Wind* (1972) to chart the variations of their elegantly unruly forms. Whenever an earthworker's documentation included a map, there would be a cartographer's grid. When Douglas Huebler made documentation itself the focus of his art, he presented his texts and photographs in gridded arrays. Mel Bochner used grids to work out the permutations of a set of numbers. And when he had extracted the range of options offered by a set of axioms, he would sometimes arrange them in rows that—in those days—had the look of verbal grids. The minimalist object had attuned all eyes to grids. One noticed them in the layouts of art magazines—especially *Avalanche*—and in museum catalogs, where film strips of performance and process pieces were sometimes juxtaposed, widening linear sequences into gridded patterns of black and white.

Working in the south of France during the early 1960s, Bernar Venet made a series of all-black paintings and photographs. He designed a book with black pages and installed a heap of coal on the floor of the Museum of Modern and Contemporary Art in Nice. On his first trip to New York, in 1966, Venet saw an exhibition of abstract art by American painters and sculptors. The canvases of Ad Reinhardt convinced him that there was nothing further to be done with painting. Objects by the minimalists convinced him to stop inventing forms. Instead, he would present

enlargements of diagrams borrowed from scientists and mathematicians. To ensure the absence of taste or intuition, Venet asked others to choose the images to be enlarged. Unintelligible to nearly everyone who saw them, these works had only one familiar feature: the grid.

Nothing is more intelligible than a snapshot. Casually pointed at the world, the camera generates much of the imagery that makes the world familiar. Pointed at itself, the camera removes us from the world. In 1971, the English artist James Hillyard arranged a pair of mirrors so that his 35mm camera could take a series of seventy self-portraits: at each of seven lens apertures, ten exposures at increasingly rapid speeds. At one extreme, the camera's picture of itself looks like a photograph of an all-white painting; at the other extreme, the image is all-black. Distributed along the axes of the grid, the set of seventy photographs makes a smooth transition from blankness to recognizable images to the inverse of the original blankness. Caught in a closed circuit, viewers have a limited set of options: to identify themselves with the self-reflective camera or not. Hillyard's *Camera Recording Its Own Condition* leaves nothing else visible, except for a bit of his hair and his fingers snapping the shutter, a fragmentary figure allegorizing the serial method.

Four years earlier, William Anastasi had produced a similar set of permutations with a Polaroid camera and one mirror. The first image shows him behind the camera, clicking the shutter. In the second, he appears in the same pose with the print produced by the first shot visible in the mirror's upper left-hand corner. Repeating the procedure seven more times, he placed each print in sequence on the surface of the mirror. In the ninth and last image, the mirror is divided into a nine-by-nine grid, as is the work itself—*Nine Polaroid Photographs of a Mirror* (1967). Hillyard's photographic grid moves in even stages from one kind of blankness to another. Anastasi's permutations generated grids within grids, each image containing more griddedness than the last, and the final one offering a hint of infinite regress.

\* \* \*

Stéphane Mallarmé's devotion to language was extreme but perhaps not equal to the love he felt for the place where words become visible: "le vide papier que la blancheur defend," or "the empty page defended by its own whiteness."[14] In his last long poem, "Un coup de dès jamais n'abolira le hasard" ("One throw of the dice cannot abolish chance"), 1897, words drift from the first to the second page of a double spread, then on to the next double spread and the next. Unfurling slowly from left to right, Mallarmé's lines are inflected by all the whiteness they

leave undisturbed. Meaning is affected as well by the primly sensuous shapes his lines assume.

Remembering Mallarmé and excited by the flicker of words in Cubist collage, Guillaume Apolinaire bent the lines of his *Calligrammes* (1918) into jittery hieroglyphs. Poets among the Italian Futurists followed suit, and soon the liberation of language from standard typography had been declared by Constructivist utopians, form masters at the Bauhaus, and the various factions of Dada. From their early modernist inventions emerged the tradition of concrete poetry: writing that generates meanings from the arrangement of words on the page. Often, the forms of a concrete poem mimic the thrusts and counterthrusts of pictorial composition. As Donald Judd said in 1964, these effects "carry with them all the structures, values, feelings of the whole European tradition." He added, "It suits me fine if that's all down the drain."[15] A few years earlier, Carl Andre had discovered that one could rid concrete poetry of composition with the help of a typewriter. As he explained, "A typewriter has even spacing on the lines, as opposed to print, which is a justified line. . . . A typewriter is, essentially, a grid. You cannot evade that situation if you use a typewriter."[16]

In his review of *The Word as Image* (1970), an exhibition at the Jewish Museum, John Perreault dismissed it as "boring, boring, boring."[17] What bored him was the persistence of composition's familiar devices in the work of the concrete poets. He preferred the symmetries and serial patterns of minimalist art. Best of all, he liked minimalist devices freed from minimalist objects like Judd's boxes or LeWitt's lattices. In the January 1969 issue of *0 TO 9*, a magazine edited by Bernadette Meyer and Vito Acconci, Perreault published a work called *Scramble*. Beginning with a squarish block of type that told the story of a trip, he numbered every word. Then he arranged the words in alphabetical order, each one accompanied by its number.[18] With the help of these numbers, one could put the words back in their original order. Yet there is not much reason to suppose that the scrambled story is worth the labor it would take to unscramble it.

In his *Word Room* (1969) at the Gain Ground Gallery, Perreault projected words on the wall, one at a time, at a scale that invited the look of language to overwhelm its usual sense. Meshing with the grid's imperatives, words were forming patterns more compelling than anything these writers were giving them to say. In 1969, Vito Acconci published a work that begins:

In the first place, he wrote, from left to right: "Afghanistan occup
Second, from one side to the other, he wrote: "Albania is a narrow m
Beginning at the margin, on the third line, he wrote: "Algeria is lo

And so it continues, the first eight lines continuing to the right-hand edge of sheet and invariably referring to themselves by number. Then the entire block of text shifts to the right, leaving blankness to the left. Shifting back, it continues to the bottom of the page, offering more geographical information as it goes.

Acconci is not presenting the reader with an opportunity to learn about Afghanistan or Albania. Rather, he provides an occasion to become conscious of the act of reading—of moving the eyes from left to right, then down a line, then from left to right, then down.[19] Another work begins:

READ THIS WORD THEN READ THIS WORD READ THIS WORD NEXT READ THIS WORD NOW SEE ONE WORD SEE ONE WORD NEXT SEE ONE WORD NOW AND THEN SEE ONE WORD AGAIN LOOK AT THREE WORDS HERE LOOK AT THREE WORDS NOW . . . [20]

As Minimalism enforces—or would like to enforce—a perfect congruence of mind, eye, and object, and to offer the gallery space as the site absolutely congruent with this congruence, so Acconci tries to merge the reading of a word with the seeing of that word, and to give the page the look of a place perfectly merged with this merger.

In a variation on language of this sort, Adrian Piper requires sentences to share the page with three sixty-four-unit grids. Each unit of each grid is numbered, in a sequence that spirals inward. One squared spiral encompasses the first grid entirely. The second grid is halved, and in each half a spiral turns in on itself. Each quadrant of the third grid has its own spiral. Thus Piper distributes her sixty-four integers in three ways. None looks any more logical—or illogical—than the others. The allure of the grid, it seems, does not emanate from the necessities it enforces. It enforces none, and that may be why so many found it so enchanting. Piper's untitled works fill three pages in the January 1969 issue of *0 TO 9*.[21] Having constituted her smallish grids as alternatives to one another, Piper fills the remaining space with further alternatives, in meticulously worded—and, of course, numbingly repetitive—sentences. Neither her gridwork nor her language are any more logical—or illogical—than the other.

*Concrete Infinity 6" Square* (1968) begins:

This square should be read as a whole; or these two vertical rectangles should be read from left to right or right to left; or, these two horizontal rectangles should be read from top to bottom or bottom to top; or, these four squares . . .

This square of typewritten words is not, strictly speaking, a grid, yet its verbal units are tightly contained by the pattern of words and

spaces that emerges as Piper's "or" drives her variations across the page. And this "or" defies the enclosure it generates, for the set of alternatives is infinite.

The artist said, much later, that her work of the late 1960s owed much to Sol LeWitt. He had turned to language in 1967, with his "Paragraphs on Conceptual Art."[22] She made the same turn

> because I wanted to explore objects that can refer both to concepts and ideas and their standard functions, as well as to themselves; objects that both refer to abstract ideas that situate those very objects in new conceptual and spatiotemporal matrices, and also draw attention to the spatiotemporal matrices in which they are embedded.[23]

She wanted to get far beyond the moment of minimalist awe, when what you see is what you see and nothing need be said about it.

*Here and Now* (1968) is a loose-leaf book with sixty-four pages. Each page is eight inches square and marked off by an eight-by-eight grid. In every grid, sixty-three units are empty. The sixty-fourth describes its position: which vertical row it occupies, which horizontal row. Paging through the book, one sees this description change as it moves from square to square, through the sequence of its sixty-four possibilities. Thus Piper locates her "here and now" with obsessive precision. She also prompts us to wonder if it is possible to contain the here and now within the boundaries of a grid and the time it takes to grasp its permutations.

"Here" must also include the art world that encouraged a sharp focus on grids, and if so, how can it not include the full sprawl of the culture that prompted the art world to become what it was in the sixties and is at the moment? "Now" is this instant, a season, the decade, one's era. But how can "now" enclose us when memory, conscious or not, is forever taking us to the time when such ideas as "now"—and "here"—were first becoming intelligible? The longer one leafs through *Here and Now*, the harder it is to distinguish the two concepts from "there" and "then." Piper uses grids to undermine our faith in griddedness, our hope that the distinctions drawn by certain lines will turn out to be inherently clear— not only here and now but forever. Inviting us to read common words as literally as if they were the common forms of minimal art, she induces literalism to defeat itself, and the grid's lingering aura of apodicticity vanishes.

ROSEMARIE CASTORO, *Sociology of City Living*, 1971. Pen on paper, 8 1/2 x 11 inches. Courtesy of the artist.

# GRID CONTINUED

There is a recent trend toward 'two home homes' which are
two boxes split by adjoining walls and having separate
entrances. The left and right hand units are mirror
reproductions of each other. Often sold as private units
are strings of apartment-like, quasi-discrete cells formed
by subdividing laterally an extended rectangular paral-
lelepiped into as many as ten or twelve separate
dwellings.

*Dan Graham, "Homes for America," 1966*[1]

Drawing from the stock of scientific knowledge—nothing advanced, just facts available in standard reference books—Dan Graham made a list of distances in miles. The first was the distance from "the retinal wall" to the cornea: .00000098 miles. It was, he calculated, .00000700 miles from his retina to the lenses of his glasses, farther to the typewriter page, to the front door of his apartment on First Avenue, to Times Square, to Washington, D.C., to the edge of the solar system. The line stops at the "edge of known universe." The distance to that point, in miles, is represented by a one with thirty-two zeros after it. Usually, Graham tried to confine the attention within conceptual structures that acknowledged the edges of the page, the surface where words appear.

*Schema* (1966) is an alphabetized list of the verbal, visual, and physical attributes of a page: adjectives, adverbs, and other parts of speech; area not occupied by type, area occupied by type; variety and weight of the paper stock; and so on. This general *Schema* can be made particular by examining a printed page, and filling in the blanks: "5 adjectives, 2 adverbs, 69.31% area not occupied by type, 31.69% area occupied by type, 1 column," and so on, to quote one of the artist's examples. There aren't many, for the information generated by this analysis lacks all practical purpose. The point is to formulate a set of procedures with the feel of linearity: alphabetizing, counting, measuring straight edges. Graham had extrapolated from minimalist order a variant that could schematize not only information but the pages—the flat paper objects—where information is gathered.

*His Side Effects/Common Drugs* (1966) is a grid. Distributed along the horizontal axis, side effects range from pallor to anorexia, with headache, depression, and torpor in between. Along the vertical axis, common drugs fall into six types, from stimulants to tranquilizers to contraceptives. Black dots centered within squares show which drugs cause which effects. *Schema* is a guide to an odd, obviously useless method of analysis. *Side Effects/Common Drugs* has the look of a found image, a grid-

ful of practical information that physicians no doubt used in 1966. Displaced to an artist's oeuvre, it acquires uselessness. It qualifies for aesthetic appraisal, as did a publicity shot of Marilyn Monroe when Andy Warhol recycled it as a seemingly endless series of paintings and prints. Warhol's *Marilyn* is a reflection on glamor. Graham's drug chart may cast a revealing light on the pharmaceutical industry or physicians who write prescriptions by rote. Seen as a work of art, its chief effect is to augment the authority of the grid, for *Side Effects/Common Drugs* begins by regulating the patterns of our seeing and ends by reducing a variety of emotional states to functions of an abstract pattern.

At the border where art and poetry met, Graham nearly always stood on the side of art.[1] In 1964, he had opened the John Daniels Gallery, and served as its director. During its first season, it offered lively group exhibitions and a solo show by Sol LeWitt. Though it moved toward the zone opened up by Minimalism, Graham's gallery was economically marginal, and its first season was its last. "If we could have continued for another two years," Graham later wrote,

> with the aid of more capital, we might have succeeded. Nevertheless, the experience of managing a gallery was particularly valuable for me in that it afforded the many conversations I had with Dan Flavin, Donald Judd, Jo Baer, Will Insley, Robert Smithson and others who, if they were not able to give works for thematic exhibitions, supported the gallery by recommending other artists and by dropping by to chat. . . .
>
> The fall after the gallery failed I began experimenting myself with art works which could be read as a reaction against the gallery experience, but also as a response to contradictions I discerned in gallery artists.[2]

Graham admired Andy Warhol, Roy Lichtenstein, and the other pop artists for acknowledging the world beyond the world of art. The Minimalists, by contrast, were content to lock their works into a resemblance to the galleries where it appeared. The effect was too hermetic for Graham's taste, though he preferred the austerities of Judd and LeWitt to the stylish grit of pop. Only Dan Flavin managed to make art restrained in form and obviously, absolutely dependent on the larger world. For if electric power were to fail, fluorescent tubes could not be lit. No piece by Flavin could be seen. No Flavin piece could exist. Graham took this dependence as virtue, for it gave art a link to the world beyond the walls of the gallery.[3]

As a gallery director, Graham had noticed that advertisements and reviews are crucial to an artist's career. Free now to be an artist full-time, he designed ads to be placed in mass-circulation magazines. *Figurative* (1965) is a cash-register receipt. In 1968, it appeared in

DAN GRAHAM, *Homes for America*, 1966. Magazine layout. Detail. Courtesy of the artist.

*Harper's Bazaar*, flanked by ads for Tampax and a Comfort-Curve bra by Warner's. Those are products to be consumed. The long line of numbers on Graham's receipt is a reminder that consumerism has a price, literally and figuratively. For if the marketplace is to fulfill one's desires, one must let it mold those desires to the shapes of the goods it puts on offer.

Toward the end of 1966, Graham published "Homes for America" in *Arts Magazine*. Disguising himself as a critic, he described the "large-scale 'tract' housing 'developments'" that had proliferated in the United States after the Second World War. His tone is flat, his eye for details of construction is sharp. Variants on a homebuyer's options—floor plan, exterior color—appear in tables that resemble the gridded poems of Acconci and Piper. Rows of tract houses in rigid perspective recall the installation shots of minimalist exhibitions that, only a few seasons earlier, had given the box and the grid their aesthetic force. The minimalist object, it would appear, is entangled with ordinary life, for it has borrowed its forms from standardized architecture and design, insisting all the while on its autonomy. And Graham, in his turn, has borrowed his forms from Minimalism.

Not only are his lists gridded but the arrangement of text and image implies an underlying grid—as it could hardly help doing. To enter the magazine page is to accept the rectangular structures of graphic design. Graham's layout of "Homes for America" is insistently squared away, and *Figurative* looks aggressively linear amid the curvy, domestic images of the advertisements that surround it in *Harper's Bazaar*. But even if Graham had

softened the design of *Figurative*, he would have had to accept the page grid. If art is to enter the larger world, it must fit itself to the structures of that world. With his affinity for minimalist form, Graham did not find that difficult to do. Nor did Steven Kaltenbach, when he designed a series of ads for the pages of *Artforum*.

Appearing monthly during 1968–69, Kaltenbach's eighth-of-a-page advertisements offered exhortations, not goods. Against a blank white background, sober type read: "Start a rumor" or "Tell a lie" or, more enigmatically, "Expose yourself" and "Art works." Though they appeared—like Graham's *Figurative*—in the advertising section of a magazine, and the space for them was purchased at the prevailing rate, Kaltenbach meant these non-ads as additions to his oeuvre. Unsigned and offering nothing for sale, they were a reproach to the commercial clutter around them. Friendly and sly, they offered relief from the self-importance of gallery advertisements and of so much art writing, in *Artforum* and elsewhere.

During 1968 Kaltenbach lived in New York and, as he moved about the city, carried a red ink pad and a rubber-stamp image of lips. That year, subway stations were filled with advertisements for Fruit of the Loom underwear. Whenever he could, the artist would leave two imprints of red lips, one next to the corporation's logo and another on the thigh of the model who appeared in the ad. Not obviously hostile, the gesture may even have been flirtatious. It conveyed disapproval, nonetheless, though the artist's target was not clear. Presumably he joined most artists of the 1960s in condemning the corporate establishment. His *Kiss* stamp recalls youth culture's talk of love and flower power. More to the aesthetic point, the anonymity of the mark—like that of his *Artforum* ads—calls into question the traditional salience of the artist's identity.

STEPHEN KALTENBACH. *Art Works*. 1968. Sidewalk plaque series. Cast bronze to be set in concrete. 5 x 8 1/8 x 5/8 inches.

Having fit themselves to the grid of the page, his magazine pieces entered a network of distribution—like Graham's work in *Harper's Bazaar*, which traveled much farther and was seen by many more people. Their tactics took art far beyond the walls of the gallery, yet art like theirs is intelligible only to the initiated. Only the initiated notice it. Finally, Graham's and Kaltenbach's media pieces addressed themselves to a world at the scale of the one Rosemarie Castoro fit into a casual grid she drew on a sheet of typing paper in 1971.

Near the upper left-hand corner of the page is a rectangle containing two dots. One dot represents her and the other represents Carl Andre, then her husband. The rectangle is their loft in SoHo. Three rectangles crawling with dots are the artists' bars of the time: St. Adrian's, on Broadway near Bleecker Street; Max's Kansas City, on Park Avenue South just above Union Square; and Les Levine's Longview Country Club, across the avenue from Max's. That is the nocturnal zone of the grid. In the daylit zone, the rectangles represent stores, movies, restaurants, bookstores, and so on. Another row lists activities: painting, drawing, making money. Castoro entitled her grid picture a "Sociology of City Living." Yet few New Yorkers live in lofts and make art. The city of art is a small metropolis.

\* \* \*

ʹDeep in that city, Jackie Winsor pursued activities not only solitary—most artists work alone—but also contemplative. She pounded nails into a long, thick strip of wood until there was hardly room for another. She gouged a trough from a thick slab of laminated plywood. More often and even more obsessively, she wound astonishing lengths of hemp around ordinary lengths of wood. Winsor had transformed the repetitive forms of Minimalism into actions so repetitious that, one assumes, she couldn't have continued them for as long as she did unless she worked in the depths of a trance.

ʹHer early works were lengths of heavy rope: readymade lines, which she stood on end or coiled into columns and rings. In 1971, she set bricks in concrete to form a sphere. Then she piled more bricks in an open square, using no concrete because gravity kept the bricks in place. Winsor was building minimalist forms by hand, though her touch did not become evident until she began winding and braiding. *Four Corners* (1972) is a set of four sticks placed in a square configuration and held there by strands of hemp wound around the corners in such profusion that four large balls were formed. One can hardly see the sticks. With repetition, Winsor had turned a square into a set of spheres. *Bound Logs*

(1972–73) repeats *Four Corners*, giving it vaguely figurative proportions. The twin logs look as if they are turbaned or possibly bandaged.

Winsor begins with forms as crisp as LeWitt's. "In my mind," she has said, "the idea is perfect." Her plans for idea's realization are perfect, as well. Then she begins and finds that the contingencies of her materials—and her touch—intrude on the idea, afflicting it with particularity. Once she began with twenty sticks, each about seven feet long, and laid them out in a ten-by-ten grid. No form could be more regular, yet all the sticks were slightly bent, one branched, and the hemp had to be wound differently at each crossing. As it leans against a blank gallery wall, *Bound Grid* (1971–72) displays a brilliantly skewed, decidedly ungeometric personality.

Winsor has said that, "basically, you make things out of the structure of who *you* are."[4] Yet she never sets aside the simple structures of line, plane, and grid that Minimalism displayed with such authority in the 1960s. They supply her personal "structure" with its coordinates. And Minimalism authorizes her repetitions, which give art-making the quiet unstoppability of daily existence. A Minimalist can have a piece fabricated from a drawing or a scribbled note. Winsor lives through the fabrication of her art.

\* \* \*

During the early 1970s, Winsor inflected the regularities of the grid with the idiosyncrasies of her methods and materials. In 1972, Eleanor Antin reversed the procedure, imposing the grid on her material which, for thirty-six days, was her body. Every day, she dieted and photographed her nude body from the front, the back, the right, and the left. Arranged in orderly rows, these pictures document the loss of ten pounds, as the artist approached her "ideal" weight. Michelangelo's sonnets transmit from ancient times the image of the stone-carver laboring to reveal the perfect form that lurks within a block of marble.[5] To invoke—and of course to mock—this persistent idea of the artist's purpose, Antin entitled her gridwork of one hundred and forty-four images *Carving: A Traditional Sculpture* (1972).

During 1972, Gordon Matta-Clark let his hair grow uncut and uncombed. When a full array of dreadlocks had appeared, he tagged each lock with a numbered piece of paper. Then a corresponding number was entered on a gridded diagram of a head. Finally, the artist stood with his back to a squared-away net—a grid in real space—as his dreadlocks were attached, one by one, to the points indicated by the chart. Ostensibly, these were steps in the manufacture of a wig that would make it possible

JACKIE WINSOR, *Bound Grid*, 1971-72. Wood and twine, 84 x 84 x 84 inches. Courtesy of the Paula Cooper Gallery, New York.

for the artist to wear dreadlocks even after he had cut them off.[6]
However, the wig was never made and *Hair* (1972) had its impact as a cautionary comment on what were then called the politics of personal liberation. In the early 1970s, unruly hair was still a sort of banner—a public refusal to fit into the rigid compartments of social convention. Yet a grid can be imposed, even on the anarchy of dreadlocks.

The year before, Matta-Clark and friends had executed *Jacks*, subtitled *The Auto Demolition Debris Zone Rip-Off Imitation Neighborhood Group Action Cars Abandoned Raised Propped Dismantled and Removed 24-Hour Service*. In the far reaches of New York City's outer boroughs, the artist and his crew mimicked the gangs that strip abandoned automobiles for salable parts. Taking cars apart, they hauled the parts away. Thus delinquency modulated into public service, a transformation that cannot quite be glimpsed in the strips of 35mm images that fill six pages of *Avalanche*.[7] The effect is of a grid just barely containing desperate actions in dilapidated places.

One could see the documentation of *Jacks* as only incidentally gridded. After all, 35mm cameras arrange images in strips that form a grid when the strips are set side by side. Photojournalism has made the device familiar, so one was not obliged to see the layout of *Jacks* as anything more than a designer's use of a convention. It may be that no allusion to the grids of Sol LeWitt or Carl Andre was intended, by the designer or the artist. In 1972, Matta-Clark made a series of photographs called *Walls*. Straight-on, black and white, they show the interiors of half-demolished apartment buildings. Traces of floors and inside walls are gridded, of course, and this architectural inevitability points in two directions: toward the pattern of city streets and, once again, to the forms of Minimalism. Here, it could not be denied, was the minimalist grid transposed.

Perhaps Matta-Clark wanted to remind the Minimalists that their style evolved from urban form at its most relentlessly standardized. Perhaps he wanted to reproach these older artists for trying, with blank surfaces, to suppress the memory of their aesthetic origins. Or it may be that Matta-Clark wanted to propose a continuity, with aesthetic disengagement at one extreme and, at the other, a sorrowful—or angry—contemplation of urban ruin. Of course, talk of intention is always speculation. Matta-Clark, who died in 1978, worked in border zones where gestures must be quick and meanings are permanently unsettled.

* * *

Traditionally, paintings and sculptures have joined us in ordinary space only because they must. They are, after all, tangible objects. Yet the work of high art pretended to have its true being in some other, superior sort of space—to wrap itself in it, if it were a statue raised up on a pedestal or, if it were a painting, to provide an opening onto this transcendent zone. Then the work of art left the wall and, dispensing with the pedestal, stood on the floor. It entered real space and acquired a new name: the minimalist object. Only in the white interior of the gallery was this transformation intelligible. Only in the world beyond the gallery could its implications be realized. Before, exhibition spaces had been anterooms to the upper chambers of the aesthetic. Now they were continuous with the ordinary spaces of the city, the highway, the countryside.

Many artists refused to recognize that continuity. Some who did left the gallery to lay claim to ever larger portions of real space, and the gridded structures of the minimalist object reappeared in their art as car-

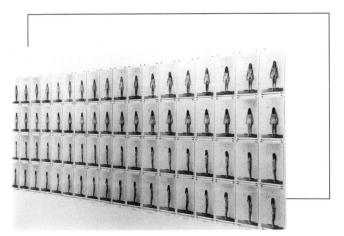

ELEANOR ANTIN, *Carving: A Traditional Sculpture*, 1972. 144 black and white photographs, each 7 x 5 inches, and text panel. Collection: The Art Institute of Chicago.

GORDON MATTA-CLARK, *Hair*, 1972. Black and white photograph, 10 x 8 inches. Courtesy of the David Zwirner Gallery, New York.

tographer's grids—in Robert Smithson's *Nonsites*, for example, or Dennis Oppenheim's documentation of his *Nebraska Project* (1968) and other works of land art. Richard Long's photographs of the terrain he has traversed bring maps to mind, for his paths could be as reliably straight or circular as they were only if he had one in hand at every step of the way. When he offers a map in place of a photograph, the gridded lines of latitude and longitude are explicit. Once, in 1974, he walked a grid: four parallel lines west to east across the wilds of Dartmoor, then four lines crossing at right angles, from north to south.

Like Michael Heizer, Walter De Maria had drawn lines on the desert floor, which could be seen in full only from an aircraft. In 1974, he began to build *The Lightning Field* (1974–77), a grid a mile long and a kilometer wide, and thus big enough to escape the ratios of scale which define an object as miniature, or monumental, or something in between. In its immensity, *The Lightning Field* is simply the size that it is—like a Sol LeWitt lattice standing on the floor of the Dwan gallery.

In 1969 the Dwan showed De Maria's variation on the minimalist idea of modular variation. Five slabs of stainless steel lay on the floor, each about six and half feet long by three and half feet wide—a good size for an ascetic's bed. From the first slab rose three ten-inch spikes, needle-sharp and evenly spaced. Fifteen spikes rose from the second slab, increasingly more from the third and the fourth, and the fifth bristled with spikes, like a geometric and extremely angry hedgehog.[8] *The Lightning Field* was the fifth *Bed of Spikes* enlarged. First he planted thirty-five poles in the desert near Flagstaff, Arizona. Three years later, he

planted four hundred poles spread in a gridded pattern across a stretch of western New Mexico, not far from the Arizona line. Mary Livingston Beebe visited the site not long afterwards. *The Lightning Field*'s four hundred poles, she reported,

> are about two inches in diameter, tapering slowly to a sharp point at the top, and are placed 220 feet apart. The grid extends a mile (twenty-five poles) by a kilometer (sixteen poles). The placement is absolutely precise—laser-perfect—and the tips are all exactly the same altitude (the length of the poles varying some with the terrain). . . . The poles themselves become light or dark against a changing sky; they often disappear altogether in the distance and appear closer up at high noon. Sometimes birds rest near the top, adding a random point of exclamation. . . .
>
> Having spent two days wandering and observing, one is absolutely convinced that from virtually every position possible, there is no point of relief. The terrain and sky change, perception of the poles changes, but the poles and their placement remain absolute. The effort and money required to produce and maintain the *Lightning Field* is mind-boggling, and for me that fact interfered somewhat with the experience. Perhaps I have difficulty, too, in being surrounded by so much precision.[9]

The grid, we feel, belongs on the page. At its most expansive, it dictates the pattern of city streets. De Maria had imprinted it on the Southwestern desert, a reminder of the frontier and an emblem of American freedom. He had designed it to engage the flow of sunlight and of weather. With *The Lightning Field*, De Maria made the grid an emblem of unbounded will.

WALTER DE MARIA, *The Lightning Field*, 1977. 400 steel poles of various heights, ranging from 26 feet 9 inches to 15 feet 1 inch, arranged in grid array: 16 by 25 poles, 1 mile x 1 kilometer. Near Quemado, New Mexico. Courtesy of the Dia Foundation for the Arts, New York. Photograph by John Cliett.

MEL BOCHNER, *Working Drawings and Others Visible Things on Paper Not Necessarily Meant to Be Viewed as Art*, 1966. 4 identical loose-leaf notebooks, each with 100 photocopies of studio notes, working drawings, and diagrams. Gallery of the School of Visual Arts, New York.

# FROM GRID TO ROOM

"The sixties came from an empty room."
*Will Insley*[1]

In an essay called "Serial Art, Systems, Solipsism" (1967), Mel Bochner noted that "systematic thinking has generally been considered the antithesis of artistic thinking." Bochner understates the point. Since the time of Plato, Western culture's articles of faith have included the belief that art is the product of unsystematic thinking—of feeling and intuition utterly at odds with system. This is an error, said Bochner, and as proof he pointed to Dan Flavin, Carl Andre, and Sol LeWitt: major figures who generate their art from formal variations of the most systematic kind.[2] Bochner built his first wood and cardboard variations on LeWitt in 1966. Mostly he worked on paper, arranging the permutations of number series in columns and grids. His drawings made their way into group shows at the Dwan Gallery and elsewhere.

Late in 1967, Bochner and Elayne Varian organized an exhibition of serial works at the Finch College Museum of Art on East 78th Street. His contribution to the show was *Sixteen Isomorphs (Negative)* (1967), a set of photographs which opposes the flatness of a grid to systematically varied images of cubes in perspective. In those days, Bochner was preoccupied by a question: if the best new art is systematic, what, precisely, is the value of the object generated by a systemized idea? If an idea is compelling, isn't a diagram of its permutations as effective as the sculptural equivalent?

In 1965 Bochner had taken a job teaching art history at the School of Visual Arts. The following year, he was asked by the director of the SVA gallery to organize a show of drawings for the Christmas season. Bochner recently recalled:

> I wanted to include work by Judd, LeWitt, Eva Hesse, Dan Graham, and all the other artists whose work I liked, and I thought it would be interesting to show working drawings—not finished works on paper but whatever the artists had actually used in carrying out a process. There were several problems with this. First, the gallery director wasn't especially happy about covering the walls with scraps of paper from various studios. Also, there

was question of how to frame these drawings. The gallery didn't have much of a budget, and there was a reluctance to spend whatever there was on the sort of thing I wanted to show.[3]

Bochner suggested that the drawings be photographed and mounted on the wall unframed. There was no money for that, either. To get around the budgetary impasse, he made Xerox copies of the drawings and presented them in four loose-leaf binders. The binders lay on four tall white boxes with a decided resemblance to minimalist objects.

No chairs were provided. To see the exhibition, *Working Drawings and Other Visible Things on Paper Not Necessarily to Be Viewed as Art*, one stood and paged through the four overstuffed notebooks. There were copies of sketches by Dan Flavin, Robert Smithson, Robert Morris, and many others. Bochner included a few finished works, including *Side Effects/Common Drugs* by Dan Graham and the score of a serial composition by Karlheinz Stockhausen. There was a worksheet covered with equations by Arthur Babakhanian, a mathematician who had helped Sol LeWitt devise some of his formal sequences; a receipt for the fabrication of several sculptures by Donald Judd; and the assembly diagram of the Xerox machine that had been used to make all these copies. The notebooks contained an immense dossier of evidence in support of the thesis that art had shifted its ground. Long allied to the expressive, the individual, the ineffably organic, it now stood on the side of the impersonal, the systematic, the quantifiable.

In 1966, Bochner had collaborated with Smithson on "The Domain of the Great Bear," an essay with photographs that assessed the Hayden Planetarium as a work of art. Two years later, he made notes on themes from *Alphaville*, a film by Jean-Luc Godard, then arranged them in a grid designed for the pages of *Arts Magazine*. Blocks of text appear in rows alternating with rows of stills from Godard's movie. Bochner admired much about Alphaville: its gritty black and white tonalities, so close to those of Minimalism and its aftermath; its private-eye hero, Lemmy Caution, forever converting things into images with his Kodak Instamatic; and, above all, its intricate permutations of *film noir* cliché. Finally, though, Bochner could not approve. As he noted:

> The implications of *Alphaville* are moralistic. Godard opts for humanistic values in the context of his projection of "technologism." He sees *Alphaville* as present and apocalyptic. The erasure of individuality and personality, or what Lemmy Caution calls "poetry," he views as tragic.[4]

Godard's style is admirably harsh and schematic, but his attitudes are all wrong. He clings to the old, "humanistic" notions of the self and thus to an aesthetic that can be traced from Abstract Expressionism

to Romanticism to the Platonic doctrine of art as the exalted trace of inspiration. Bochner prefers a schematism unredeemed by laments for Truths proclaimed long ago by religion and metaphysics, and sustained, in modern times, by traditional art and the pieties of popular culture.

By the time his *Alphaville* essay appeared, Bochner had produced a remarkable number of grid drawings, many of them on grid paper. As one drawing entailed another or several, they led him deep into a branching labyrinth of serial form. This was a zone of thought turned in upon itself so intricately that he seemed, for a season or two, to be reducing his art to notes on his mental processes. Yet this was not a real danger. Bochner said long afterward, "I never saw myself as a conceptual artist. I never saw that easy split between conception and perception. There is no art which exists purely as thought."[5] In fact, he had never tried to exile his art from real space. As he declared in 1970, "There is no art that does not bear some burden of physicality."[6]

There would have been no need to state this obvious point if a generation of artists—Bochner among them—had not glimpsed in the minimalist box the possibility of a congruence of form and concept so precise that it would transcend mere physicality. This was a metaphysician's vision of Mind meshing with matter to unveil the ultimately Real. Bochner found it unconvincing, yet concepts had taken him so far from the gallery that the way back to inhabitable space was not immediately clear. He found it in a procedure that marks a path, or at least line, and is no less physical than conceptual: the measurement of walls. A portion of the notebook page he reproduced in the catalog of the show at the Finch College Museum reads:

THROUGH AN OPERATION (MEASUREMENT) BACKGROUND
(THE REALM OF IDEAS) → (NOT NECESSARILY EVIDENT
DEFINES THE PASSAGE TO THINGS (DENSITY) = OBJECTS[7]

This is a bit murky, but properly so, for Bochner would go on to cultivate the discrepancies that appear as one moves from thought to action, from action to thing. To make *Centers Estimated and Measured* (1971), he first tried to mark the center of a sheet of paper without a ruler. Then, accepting the ruler's help, he found and marked the actual center. The marks are close but, of course, do not coincide.

To execute *Centers Estimated and Measured*, he treated a piece of paper as a miniature wall. For *Eye Level: Estimated/Measured* (1971), he pinned a large paper sheet to an actual wall and drew a free-hand line across it at the level of his eye. Then he redrew the line with a ruler. One wavers, the other is straight. Two methods of accounting for a surface produce results that are similar but, again, not identical. During the

next three years, Bochner produced an astonishing sequence of works, all
driven by his intuition that concepts shape perceptions, perceptions
inflect concepts, and their interactions are fraught with glitches. His most
elaborately complex work from this period is *Theory of Indifference*, which
he exhibited at the Sonnabend Gallery in 1973.

He divided the main space of the gallery with a thin variant on
the minimalist box: a wall that did not quite reach the ceiling. The point
of the box was to be intelligible in a glance. The function of this wall
was to render to the two halves of the *Theory of Indifference* impossible to
see at the same time. On its north side, squares marked on the floor with
masking tape structured one half of the *Theory*. On the south side, more
squares structured the second half. By distributing pennies among the
squares in groups of three, Bochner displayed the full range possibilities
for being in or out: all in, some in, all out, all not in, some not in, all not
in, all out, some out, and so on.

On the south side of the wall, one saw half the variations. With
these in mind, one went around to the other side and tried, with the help
of memory, to match the first half to the second. Bochner wanted to force
the recognition of a subtle point: we grasp concepts with means supplied
in part by perceptible things, yet the contingencies of perception prevent
these objects from being as helpful as we wish. Much that seems clear
about the *Axiom of Indifference*, even irritatingly obvious, turns out upon
reflection to be maddeningly opaque. For example, the artist gives the
ambiguities of the word "all" a troubling density. All what? All the pen-
nies in a group of three, in the entire piece, in the world? The more the
phrases written on the strips of tape offer to help, the more they hin-
der—or help one to see how little one has seen with any clarity.

Soon after the work went on view, the artist and critic Bruce
Boice published an explication in *Arts Magazine*. As he elucidates the
boggling complexities of the *Axiom*, his guiding point is that Bochner,

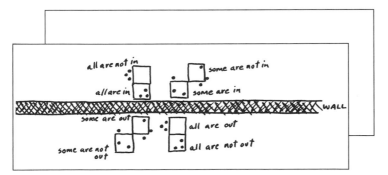

MEL BOCHNER, drawing for *Axiom of Indifference*, ink on paper, 8¹/₂ x 11 inches.
From *(towards) Axiom of Indifference*, loose-leaf notebook. Courtesy Sonnabend
Gallery, New York.

rather than showing the applications of logic to the physical world, . . . shows . . . in a sense, the inapplicability of those propositions to the physical world. The propositions of logic, in fact, have nothing to do with the physical world. In the same way, the physical world is entirely irrelevant to mathematics and geometry as well as logic.[8]

Boice's essay is brilliantly detailed and precise, yet it leaves the misleading impression that Bochner intended the *Axiom of Indifference* to demonstrate that logic and physical reality are incommensurate.

Plato and his predecessors—notably Pythagoras—believed the opposite: that the structures of logic reveal the structure of the world. The nineteenth-century American philosopher C. S. Pierce and his successors have argued with various degrees of insistence that, after all, logical thought does not deliver a picture of the Real—of the ways things are in themselves, apart from the vagaries of thought and perception. Arguments of this sort had been presented, challenged, and refined by professional philosophers for more than a century when Bochner showed *Axiom of Indifference* at the Sonnabend Gallery. His purpose was not to join their discussion or to illustrate it. He didn't make this work of art to prove anything. Rather, he wanted to provide an occasion for experience heightened by self-consciousness.

In his *Notes on Sculpture*, Robert Morris had argued that, if an exhibition is properly installed, all its "variables" can be controlled. Not only can experience be orderly but this orderliness can become the focus of aesthetic attention.[9] Bochner shifted the gallery-goer's attention to the ambiguities built into thought, perception, and the nuances of their interdependence. He had followed his interests onto the page and into the far reaches of serial thought. He had kept track of artists at large in the desert. The works of his friend Robert Smithson were of particular interest to him. Yet by 1970, he had returned to the white cube of gallery space, for it was here that the work of the Minimalists had first impressed him and here that it had been crucial to question their covertly Platonic devotion to perfectly clarified Form. So it was in this place that his dismissal of the object could be seen as a crucial gesture. It was here, in the space of the gallery, that thought, perception, and gesture could become—so to speak—alive to one another, and the achievement of that precarious awareness become the salient quality of his art.

\*　\*　\*

Walls are usually painted a single color, and a monochrome painting is usually an attempt to upstage a wall, to claim high aesthetic value for a flat, uniform effect that ordinarily stays in the background. To

assert itself, a monochrome painting must assert an irony: this blankness, in other circumstances so easy to overlook, is now worthy of exclusive attention from the most sophisticated gaze. If monochrome dispenses with that irony, it tends to disappear—to blend with its setting, as in the art of Robert Huot. During the 1960s, his paintings became emptier and smoother, until they had become uninflected monochromes. In 1968 they vanished, leaving only the wall. With tape, Huot marked off quirks of interior detailing and those borders which divide a wall into zones of matte and gloss. His show at the Paula Cooper Gallery in March 1969 is described in full by its title: *Two Blue Walls (Pratt & Lambert #5020 Alkyd); Sanded Floor Coated with Polyurethane; Shadows Cast by Architectural Details and Fixtures Using Available Light.*

The minimalist object had presented itself as a distillate of interior space. Dispensing with the object, Huot had applied fresh coats of paint and polyurethane to the surfaces of gallery, drawn attention to the shadows cast by its lights, and offered the space itself as an object. Dimming the light, Michael Asher did the same. At *Documenta* 5 (1972), he built a room and sealed it off from the rest of the exhibition. Having painted one half of the room white and the other black, he set a pair of fluorescent tubes in the ceiling of the white section. Adjusting their strength to the reflective power of the white paint, the artist gave this part of the room just as much light as it needed to reveal itself.

Seen from the white section, the black one looked like a dimensionless void. From the opposite direction, the white area seemed to have been compressed and filled with a sensuous haze. At the dividing line, one area of the floor seemed higher than the other, an illusion that varied with one's direction. Easily dispelled, it recurred and became no less reliable than the solidity of the surrounding walls. Asher's work at *Documenta* was a variant on the all-white space he had designed three years earlier for *Spaces*, an exhibition at The Museum of Modern Art. As Dore Ashton reported, the artist

> has established an environment in which minimal light and sound stimuli place the subject into a condition of suspension. If he navigates the obscurity slowly, he may well feel dizziness and perceptual disorientation. The thick carpeting and sound-proofed walls and ceiling make it impossible for the sensitive subject to respond, as he would normally, while moving through. In the abnormality of response he may well find a small adventure comparable to those reported by explorers stranded in Antarctica or at sea.[10]

Ashton's review echoes catalog notes by Jennifer Licht, the curator of *Spaces*. "One's expectation," Licht wrote, "is for something to look at, but Asher reduces visual evidence to such a degree that the room

can be characterized as a void; and he calls on senses that are less accustomed than sight to apprehend space."[11]

With vision comparatively useless, viewers become gropers in undifferentiated space. Touch and other, usually dormant bodily senses awaken, and the sensorium—to use a McLuhanesque word much in play during the late sixties—is realigned. But so far as Philip Leider could tell, his sensorium preserved its familiar alignment. "What Mrs. Licht describes simply does not happen," he wrote,

> ... the room with its two wide-open doorways is in no sense a void and never even gives the illusion of being one. The room, its space and shape, are apprehended plainly by sight. Its sounds are apprehended by ear. Its texture is apprehended by touch. The sound-proofing and sound control simply don't provide enough to make the game worth the candle-power.[12]

Only a willful sensibility would look for a perfect fit between a minimalist object and the spare white space of a gallery, and only willfulness could sustain the belief that a perfect fit had been achieved. To reduce the object to a salient aspect—to a line or a plane or a concept—required further willfulness, and still more was needed to drive the strategies of Asher and others who designed blank white spaces to absorb the object, leaving a vacancy charged with aesthetic intention. Sometimes, a member of the audience would feel that intention and, without any fuss, accept it as realized, as a member of a different audience sees a dab of Monet's paint as having realized his intention to apply just that dab of red or yellow. Often, though, one needed to insist, willfully, that a strategy like Asher's was successful.

This was less a self-deception than an act of solidarity with gestures perceived to be necessary. Leider, the founding editor of *Artforum*, was willing to feel that sort of solidarity with the intentions of, say, Robert Smithson, but not with Michael Asher's. He doesn't say why. He simply dismisses Asher's installation at *Spaces* with the off-handedness of Judd dismissing the entire tradition of geometric abstraction in Europe. Willfulness, an emotional equivalent to apodictic form, simply presents itself. It does not try to justify itself.

In 1970 Michael Asher built another all-white room in the already-white art gallery of Pomona College, in Claremont, California—though the words "room" and "object" turned ambiguous under the gaze fixated on the relationships between works of minimalist art and exhibition space. Perhaps Asher's Pomona installation was not, in fact, a room within a room but a minimalist object expanded to the size of a room and provided with a doorway. Perhaps those are two ways of describing the same thing, and we ought to focus on Asher's tactic of presenting the

exhibition space as the exhibition itself. Through sensory deprivation, he heightens our awareness of galleries and museums as institutions: controllers of access and definers of meaning.[13] Thus he is a critic of the institutions that have invited him to revamp their interiors.

There was, no doubt, a critical edge to be felt as one drifted through Asher's dimmed-out rooms. However, the points about power and access that he made with his installations of the late 1960s and early seventies were more cogently made by broadcasting in detail the policies of such institutions as the Museum of Modern Art and the Whitney Museum of American Art—as, for example, the Art Workers Coalition was doing in those days. Whatever Asher's works added to the political agitation of the time, they had their impact as art. Readjusting minimalist clarities of form and boundary, Asher generated dimness and intimations of the infinite. And these, according to an aesthetic doctrine in force since the 1750s, are sources of the sublime.[14]

\*   \*   \*

Before Stephen Kaltenbach began prowling the New York subways with rubber-stamp lips in his pocket, he installed a nine-by-nine-

MICHAEL ASHER, *untitled installation*, 1970. Claremont, California, Pomona College, Gladys K. Montgomery Art Center Gallery. View from outer compartment to inner one, with axiometric drawing.

by-nine-foot cube in a twelve-by-twelve-foot space at the Whitney Museum. Jean Louis Bourgeois called *Room Cube* (1969) "a white Don Judd gone quietly mad."[15] Kaltenbach later said:

> I had been removing the number of elements in my work one by one; they were becoming simpler and simpler. I realized that you could only remove so many elements from a volumetric form and still have a volumetric form. Finally it has to go, so if I wanted to continue working that way I would have to begin reducing the number of elements in the environment, which intrude and complicate the visual experience. I decided I would take over the space and control everything from the door in.[16]

In a review for *Arts Magazine*, Cindy Nemser talked of the "strange, nightmarish feelings" that assaulted her as she squeezed her way through the space between the *Room Cube* and its container:

> My first reaction was a feeling of claustrophobia; the walls were closing in on me. Then I was seized by a feeling of disorientation. As I continued to thread my way, anger, frustration, and a sense of isolation became part of my experience.
> . . . Kaltenbach has taken the neutral objects of the minimal artists, used their perceptual theories, and revealed the latent horror of those enigmatic presences.[17]

Say that *Room Cube* occupies a particularly uncomfortable cell in limbo. A year after installing it at the Whitney, Kaltenbach built two rooms—one heavenly and the other hellish—at the Reese Palley Gallery in San Francisco. The first was white-walled and empty, already a minimalist image of paradise. As the lighting was dimmed, spots of luminescent paint began to glow. Or, if the viewer could abandon the reassuring literalism of life in the real time and real space of minimalist aesthetic, the stars came out and the depths of heaven opened up. Kaltenbach had transposed the idiom of the sublime to the key of childhood décor. In the other room, a grill applied heat to a small pile of rocks. From the ceiling, heat lamps glared. One reviewer reported that Kaltenbach's art-gallery version of hell was "bearable for maybe ninety seconds."[18]

Kaltenbach's welcoming room went from day to night. Rosemarie Castoro's *Room Revelation* (1970) reversed the cycle. This cubical was dark when one entered. Then, with the closing of the door, a rheostat brought the lights to full strength over a period of three minutes. "Every time somebody came into the room, the lights would go out and the cycle would begin again," says the artist. "It was like a compressed day. The return of reality, which can be very healing."[19] Reality is disquieting in Bruce Nauman's *Yellow Room* (1973), a triangular space set within the comfortingly rectangular space of the gallery. As the artist has said of

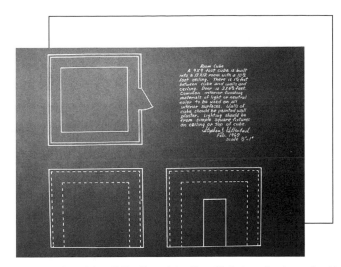

STEPHEN KALTENBACH, *Room Cube*, 1967. Blueprint, 40 x 60 inches. Courtesy of artist.

three-sided spaces, "There is no comfortable place to stay inside them or outside them. It is not like a circle or a square that gives you stability."[20] To heighten the discomfort of this interior, the artist filled it with a particularly grating tint of yellow fluorescence.

Nauman's *Green-Light Corridor* (1970–71) is *Yellow Room* compressed to a space ten feet high, thirty feet long, and twelve inches wide. Ghastly yellow has changed to ghastly green. *Performance Corridor* (1969) is twenty inches wide—just roomy enough to permit the artist to enter and walk back and forth for an hour in what he later called a "stylized" manner.[21] A video camera recorded his performance, and when Nauman showed this corridor at the Whitney, in an exhibition called *Anti-Illusion: Procedures/Materials* (1969), museum visitors were allowed to walk into the piece and perform in any way they liked—or could manage. The shape of the space narrowed the public's range of possibilities. Discussing another corridor, Nauman said that "someone else can be a performer, but he can only do what I want him to do. I mistrust audience participation."[22]

In his *Notes on Sculpture* (1966), Robert Morris had declared that the work of art must be at once "autonomous" and immersed in its setting with a new thoroughness. He added:

> That many considerations must be taken into account in order
> that the work keep its place as a term in the expanded situation
> hardly indicates a lack of interest in the object itself. But the con-
> cerns are now for more control of and/or cooperation of the entire
> situation. Control is necessary if the variables of object, light,
> space, body, are to function.[23]

The body belongs to the viewer, as in Nauman's revision of Morris's scenario, though Nauman expands the viewer's role to that of

BRUCE NAUMAN, *Green Light Corridor*, 1970. Wallboard and green fluorescent light fixtures. Dimensions variable, approximately 120 x 480 x 12 inches. Collection: Solomon R. Guggenheim Museum, New York, Panza Collection.

"performer." Further, the member of the audience who enters the *Performance Corridor* also plays the part of the object formerly played by Morris's minimalist object. For the *Corridor* is gallery space claustrophobically remodeled: the setting where viewers become performers and performers become objects under the artist's control, doing what the artist wants them to do.

Larry Bell's contribution to *Spaces*, at the Museum of Modern Art, was a dark room partitioned by large panels of glass. Dore Ashton found it to be "more like tunnel than a room." Unable to locate the glass panels in the dark, she "found only a long wall along which I groped my way to the end and back, knowing only the half-pleasant trepidation that spelunkers must know."[24] In the late 1960s, while he was still a student at the University of California, Chris Burden built a makeshift corridor from pipes, wire, and sheets of black plastic. Two hundred feet long, it was prey to the wind, which forced the flimsy sheets together. As the artist recalled:

> You couldn't see down it except on rare occasions. If you walked down it, it would engulf you, but if you started running, your body would make an air pocket that would push it open in front of you. It was like magic. The stuff would open in front of you and close behind you. That's when I realized that what I had made was not a piece of sculpture but something that had to be activated. These pieces were about physical activity, about how they manipulated my body.[25]

The static white cube had come alive, or, anyway, displayed the liveliness of the undead.

DORTHEA ROCKBURNE, *Drawing Which Makes Itself*, 1973. Wall drawing, 13 feet 4 inches x 8 feet 4 inches. The Museum of Modern Art, New York. Gift of J. Fredrick Byers III.

# FROM ROOM TO MAZE

'Originless, fetishistic, real, imaginary, mnemonic, antiarchitectural, claustrophobic, metaphorical, metonymic, disorienting, Minotaurless, Baroque, spatial, Minimal, linear, neurological, intestinal, threadless, appropriated, timeless, textual, iconophobic, illegal, expensive, temporal, graffiti prone . . .' Enough, Ignatz, it's getting us nowhere.

*Robert Morris, "Robert Morris Replies to Roger Denson (Or Is That a Mouse in My Paragone?), 1993*[1]

The artist Patrick Ireland is the critic Brian O'Doherty, whose focus on art widened in 1976 to include what he called "the white cube" of gallery space.[1] This is space of a specialized kind, wrote O'Doherty, and its history is entwined, of course, with the history of modernist art. As sculpture dispensed with the pedestal, the viewer was left "waist-deep in wall-to-wall space." The frames dropped away from pictures and "space slid across the wall, creating turbulence in the corners." A degree of calm returned when two-dimensional collage became three-dimensional assemblage and settled comfortably on the floor. "Homogenous" now, space

> flowed easily into every part of the gallery. . . . No longer confined to the zone around the artwork . . . the new space pushed gently against its confining box. Gradually, the gallery was infiltrated with consciousness. Its walls became ground, its floor a pedestal, its corners vortices, its ceiling a frozen sky.[2]

Like other galleries of the period, the Bykert had white walls and a white ceiling. Early in 1973, Dorthea Rockburne spread the white of those surfaces across the parquet floor. In one of the gallery's two rooms, she mounted white sheets of paper on the walls. In the other room, the walls bore black sheets of carbon paper. The entire installation formed a single work: *Drawing Which Makes Itself* (1973). Each paper sheet had been creased along lines dictated, seemingly, by the shape of its surface. The artist then echoed these creases with ruled lines of black ink. The sheets of carbon paper, too, had been folded. From their creases ink lines extended along the walls and, sometimes, onto the floor. "The idea," Rockburne says,

> was to make drawings that were based on information contained within the paper, not on anything external. Yet I wanted to relate these works to the surfaces of the exhibition space, which I had been doing for several years with my chipboard and paper pieces. Working with Set Theory, I had been able to define not only the

units of a piece but the walls where the pieces were installed. Now I was including the floor in the interaction of all the elements, which included members of the audience. Because I knew that people would leave tracks on the white floor, a kind of record of their viewing. I was interested in handprints, footprints, mind prints, emotion prints. The problem was that halfway through the show, there was big snowstorm and people began tracking in too much dirt. The floor got too mucky, so I decided it would have to be repainted, which meant that some of the carbon-paper drawings had to be done again. People couldn't believe that I was reinstalling the show at that point, but I felt that it was absolutely necessary.[3]

With this installation, Rockburne claimed the three dimensions of gallery space for procedures executed on the two-dimensions of wall and paper. By inflecting planes with austere patterns of lines, these procedures recalled the form—and the authority—of the minimalist object. Dismantling that form, Rockburne undermined its authority and the very idea that the forms of art should claim to be authoritative. *Drawing Which Makes Itself* filled the white cube of gallery space with contingencies generated from the space itself, in all its contingency. Impatient with the mind's Platonic tropisms, its reflexive leaps to disengaged generalities, Rockburne offered forms that made sense only as responses to a particular situation.

And she expanded the situation for art with *Neighborhood* (1973), a drawing which made itself from elements that had appeared in the Bykert installation. Redeployed, they evolved. Opaque sheets of white paper became translucent vellum. Before, lines had reached over the wall from the edge of a sheet. Now they reached under it, as well. By carefully regulated steps, Rockburne was expanding her universe of formal options. In the dry idiom of the era, she stated: "The way in which external borders of territories shift by being informed through interior and internalized functions is in part the context of the work."[4] Shifting outward, inexorably, borders eventually vanished and Rockburne followed her love of math and astronomy into the infinite of her later work.[5]

The white cube of gallery space having become so spacious in the aftermath of Minimalism, Jean Louis Bourgeois was shocked to find himself crowded up against the wall by Stephen Kaltenbach's *Room Cube*. Yet, no matter how awkward it was to squeeze through the installation's corridors of stingy, leftover space, there was one consolation: he never felt lost.

Though always obscured by the oppressive cube, the three other walls are always sensed; you never lose your sense of overall place. It is this strong sense of orientation that keeps the work a room piece instead of becoming a maze.[6]

Nauman's corridors were even less mazelike, until he furnished them with video equipment.

For his show at the Nick Wilder Gallery, Los Angeles, in 1970, Nauman built six narrow passages. Only three could be entered. Much of the gallery was walled off, though there was access of sorts: a video camera mounted in an upper corner of this space panned back and forth, sending images of emptiness to a monitor outside. In the accessible corridors were other configurations of camera and monitor. "The Wilder piece was quite complicated," Willoughby Sharp once said to the artist. Yes, he replied, "It is hard to understand"—all the more so now that it survives only in fragmentary installation shots and Nauman's descriptions.

At the entrance to one corridor, just twenty-five inches wide, a camera was mounted high up. At the far end of the space, thirty-four feet away, a monitor stood on the floor. After entering, the artist recalled,

> You had to go in about ten feet before you appeared on the television screen that was still twenty feet away from you. I used a wide-angle lens, which disturbed the space even more. The camera was ten feet up, so that when you did see yourself on the screen, it was from the back, from above and behind, which was quite different from the way you normally saw yourself or the way you experienced the corridor around yourself. When you realized that you were on the screen, being in the corridor was like stepping off a cliff or down into a hole.[7]

Confounding an inhabitable space with the video monitor's dim images of that same space, Nauman played not very kind jokes on the audience and space itself. The reassuringly wide-open expanse of the white cube had become a labyrinth.

Removing art from the picture frame and the pedestal, the minimalist, had relocated it on the floor, which meant that the space of the gallery was not only "homogenous," as O'Doherty noted. It was real, and one moved through this real space in real time.[8] Thus it made sense for Carl Andre to say, in 1970, "My idea of a piece of sculpture is a road. That is, a road that doesn't reveal itself at any particular point or from any particular point." Traditionally, a painting is expected to guide the viewer to the correct standpoint, the one which brings the image into proper focus and opens the way into the imaginary, transcendent space beyond the frame. To see a sculpture properly, one must circumambulate it with an eye for a short series of optimum vantage points.

Andre and the other Minimalists excused the viewer from this always anxiety-ridden search for the right point of view. For, as Andre said, when you share real space with a work of art, "There is no one place, or even a group of places you should be."[9] The Minimalists had rescued art from the clutches of "Renaissance perspective," with its

promise to impose on mere appearances the point of view that reveals the essences of things, as in a mirror. For the mirror built into the system of Renaissance perspective is a metaphor for the mind—rather, for the suprapersonal Mind capable of "reflecting truly every object placed before it," in the words of Leonardo da Vinci.[10] To mirror the world in high art was to picture, not ordinary fact, but transcendent Truth.

Dan Graham admired Minimalism for having relieved art from this metaphysical task. No longer pretending to stand somewhere outside of ordinary reality, the art object joined us in our world, immersed now in the contingencies that have always engulfed us. Yet Graham had reservations. It seemed to him that, for all their talk of real space and an infinity of possible viewpoints, each Minimalist covertly dictated one right way to see his work. If there is only one proper viewpoint, there is only one truth. Implacably literalist, it trumps all others and thus counts as transcendently True. The Minimalists had exchanged traditional metaphysics for a newfangled kind, the metaphysics of real space.

The old metaphysics of imaginary space is not, of course, a coherent doctrine. Rather, it is the shared core of romanticism and neoclassicism, symbolism and the high-minded varieties of realism, *arte metafisica* and surrealism, utopian modernism and American formalism—all the aesthetic programs that promise to deliver a vision of the Real and the True. Under the aegis of the old metaphysics, art is understood as a means of guiding the mind to some unchanging, essential "Idea"—to borrow a word from Giovanni Pietro Bellori, a seventeenth-century neo-Platonist who wished to raise the art of Raphael and Poussin to the status of high intellectual endeavor.[11] His writings sound irredeemably old-fashioned now, of course. Yet they were important to those theorists—Shaftesbury, Reynolds, Winckelmann—who laid the foundations of modern aesthetics. Moreover, ethereal entities akin to Bellori's "Idea" drift through the manifestos and off-hand quips of twentieth-century avant-gardists.

When Picasso said, "Art is a lie that tells the truth," he casually invoked a neo-Platonist rationale for his defiance of familiar appearances. And there is a theosophically tinged neo-Platonism in Mondrian's promise that, when painting, sculpture, and architecture attain their essences and unite, the world will be made new on the model of eternal Truth. From that moment on, we will live in a utopia "not merely rational or utilitarian but also pure and complete in its beauty."[12] Against all this idealism—ancient, modern, and modernist—Morris directed his argument that aesthetic value is to be found in the immediacies, the contingencies, stirred up as one moves through real space in real time.

Unlike paintings and sculptures aspiring to some version of the

"Idea," a work of minimalist art is to be understood as significantly changed when space and light change. "In some sense," Morris argued, this austere, symmetrical object

> takes these two things to itself, as its variation is a function of their variation. Even its most patently unalterable property, shape, does not remain constant. For it is the viewer who changes the shape constantly by his change in position relative to the work. Oddly, it is the strength of the constant, known shape, the gestalt, that allows this awareness to become so much more emphatic in these works than in previous sculpture.[13]

It was here, in Morris's stress on the "strength" of the "known shape," that Graham and his generation found reason to wonder if Minimalism had, as promised, dispensed with the ancient and persistent devotion to transcendent Ideas. For the "known shape" of, say, an *L-Beam* might be a real thing in real space, an array of elusive contingencies, or it might be a concept, clear and distinct and subject to the mind's control. Morris seemed, at times, to be more at home in the mental space of traditional metaphysics—and aesthetics—than in the brave new reality of inhabitable space. At the threshold of the gallery's white cube, he appeared to hesitate.

Pointing to "the simpler regular polyhedrons such as cubes and pyramids," Morris noted that "one need not move around the object for the sense of the whole, the gestalt, to occur. One sees and immediately 'believes' that the pattern within one's mind corresponds to the existential fact of the object."[14] Which, for him, was primary: "the pattern within one's mind" or "the existential fact"? And how could it be claimed that he had extricated himself from the snares of metaphysics if he was still taking as given the perennial distinction between thought and thing, mind and matter?

Though it was difficult to pin down Morris's attitude toward palpable objects, as opposed to manipulable concepts, his interest in control was hard to miss. He had declared, after all, that "control is necessary if the variables of object, light, space, body, are to function."[15] For these variables to function precisely as he wished, Morris had to establish and maintain two orders of experience. In one we are immersed, as the artwork is immersed, in the flow of ordinary time and space. The other order of experience takes us out of that flow, to some point where the variables of the art-environment form a "pattern within one's mind" as clear as the concept of a cube or a pyramid.

In 1973 Morris made several ink drawings of labyrinths in axonometric projections which, even more dramatically than traditional systems of perspective, enmesh objects in spatial artifice. Shown from

above, the interiors of these labyrinths form patterns conceptualized with ease. One of these drawings guided Morris in the construction of a labyrinth eight feet high and thirty feet in diameter. In photographs taken from above, it is as clear as an axonometric drawing. In the accounts of those who negotiated its narrow passageways, it became a generator of real-time, real-space experience of a disquieting kind. When Max Kozloff first came across it, Morris's *Labyrinth* (1974), looked to him like one of the artist's "earlier minimal pieces." It is bigger, of course, and "therefore more barrenly intimidating, a sort of unearthly gas tank in a museum." Kozloff entered and at once felt "imprisoned,"

> . . . watchful for . . . hairpin turns, I am possessed by an excited resentment. Higher than many, my eyes cannot track any of the overhead gallery lights, as if my internal sextant had gone awry. Left and right, north and south, all are left behind me in some obviously saner and more human space. Worse, in these contorted, blinded circuits (they had originally been planned to be 16 feet high), the sound of someone scraping the wall would mean an unhappy bottleneck along the way.

Just before forcing himself through the narrow entrance to *Labyrinth*, Kozloff had thought of "words starting with 'm': misgiving, minimal, minatory, Minotaur."[16]—the key letter an echo, no doubt, of the artist's initial. Morris and Andre had explicitly forbidden associations of this kind, of any kind: one was to see form as form, not as sign, symbol, or allegory.[17] Toward the end of the 1970s, Morris broke this rule in a manner that obliquely reinforced it. Working again in ink and in axonometric projection, he remade the labyrinth drawings. Now the patterns were more open, less schematic. Patterning became architectural. Walkways and towers, walls and stockades appeared.

These were the furnishings of a dystopian world called *The Realm of the Carceral* (1978). Here, control was absolute. From the writings of Michel Foucault, Morris had extracted a theory of institutional power as "one-way subjugation," and adapted it to the already coercive forms of his labyrinthine style.[18] Depicting "Security Walls," "The Hot and Cold Pools of Persuasion," and so on, the artist's lines and planes could no longer claim to be autonomous forms. They were performing a task of illustration. Yet the "Realm" they illustrated made the ordinary flow of associations unthinkable, along with the unruly surges of symbol-making and allegorizing. Morris had bent his rule against meaning just enough to allow the production of forms that confined meaning to a claustrophobically narrow range of possibilities.

In the realm of Morris's art, only one point of view is permissible. That is what makes it a carceral realm. To enter this zone is to

ROBERT MORRIS, *Untitled* (Section of a Rectangular Labyrinth), 1973. Ink on paper, 42 x 60 inches. Courtesy of Sonnabend Gallery, New York.

become the willing prisoner of formal necessities. What you see is what you must see, what you have no choice but to accept as adequate. In Morris's art of the 1960s and '70s, bleak arrays of strictly controlled facts play the part of essential Truths in the art of earlier times. Thus he was suspected of harboring metaphysical impulses behind the drone of his antimetaphysical rhetoric. It was Morris's penchant for mirrors that made him the Minimalist most vulnerable to these suspicious, at least in the view of Dan Graham, who has stated that mirrors objectify. Giving us "detached" images of ourselves, they encourage the belief that each individual possesses an essential, timeless being—much in the manner of images structured by "Renaissance perspective."[19]

Of course Morris didn't use mirrors in the manner of a sixteenth-century painter working out the logic of a vanishing point. For *Art in Process IV*, the show organized by Mel Bochner and Elayne Varian in 1969, he devised a work called *Art in Progress*. It appeared in stages. First, the artist and his assistants installed a twelve-paneled mirror on the walls of a smallish room. Then they installed a photographic mural of an audience looking up at a movie—and out at the viewer as, of course, the viewer's mirror image would do. A rotating camera filmed the installation. When it was done, mirror and mural were removed. During the run of the show, a rotating projector showed a looped film of the installation on the now bare walls. Real action in real space had become an image of real action in real space, and as the film showed the mirrored panels it became a mirror of a mirror. When it showed the photomural, viewers of Morris's movie found themselves face to face with movie viewers.

Among the illustrations of Brian O'Doherty's "white cube" essays is a reproduction of *Main Gallery, West Wall* (1967), a photo silk

screen on canvas by William Anastasi. The work appears in situ—that is, hanging on the gallery wall that it depicts. Just above the upper edge of the canvas are two air ducts. Just below the edge are the same ducts, rendered in precise detail and, of course, somewhat smaller. Four electrical outlets appear along the bottom of this installation photograph. Two are actual, the other two are the painted twins of the first two. For the most part the painting is an expanse of white paint, thus an impeccably precise image of its blank white setting—and the predecessor, by two years, of the mirrored mirrors of Morris's Finch College installation.

For those who had taken encouragement from the literalist strategies of Minimalism, works like these were troubling. For their meanings were not to be found in real space. Rather, one grasped them by tracing the labyrinthine switchbacks of their mirrorings. Anastasi and Morris—and Nauman, too, with his video corridors—had defeated the machinery of traditional perspective only to elevate art at least halfway toward a realm of concept. Its full immersion in real space had been brief. Or so Graham believed.

Michael Fried and other formalist critics praised art that sails from the real to the Real, from earth-bound happenstance to the realm of the timelessly True. The Minimalists had refused to make that ascent. Then, in Graham's view, their refusal acquired programmatic edge, "and minimal art became a formalistic art paradigm"[20] after its own, *faux*-literal fashion. With his image of a sculpture as a road, traversable in infinite ways, Carl Andre had opened art to contingency—but only in theory. In practice, Minimalism had turned out to be just another style of art, another institutionally approved means of controlling the aesthetic response.

That is why Dan Graham and other young artists suspected Morris and the Minimalists of having promulgated, at the very least, a "formalistic art paradigm" with authoritarian tendencies. Yet they admired the austerity of the style, its plain geometries and ordinary materials. The difficulty was to make good on the promise of the plain and the ordinary—to persuade these traits to remain in real time and real space where, it would seem, they belonged. In the mid-1970s, a few seasons before Morris confessed in full his need for control, Graham had sensed that need and tried to counter it with the video monitors and mirrors that the Minimalists—and Morris, in particular—had stamped as aesthetically credible.

For his most intricately structured works, Graham installed identical configurations of mirror, camera, and monitor in separate rooms. In *Video Piece for Two Glass Office Buildings* (1976), the rooms are to face each other across a street, and thus give viewers a choice: they can look at the

mirrored back wall of the room they are in, which reflects an image of the façade and interior opposite; or they can turn around and view the monitor, which shows the mirrored wall in the opposite room, with its image of the room where the viewers are standing. The mazy difference between these choices is further complicated by an eight-second delay in one of the monitor's transmissions.

Even in *Present Continuous Pasts(s)* (1974), which requires just one video camera in one room with mirrored walls, the paths of Graham's images can be difficult to follow. Though the mirrors give viewers a direct, "present-time" view of themselves, camera images appear on the monitor only after an eight-second delay—one of the artist's favorite devices. The complexities produced by this temporal slippage are labyrinthine, for, as Graham notes,

> a person viewing the monitor sees both the image of himself, 8 seconds ago, and what was reflected on the mirror from the monitor, 8 seconds ago of himself which is 16 seconds in the past (as the camera view of 8 seconds prior was playing back on the monitor 8 seconds ago and this was reflected on the mirror along with the then present reflection of the viewer). An infinite regress of time continuums within time continuums (always separated by 8-second intervals) within time continuums is created.[21]

Providing "an instantaneous Renaissance perspective," said Graham, the mirror reduces us to objects whose only life is as ghostly essences—souls unable to enter real space.[22] Video, by contrast, does not detach us from ourselves. When the transmission of our images is delayed by a few seconds, we enter a feedback loop and our "perception of external behavior" is linked to "anterior, mental perception." This can be bewildering, but for a good purpose and only for a moment.

In Graham's view, the clarity of minimalist installations had produced "a formalistic art paradigm" no less Platonic—no less driven by the yearning for transcendence—than the "paradigms" of Mondrian or the color-field painters of the 1960s. Minimalist simplicity needed to be redeemed. With minimalist means, Graham turned it into complexity, and when his maze-like patterns of imagery collapsed so did all the old dichotomies of the metaphysical tradition: inner and outer, mind and body, intention and act. Thus "'private' mental intention and external behavior are experienced as one," and the viewer is delivered into real time.[23]

\*   \*   \*

Describing his *Serial Project No. 1* (1966), Sol LeWitt said, "The autonomous parts are units, rows, sets or any logical division that would

be read as a complete thought. The series would be read by the viewer in a linear or narrative manner (1 2 3 4 5; A B B C C C; 1 2 3, 3 1 2, 2 3 1; 1 3 2; 2 1 3; 3 2 1) even though in its final form many of these sets would be operating simultaneously, making comprehension difficult."[24] Robert Smithson felt that LeWitt made comprehension impossible. In Minimalism, clarity need not be complicated to become labyrinthine. It need only be free to work out its implications. In an anonymous press release for LeWitt's exhibition of *Serial Project No. 1* at the Dwan Gallery Smithson wrote, "The entire concept is based on simple arithmetic, yet the result is incomprehensible. Extreme order brings extreme disorder. The ratio between the order and the disorder is contingent. Every step around his work brings unexpected intersections of infinity."[25] If the simplest number sequence can generate a maze, Smithson believed, so can a series of mirror images.

For the *Cayuga Salt Mine Project* (1969), he placed a row of rectangular mirrors in a gallery at Cornell University's Johnson Museum. Each sheet of glass rested horizontally on heaps of rock salt a few inches high. In open land between the gallery and the source of the salt, the nearby Cayuga mine, Smithson placed another batch of mirrors—a "trail," as he called it, leading from underground site to interior nonsite. It was winter, so he stood the mirrors upright in deep snow. With this work, Smithson invented a new genre: the mirror displacement, which mixes the mirror's immediate surroundings with reflections of the sky and distant landscape. As memory can change the present with the past, so a looking glass can disrupt the even flow of space.

From disruptions like these come ambiguities of perception and thought, puzzles of the kind that Minimalists tried to prevent. If audiences were to be persuaded for even a few seasons that the minimalist object had attained apodictic clarity, that object needed to stay safely indoors, enclosed by an interior orderly enough to second its geometries. Impatient with the rhetoric of absolute clarity, Smithson continued to take art outdoors, to landscapes as disorderly as he could find. In September 1969, *Artforum* published "Incidents of Mirror-Travel in the Yucatan," his account of a trip to that jungly, swampy, scrubby region of Mexico. At nine sites discovered in his wanderings through the Yucatan peninsula, he placed a set of mirrors on the ground or amid the branches of a tree.

Photographs of these arrangements illustrated his article, or rather served as the occasions for nine commentaries that meandered widely and sometimes turned back on themselves. In a burnt-over field, the twelve mirrors of the first set "were cantilevered into mounds of red soil. . . . Bits of earth spilled onto the surfaces, thus sabotaging the per-

fect reflections of the sky. Dirt hung in the sultry sky. Bits of blazing cloud mixed with the ashy mass."[26] Accounts of subsequent displacements grow more complex, as Smithson's notes on the landscape lead to speculations on Mayan myth, geological history, relations between time and space, the nature of color, ambiguities of scale, and more. At Palenque he says that "writing about mirrors brings one into a groundless jungle where words buzz incessantly instead of insects."[27] Colluding, language and world yield details that are at once linguistic and not, and Smithson feels that every hybrid nuance of the scene is afflicted by entropy, the decay of the particular that inclines all things toward sameness.

Smithson's essays are compendiums of entropy-haunted observations provoked by the New Jersey suburbs (where "the buildings don't *fall* into ruin after they are built but rather *rise* into ruin before they are built"),[28] Hollywood movies ("We are faced with inventories of limbo. . . . Tangled jungles, blind paths, secret passages, lost cities invade our perception."),[29] museological tactics ("an interminable avalanche of categories"),[30] the mirrored surfaces of architecture stylish in the 1930s ("tired distances. . . . Emblems of nothingness").[31] Attending with demonic insistence to "the actualities of perception," Smithson noticed entropic pressures on everything he saw and read, and in his seeing and reading, as well. The eighth of the Yucatan mirror displacements prompted him to say that:

> Sight turned away from its own looking. Particles of matter slowly crumbled down the slope that held the mirrors. Tinges, stains, tints, and tones crumbled into the eyes. The eyes became two wastebaskets filled with diverse colors, variegations, ashy hues, blotches and sunburned chromatics. To reconstruct what the eyes see in words, in an "ideal language," is a vain exploit. Why not reconstruct one's inability to see?[32]

Presumably that reconstruction, too, would be flawed. To follow Smithson from sentence to sentence through "Incidents of Mirror-Travel" is to watch him slog along in a miasma of ambiguity, from one bewildering fork in the trail to the next. He is never lost, or it would be truer to say that Smithson's prose took him to regions where the distinction between losing and finding one's way is impossible to make.

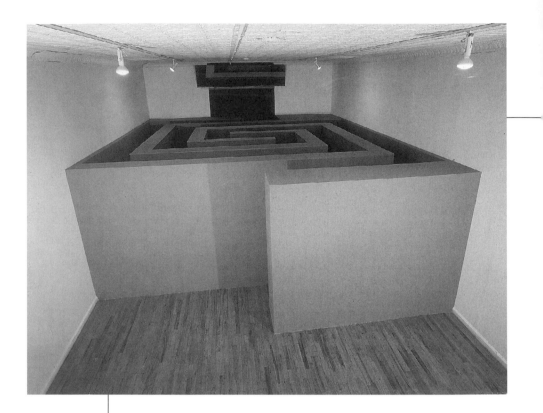

PATRICK IRELAND, *Labyrinth*, 1967. Painted wood, 48 x 144 x 144 inches. Installation at Finch College Museum of Art/Contemporary Wing, New York. Courtesy of the artist.

"What you see is what you see."
*Frank Stella, 1966*[1]

"Where there is real time . . . what you do is what you do."
*Robert Morris, 1975*[2]

"What was there was there, including you."
*Patrick Ireland, 1975*[3]

For an exhibition at the Finch College Museum of Contemporary Art, in 1967, Patrick Ireland built a labyrinth with a pattern so simple that one could not get lost in it. So there was no question of finding one's way. Low enough to permit an overview, the walls were too high to be stepped over. One had to follow the prescribed route, confined to a corridor but able to place oneself in the overall pattern. Seven years later, Robert Morris's labyrinth would separate overview from inner view. Ireland united them. Thus, as he later said, his airy structure overcame

> the dislocation you have in a labyrinth where your head is always in advance of or behind your body. . . . I wanted to make labyrinths very easy, to diminish the urgency of a solution and to emphasize a rather lax process. . . . Mine weren't authoritarian or concerned with "ingenuity." What was there was there, including you.

Ireland etched labyrinthine patterns on mirrors. He suspended an opaque mass from the ceiling and placed a mirror on the floor below it. In this mirror one could see interior of the floating mass, which was shaped into a labyrinth. Always, Ireland built his mazes from right angles. In the late 1960s, he says, he was "very strong on concrete ideas and things . . . and very much against curves. You're always slipping off curves." Ireland's right-angled labyrinths are grids one can enter, bodily or by looking. Having entered, one is guided by the artist's wish for "a very clear idea of a labyrinth, like a formal garden."[4] Yet his grids of 1967–68 leave one thoroughly baffled.

Looking about for a system of notation that wouldn't be too obviously verbal, hence literary, Ireland recalled Ogham, an ancient Celtic alphabet he learned as a child. An inscription in Ogham begins with a long, straight, horizontal line, meaningless in itself but the first step toward letters, which are formed by making one to five vertical strokes in one of four ways: crossing the horizontal line, standing above it, hanging below it, or crossing it slantwise. Placed one above each other on a sheet of paper, lines of Ogham form a subtly flickering gridwork.

PATRICK IRELAND, *One*, 1968. Colored pencil on paper, 22 1/8 x 22 7/8 inches. Courtesy of the artist.

Ireland used this alphabet to spell out the permutations of "ONE": "NEO, EON, OEN, ENO, NOE." "HERE" and "NOW" received the same treatment. Ireland's Ogham grids lure the mind into mazy paths of language—or, because this language is unknown to art-world viewers and hardly looks linguistic in its written form, one follows the artist's explications into a labyrinth of ideas about language.

When it is grasped, a word's meaning feels inevitable. Yet there is nothing inevitable about a word's intelligibility. Languages are learned in circumstances shaped by happenstance, as language themselves are shaped. We know—even as, in a way, we forget—that meaning appears against a backdrop of unmeaning, of intelligibility unrealized: not everyone speaks our language, nor is any language spoken universally. One's knowledge of a language feels natural, inevitable, only if one maintains an ignorance of these contingencies. Thus our knowing depends on and is permeated by our unknowing. One way out of these ruminative switchbacks is along the elegant lines of Ireland's Ogham inscriptions. As writings, they have the silence of illegibility. See them as works of visual art and their silence acquires a purpose: to introduce the visual clarity of lines detached from the prior clarity of the minimalist object.

Yet Ireland wants even the simplest simplicities to have a complement of complexity, so he devised a way for a straight line to function as a maze. First he set sawhorses in a long line, then he marked the top of this extended beam at intervals. Each marking signified a turning, to the left or the right. Having memorized the sequence, one inched one's way along the line, blindfolded and feeling for the markings. As each was found, one turned, as directed by the pattern in one's mind—for that's where the labyrinth was, in memory. And it may be that the lines of

Ireland's rope drawings, suspended in the air, are the fragments of a disintegrated labyrinth. Moving through the gallery, noting where the artist's lines echo or elaborate the structure of the space, one tries to fit together the remnants of a maze one never had the chance to memorize.

<div align="center">*    *    *</div>

For reassurance, the mind turns from labyrinths to the grids they were at previous, simpler stage of existence. Despite their urban flavor, grids possess—or, anyway, claim—an innocence akin to the pastoral kind. Map-grids are the most reassuring of all because they bring so much territory under the mind's control, yet Alice Aycock managed, in 1975, to call our faith in cartography into question. From the observation deck of the Empire State building, she took pictures with her camera pointed in the cardinal points of the compass. This produced sixteen images, not four, because she determined each direction in four ways: with a compass, by consulting Hagstrom's map of New York, by consulting another map, this one published by Map Industries, and by aligning her camera with the grid of city streets. As the city stood still, Aycock shifted the grid.[5] Three years earlier, she held her grid in place while its contents slowly shifted.

Mounting a 35mm camera on a tripod, Aycock pointed it at the sky and tripped the shutter at regular intervals until an entire roll of film was exposed. Displayed in rows, her pictures formed a gridded record of clouds forming and vanishing or simply passing by. In a caption to this piece, published by *Avalanche* in 1972, the artist reported that she had recently been doing "research on the highway system in which the driving experience could be defined as a *sequence of transitional* movements through space and time."[6] This description of driving sounds less vacuous when heard as a preface to a later comment: "When you look at a map the pattern of contemporary highways is an incredible labyrinthine structure. If you don't have any set goals, you just wander in it." On the site of "the necessary structure" occurs "the contingent event," she added.[7] In 1972, she had built a structure for generating contingencies: a wooden maze thirty-two feet in diameter and six feet high.

A year later the maze had evolved into a kind of burrow—*Low Building with Dirt Roof (For Mary)* (1973). Twenty feet long and twelve feet wide, it has a peaked roof only thirty inches high. Destroyed soon after it was completed, it was rebuilt in 1990 at the Storm King Art Center. In season, weeds sprout from the dirt covering its roof, which looks from a distance like a slight rise in the ground. Aycock's 1972 *Maze* sprawled around itself in concentric circles, open to the sky. Providing

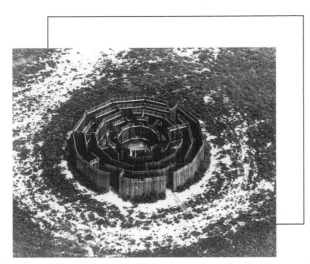

ALICE AYCOCK, *Maze*, 1972. Wood, 6 feet high, 32 feet in diameter. Gibney Farm, New Kingston, Pennsylvania. Courtesy of the artist.

hardly room in which to sit up, *Low Building* compressed two kinds of space into one: as snug as an attic, it is as oppressive as the narrowest subcellar. In *A Simple Network of Underground Tunnels* (1975), the artist joined the compacted unity of *Low Building* to the expansive, fragmented space of *Maze*.

The tunnels of Aycock's *Simple Network* connect six wells lined with concrete blocks. Three can be entered from ground level, by visitors and daylight. The rest are accessible only from within the earth. The white cube of art space becomes cryptlike, though death and burial are not the only associations the artist would like to stir up. In a statement about the work, she wrote of

> the circular pits of the Matmatis people who live beneath the Tunisian desert; square courtyards extending 30 feet below the earth which are light wells for underground dwellings in the loess belt of China; burial holes now inhabited by the living in Siwa, Egypt; tunnels to underground bunkers (Mallory, Keith, and Arvid Otrar, *The Architecture of War*, p. 118); the Federal Reserve Bank of New York—subterranean vaults five stories deep . . .

Aycock's early sculptures were minimalist objects revamped to display a resemblance to stairways and other domestic forms. She turned the two-dimensional grid into a net for snaring images of the sky, and her commentary on *A Simple Network of Underground Tunnels* treats its chambers as repositories for the contents of her mind. "Once underground," she writes, "a person crawls in the dark from light source to light source. The structure is understood by physically exploring it while remembering the surface configuration"—and much else, if Aycock's example is any indication. From the vaults of the Federal Reserve she continues on,

quoting Aristophanes and Jorge Luis Borges, alluding to vampires and troglodytes and Rider Haggard's heroine, the cave-dwelling She.

A *Simple Network* is claustrophobic, to put it mildly, and yet, "at the intersection of the tunnels and the closed vertical walls there is a drop-off where one reaches out into dark empty space." Here Aycock quotes the passage in "The Pit and the Pendulum" which brings the doomed protagonist to an understanding that, in the darkness, an infinite void has opened before him.[8] And here an oeuvre built from the lines and planes and grids of minimalism falls into a mazy abyss of allusion— of literary content, as it was called when minimalist hard-liners were counting on blankness to keep it out.

*     *     *

Of course the minimalist object could be seen as absolutely untouched by language, an antiliterary blank, only because it was so intricately entangled with theory. An embodiment of concepts, minimalist art became conceptual art at high speed, and just as quickly evolved into process art, performance art, earth art, story art, and so on. The evolutionary pressures exerted by language were extreme, and the results sometimes extravagant, yet minimalism's dependence on symmetry— simple, one-to-one correspondence—persisted through every mutation. One sees this symmetry in the forms of artworks and in the relations between forms and their rationales.

Having set down a pattern of numbers on paper, Sol LeWitt would transpose it to three dimensions without modification. "The process," he stated in 1969, "is mechanical and should not be tampered with. It should run its course."[9] In 1974, Allen Ruppersberg selected a text and transcribed its words—one by one and with no modification of their sequence—onto an unprimed canvas. It is a long text, and when the transcription was done, he had filled twenty six-by-six foot canvases. Ruppersberg had copied *The Picture of Dorian Gray*, by Oscar Wilde, a tale of a portrait undergoing the ravages that, for some reason, do not show in the face of its dissolute subject. With his painting—or twenty-part work on canvas—about a book about a painting, Ruppersberg insinuates mazy involutions into the simple, one-to-one pattern of correspondence he inherited from minimalism and put to work in the transcription of Wilde's story. Yet he preserves that elemental symmetry, even as he compromises art with literature as thoroughly as he can without reverting to the history painter's illustrations of stories from myth and Scripture.

A year before he chained himself to the task of copying *Dorian Gray*, Ruppersberg donned a straightjacket, looked into a video camera,

and delivered a thirty-three minute lecture on the life and death of Houdini, the legendary escape artist. "It is said," he notes early on,

> that Houdini's genius did not lie in the invention of new effects from scratch; rather, he was a developer of the unsuspected potentials of drama in old effects. The uninspired midway performer, getting out of a pair of handcuffs with a duplicate key, seldom played it for the drama. And for a long time Houdini, after he had acquired a pair of cuffs from some pawnshop, fell into the trap of showing his cleverness by making it all look easy. The drama lay in making the feat seem hard.[10]

There is no drama in Ruppersberg's recitation. Unlike Houdini, he does not escape from the labyrinthine coils of his straightjacket. He doesn't try. For art is not an escape from a maze, the solution to a puzzle, a charm against danger, or a key to knowledge. Speaking at length of a magician whose stock in trade was amazement, Ruppersberg offers as few surprises as a minimalist box. For art is not entertainment. Art is an invitation to enter a certain state of being.

For artist and viewer alike, art shows the way to autonomy, or, anyway, to the *feeling* that one is, for the duration of the aesthetic moment, uncoerced by any external necessity. Now, this sense of autonomy may be a delusion. From the points of view enforced by institutional styles of thought—philosophical, psychiatric, historical—the idea that aesthetic experience suspends us in a state of uncompromised freedom can only be a delusion. Nonetheless, many of us seek this freedom and convince ourselves that we have found it in the fullness of thought and feeling induced by certain works of art. In modern times, the possibility of autonomous being, however slim or deluded, is crucial to the idea of the self—though it might be more accurate to say that modern times were launched by those who first claimed autonomy for themselves.

To animate feelings of autonomy in us, works of art must somehow give the impression of being autonomous themselves. In the generation of this effect, no theme or style is either mandatory or proscribed. Art need not, for example, follow minimalism into real space and real time. Yet that is the direction Ruppersberg took, immersing himself in pop-culture glitz and the blur of daily life. Like others of his generation, he saw no reason to flee from all that he had found—or rediscovered. The Minimalists, his predecessors, believed that when space and time are really Real, they have room only for an art unblemished by ordinary things. Ruppersberg disagreed, and with his aptitude for the switchbacks of intangible labyrinths, he saw that nothing is more richly ordinary than a relic of the extraordinary—the moth-eaten legend of the great Houdini, for example.

Invited to lecture at the University of Wisconsin in 1970, Dennis Oppenheim whiled away a spare moment by paging through a psychology text. There he found a diagram of a labyrinth for mice. Two years earlier, Carl Andre had arranged hay bales in a meandering line. Now Oppenheim used the same material to convert the mouse maze into a maze for cattle living nearby. Drawn into it by tactically placed heaps of food, the animals quickly learned its patterns and discovered, as well, that the structure itself was edible. Andre talked of the disintegration that weather would afflict on his bales of hay. Oppenheim's were eaten.

This maze led to no more. Questioned in 1976, Oppenheim said, "I've never been that much of a mazist." Then he added that "the mental kind of wandering I am doing now is probably like a maze. I'm certainly given to searching out things that can be schematized, and in lots of my recent pieces, the installation involves leaving tracks."[11] Oppenheim improvised his cattle labyrinth after another project proved too costly. The plan was to transpose a set of earthworks, as they were called, from a battlefield of the First World War to a site in the United States. With shifts like these, Oppenheim conflated disparate spaces and temporal zones, with labyrinthine results.

After the winter of 1968, which he spent drawing patterns from elsewhere on the ice of the St. James River, Oppenheim launched a series of *Transplants*. For the first of them, he commissioned truckers to gather up the refuse from a day's trading on the New York Stock Exchange, then deposit it on the roof of a building in midtown Manhattan. A bit later, he inscribed the outlines of five art-world interiors on five distant landscapes—the shape of a gallery in Amsterdam's Stedelijk Museum, for example, on a field near Jersey City, New Jersey. Documented with photographs and maps, these *Gallery Transplants* eventually returned to the gallery. A circle was closed but not tightly, for these displacements occurred over such vast reaches of space that the mind can always find a way out, along the path of some neglected implication.

Oppenheim mingles real times and spaces with the atemporal space of maps and the time frozen in the depths of photographs. Smithson's *Mirror Displacements* interrupt real space with fragments of reflected space, then allowed all sense of inhabitable space to wander off along the twisting paths of his commentary. Ireland's straight-line maze leads the body through real space as the mind constructs, from memory, the space of a labyrinth that doesn't exist. And his *Ogham* grids open the two-dimensional space of the page to the infinite, imaginary space of a language silenced by the viewer's ignorance. Yet the clear, gridded forms

DENNIS OPPENHEIM, *Gallery Transplant*, 1969. Floor specification of Gallery #3, Stedelijk Museum, Amsterdam, transplanted to Jersey City, New Jersey. Snow, dirt, gravel. Photograph, 60 x 40 inches. Courtesy of the artist.

of that silence echo the clarity of the gallery's white cube. Aycock's art mimics the varieties of architectural space—attic, cellar, and tunnel—and mixes them, maze-like, with the space of literary and historical memory, the space of nightmare, and even, by implication, the newly welcoming space one enters upon escaping a nightmare's clutches.

\*     \*     \*

The city plan is developed on a grid of units 13,260 feet square (approximately 2½ miles) which are grouped within a larger grid of areas 26 units square (approximately 65⅓ miles) which then divides the city into a 10 by 10 area square (675 miles) or 100 areas in all. The area grid thus provides five concentric square stages from its perimeter into the center. The four arms of the spiral which occupy the outer four stages comprise the Outer City. They are separated by the Outer Fields of cultivated land and countryside is thus pulled into the center of the city where it is released to for the Inner Field occupying the central fifth stage.[12]

This is Will Insley's overview of ONECITY, a self-enclosed megalopolis populated by four hundred million people. It exists, he says, "outside the practical network" of habitable environments, "in the

wilderness of things which do not *work* but simply *are*."[13] ONECITY followed, by increasingly tortuous steps, from the shock Insley felt when he saw the green-and-yellow stripes of a canvas from Frank Stella's Moroccan series, 1964.

It was, he recalled, "the most amazing painting" he had ever seen. "I was struck by the clarity of the Liquitex color, the lack of painterly texture and absolute structure of the image." Insley had been working messily in oils. He switched to acrylics and suppressed evidence of his touch. He laid grids over the canvas and built color-blocks with careful applications of masking tape. Unlike Stella, he did not try to give his paintings a look of firm containment. He did not even call them paintings. They were, he declared, "wall fragments." Some are symmetrical, others have mountainous profiles of the sort generated by graphs.

"If there is a wall fragment," he reasoned, "there must be a wall, and if a wall, a building; and if a building, a city, a civilization; if a civilization, a religion." These ruminations led the artist, in 1967, from *Wall Fragments* to drawings and models of buildings. He later discovered ONECITY—that is, all his imaginings coalesced in the idea of this unimaginably vast gridwork. Minimalist unities appear all at once in tangible, self-enclosed forms. Insley's reside in the sum of everything that he has painted, drawn, and built over the past quarter of a century, and his fictive city will gather into itself all the images he makes in the future. It is a constantly shifting unity, no more or less complete now than it will ever be, for it is, in effect, infinite in its complexity and therefore infinitely adept at absorbing and integrating the new forms it generates.

Insley says that ever since he moved to New York in 1957 he has been "preoccupied with walking the street grid and exploring empty parking lots and playing fields at night."[14] ONECITY is his extrapolation from these wanderings, obsessive but not feverish. Insley elaborates the urban grid with the calmest of serial devices:

> "this /building/
> grows from center point out
> according to
> a square slip spiral ratio
> of numbers .1.2.3.4.
> obeying always and only
> laws inherent to the ratio"[15]

Rendered in two dimensions or three, Insley's architecture looks like the patterns of drafting paper infiltrated by mind. Space appears as line and right angle reflect on themselves, doubling, crossing and recrossing, layering and offsetting the grid until forms spread over the page or across the floor like inorganic protein.

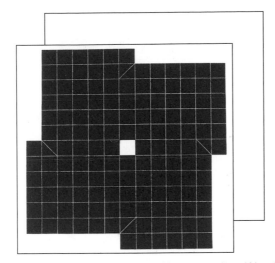

WILL INSLEY, *Wall Fragment No. 63.6*, 1963. Acrylic on masonite, 104 x 104 inches. Courtesy of the artist.

Questioned in 1975 about his "interest in labyrinths," Insley said, "I never really thought of myself as doing labyrinths." He acknowledged, though, that the ratios he spins into buildings are "spiral oriented, even if the buildings are generally square," and spirals can be labyrinthine. However, a labyrinth requires one to enter at a certain point, then presents a succession of choices. "In my buildings," he said, "you can start anywhere and go anywhere." Possibility is wide open because Insley does not shape spaces to specific purposes. "The reason for the existence of the building is the building itself . . . purely controlled space."[16]

Insley's talk of control echoes Robert Morris's remarks on the necessity of controlling "the variables of object, light, space, and body."[17] And Insley has said that minimalism generally, not just the work of Stella in particular, pointed him the direction of ONECITY. Nonetheless, he added, "The Box is a box about a box." Because the minimalist object's potential is so drastically limited by the box of gallery space, Insley approved when Smithson and others went to work into the far reaches of the American landscape. Yet he found the earthworkers' documents more interesting than the outsized forms they built in the desert. Photographs and diagrams open a way beyond fact to the realms of fiction, where invention is unencumbered by any practical concern.[18]

Over the years, Insley has imagined for ONECITY a social structure as involuted as its grid. From descriptions of "the day people and the night people" and their ways of life emerge hazy intimations of a religion, hence of blasphemies. The artist has said that

ONECITY exists in my mind as an extreme statement projected from my experiences in the real world (living in cities), but it is

WILL INSLEY, *Building/No. 14, Channel Space Auto-Run, Central Spiral, Plan and Section*, 1969/1974. Pencil on ragboard, 30 x 30 inches. Courtesy of Jon and Joanne Hendricks, New York.

> not dedicated to GOOD. Nor, for that matter, is it dedicated to
> BAD. It makes no moral judgment whatsoever. . . . I've often said
> that art should exist beyond moral responsibility. Architects, of
> course, are very concerned that things work and people don't fall
> down stairs. I've been called "immoral" by architects. I suppose
> that there are many things in ONECITY that are immoral or at
> least physically dangerous. I don't necessarily consider ONECITY a
> good city to live in; it could be a nightmare.[19]

Of all the bodies of work that emerged from the minimalist box, Insley's is among the richest, the most extravagantly complex. His megalopolis is a vision of austere glamor, shadowy and dazzling by turns. Its angular mazes lead one as far into the speculative distances as one wishes to go, yet all paths lead back to the minimalist blankness where Insley began. Asked if his imaginary buildings are inhabited, he said,

> You inhabit them as you go through, but you don't live there.
> This is a problem. It's rather amusing, because several years ago a
> friend, who was an architect, looked at a model and tried to find
> what was inside. Where were the doors? Where were the win-
> dows? There were none—just space.[20]

SCOTT BURTON, *Inlaid Table*, 1977-78. Galvanized steel and mother-of-pearl, 22 x 15 1/2 15 1/2 inches. Max Protech Gallery, New York.

# IRONY

"Sculpture is in your space. And there's a challenge to kick it back out of your space into something pictorial. Or you can make a painting and kick it more into the space you're in. You can have a painting that has the qualities of painting, drawing, and sculpture. And I often try to make all three appear in one project. Or, at least, make something eccentric."

*Richard Artschwager, 1996[1]*

Among the impeccably finished metal sculptures Walter De Maria built in the mid-1960s is an L-shaped trough named *Elle* (1966). Form and language intersect and the upshot is a pun: "L" equals "elle" or, in English, "she." This trough is one of many, all geometric in form, and it is likely that De Maria settled on an L-shape before it occurred to him that there was a mild pun to be made. Bruce Nauman's puns are more pointed, no doubt because he set out in his dogged way to make a series of them. *Waxing Hot* (1966–67) is a photograph of the artist's hands applying wax to three small objects in the form of the letters "H," "O," and "T." *Eating My Words*, from the same portfolio of *Eleven Color Photographs*, shows him with a plateful of some white, presumably edible substance shaped into the word "WORDS." He has eaten the "W" and is reaching for the "O."

Another image in the portfolio, entitled *Feet of Clay*, shows feet covered with clay. *Bound to Fail* is a picture of a back and arms bound with a heavy rope. Nauman remade this image in wax over plaster and renamed it *Henry Moore Bound to Fail (back view)* (1967). Because it is a wall piece there is no front view, just as, for a young artist of Nauman's minimalist heritage, there was no view of Henry Moore, that modernist warhorse, as anything but a monumental failure. Modernism's aspirations to Truth and an exalted vision of humanity looked at best irrelevant under Nauman's deadpan gaze. Minimalists aside, the only earlier artists who interested him were Marcel Duchamp and Jasper Johns.

Duchamp built puns into his images and objects. So did Johns, and their examples may well account for Nauman's belief that silly jokes can be the stuff of serious art. De Maria was associated in the early 1960s with the Fluxus group, a band of Dada revivalists, and their jokiness may have authorized his. Yet the sheer, somehow sublime flatness of his and Nauman's punning has a strong flavor of minimalist literalism gone askew. "What you see is what you see," Frank Stella had said. If what you see is a simple shape or pattern, the illusion of absolute clarity is

RICHARD ARTSCHWAGER, *Description of a Table*, 1964. Formica, 26 ¹/₂ x 32 x 32 inches.

easy to maintain. But if seeing becomes hearing, the inveterate slipperiness of language is difficult to ignore. With the literalist eyes of a minimalist, Nauman looked at the ambiguity of "WORDS" and ended up eating them—literally.

If you can see visible form as somehow beyond the reach of language, it looks pure. But how can that purity be maintained? How is it possible to say or think that a form is purely what it is without sullying its purity? This is the question John Baldessari raised by emptying a canvas of all but the declaration that *Everything Is Purged from This Painting but Art, No Ideas Have Entered This Work*. One says, of course they have, for ideas cannot be kept out, and furthermore it is the idea of disavowing ideas that makes this painting from 1966–67 not only a work of art but typical of its period. As soon as the minimalist object made its mute claim to be what it is, no more and no less, its literalism came under friendly, even respectful attack. Only those who had been impressed by the pretension to apodicticity felt the need to mock it.

With its straight lines and flat planes, its right angles and symmetries and simple repetitions, Minimalism was a style with self-evident rules. In a spirit of ironic obedience, Richard Artschwager inflected the surfaces of a box with patterns echoing the form's own corners and edges. What emerged was a three-dimensional pictogram of a table covered by a white tablecloth. By naming the work *Description of a Table* (1964), Artschwager hinted at the unavoidability of language. More than a decade later, Scott Burton turned a tallish box into a table—not a description of a table but the thing itself, in all its utilitarian familiarity—by decorating its surfaces of galvanized steel with gridded insets of mother-of-pearl. With its odd sumptuousness, this *Inlaid Table* (1977–78),

turned a pun on Minimalism's covert functionalism into a reminder that the works of Andre and LeWitt are often, in their fashion, visually alluring. And Flavin's glowing objects, like Judd's highly finished ones, are frankly beautiful.

In 1972 Burton made plans to cast a wooden armchair in bronze and designate it a sculpture. Behind this tactic stands the precedent of the found object, yet he was not merely producing a companion for Duchamp's *Bicycle Wheel* (1913) and *Bottle Rack* (1914). For Burton intended to transform his found object from wood to metal, and in 1975 he did. By casting the armchair in a material immemorially associated with sculpture, he gave it the status of fine art. By casting it without altering any detail, he endowed it with a literalism learned from the minimalist object and not from the Duchampian readymade, which never pretended to be simply what it is. Rather, what the readymade is—an ordinary object—is what it is not—a work of art. No such involutions accompanied Burton's armchair on its way from wood to bronze.

Nonetheless, like Artschwager before him, Burton insinuated an irony into his literalism by claiming minimalist apodicticity for an object undeniably a piece of furniture. And he claimed it as well for the men who appeared in his *Behavior Tableaux* of the 1970s. Identically dressed, the figures on Burton's stage were not so much actors or dancers as embodiments of a temporal structure: the stylized, often symmetrical series of movements they performed in silence and slow motion for an hour or more. In a review of *Pair Behavior Tableaux*, which Burton presented at the Guggenheim Museum in 1976, John Perreault issued a warning: "This performance is almost unbearable."

In 1965, Donald Judd had declared, "A work need only be interesting."[2] Toward the end of that year Barbara Rose said, in "ABC Art," that if "you are bored" when faced with objects like Judd's, "probably you are intended to be."[3] Not long afterward, Lucy R. Lippard coined the phrase "rejective art" and argued that, "by its very restrictiveness," it "opens new areas of aesthetic experience." Many condemned the work of Judd, Ad Reinhardt, and others as boring. Some praised it for the same quality. All this talk, said Lippard, suggested that the boredom in question must be "pretty fascinating."[4] Here was a paradox difficult to untangle in light of Minimalism's other virtues: clarity, candor, simplicity. When Rose reprinted "ABC Art" in Gregory Battcock's *Minimal Art* anthology in 1968, she left out the section on boredom. By then, the topic had been dropped. Unfriendly sensibilities found it too boring to pursue, and it was too knotted for Minimalism's admirers to unravel.

A decade later, Perreault reported that he found it nearly impossible to sit through *Pair Behavior Tableaux*, and yet, "oddly enough, after

suffering through it, I went to see it again." For reasons he doesn't try to explain, tedium can be compelling. And Burton's *Tableaux* are truly tedious. "In this theater of nuance," says Perreault,

> nothing is improvised. Everything is controlled and composed. The harsh white light, the lines of dreamlike movements and gestures, the often arch poses are tough and suffocating. . . .
>
> So many of the tableaux have to do with threat. A hand moves back so slowly that only much later do you realize that the awkward stance is a preparation for violence: a slap, a punch, a violence you never see, making it, therefore, all the more disconcerting because of the remoteness.

127

Burton confined his audience to the back rows of the Guggenheim's auditorium. From that distance, his performers seemed to function mechanically. Perreault calls them "zombies" and "robot lovers."[5] Though they are human and assume legible postures, they have the presence of objects. Conversely, according to the ironies of Burton's logic, a minimalist object can have a human presence. It can have a posture, as a piece of furniture does. Hence a box becomes the slim, slightly awkward *Inlaid Table*. A squat cone becomes elegant and charmingly unstable when inverted and mounted on its point, to serve as a *Public Table* (1979).

To chide and, of course, to celebrate the much discussed presence of the minimalist object, Bill Bollinger placed a two-ton rock on the ground floor of the Whitney Museum as one of his contributions to the *Anti-Illusion* show, in 1969.[6] Out in the desert, Michael Heizer was tipping thirty, fifty-two, and sixty-eight ton rocks into concrete-lined troughs. As he has said and few since the end of the 1960s have wanted to dispute, "A piece of rock can be a sculpture."[7] If a rock can be a variant on the minimalist object, hence a sculpture, all rocks are liable to Burton's ironies about form and function. In 1981 and '82, he assembled an array of medium-sized chunks of granite, marble, and lava, and—with a few carefully considered cuts—produced the smooth surfaces that converted these potential works of art into tables, chairs, and settees. Of course, they counted as artworks, as well.

\*   \*   \*

If it is a plane stretched out on the floor or a lattice flickering through space, a work of minimalist art presents itself as a solid object—unless it's a Judd box with translucent sides. But even when its surfaces are opaque, the minimalist object is suspected of being hollow. Giving off a fluorescent glow, Robert Morris's *Ring of Light* (1965–66) confirms the

suspicion, which Bruce Nauman addressed with *Cast of the Space Under My Chair* (1965–68). This cube of concrete, a bit over seventeen inches high, is obviously not hollow. Nor does it have the minimalist look of embodying a simple concept. It is too dense and irregular.

This is the minimalist object particularized, deprived of the clarity, the "rightness," that gives a form the power to generate the "strong gestalt sensations" that Robert Morris sought in the mid-1960s.[8] A chunk of emptiness solidified, Nauman's *Cast* has the air of a glum memento. As a boy might make a plaster cast of his footprint, for no practical reason, only because he has learned how to do it and it is, after all, his footprint, so Nauman made a miniature monument of a space in his studio that was peripherally familiar and thus the object of a feeling bordering on affection.

Jasper Johns once heard that Willem de Kooning had said, in exasperation, that Johns's dealer, Leo Castelli, could sell anything, even a couple of beer cans. In 1960 Johns cast two sets of two ale cans in bronze, applied their labels in oil paint, and Castelli sold them. Nauman told an interviewer that he remembered something de Kooning had said about pictorial structure, to the effect that "when you paint a chair, you should paint the space between the rungs, not the chair itself."[9] And so, like Johns before him, he took a cue from de Kooning and literalized it. Moreover, by alluding to painters' interest in negative space, Nauman's *Cast* recalls Donald Judd's remark that the minimalist object owes more to painting than to sculpture, despite its three dimensions.[10] Yet Nauman's cube of solid concrete has only an ironic resemblance to a box by Judd or Morris, for he has removed it from the realm of "strong gestalt sensations" and immersed it in the hermetic and vaguely sad domesticity of studio life.

The quiet of small-town streets surrounds Jackie Winsor's *Fence Piece* (1970), an open box built from thin pointed strips of wood like pickets. Line, plane, right angle—all the elements of Minimalism are here. Thus *Fence Piece* addresses us in real time and real space. Yet one responds from the depths of memory. Though Winsor, like Nauman, was impressed by the stopped time of apodictic form, she felt the need to inflect that absolute present—to complicate it—with contingencies far beyond the reach of minimalist authority. In the black-and-white photographs standard at the time, Keith Sonnier's *Dis-Play II* (1970) looks like a sober inventory of geometric shapes: cube, column, plane. One sees that the installation includes its own lighting fixtures. What can't be seen in black and white is the glow of black lights on the fluorescent dyes Sonnier scattered on the floor. And there were strobe lights, silent echoes of the strobe cuts in Andy Warhol's films and the manic strobe pulse at

JACKIE WINSOR, *Fence Piece*, 1970. Wood and nails, 49 x 49 x 49 inches. Courtesy of the Paula Cooper Gallery, New York.

the Dom, Warhol's discotheque on St. Mark's Place. *Dis-Play II* soaked minimalist form in the light of all that its austerity was intended to keep at bay, from the nocturnal hysteria of the Dom to the Day-Glo excesses of "youth culture," as it was called.

\* \* \*

Invited to participate in the *Anti-Illusion* show at the Whitney, Rafael Ferrer delivered immense blocks of ice to the museum entrance. They melted quickly in the late spring air. Of course entropy afflicts all things, and a metal box will vanish, in the very long run, as surely as a block of ice. That nothing is permanent is easy to overlook, especially when one focuses on the "rightness" of the fit between an array of boxes and the rectilinear space that contains them. With his frozen stand-ins for the minimalist object, Ferrer presented a cautionary spectacle to those tempted to take the box's static aura as a sign that real time can be timeless.

A few months before he painted a blue line across a Pennsylvania wheat field, Bill Beckley had applied blue paint to a stand of spindly trees in a Pennsylvania forest. Up close, the results looked almost random. From a distance, the outline of a box appeared in sharp focus. The minimalist object was a product of a thoroughly urban space, yet the idea of it was as transportable as any other. Taking it deep into the countryside, Beckley didn't give the box new life so much as conjure up a swaying, ghostly reminder of its canonical embodiments in plywood and steel. Next he used white paint to mark off a cubical volume in the branches of a leafless shrub. He did it again, in another shrub, and then a

third time. With each repetition, Beckley placed the airy volume of white closer to the tips of the branches. Tenuous at the outset, the cube seemed to be ascending beyond the grasp of material things, as if driven by a need to exist as sheer concept.

When Beckley returned to the city, his forms became less elusive. Never, though, did he allow them to become solid. At 112 Greene Street, an ad hoc gallery run by Jeffery Lew, Beckley suspended three planks between a set of columns. The effect, as he noted in the pages of *Avalanche*, was vaguely "Juddlike." On the lowest plank, he placed a mattress. The second served a rooster as a floor, and the third was his ceiling. To keep the bird in place, the artist enclosed the space between the upper platforms with chicken wire. It troubled him, he said, to have to imprison the rooster,

> but the shows at Greene Street were changing every week and there wasn't sufficient time to train the rooster to return instinctively to his platform. To anyone in the gallery, walking or standing provided a view of the rooster, while lying on the bed obliterated him from sight. The sounds he produced, his poc-pocs, then reaffirmed his presence. Another possibility created by the situation was that one might lie down and fall asleep, become unconscious, and later be made conscious again by the rooster.[11]

Of course one would not have sought out this bed if one wanted to rest, only if one wanted to become aware—across what is sometimes called aesthetic distance—of what it is to try to get some rest. With *Rooster, Bed, Lying* (1971), Beckley gave a touch of domesticity to the minimalist object's antiutilitarianism. And he suspended the minimalist effort to exert control. "The thing about animals," he says, "is that they shit. They piss. You can't really tell them what to do."[12] After the 112 Greene Street installation came down, Beckley mounted a plain white beam in a door frame. To go through the door, one had to stoop. Looking over the edge of the beam, one saw that it was a box containing a turtle. Unlike the rooster, this animal drew little attention to itself. It hardly moved. With *Pet Turtle for Donald Judd* (1971), Beckley gave a new look to the stasis of the minimalist object.

William Wegman made art with an animal who did listen to instructions, a Weimaraner retriever named Man Ray. In a series of seven photographs called *Before/On/After: Permutations* (1972), the minimalist box serves as a device for helping Man Ray demonstrate a series of prepositional states: in one photograph he stands *on* the box, in another he stands *before* it, and so on. In every instance, he seems to gaze intently at a placard showing geometric shapes: a circle, a square, a triangle. It's as if the dog is learning from these forms how to be clear about his relation-

BILL BECKLEY, *Rooster, Bed, Lying*, 1971. Three wooden platforms, chicken wire, bedding, and live rooster. Installation, 112 Greene Street, New York. Courtesy of the artist.

ship to the primary form: the box. These seven permutations purport to show thought and behavior attaining perfect congruence. Of course they don't show that at all, only the artist's inclination to mock Minimalism's various claims about fitting form to thought, thought to form, and both to the white cube of gallery space.

*Folly, Soucy, Man Ray* (1973) names a six-part photographic piece and the three dogs it arranges in a serial pattern. Each print pictures the hindquarters of one dog and the forequarters of another. To see all three animals in full, one must follow the permutations of their parts to the point where complete images can be imagined. Here, canine bodies stand in for the minimalist object. Boxes and their constituent planes, corners, and lines reappear in Wegman's drawings. Eight aimless lines— some curvy, others bent—are given the job of representing *4 Hairpins/4 Paperclips* (1973). In *House and Bit*, a drawing from the mid-1970s, ten lines form a pentagonal perspective. If this is a house, it must be a birdhouse, though the opening—a minuscule circle created, presumably, by the parallel lines we read as a drill bit—looks as if it's too small even for a sparrow. As Wegman saw the minimalist object, its authority was the product of willful attribution, and therefore unquestionable—apodictic— only in the eyes of those on the lookout for authoritarian presences. See the minimalist object whimsically, and it becomes a vehicle for jokes, as in Wegman's art.

Properly installed, the box directs attention from itself to the realness of real space, then back to itself, precisely as it is. By compressing this object until it was almost small enough to fit in the palm of one's hand, Joel Shapiro gave the space of the gallery a make-believe immensity. Even without their peaked roofs, his sculptures of the early 1970s would have looked like houses—toy houses, to join his toy chairs in a minimalist version of storytime. Yet Shapiro had no reluctance to take the

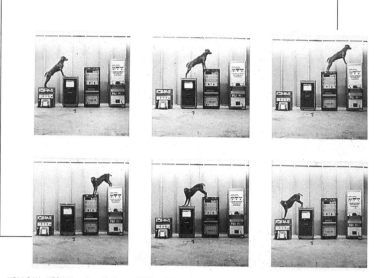

WILLIAM WEGMAN, *Ray-O-Vac*, 1972. Six black and white photographs, 32 1/2 x 43 1/2 inches overall. Courtesy of the artist.

box as seriously as it took itself. Perhaps he took it more seriously still, and his compressions were driven by a wish to endow the object with even more conceptual weight and formal stasis than it has in the art of Morris and Judd. In Paul Thek's hands, the minimalist object became a set of building blocks. For their transportation, he built a cart in the shape of an open box, with circular slabs for wheels. These are playful forms, unquestionably. The only question is about their ratio of playfulness to irony.

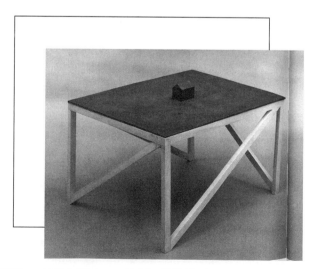

JOEL SHAPIRO, *untitled (House on Field)*, 1975-76. Bronze and wood. 21 x 28 1/2 x 21 1/2 inches. Whitney Museum of American Art, New York; Purchase, with funds from Mrs. Oscar Kolin.

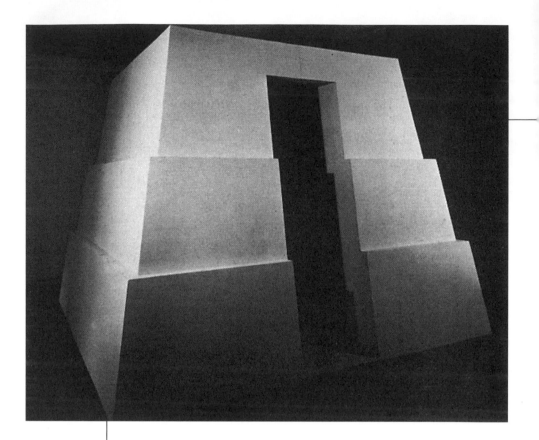

PAUL THEK, *The Tomb — Death of a Hippy*, 1967. Exterior view. Painted wood, 102 x
126 x 126 inches.

# DREAD

"In New York at that time there was such an enormous tendency toward the minimal, the non-emotional, the anti-emotional, even, that I wanted to say something again about emotion, about the ugly side of things. I wanted to return the raw, human, fleshy characteristics to the art. People thought that it was sado-masochism trick. That did not even occur to me. But if they wished to see it like that, it is OK with me: sado-masochism at least is a human characteristic, at least it is not made by a machine."

*Paul Thek, 1969*[1]

The minimalist object is clear, static, blank. A properly reciprocal gaze is direct, unblinking, undistracted by speculation. The thing viewed shapes the nature of the viewing, not seductively but imperatively, and the acquiescent viewer is locked into the gallery space as securely as the box itself. Among the least acquiescent viewers were those artists who acknowledged in full the authority of the minimalist object. Here, they felt, was aesthetic necessity made visible. Yet they felt the need to look farther, to zones where one's way of seeing would not be so powerfully regulated by the premises of minimalism.

If the gallery wall was blocking the lines of sight, artists would break out. They would escape to the space of the street and the country-side, a feat Dennis Oppenheim performed many times in the late 1960s. On one of his breakouts, he took the minimalist box with him, having turned it into a series of *Viewing Stations*, which he installed in the Long Island countryside during the winter of 1967. These were truncated pyramids: boxes made to serve as platforms for gazing beyond the premises of minimalism, into the immensities of an American landscape. The point, he later said, was "not making but seeing."[2]

Oppenheim was born and educated in northern California. Minimalism drew him to Manhattan, yet even before he settled in, he had concluded that the style was frozen, possibly dying. In 1967 he showed sixteen fiberglass *Tomb Stones* at the Hansen Fuller Gallery, in San Francisco. The artist arranged them gridwise, to show their incremental diminution. Rectangular, fabricated from a mundane material, locked into a serial pattern, these objects were minimalist in all but spirit. Illuminated from within, they made, in the artist's words, "a satirical statement" on the box.[3] Directing the gaze into the open and, by implication, the future, the *Viewing Stations* were optimistic. The *Tomb Stones* were mocking and also morbid. For these works weren't content to suggest that the authority of the box was dying. They hinted, as well, that minimalist form had been deathly from the moment of its birth. Oppenheim wasn't the only artist to

DENNIS OPPENHEIM, blueprint of *Viewing Station #1*. Blueprint, 15 x 30 inches.
Courtesy of the artist.

be disquieted by minimalism. When asked what Carl Andre's gridded
floor pieces meant to her, Eva Hesse said, "It was the concentration camp.
It was the showers where they put in the gas."[4]

Hesse was born in Germany in 1936. In 1970 she died of a brain
tumor. When she was three years old, she and her family arrived in New
York, by way of Amsterdam, driven from Europe by the Nazi regime. After
art school, she drifted through several styles, mixing them as she went. In
her early paintings, reminiscences of European Expressionism blend with
painterly devices learned from de Kooning and his generation. With her
wavering line, Hesse gives tentative life to geometries of constructivist lin-
eage. Her art became her own in the mid-1960s, after she confronted the
clarity of minimalist form. It oppressed her, horrifyingly, as her comment
on Andre shows. Yet those same clarities, as elaborated by Sol LeWitt in
particular, supplied her mature work with its starting points.

*Hang-Up* (1966) is a large, hollow rectangle. Seventy-two inches
high by eighty-four inches wide, it lies flat against the wall. From a point
near its upper left-hand corner, a long, erratic loop of wire reaches into
space. With its resemblance to a picture frame, *Hang-Up* acknowledges
Donald Judd's argument that minimalist objects are only incidentally
sculptural. Their direct antecedents are pictorial. Having absorbed the
current definitions and redefinitions of painting and sculpture, object and
image, Hesse placed *Hang-Up* at the center of the ambiguities surround-
ing the very idea of medium in the mid-1960s.

The gesture of the wire is dramatic yet tentative. After leaving the
upper edge of the frame, it returns to the lower edge. This wire models
itself on a vein or a tube in a life-support system, as if its job were to sustain
the medium of painting—or, anyway, a memory of it. In other works, Hesse

put the minimalist repertory of line, plane, grid, and box through further permutations. At every step, order became disorderly. From modular progressions of the clearest kind, tangles of cord and wire would emerge, bringing with them suggestions of neurons or veins or unkempt hair. What is rigid in a minimalist object is pliable in Hesse's art, and even when a fiberglass surface is in fact hard, it has the look of flesh. Asked by Cindy Nemser about the "anthropomorphic" look of her work, Hesse replied:

> First, when I work, it's only the abstract qualities that I'm really working with, which is to say the material, the form it's going to take, the size, the scale, the positioning, or where it comes from in my room—if it hangs on the ceiling or lies on the floor. However, I don't value the totality of the image on these abstract or aesthetic points. For me it's a total image that has to do with me and my life . . . it is inevitable that it is my life, my feelings, my thoughts . . . the total absurdity of life. I guess that's where I relate, if I do, to certain artists I feel very close to, and not so much through having studied their writings or works, but because, for me, there's this total *absurdity* in their work.[5]

Hesse would sometimes call her work "ugly" or speculate about the source of its "silliness." She was not being apologetic. After telling Nemser of a modular piece called *Aught* (1968)—"the same mats repeated over and over and over again"—she said that "the piece is strikingly ridiculous and that is its best quality."[6] Perhaps the art of Sol LeWitt was absurd as well. He called it "irrational."[7] Yet it is not obviously so. One must seek its irrationality, its absurdity, in a calm engagement with its sensible-looking variations on seemingly rational forms. Hesse's art is frankly absurd, ridiculous, silly, ugly: a confident display of flagrant imperfections. The minimalist object presents its irrationality as irreproachable, the sign of self-sufficiency answerable to nothing and to no one. Remaking that object and its elements, giving them the feel of flesh and nerves and connective tissue, Hesse endowed them with vulnerability.

*Accession II* (1967) is an open metal cube, its surfaces pierced by thousands of small holes in neatly aligned rows. Into each opening Hesse inserted a short length of rubber tubing, pushing it just far enough to leave the outside of the box smooth. Inside, the tubing forms a dense, bristly surface—weirdly organic but not reassuring, not familiar. It's as if the minimalist box has been opened up to reveal an absurdity deeper than the ones it was willing to proclaim. At the bottom of another box, *Inside I* (1967), a length of string lies in an abject heap. Hesse's forms often look sutured or bandaged. She permates line and plane and box with dread, and it is tempting to see in the uneasiness of her forms a premonition of her illness. Yet she arrived at her mature style several years before her brain tumor was discovered.

EVA HESSE, *Inside I*, 1967. Acrylic, string, papier mâché over wood. 12 x 12 x 12 inches. Courtesy of the Robert Miller Gallery, New York.

In his review of "Eccentric Abstraction," 1966, a show organized by Lucy Lippard, Mel Bochner wrote that Hesse's form evoke "atrophied organs and private parts." Yet, he added, they "are not garish or horrifying. The lacerated shiny surfaces have a detached presence that is real. Hesse's work has an awkwardness similar to that of reality that is equally empty of inherent meaning or simplistic contrasts."[8] The minimalists presented the real as blankness ordered by arbitrary patterns, systems "empty of inherent meaning." Some artists found the minimalist object too blank, and rebuilt it with ironic intent. The real, they felt, includes a degree of wit. Hesse agreed. Yet she was aghast at Andre's grids, and the wit of her revised minimalism is tinged by terrors that persisted from her earliest years.

\* \* \*

In his "Anti-Form" essay, Robert Morris noted that

> the use of the rectangular has a long history. The right angle has been in use since the first post-and-lintel constructions. Its efficiency is unparalleled in building with rigid materials, stretching a piece of canvas, etc. This generalized usefulness has moved the rectangle through architecture, painting, sculpture, objects.

But, he added, only in the construction of the minimalist box does rectangularity provide "the final definition of the work."[9] Only here does rectangularity itself present itself as self-sufficient, an autonomous virtue admirable in itself.

Alone with a box in the boxy white interior of a Manhattan gallery, one may well feel that the object epitomizes a clarity of form to

GORDON MATTA-CLARK, *Four Corners*, 1974. Architectural fragments. Installation at the John Gibson Gallery, New York. Courtesy of the Holly Solomon Gallery, New York.

be found throughout Western culture—in the layouts of formal gardens, for example, or in architectural structure. This feeling is reinforced by the gridded glass and steel buildings of the postwar era, yet instances of architectural idiosyncrasy are easy to bring to mind. In literalist fashion, Gordon Matta-Clark collected a set of four such instances and brought them to his New York gallery. After the completion of *Splitting*—the work of drawing a line with a chain saw through a house in New Jersey—he cut a squared-off portion from each of the building's four upper corners. Neatly positioned on the gallery floor, their family resemblance to the minimalist box was obvious. Yet these were not good gestalts. They were fragments of a structure which, even when whole, was inflected by the quirks of local style and building practice—contingencies of the kind that the clarity of minimalist form invites one to forget. Matta-Clark's *Four Corners* (1974) charges the box with the melancholy of lives lived in vernacular structures on the margins of history, and far beyond those margins, in the anonymity that many understand as a kind of death.

Paul Thek built a series of Plexiglas boxes in 1965–67. If he had left them empty, they would have been not only transparent but, in a way, invisible. As the sixties ended, this form was in no need of reiteration. Thek drew attention to his boxes by reducing them to containers for the chunks of rotten meat he rendered with horrific exactitude in vividly tinted wax. Slimmer boxes contained fragments of human bodies: the arms and legs of the "warrior" mentioned in the title of one of these works. Thek was using Morris's "unitary" form to display evidence of dismemberment. His waxen body parts are always armored, though; in one case, the armor turns out to be a sheath of layered butterfly wings.

In Thek's universe, the body is not merely mortal. It is liable to extreme violence and spectacular putrefaction. To remain intact, the body needs superpowers. Or so Thek implied by casting in latex the figure of *Fishman* (1968). Though cast from the artist's own body, this more than

human character had the presence of a comic-book superhero. *Fishman* was first seen in 1969 amid the branches of a tree in the courtyard of the Stable Gallery, in Manhattan. Arms and legs stretched out, suspended on high, he seemed to cleave the ocean of air, attended by the forces of nature whose emblems were the fish that clustered close to his body.

The year before, Thek built a ziggurat big enough to enter. From the outside, its stepped form offered what so many objects offered in those days: a variation on the basic minimalist box. Robert Morris's boxes were a dreary gray. This one was bright pink. Viewers struck by the awfulness of this color found this box's allusion to ancient funerary architecture no more than faintly peculiar. Inside, the point of the allusion became clear. On the floor lay a wax effigy of the artist in hippy garb: white suit, long scarf, jewelry. His limbs slack, his tongue protruding, he was obviously dead, not sleeping. Thek had turned the interior of the minimalist box into a shrine for the display of a relic symbolizing much that the art world ignored, not blithely but with resolute determination.

From the art world's elevated vantage point, self-styled "youth culture" was childish, silly, negligible. Its pretensions to a revolutionary way of life were, at best, adolescent. The minimalist object was serious. It was the mature—the culminating—achievement of a long history. If the box shut out politics, it would ignore youth culture as well. Thek either couldn't or wouldn't follow the logic of minimalism's exclusions. Nor did he simply reject the minimalist aesthetic. In 1988 Thek died of AIDS. Two decades earlier, having envisioned himself as a user killed by an overdose, the artist replicated the image of his dead self with impersonal precision—as Morris had replicated one cube to make a series of four.[10] Sequestered with this figure in a ziggurat, one wondered if Thek was indicting minimalist literalism itself as an agent of death, and

PAUL THEK, *Hippopotamus*, 1965. Beeswax, Plexiglas, and metal, 11 3/8 x 19 3/4 x 11 1/2. From the *Technological Reliquaries* series. Collection: The Walker Art Canter, Minneapolis.

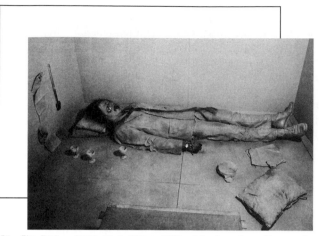

PAUL THEK, *The Tomb — Death of a Hippy*, 1967. Interior view. Figure of wax with dynal hair, suit, shoes, glass, bowl, jewelry, and letters.

lamenting the utopian hope that youth culture, even at it most frivolous, had for a season or two sustained.

<center>*   *   *</center>

Toward the end of 1972, Michael Heizer organized a platoon of earth-moving machines in Garden Valley, Nevada. During the next two years, they heaped more than nine thousand tons of earth into a trapezoidal mass one hundred and forty feet long and twenty-four feet high. Called *Complex One*, it is the first of four parts of *City*, which will eventually occupy sixteen acres. Begun in 1980 and completed in 1988, *Complex Two* is an immense, slowly ascending ramp measured off by forms like the ancient commemorative markers called steles. The rest of *City* remains on the drawing board.

*Complex One* is sculpture on the scale of architecture—or a painting on the scale of the Western desert. Elizabeth C. Baker, the editor of *Art in America* and one of the very few who have made the long trek from the art world to Garden Valley, Nevada, reported that when seen from "half a mile away or farther, say, the work appears to be a rectangular plane standing straight up, framed by bands of concrete." It resembles the abstract paintings Heizer made in the late 1960s. "As you go closer," Baker continues,

> the rectangular framing quite literally comes apart—light starts to slip between different sections of the horizontal and vertical parts, and between column sections and the man mound. What appear at a distance to be continuous bands are seen to consist of a number of thick elements positioned at different and surprising intervals from the mound and from each other. . . . Close up, the parts interact sculpturally with one another and with the viewer in a "normal" sculptural way.[11]

As she approached *Complex One*, Baker saw that its resemblance to a painting was the product of its resemblance to sculpture. Neither one nor the other, it is a minimalist object: a sculptural mass with the flat, rectilinear surfaces of a painting. Early in the 1990s the artist said:

> the work is a place that has been made out of a place, an extremely large one. Size is the issue. In European art, which is basically decorative, there is scale. In *Complex One* there is none of the relationship, the ratio of object to setting, that produces scale. It is the size it is. This is what makes it real, makes it modern, makes it pure.[12]

And this is what makes it a direct descendant of the minimalist boxes that displaced art from the far reaches of the imaginary to the immediacies of real space. *Complex One* inhabits the static now of a mid-sixties piece by Morris or Judd. Yet it is alive to time and its passing, for, as Heizer has tirelessly noted, he gave this massive object the shape of a mastaba—an early form of Egyptian tomb.[13]

When work on *Complex One* began, he took up residence in the desert. There he is autonomous, or can claim to be, for he pumps his own water and generates his own electricity. His studio is a construction site, where work continues in what he calls "the funeral monument tradition."[14] Paul Thek turned the minimalist box into a ziggurat, an emblem of Babylon and the finality of death. Yet a funeral monument needn't be so flagrantly bleak. Mixing minimalism's *now* with the cyclical time of ancient tradition, *Complex One* endows the idea of the temporal with a degree of leniency—a distant sort of friendliness to human hopes. When *Complex One* is complete, there will be time enough, one likes to believe, for the artist to finish *Complex Two* and launch *Complex Three* and *Complex Four*. From well-laid plans, one generates a faith in the future.

MICHAEL HEIZER, *Complex One/City*, 1972-76. Concrete, granite, and earth, 110 x 140 x 23¹/₂ feet. Collection: Virginia Dwan and the artist.

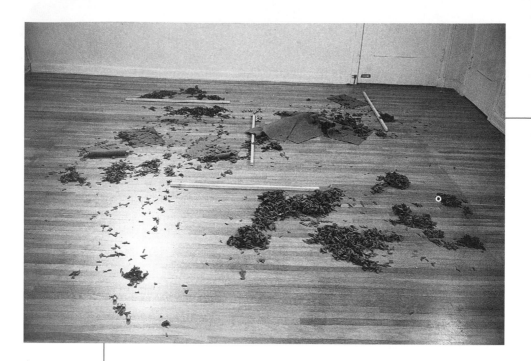

BARRY LE VA, *With in Boundaries, with out boundaries*, 1967. Felt, ball bearings,
aluminum. 10 x 10 feet. Courtesy of the artist.

# DISINTEGRATION

"Everything fine. Sandbag piece looks great. Dennis dyed
water red! See you about Saturday. Love, Peter"

*Postcard from Peter Hutchinson to John and Susan Gibson, 1969*[1]

**E**ach of the minimalists had a doctrine, and each rested his
doctrine on a single term. Donald Judd's was "object, " which he pre-
sented in 1965. Robert Morris countered a year later with "gestalt." Soon
Sol LeWitt had come up with "concept."² Neither "concept" nor
"gestalt" entails an object. However, Judd's "object" entails both of
them, so his term took precedence in the discussion of minimalism, as
Morris acknowledged by exchanging talk of "gestalts" for comments on
"objects."³ Carl Andre's favored word was "place," which removed him
from direct competition with the other three. A box or lattice occupies a
place. A work by Andre *is* a place, "an area within an environment which
has been altered in such a way as to make the general environment more
conspicuous"—or so he argued in 1968.

An object achieves a form, realizes a concept. That done, it
rests. It is static and any change in its condition, even a light scratch,
counts as serious damage. In minimalist aesthetics, "object" entails "pre-
cious" no less firmly than "concept" and "gestalt." By arranging bricks
and metal plates on the floor—by constructing "places"—Andre dis-
pensed with objects and thus with preciousness. "My works," he said,
"are in a constant state of change. I'm not interested in reaching an ideal
state with my works. As people walk on them, as the steel rusts, as the
brick crumbles, as the materials weather, the work becomes its own
record of everything that's happened to it."⁴ Records of this sort are not
permanent. As Andre said, the one hundred and eighty-three bales of hay
he laid end to end will "break down and gradually disappear."⁵ So, in
time, will his aluminum and steel. Nonetheless, Andre's metal pieces
look durable.

One knows that entropy afflicts all things. One knows as well
that, when an Andre exhibition closes, the components of his metal car-
pets will be taken up and stacked away in storage. Yet, twelve rows of his
twelve-by-twelve inch plates of steel look as static and blank—as stub-
bornly *there* in real space—as a Judd box or a Morris cube. The mutabil-

ity of Andre's art is largely notional, which is not to say insignificant. Much in minimalism and its aftermath is notional. Moreover, Andre's "scatter pieces" did look believably random. He would make these works by shaking a bagful of minuscule plastic blocks onto the floor. As the blocks fell, so they lay. Most photographs of these works are from 1966. And most of the works Andre has shown since then have been metal carpets, strictly gridded presences that become the focus of whatever spaces they occupy. Despite his talk of "particles" and "place," Andre did not dismantle the minimalist object. Rather, he gave it flexibility. Fitted with precision to the idiosyncrasies of their settings, his carpets don't merely display their rigidity. They proclaim it.

In 1966, Barry Le Va was a student at the Otis Art Institute in Los Angeles. When he was younger, the paintings of de Kooning, Pollock, and their generation had impressed him. Now he kept track of the minimalists. "They had taken the expressionism out of art," he recently said,

> and that seemed to be a good idea. Also, they were the first artists
> to write in a serious way. This was really important—the clarity of
> minimalist thought, which also showed in the work. Sol LeWitt's
> thought structures were so logical. There was something exciting
> about a conceptual process that didn't contain itself. It produced
> the work and then, as you looked at it, figured it out, the work
> dissolved into thought. Into contemplation. That was an exciting
> process, yet the object remained. The objecthood of the object is
> reinforced."[6]

And the walls of the gallery are reinforced, in their turn. An enclosure becomes a prison, as Le Va argued with *Velocity #1*, his programmatic failure to escape the white cube.

He wanted to find a passage to thought that didn't begin with an adamantly objectlike object of the minimalist kind. For if thought begins there, that is where it will end, reabsorbed by the blunt clarity of the minimalist presence. To undermine the obstinate authority of the object—and, by the way, avoid its traditional preciousness—Le Va tried to transpose drawings into three dimensions without producing sculpture. Verging on paradox, this project led the artist through a series of frustrations. One day, he remembers,

> after I'd been constructing a piece for about three hours, I sud-
> denly became aware of all the debris on the floor, bits of canvas
> and other stuff, and this residue seemed much more interesting
> and significant than what I was making. It had exactly what I was
> after. Not so much indications of a specific process, of what had
> been done to the material, as of marking off stages in time. And
> as a result I became involved in some problems of perception—
> how you perceive anything as ordered or disordered.[7]

Scraps became Le Va's materials—bits of felt, wide and narrow, large and small, lengths of wood and aluminum tubing. Felt cut to minuscule shreds led to ground chalk, powdered oxides, and flour. The artist would distribute these materials across the floor in varying mixtures, guided by a plan but responding to happenstance. Sometimes the array included ball bearings or shards of glass. At the very beginning, in 1966, he scattered the parts of a jigsaw puzzle over sheets of felt. These bits of a larger picture are misleading if taken literally, for Le Va does not invite us to reimagine his scattered materials as a coherent whole. His scraps are not puzzle parts, each with its proper place in a correct solution. They are clues to a process we are free to construe however we can.

With their tangles of straight lines and squiggles, rectangles and shapes without names, Le Va's drawings have the finality of a film script: the scenario is complete, now the action can begin. Screenwriter and director, he must also be the actor, because only he could translate his notations into action. After watching Le Va at work in 1968, Fidel A. Danieli reported that

> Each time the parts of a piece are set out afresh, an entirely new grouping, if not a new sculpture results, for his plans are only used to inaugurate the parts and not as a precise layout. He might start a presentation with a drawing in hand, but he prefers to react to the feel and structure of a different space and to the parts ready for distribution. The largest elements are cast out first and arrayed and arranged and so on to the smallest. An area does not work well if it seems pleasing; the parts are then provoked or manipulated (moved or even kicked) until it feels right—either very planned or very unforeseen. A piece is completed when all combinations of parallel and diagonal alignments, varieties of folds and weighted masses, overlaps, empty areas, and zones of disorder are mixed to a maximum degree.[8]

Thus Le Va would occupy a floor and, implicitly, a space with an overflow of contingencies—an overload of clues to a process so complex that the artist himself couldn't reconstruct it in detail. Yet that is what he invites the viewer to do.

"For quite a while," he says, "I've been reading the Sherlock Holmes stories. I'm intrigued by the way Holmes moves from clue to clue, reconstructing a crime." Confronted with the scene of Le Va's activity, one begins with the title of the work: *Equal Quantities: Placed or Dropped In, Out, and On in Relation to Specific Boundaries* (1967), for example, or *Centerpoints and Lengths (Through Points of Tangency): 5 Areas in 2 Areas; Separated and Partially Included and Separated and Partially Excluded* (1975). Here are clues to guide one's scan of the floor, and sometimes a portion of a title seems to match up with what went on in this or that region of the work. Yet the explanation rarely holds, the clue slips away,

and no less elusive is whatever evidence of a system one manages to gather from the materials themselves. Finally, one can't reconstruct the plot that led to this jumbled denouement. One can only speculate about the motives that shaped these low heaps and dense eddies of material. Nothing is certain except that we can be certain of nothing when trying to make sense of art that so effectively undermines the hope of finding the one right way to see it.

Sherlock Holmes, says Le Va, has "a good eye."[9] He does not mean, of course, that Holmes has the eye of an old-fashioned connoisseur, attuned to such matters as composition, color, and finish. Nor is it like the eye that evolved in New York in the mid-1960s: attracted to stasis and willing to see the minimalist object precisely as instructed by the object's form and its supporting doctrine. Holmes's eye is empirical, alert to nuance, an extension of a wide-ranging, feverishly resourceful mind. His eye never rests until it has sifted the relevant from the irrelevant. Having accumulated the crucial residue of clues, Holmes arranges them in a deductive chain that ties the criminal to the crime. The mystery is solved, as the mysteries posed by Le Va's works never are.

In April 1970, the Allen Art Museum at Oberlin College in Ohio, launched an exhibition called *Art in the Mind*. Le Va contributed a scheme for extracting a series of short texts from a very long text:

> FICTIONAL EXCERPTS
>
> all excerpts are lines 25, 26, 27, 28,
> of every 100th page of:
>
> THE COMPLETE SHERLOCK HOLMES
> SIR ARTHUR CONAN DOYLE
>
> DOUBLEDAY AND COMPANY[10]

In the first excerpt is a clue to Le Va's motive, for it ends with a character saying, "Pray step into my little sanctum. A small place, miss, but furnished to my own liking. An oasis of art in the howling desert of South Lon—." One can imagine Le Va finding this talk of art on page one hundred of his *Complete Sherlock Holmes*, being amused, and looking for a system that would extract it from the hundreds and hundreds of pages of the book.

Yet the system he devised does not produce another excerpt on the subject of art, though Holmes talks of it fairly often, and Watson compares him to an artist when he is not describing him as a scientist or a seer. Our first clue leads nowhere. Yet there is no reason to feel stymied. As he disintegrated the minimalist object, Le Va displaced the minimalist virtue of autonomy to the contingent details—the scattered clues—that constitute his art.

Holmes's eye is good because it turns up the evidence that brings every story to a doubly conclusive end: as the crime is reconstructed, the criminal is tracked down and apprehended. Because the stories told by Le Va's works are doubly, triply, infinitely inconclusive, he encourages the viewer to develop the sort of eye that is alert to evidence, fascinated by it, yet willing to turn from an investigation of visible things to a contemplation of its own efforts. Le Va wants to immerse us in contingencies so rich in possible meanings that meaning emerges, if only tenuously, from the experience of contingency itself.

\* \* \*

To free art from the box, dismantle it. Encourage it to crumble. Use, instead of metal and plywood, materials with no aptitude for straight lines and right angles. Barry Le Va chose scraps of felt. Alan Saret tangled strips of latex with lengths of electrical wire. Before her latex could solidify, Lynda Benglis poured it on gallery floors. Rafael Ferrer preferred autumn leaves. Toward the end of 1968, he loaded eighty-four bushels of them onto a truck and drove to 29 West 57th Street, the address of the Dwan, Fischbach, and Tibor de Nagy Galleries. There, Ferrer and four friends filled the elevator with leaves. Then they dumped twenty-one bushels of leaves in the front room of the Leo Castelli Gallery, at 4 East 77th Street. The rest they unloaded in the stairwells of the Warehouse Show, on 108th Street, where Robert Morris had invited nine young artists to put their challenges to the box on display.

After placing a two-ton boulder near the Whitney elevators for the duration of the *Anti-Illusion* show, Bill Bollinger made several more works by spreading industrial sweeping compound over his portion of the floor. With this "gritty green substance," Scott Burton reported, the artist not only produced

> landscapelike sensations of great beauty (the graphite work is like walking into a Seurat drawing), but he also makes something which cannot stay in any one state for any determinable length of time. These sculptures, with their hundreds of thousands of separate (and possibly modular) parts, are not isolated but right upon by the spectator, whose body thus becomes an active accomplice of the transient and limitless formal possibilities of the work.[11]

Lynda Benglis had been invited to pour latex over the stone floors of the Whitney. Recently she had begun to use polyurethane. Marcia Tucker and James Monte, the organizers of *Anti-Illusion*, had no objection to that. Industrial materials of all sorts were welcome in the realm of antiform. Benglis was known for tinting her materials—a dubi-

ous predilection, though some of Donald Judd's objects sported rather flashy hues. Nonetheless, the two curators balked when they learned that Benglis had added a hot green and Day-Glo pink to her palette. Antiform had evolved from the drab gray minimalism of Robert Morris and other young artists chosen for *Anti-Illusion* intended to confine themselves to properly dreary industrial tones. Though Keith Sonnier planned to include neon in his wall pieces, it would hide behind a scrim. As tactfully as they could, Tucker and Monte suggested that Benglis lower the chromatic temperature of her art.

"The problem," she recalled,

> was that I was interested in that black stone floor at the Whitney and having my piece pop up from the floor—having the contrast you get from bright colors against a dark background. It would have looked really very electric. But Jim and Marcia said, this show is called *Anti-Illusion* and you're interested in illusion. We can't put a piece like yours in front of the Robert Ryman paintings, which would be all white on a white wall. We can't put it near the Richard Serra, which is made of lead. They offered to build a ramp for it, near the entrance to the museum, to sort of get it off to one side.[12]

Offended, Benglis chose to include nothing in the show, though her work is discussed in the catalog of the exhibition, which was in the last stages of production when this setback occurred.

Eva Hesse's contributions to *Anti-Illusion* included an immense, saggy curtain of rubberized gauze. Propped up by fiberglass poles, it seemed to lean against the museum walls in utter exhaustion. Joel Shapiro tacked coils of black nylon filament to his portion of the wall, as if to disguise it with an antiformalist's version of a beard. Because he had met Robert Morris too late to be included in the Warehouse show, Ferrer had invited himself. His presence in *Anti-Illusion* was official. In an upstairs gallery he smeared a wall with automotive grease, then covered this improvised adhesive with a thick layer of hay. Downstairs, he stewed autumn leaves over the blocks of ice he had installed at the museum's entrance.

Across the surface of Coyote Dry Lake, a stretch of the Mojave Desert with the texture of crinkled paper, Michael Heizer scattered black, white, red, and yellow powders. Executed with the help—or at the whim—of the wind, these *Primitive Dry Paintings* (1969) counted as scatter pieces, as did the massive tangle of paper Dennis Oppenheim transplanted from Wall Street to midtown. *U.S. Highway #20* (1969) executed off the shore of Tobago, was another variation on this genre—which, in the absence of exemplary instances, was constituted entirely by variations. While Peter Hutchinson was diving under the sea with sandbags

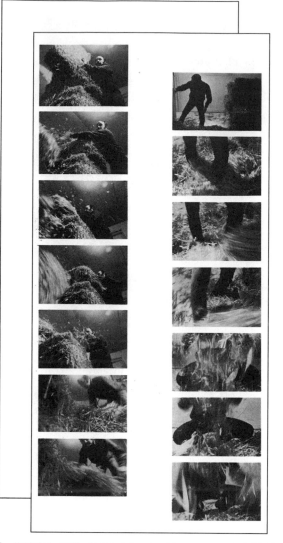

RAFAEL FERRER, *Untitled*, 1969. Straw and automotive grease. Installation at the Whitney Museum of American Art, New York. Photographs by Robert Fiore.

and his string of calabashes, Oppenheim marked its surface with a line of red dye. At first, the line echoed the curve of a coastal highway. Then, drifting free of the artist's intention, it filled the water with a vast cloud of red. Midway through the process, Oppenheim lit the patches of gasoline he had placed along his watery highway, and fire surged into the air.

In *Statements* (1968), his list of ways a work of art might be made, Lawrence Weiner included: "One standard dye marker thrown into the sea." Unlike Oppenheim's *U.S. Highway #20*, this piece was never executed. Because Weiner's aesthetic doesn't require a proposal to be carried out, the effect of his dye-marker piece is ambiguous. Does it disintegrate

the object, turning it into a billow of color, or simply dispense with tangibility altogether? Robert Morris raised similar questions with *Steam* (1967). Under a rectangular bed of stones, he installed enough steam outlets to generate a dense, ever-shifting cloud of white. Lucy Lippard and John Chandler cited this amorphous presence as proof that, in defiance of minimalism's authoritarian tangibility, art was undergoing "dematerialization."[13] It's true that steam is intangible. But it is a physical substance, nonetheless, and Morris presented his artificial cloud as a direct descendant of the minimalist object—no less material and far less vulnerable to certain theoretical objections.

Morris charted the evolution from boxes to scatter pieces in a series of three essays: "Anti-Form" (1968), "Notes on Sculpture, Part 4: Beyond Objects" (1969), "Some Notes on the Phenomenology of Making: The Search for the Motivated" (1970). In the first, he made a point that few would dispute: artists impose forms on materials. Thus a "duality" appears, even in minimalism, which Morris had just a few years earlier called an art of "unitary" objects.[14] He had argued further that these objects could be perfectly unified with the space of the gallery if the "variables of object, light, space, and body" were brought under "control."[15] Now he sees that his dream of absolute congruence hid the gulf that separated minimalist forms from minimalist materials. Metal and wood are not, after all, inherently rectilinear. To close this gulf, artists must dispense with "static a priori" forms and let their materials show them how to shape their works.[16] "Sometimes," Morris wrote,

> a direct manipulation of a given material without the use of a tool is made. In these cases considerations of gravity become as important as those of space. The focus on matter and gravity as a means results in forms that were not projected in advance.
> Considerations of ordering are necessarily casual and imprecise and unemphasized. Random piling, loose stacking, hanging, give passing form to the material. Chance is accepted and indeterminacy is implied . . .[17]

Nearly as soon as the minimalists were given their label, a generation of successors appeared. Dismantling the minimalist object, they had given the autonomy of objects to lines and planes. They had reduced the box to scraps of felt and wood, and, further, to powder and surges of color in the sea. As a founder of minimalism, Morris had invited nine of these younger artists to do whatever they pleased at the Castelli Warehouse. As the author of "Anti-Form," he joined their ranks. He became one of his own successors. He too piled strips of felt on the floor, he mixed dirt with peat moss, bricks, bits of metal and felt, and he dissolved the box into a cloud of steam.

Morris's *Untitled (Threadwaste)* was a vast sprawl of the stringy, greasy material used to pack freight car bearings. He produced the work twice, first on the floor of his New York studio, in 1968, then the following year, at the Castelli Gallery. Mixed in with threadwaste were chunks of asbestos, pieces of felt, and lengths of copper tubing. Here and there stood a double-sided mirror, wedged into a heap of stuff. The allusion to the *Mirror Displacements* of Robert Smithson is direct but not especially telling. Smithson's mirrors were turnings in labyrinths that led from landscape to the quirkier ramifications of language. Morris's mirrors could hardly be distinguished from the chaos they reflected. Materials and their reflections sank together into a morass of antiform.

When he was still a minimalist, matching the shapes of his plywood pieces to "static a priori" forms, Morris noted that "one need not move around the object for the sense of the whole, the gestalt, to occur."[18] Now that he was letting amorphous materials supply his works with their forms—or antiforms—there were no strong gestalts to be perceived, no coherent "sense of the whole" to be grasped. Yet Morris's art still felt static, still gave off a strong flavor of the a priori. For his antiform theory was his theory of "unitary form" inverted. Strong gestalts had become weak gestalts, to permit a greater congruence of form and material, but the old congruence of form and theory was as tight as ever.

Of his cubes, Morris had said, "One sees and immediately 'believes' that the pattern within one's mind corresponds to the existential fact of the object." His works in the antiform mode force the same correspondence. That is why *Threadwaste* had the look of an illustration, a demonstration of theory. And that is why Barry Le Va said, in the mid-seventies, that even after Morris abandoned minimalism he was "still tied to an object aesthetic, an art still captured in a single glance."[19] It takes only an instant to see that the fact of *Threadwaste* makes a precise fit with the theory of antiform, and thus the work sustains a series of dualisms: theory/practice, form/material, reality/appearance, scheme/content, mind/body.

These are the patterns of metaphysical thought, which offers to loft us above ordinary realities to the realm of the Real. Having converted the shifting, dubious truths of everyday life into the eternally, indubitably True, metaphysical thought teaches us to understand everything in a single glance. Metaphysical thought is reassuring, and so it persists, even in the art of Robert Morris, who rejected it explicitly.[20] Whether objects or antiobjects, his works dictate the one right way to see them, as if to prepare us for the metaphysicians' lessons about the one right way to see anything at all. This is not to suggest that Morris and the minimalists formed a united front, any more than metaphysicians are in

ROBERT MORRIS. *Untitled (Threadwaste)*, 1968. Threadwaste, asphalt, mirrors, copper tubing, and felt, overall dimensions variable. The Museum of Modern Art, New York. Gift of Philip Johnson.

accord on the nature of the True and the Real. Rather, minimalists and metaphysicians agree—the latter more consciously than former—that contingency can be overcome. Certainty can be absolute.

Art theory, aesthetics, and metaphysics deliver an illusion of control, of a mastery over meaning if not events. Sometimes meaning resides in control itself, as Morris acknowledged with the coercive mazes and prison imagery that succeeded the false liberation of his antiform. Le Va and his generation were impressed by the minimalist object, yet they sensed the domineering impulses built into its clarity. In the minimalists' talk of real time and real space, these younger artists heard a yearning for the authority of the Real. For they had intuited a recurring pattern of Western thought: when anti-Platonism turns militant, it turns covertly Platonic. If minimalist form was too bluntly clear, they would dismantle it, freeing line, plane, and grid to drift—or plunge—into ambiguity. They would let the very idea of the object disintegrate, without benefit of theory.

MICHAEL HEIZER, *Double Negative*, 1969-70. Two removals of 24,000 tons of rhyolite and sandstone, 1,500 x 50 x 30 feet. Mormon Mesa, Overton, Nevada. The Museum of Contemporary Art, Los Angeles.

# ABSENCE

"1968 was the year of holes in the ground. I think that Michael Heizer was among the very few artists who actually made one, but everybody was talking about it—how it wasn't necessary to make objects any more. It was better to make a negative object. A hole in the ground."

*Dennis Oppenheim, 2000*[1]

In 1964, Donald Judd made two boxes and painted them cadmium red light. That same year, Andy Warhol made dozens of boxes and imprinted them with supermarket logos: Brillo, Del Monte, Heinz. To make a latticework, Sol LeWitt would transpose a grid from drawing paper to three dimensions. Warhol kept his grids flat on the canvas and filled them with images of movie stars, Campbell's Soup cans, and electric chairs. Pop artists and Minimalists agreed on the virtues of simple, rectilinear form. They even shared an affinity for blankness. During the 1960s, Warhol liked to juxtapose a picture with a passage of monochrome color, and there is an empty, minimalist shimmer to the blank aluminum surfaces that punctuate the billows of imagery in James Rosenquist's immense, multipaneled paintings of the 1960s: *F-111* (1965) and *Horse-Blinders* (1968–69).

Claes Oldenburg turned minimalist cubes into pop-art spheres, sixteen of them, each twenty-four inches in diameter. To focus attention on form, Minimalists titled nearly everything "Untitled." Oldenburg called his spheres *Giant Pool Balls* (1974), for that is what they resembled, and a pop aesthetic supplies no rationale for denying the obvious. When, in 1967, the artist hired a team of gravediggers to dig a six-by-three-foot hole in Central Park, behind the Metropolitan Museum, he did not talk of negative form. This was a grave, a reminder of death and therefore, as Oldenburg said, "a perfect antiwar monument."[2] Soon after the hole was dug, he had it filled in, and it became the perfect antimonument.

Oldenburg had responded to the disaster of Vietnam. *Box in the Hole* was Sol LeWitt's response to certain formal possibilities. His lattices and open cubes had risen from the floor. Now, in 1968, he directed a "cube of unknown contents" to be "cast inside larger cube of concrete and buried in the earth." The procedure was carried out in a lawn in Bergeyk, Holland.[3] That year Lawrence Weiner's published *Statements*, a short book which includes this:

One hole in the ground approximately one foot by one foot/One
gallon water-base white paint poured into this hole.[4]

It was not imperative for the artist or anyone else to do this,
Weiner having declared of all the works he had or ever would propose:
"The piece need not be built."[5] Early in 1969, LeWitt published
"Sentences on Conceptual Art," the tenth of which states as an incontro-
vertible axiom:

> Ideas alone can be works of art; they are in a chain of develop-
> ment that eventually find some form. All ideas need not be made
> physical.[6]

To contribute an idea to *Art in the Mind* (1970) might well be
enough. Bruce Nauman offered this:

> Drill a hole into the heart of a large tree and insert a microphone.
> Mount the amplifier and speaker in an empty room and adjust the
> volume to make audible any sound that might come from the tree.
> Sept. 69
>
> Drill a hole about a mile into the earth and drop a microphone to
> within a few feet of the bottom. Mount the amplifier and speaker
> in a very large empty room and adjust the volume to make audi-
> ble any sound that might come from the cavity.
> September 1969[7]

Nauman imagines the hole as a speaking void, a silence charged
with the exhaustion afflicting the discussion of objects.

Robert Morris had argued the year before, in "Anti-Form," that
the shape of an artwork must evolve from the nature of the artist's mate-
rials. The box, he implied, had made its rectangular case. If it were to
continue making it, the minimalist object would turn into an illustration
of itself. It would become representational, and lose the power it had
gained from being, with unencumbered directness, precisely what it was.
This slippage, from immediacy to repetition, didn't trouble Donald Judd,
who continued to make variations on the basic Judd box until his death
in 1994. Andre, likewise, is still making the sort of works that he had
made many times by 1968. In that year, however, he felt the allure of the
void, the nonobject, and declared that "a thing is hole in a thing it is
not."[8] Sol LeWitt didn't stop making objects, but he did bury one in a
hole.

None of these gestures and declarations seemed adequate to
younger artists whose idea of art had been shaped by minimalism. The
style had cleared the aesthetic underbrush. Now it loomed over an
empty field. The once-redemptive presence of the minimalist object
needed to become an absence. Until it did, it served only to mark the

midpoint of a depleted situation—"ground zero," as Dennis Oppenheim recently called it.

The box, he added, "had reached an impasse. Yet you could also see it as a catalyst. Because if ground zero has been located, there is always the possibility to going beneath it."[9] Three decades earlier, he had talked of

> trying to get below ground level. Because I wasn't very excited
> about objects that protrude from the ground. I felt this implied an
> embellishment of external space. To me a piece of sculpture inside
> a room is a disruption of interior space. It's a protrusion, an unnec-
> essary addition to what could be a sufficient space in itself. My
> transition to earth materials took place in Oakland a few summers
> ago, when I cut a wedge from the side of a mountain. I was more
> concerned with the negative process of excavating that shape from
> the mountainside than with making an earthwork as such.[10]

Oppenheim saw *Annual Rings* and other ice drawings of 1968 as excavations, too. When documentation of these *Snow Projects* went on view at the John Gibson Gallery, the title of the show was *Below Zero*— an allusion to winter temperatures and a tactic for eluding the now monumental weight of the minimalist object.

These boxes of modest size turned into monuments—they came to feel oppressive—by taking on the look of architecture distilled. They seemed to embody the very premises of urban form and space. In what may have been a quest for the premises of those premises, Gordon Matta-Clark descended to the basement of 112 Greene Street, in Soho, on New Year's Day, 1971, and began to dig a hole. When he was done, this nonobject was eight feet long and six feet wide—bigger than a grave but only four feet deep. The artist planted a young cherry tree in this hole, in the hope that it would become a site where life could flourish.

Or perhaps he meant to show that the foundations of urban life are deadly, for—as he had every reason to expect—the tree died after three months in the basement. Around the edges of the hole, Matta-Clark planted mushrooms: pale organisms with no need for sun and open air. Toward the middle of 1971, he put the remains of the cherry tree in a bottle, enclosed the bottle in a six-foot length of pipe, and placed it in the hole. He then filled the cavity with concrete. Matta-Clark's hole in the urban ground was now a grave, though not of human proportions.

On a journey to the Yucatan in 1969, Robert Smithson overturned rocks to reveal voids readymade. "First the rock was photographed," he wrote,

> then the pit that remained. . . . Each pit contained miniature
> earthworks—tracks and traces of insects and other sundry small
> creatures. In some, beetle dung, cobwebs, and nameless slime. In

others, cocoons, tiny ant nests, and raw roots. If an artist could see the world through the eyes of a caterpillar, he might be able to make some fascinating art. Each one of these dens was also the entrance to the abyss. Dungeons that dropped away from the eyes into a damp cosmos of fungus and mold—an exhibition of clammy solitude.[11]

In the late 1960s, a hole in the ground is sometimes a minimalist box in reverse: a rectangular absence in place of a rectangular presence. It permits no allusions, except to the grave. Allusive or not, holes in the ground were a reproach to sculpture's traditionally upward thrust, the assertive impulse that Carl Andre called "priapic." By implication, then, sculptural holes are not only graves: receptacles of death. Antiphallic, they are vaginal: passages to life. Only in Smithson's descriptions of readymade voids—the holes revealed when he overturned a few rocks—do allusions to birth and female sexuality appear, and they are vague. Moreover, his tone is queasy. Smithson's Mother Earth is a slimy presence infested with ants and beetles and other creatures too lowly to have familiar names. If openings in her surface have any sexual allure for the artist, it is obscured by terror, for each hole looked to him like "the entrance to the abyss," a place of "damp chaos" and "clammy solitude."

Sometimes, Smithson was drawn beyond the boundaries of the art world by fascinated revulsion. The fascination was at least as strong as the revulsion, which was a small price to pay for an escape from the boredom he felt within the blank walls of a proper gallery. Talking to Allan Kaprow in 1967, Smithson said, in mock disbelief, "There's even a lot of talk about interesting space. They're making interesting spaces and things like that. I never saw an interesting space. I don't even know what a space is."[12] Pretending not to understand the white cube of gallery space, he places it among those things whose unintelligibility makes them in a sense nonexistent. If there must be galleries, he went on, they ought to be empty. "A museum devoted to different kinds of emptiness could be developed," he said. "Installations should empty rooms, not fill them."[13]

Michael Asher redefined the installation of art in just that way, and amid the crowd of other artists' works at the Whitney's *Anti-Illusion* show he found a way to make his work invisible. James Monte, one of the curators of exhibition, described Asher's contribution as

a curtain of air defining the height, width, and depth of an entrance from one gallery to the adjacent gallery. The piece is a cubic volume of space, circumscribed by an activated air mass within the confines of that space. The space is acknowledged by the pressure felt when moving into or out of its confines. The disembodied literalism of the piece neatly alludes to a slab form without carpentry. Feeling and therefore knowing replaces the cycle of seeing and hence knowing the sculptural presence.[14]

Asher's current of air was an invisible plane. Michael Heizer's troughs in the desert count as lines. They are also, as the artist said, "Sculptures from which the weight has been removed."[15] In 1969, Heizer began cutting a pair of notches into the edge of a plateau that curves across the southern tip of Nevada. Thus a remarkable weight was removed, for each notch is fifty feet deep and thirty feet wide. Across an immense gap, they face each other, in precise alignment. Completed in 1970, the work is called *Double Negative*. Though it is a sculpture, as the artist has said,[16] it only alludes to the idea of an object, for a beam large enough to fit into its notches would have to be more than 1,500 feet long and 50 by 30 feet in cross section.

Heizer's dealer, Virginia Dwan, is among the few who have trekked from Manhattan to the site of *Double Negative*. Standing on the floor of a cut, surrounded by its fifty-foot walls, reminded her of being in a cathedral.[17] True to his minimalist heritage, Heizer spoke of *Double Negative* without benefit of metaphors. Nor did he talk of scenic effect. "All it really is," he said, "is absence."[18]

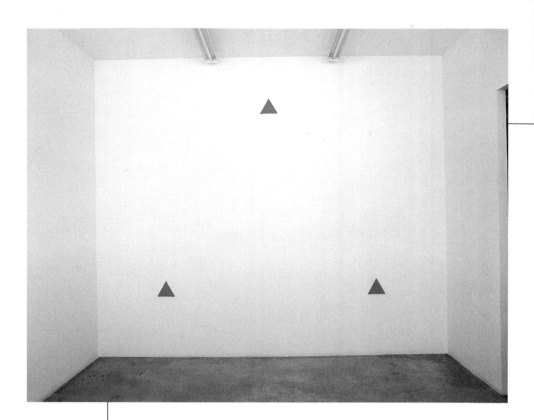

ROBERT BARRY, *Orange Triangle*, 1967. Acrylic on canvas, 60 x 60 inches overall.

# ABSENCE REVISED

"*David Batchelor:* Do you think your work has changed significantly over the last twenty or so years?
*Lawrence Weiner:* Yes. I hope it's got a little bit better. And a little less crude. Earlier there was a bit of aggression with the situation that people were not understanding that art was your relationship with your environment."
*1989*[1]

# M

ichael Asher's surface of moving air was an ironic object. With his empty rooms, he pushed absence beyond irony to intimations of the sublime. Seth Siegelaub was more matter-of-fact. As he saw it, the art object needn't be the target of irony. It was simply obsolete, and the pristine space of the gallery had become an ordinary office. Of course, all galleries find room for desks and filing cabinets. Usually this workaday zone is kept out of sight or at least to the side, to preserve the white cube's illusion of purity. In the office he rented at 44 West 52nd Street, an undistinguished address well off the art-world circuit, Siegelaub let utilitarian space expand until there was hardly any left for exhibition. For he had no paintings or sculptures—in short, no objects—to exhibit. The art that interested him "concerns itself with things not germane to physical presence," he said in 1969. Art of this sort offers nothing to be seen in the flesh, as devotees of traditional mediums say, so there is nothing lost in reproduction. Catalogs induce no frustrations. In fact, added Siegelaub, "the 'exhibition' can be the 'catalog.'"[2]

A few years before, Donald Judd had diverted industrial fabrication to the production of art. Now, by using a midtown office as a point in his distribution network, Siegelaub turned drab urban premises into art space. He was replaying, with variations, the minimalist tactic of aestheticizing the ordinary—as Michael Heizer had done by giving bulldozers the job of making art in the desert. Of course the distance from southern Nevada to East 52nd Street is great, and Siegelaub had no intention of traversing it. He was less interested in artists who built large things—or nonthings—than in Lawrence Weiner, who had announced that his ideas for artworks were complete in themselves. To realize them was always possible but never necessary. At this outpost of the art world, objects and even actions had fallen into disrepute. In the catalog of Siegelaub's first exhibition, *January 5–31, 1969*, Douglas Huebler announced: "The world is full of objects, more or less interesting; I do not wish to add any more."

Late in 1969 Siegelaub assembled Huebler, Weiner, Robert Barry,

and Joseph Kosuth in a studio at WBAI, a New York radio station, to discuss "art whose primary existence in the world does not relate to space, nor to its exhibition in space, nor to its imposing things on walls." Nor to the creation of voids. Siegelaub wanted to discuss art that had disentangled itself from physicality of any kind, from the very idea of it. Weiner launched the discussion by denying "wholeheartedly that there could ever be an art without space per se. . . . Anything that exists has a certain space around it; even an idea exists within a certain space." "I would agree altogether," said Huebler. "Whatever you do involves space."[3]

In the 1950s, Huebler made painterly paintings in the New York manner. During the next decade, he turned to sculpture. Though he gave his works the prevailing, hard-edged look, their symmetries were too idiosyncratic to attract the minimalist label. One of them appeared in *Primary Structures* (1966), accompanied by the artist's statement: "I wish to make an image that has no privileged position in space and neither an 'inside' nor an 'outside.'"[4] No object could fulfill this wish, so Huebler stopped making them.

On the first day of Siegelaub's *January* show, he spread a patch of sawdust, seven by seven feet, on the office floor. Every half-hour, Adrian Piper—the gallery's administrative assistant—took a Polaroid picture of the piece, to record the disturbances left by visitors' footprints. At the end of six hours, she had taped twelve images to the wall, in no particular order, and the sawdust was swept up. This was Huebler's *Duration Piece #6*. His first Location Piece is a set of thirteen photographs of clouds accompanied by a text:

> In February 1969, the airspace over each of the thirteen states
> between New York and Los Angeles was documented by a photo-
> graph as the camera was pointed more or less straight out the air-
> plane window (with no "interesting" view intended). The
> photographs join together the east and west coast of the United
> States as each serves to "mark" one of the thirteen states flown over
> during that particular flight. The photographs are not, however,
> "keyed" to the state over which they are made, but only exist as
> documents that join with an American Airlines System Map and this
> statement to constitute the form of this piece.[5]

A *Location Piece* is a map, but not the sort that that lends itself to any practical use. Huebler intended these works to focus the attention neither on objects nor on space, but on the ways we convert space into a manageable idea: a continuum where objects can be assigned believable locations. That focus sharpened in a series of works on paper the artist made in 1968. He called them drawings, though they could just as well be described as charts. One consists solely of four dots and two sentences of annotation.

•    •

•    •

A    B

A. REPRESENTS A POINT WHICH IS LOCATED PRECISELY
ON THE SURFACE OF THE PAPER ON WHICH IT APPEARS.

B. REPRESENTS A POINT WHICH IS ACTUALLY LOCATED
AT ONE HALF THE DISTANCE BETWEEN THE RIGHT EYE
OF ITS PERCIPIENT AND THE SURFACE UPON WHICH
THESE WORDS APPEAR.

Huebler was aware that a viewer might see these dots as the
corners of a square pinned flat to the page—or, in the terms of the late
1960s, as an abbreviated image of a minimalist plane. He hoped, of
course, for a more speculative response, one that mixed the observation
of fact with a realization that the possible locations of dot B are infinite.
Because the figure diagrammed by the four dots is endlessly malleable, it
is forever unchartable. All one can grasp is one's experience, which is
inward and in its own way just as elusive as dot B.

In tight collaboration with minimalist theory, the minimalist
object tells us how to see it and how to interpret what we see. With mini-
malist means—geometric form, modular repetition, a mixture of image and
text—Huebler cast us upon our own resources. "The subject of art," he
stated in 1970, "is the percipient engaged in a self-producing activity that,
itself, replaces appearances and becomes the virtual image of the work."
This activity is inward and unobservable, for it occurs in the space of the
mind or the imagination—the unreal space which Minimalism disdained
and Siegelaub wanted to believe was the realm of the best new art.

Huebler sympathized. Siegelaub, after all, sympathized with
him. Yet he couldn't deny that *Duration Piece #6* took place in a room.
*Location Piece #1* required him to fly coast-to-coast, through a considerable
stretch of real space. In reply to Siegelaub, he could say at most that he
was not concerned "with the specific space wherein the so-called art
image exists. There doesn't have to be a museum, gallery, or anything for
what I do, because the environment does not affect what I do and is not
affected by what I have done."[6] But there does have to be an environ-
ment. One can't simply step from ordinary space to the space of the
mind, Siegelaub's dream of an absolutely immaterial art to the contrary.

"Maybe," said Robert Barry, "we are just dealing with a space
that is different from the space that one experiences when confronting a
traditional object."[7] When art changes, space changes, or we understand
it in new ways. Like Huebler's work, Barry's moved with ease from real
space to the unreal—or metaphorical—space of speculative thought.
Questioned about his contribution to *Prospect 69*, a roundup of new art at

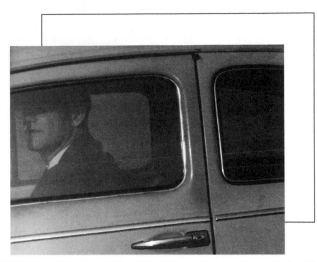

DOUGLAS HUEBLER, *Location Piece #28*, 1969. Fifteen photographs, each 8 x 10 inches, with text. Detail. Photograph courtesy Darcy Huebler.

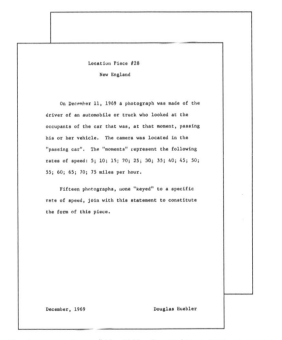

Location Piece #28

New England

On December 11, 1969 a photograph was made of the driver of an automobile or truck who looked at the occupants of the car that was, at that moment, passing his or her vehicle. The camera was located in the "passing car". The "moments" represent the following rates of speed: 5; 10; 15; 70; 25; 30; 35; 40; 45; 50; 55; 60; 65; 70; 75 miles per hour.

Fifteen photographs, none "keyed" to a specific rate of speed, join with this statement to constitute the form of this piece.

December, 1969          Douglas Huebler

DOUGLAS HUEBLER, *Location Piece #28*, 1969. Typewritten text on paper, 8½ x 11 inches. Reproduction courtesy Darcy Huebler.

the Kunsthalle in Düsseldorf, Barry said, "The piece will consist of the ideas that people will have from reading this interview. . . . The piece in its entirety is unknowable because it exists in the minds of so many people. Each person can really know that part which is in his own mind."[8]

For the *January Show*, he installed two radio transmitters, one emitting an FM wave of 88 megacycles and the other tuned to an AM

frequency of 1600 kilocycles. Neither sound is perceptible to the human ear, nor was the radio equipment visible. Barry concealed it, making his works known only with a pair of wall labels. His very small paintings had recently turned into works made of wire. Then wire became nearly invisible monofilament, and soon he announced a *Telepathic Piece* (1969) in the catalog of the Simon Fraser Exhibition, organized by Seth Siegelaub for a university in Vancouver:

> (During the exhibition I will try to communicate telepathically a work of art, the nature of which is a series of thoughts that are not applicable to language or image.) At the conclusion of the exhibition the information about the work of art was made known in this catalog.[9]

By announcing this work, Barry executed it, and all the "information" he deemed pertinent to the audience's understanding is contained in these two sentences. Another piece from 1969 was more elaborate. First a poster was published:

> Robert Barry
> Inert Gas Series
> Helium, Neon, Argon, Krypton, Xenon
> From a measured volume to indefinite expansion
> April 1969
> Seth Siegelaub, 6000 Sunset Boulevard, Hollywood California, 90028
> HO 4-8383

Next, the artist released vials of inert gases at various sites around Los Angeles. Because these substances are colorless, odorless, and invisible, we have only Barry's word that the series was, in fact, executed. But no difficulty lurks here, for this work is not a matter of fact, and photographs of opened vials in the mountains or in Beverly Hills have no documentary weight. One of Barry's photographs suggests that he opened a vial of argon at the edge of the Pacific Ocean. There is no reason to doubt that he did. But even if he did not, the imagination departs from this image to the idea of boundless dispersal, and in our pursuit of that idea the work acquires its myriad meanings.

If, as Siegelaub claimed, the moment's most interesting art "can be communicated with books and catalogues," then catalog and exhibition become one. This notion was elegant in its obviousness, and easily borrowed. Athena T. Spear, who organized *Art in the Mind* for the Allen Art Museum in 1970, explained in her catalog introduction that she was interested in

> pure or radical conceptual art, which uses as its exclusive medium the written language. Since one of its main objectives is to investi-

gate and redefine the concept "art," a great deal of this writing
verges upon art theory and philosophy. Most (if not all) conceptual
artists began working in a visual medium, but have eliminated every
trace of visual elements from their present art. Yet, their work still
belongs to the world of form, because it consists of *structuring* artistic
thought and creating thought structures. As Sol LeWitt, one of the
progenitors of conceptual art, put it: "Since no form is intrinsically
superior to another, the artist may use any form, from expression of
words (written or spoken) to physical reality, equally." And in the
words of Ian Burn, a younger member of the movement: "Artists are
exploring language to create access to ways of seeing."[10]

Because *Art in the Mind* was devoted entirely to works of art that
would fit in full on one or more sheets of eight-and-a-half-by-eleven-inch
typing paper, the exhibition was its catalog. Like many of the artists
included in Information, Barry was asked to contribute to *Art in the Mind*.
He replied by handwritten letter:

> Dear Athena Spear—
> I recommend the following artist for inclusion in the *Art in the
> Mind* "exhibition.":
>> James Umland
>> 1139 Calhoun Ave.
>> Bronx, New York
>> 10465
> You may consider this my contribution.
> Robert Barry
> 27 Mar 70[11]

Scott Burton used his space in the catalog to propose a new pro-
cedure for art-making. Toward the left-hand side of his catalog page, he
placed a dotted line. To the right of the line, he placed these instructions:

> Detach at dotted line and discard this portion.[12]

Thus the viewer is invited to complete the work. On another
page, another artist proposed yet another new method for making art:

> A piece that is essentially the same as a piece made by any of the
> first conceptual artists, dated two years earlier than the original
> and signed by somebody else.
>> EDUARDO COSTA
>> January 1970[13]

The Euclidean repetitions of Minimalism argue that originality
is not a matter of fresh form. From this argument, Costa elaborated a
corollary: If form need not be new, there is no need to think up a new
concept. Why not just restate someone else's concept? And move its date
forward, to mock the avant-garde's traditional obsession with priority. By

the standards of Costa's proposal, it would have been legitimate for the organizer of *Art in the Mind* to claim the idea of the exhibition-as-catalog for her own. She didn't bother, nor did her failure to acknowledge Siegelaub's precedent seem to have troubled him. After all, the precedent was not entirely his. Dan Graham's magazine pieces of the mid-sixties were fully realized on the page, as were the gridded, serial writings of Adrian Piper and Vito Acconci.

Siegelaub's next exhibition opened on the April 18, 1970, in Paris. Twenty-two artists had been invited to submit preliminary proposals before the end of the previous year. Ian Wilson's read:

> I. My project will be to visit you in Paris, April, 1970, and there make clear the idea of oral communication as artform.

The artists were then asked to describe, before February 2, 1970, their "definitive participation in the exhibition." Wilson wrote:

> II. Ian Wilson came to Paris in January 1970 and talked about the idea of oral communication as artform.[14]

These two statements were Wilson's contribution to the catalog of the Paris show—and thus to the show, for this was another conflation of publication and gallery.

In July 1970, he recorded a conversation with Robert Barry, who believed Wilson's art had evolved by diffusion. At first, he said, it seemed that Wilson employed "oral communication" as "the means of making art." Now, "we are dealing with the *idea* of oral communication rather than individual instances." Wilson agrees, tentatively, and later notes that if one wants to make art of some ordinary material or activity one "has to *call* it art." A formal endowment of aesthetic status must be made. If the activity is as common as "oral communication"—talking—the process of making an artwork may well seep into everyday life and linger there for the taking. This new medium, says Wilson, "is just an idea, part of the community now, an idea which can be used to illuminate a certain aspect of art."

Barry recalls that he "was using radio carrier waves which dissolve when I first heard about oral communication" as art. He

> thought about it in those terms, or like the gas I was releasing into the atmosphere then, something that was gone, and you didn't have a chance to do anything with it. . . . It goes back to Sol LeWitt's idea, where he says that all good art is a very simple idea. They are basically simple ideas, but the thing about them is that the potential implied in each idea is the possibility of each idea for those people who are willing to involve themselves with that idea.[15]

Realizing for themselves "the possibility of each idea," mem-

bers of the audience give the work of art its meaning. This is not a new notion.

At the outset of the modern period, an equivalent to the Copernican revolution occurred in the Western way of thinking about art. Since ancient times, philosophers had tried to say which of the world's objects are beautiful, and why. Early in the eighteenth century, a few British writers found reason to doubt that beauty is a trait borne in on the mind by outward things. The flow, they came to believe, is in the other direction: the mind in its inwardness attributes beauty to such outward things as paintings, statues, flowers, and so on. Speculations along these lines first appeared in the writings of Anthony Ashley Cooper, Lord, Shaftesbury. Transposing Shaftesbury's residual neo-Platonism to the idiom of John Locke's empiricism, Frances Hutcheson sharpened the focus of what we might now call a theory of beauty as a product of subjective experience. Following Hutcheson, David Hume reasoned his way to the point of declaring, in 1757, that "Beauty is no quality in things themselves: It exists merely in the mind which contemplates them; and each mind perceives a different beauty."[16]

Immanuel Kant borrowed from these British writers the theory that "beauty is no quality in things" and spliced it into the vast system of metaphysics he called "critical idealism."[17] Since then, the theory has infiltrated modern life in the guise of common sense. Startling in the 1700s, it is now taken thoroughly for granted. We believe that art is matter of subjective experience much as we believe in other inventions of early modern times—civil rights, for example, or the doctrine of equality. Doubts about such things would lead many of us to fear that something had gone amiss with our humanity.

By leading art to and sometimes beyond the verge of imperceptibility, Barry, Wilson, and Huebler invited subjective experience to dominate the aesthetic foreground at the expense of nearly everything else. "The act of perceiving is what concerns me rather than the thing perceived," Huebler declared in 1969.[18] He and the others seemed to offer their works not as art but as occasions for art, which was to occur as each member of the audience responded in his or her turn. At *Prospect 71*, Barry projected eight sentences on the gallery wall, in continuous rotation:

IT IS PURPOSEFUL.
IT IS VARIED.
IT IS DIRECT.
IT IS AMORPHOUS.
IT IS INFLUENCED.
IT IS REMOTE.
IT IS DEFINED.
IT IS INCONSISTENT.

No initiated viewer doubted that Barry's installation was an art-work, but is "IT" art—in other words, is "art" the referent of this insistent pronoun? Perhaps, perhaps not. Viewers must decide for themselves. In any case, another question arises: are these sentences true? Is there any legitimate—or interesting—way to construe them as true or false? The object had been a life raft. In its absence, viewers could only sink or swim.

During the Middle Ages, audiences understood pictures and statues with the help of priestly instruction. At the outset of the Renaissance, secular impulses began a slow migration from new science and political theory to the precincts of art. Meanings that had seemed certain became dubious or at least questionable. To manage this uncertainty, explicators appeared: connoisseurs, critics, historians, and, in the mid-nineteenth century, proponents of the avant-garde. There was nothing medieval about the rhetoric employed by these figures, yet many of them performed a priestly function. For the sacred persisted, covertly, in modern art. Kandinsky's exhortations about the "spiritual content" of modern painting, for example, implies a realm of timeless, transcendent Truths waiting to be revealed by artists.[19] Writers who tease this content from Kandinsky's images and offer it as an object of belief are distant—and highly specialized—descendants of the priests who told their flocks precisely how to understand the paintings of Giotto and Piero della Francesca.

Standing in awe before a minimalist object, rendered mute by its apodictic presence, Annette Michelson assumes the posture of a neo-Platonic adept overcome by a vision of the Real and the True. However, metaphysics and theology are at the very least compatible, and the doctrines of the Church acquired a tinge of neo-Platonism in late antiquity. So Michelson's worshipful attitude could be seen as that of a priest who points in silence to a mystery too exalted for mere, earthly words. And if our eyes follow her gesture in a properly obeisant spirit, our vision will be filled by a revelation far greater, far more significant in its Reality, than any quirk in an individual's way of seeing. The object's magisterially objective presence will overwhelm the merely subjective.

In place of Minimalism's authoritarian presences, Huebler and Barry put contingent, always shifting absences. Never claiming to be absolute, these absences ask only to be the sites of individual experience. By dispensing with the object, they replayed in the terms of the sixties the transition from premodern to modern culture, from a world where meanings are dispensed by God or Nature or the eternal Forms of the Real to a world where we who are concerned with meanings seem to be the ones who generate them. As Siegelaub understood, Barry and Huebler were extremists in the matter of subjectivity. When he praised

their art for having turned entirely inward, with no use for real space, he expected to hear no quibbles. They had stated, after all, that their works are completed in the minds of the audience. Long afterward, Weiner echoed them with the argument that his art allows members of the audience to impose "their own needs, their own desires, and their own functions."[20] Meanings happen in people's heads. Nonetheless, art is encountered in the space people share.

At the panel discussion, that evening in 1969, only Joseph Kosuth disagreed. Space, he said, "has to do with physical objects and the place for them. I don't find those the issues. It's just not relevant to the work I'm doing."[21] The work he was doing did, in fact, entail physical objects. His *One and Three Chairs (Etymological)* (1965) places a folding chair between a photograph of the chair and a photostat of a dictionary definition of "chair." That year, he had the word "five" fabricated five times in blue neon. The artist does not deny that these are physical objects, only that their physicality is relevant.

Though Kosuth's denial was high-handed, he made it calmly, for his model was a group of calm and high-handed philosophers who flourished during the 1920s and '30s. Known as logical positivists, they are remembered chiefly for their verification principle, which holds that the meaning of a statement consists in the method of verifying it. Any utterance unable to meet this test had to be rejected as meaningless, a form of gibberish. Commentators would say, what about reports on feelings? I say I'm happy, yet I can't verify this inward state, nor can anyone else. Is what I say about my happiness therefore meaningless? Yes, said the logical positivists, though at least one of them, A. J. Ayer, was willing to admit that unverifiable statements may be "emotionally significant" to those who make them.[22] But significance of that sort is of no philosophical interest.

We may find emotional significance in Keats's talk of the night being "tender" or Shakespeare's notion that blood could be an "argument."[23] We may even find such talk intellectually engaging. Nonetheless, "Tender is the night" is a "pseudoproposition" by logical positivist standards, and thus not intelligible in any philosophically respectable sense of the word.[24] When new, these standards were impressive, even exhilarating, yet they followed from a verification principle that no one ever found a way to verify. The principle could only be asserted, as an axiom. One accepted it or not, according to taste. Similarly, Kosuth could make no argument to support his contention that space was irrelevant to his art. He could only state it, axiomatically, and proceed to another axiom in the logical positivist style: "Works of art are analytic propositions."[25]

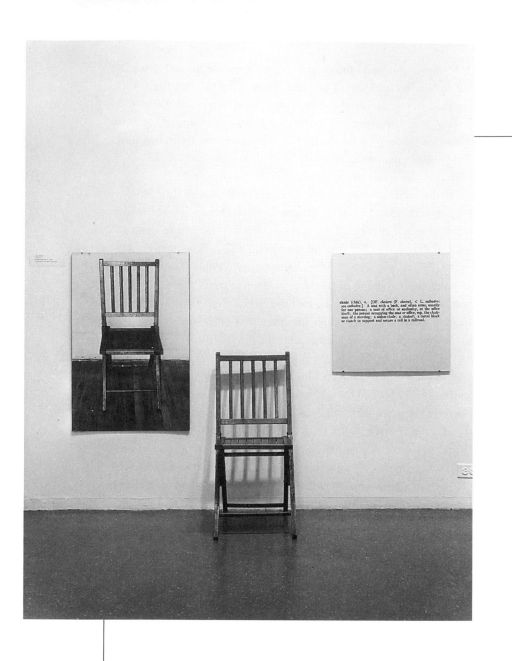

JOSEPH KOSUTH, *One and Three Chairs*, 1965. Wooden folding chair, photographic copy of a chair, and photographic enlargement of a dictionary definition of a chair; chair, 32 3/8 x 14 x 20 7/8 inches; photo panel, 34 x 24 1/8 inches; text panel, 24 x 24 inches. The Museum of Modern Art, New York. Larry Aldrich Foundation Fund.

# BEYOND ABSENCE

"Meaning is always a presupposition of function."

*T. Segerstedt, quoted by Joseph Kosuth, 1969*[1]

J oseph Kosuth learned to use the word "proposition" from the philosopher A. J. Ayer, who reserved it for "what is expressed by sentences which are literally meaningful." Ayer added that a sentence or "statement is held to be literally meaningful if and only if it is either analytic or empirically verifiable."[2] Kosuth was not much interested in statements or works of art that invited empirical verification. His hero among the Minimalists was Donald Judd, for it was Judd who defined art as a matter of definition: "If someone calls it art, it's art."[3]

By this standard, there is no need to examine a thing to see if it looks like art. None of the empiricist's behavior is necessary. One need only listen to the artist's declaration. Thus Kosuth's hero among the early modernists was Marcel Duchamp, who made art by fiat. An object designed to function as a bottle rack began to function as a work of art— *Bottle Rack* (1914)—the moment Duchamp declared it a part of his oeuvre. In this shift of function Kosuth saw an equivalent to statements of the kind that Ayer and most philosophers before him call "analytic."

As Kosuth wrote in 1969, "A. J. Ayer's evaluation of Kant's distinction between analytic and synthetic is useful to us here: 'A proposition is analytic when its validity depends solely on the definitions of the symbols it contains, and synthetic when its validity is determined by the facts of experience.'" Kosuth goes on to say,

> The analogy I will attempt to make is one between the art condition and the condition of the analytic proposition. In that they don't appear to be believable as anything else, or be about anything (other than art), the forms of art most clearly finally referable only to art have been forms closest to analytical propositions.
>
> Works of art are analytical propositions. That is, if viewed within their context—as art—they provide no information whatsoever about any matter of fact. A work of art is a tautology in that it is a presentation of the artist's intention, that is, he is saying that the particular work of art *is* art, which means, is a *definition* of art. Thus that it is art is true a priori (which is what Judd means when he states that "if someone calls it art, it's art").[4]

In a secular, bourgeois society where no one can be compelled to accept the definitions offered by sacred texts or authoritarian regimes, everyone is free to define anything in any manner he or she pleases. If Kosuth, treading closely on the heels of Judd, wants to define art as a matter of definition, he cannot be impeached on logical grounds. Nor does Kosuth violate a transcendent Truth about history by arguing that his art is an advance on Duchamp's because it is "a purely logical enquiry . . . concerned with the formal consequences of our definitions (of art) and not with questions of empirical fact"—questions that Duchamp's readymade works of art cannot help raising simply because they are palpable objects. As Kosuth said in his discussion with Barry, Huebler, and Weiner, objects and the space they occupy are "just not relevant to the work I'm doing."[5]

Most artists are competitive. Kosuth is nakedly combative. To have something to win, he treats art as a game. To make sure he wins, he makes all the rules. He is free to do this. The trouble is that games get tedious after a while. They are immediately tedious when one knows the outcome in advance. Even Judd, who spent a career making variations on the Judd-style box, said that a work of art needs to be "interesting."[6] Few find much interest in tautologies—propositions in the form of "*x* is *x*" or, to elaborate the form a bit, "Art is what I say is art and I say *this* is art and so it *is* art." Kosuth had few if any competitors when he set out to become the art world's maestro of tautology. By 1969, he had succeeded.[7]

Kosuth was the only artist of the period to hitch his wagon to logical positivism, which had made its big splash four decades earlier. Soon afterwards it sank, or was shot down by critics of the unverifiable verification principle.[8] By 1951, Willard V. Quine had knocked the props out from under Kant's distinction between analytic and synthetic propositions. Ayer, who rested so much on this neat dichotomy, tried not to notice.[9] No such effort was necessary for Kosuth, who seems to have known little about any of this.

Conventional French wisdom defines painters as "bête" or "dumb." Duchamp painted in the hope of disproving this proverbial judgment, then gave up, having concluded that there is indeed something stupid about painters or, at least, about the art of painting. It's too "retinal," he said, meaning that painting is too exclusively addressed to the eye, and therefore a touch mindless.[10] Maybe Duchamp was right. Yet one can easily think of painters who are considered stupid by ordinary standards yet paint with brilliance. And, painters aside, aren't there paintings that look stupid from one point of view and dazzlingly intelligent from another? In thinking about art, simple oppositions of bright to dull are not of much use. Isn't it possible that Kosuth's philosophical

naiveté was no handicap? If a painter can be stupid, why can't a conceptual artist be poorly read? Kosuth may have been all thumbs when he handled concepts, but couldn't that be seen—or understood—as charming? Or not, according to one's taste. But this is not the most interesting question to be asked about Kosuth's art.

To find our way to that question, we must return to the business of philosophy, which is "to ascertain and make clear the meaning of statements and questions"—or so said a logical positivist named Moritz Schlick in 1932.[11] Philosophers in other camps may have rejected logical positivism's accounts of meaning, yet they could not be philosophers and repudiate Schlick's effort to attain logically defensible certainty about matters of acknowledged importance. The point of philosophy is to be rational, to seek and establish the truth about the meaning of utterances or the constitution of the world or the nature of our knowing about such things as utterances or things in the world.

Sometime before his death in 1677, Baruch Spinoza wrote that

> human reason . . . begins with its native powers and thus creates
> its first intellectual tools. Through these it acquires further powers
> for other intellectual operations and through them further tools for
> and the power of extending its inquiries until by degrees it
> reaches the summit of wisdom.[12]

At the summit of wisdom, one attains the truth about ultimate things: god, being, mind, body, the nature of the good. Just as important, an ascent to the summit leaves one in possession of a language for truly representing these things. The invention and revision of this language is the great project of metaphysics, which the logical positivists drastically specialized under pressure from scientific styles of reasoning. The existence of god or the good might not be verifiable, they admitted, but surely we can achieve certainty about the functions of language.

In nineteenth-century America, a few writers found themselves calling the metaphysical project into question. Charles Sanders Peirce is the figure usually named at this point, though it's worth mentioning that Ralph Waldo Emerson and Henry David Thoreau also felt impatient with the metaphysician's yearning for an absolutely true picture of ultimate, unchanging realities. Of course, they conveyed their exasperation by literary rather than philosophical means.[13] The descendants of Peirce, Emerson, and Thoreau are called pragmatists. Alive to historical contingency and social convention, they do not suppose that philosophy has an essence, which, if discovered, would dictate rules for philosophers to follow. So the pragmatists are a disparate bunch.

One who bears the label, Richard Rorty, has become known beyond the borders of professional philosophy for having suggested, with

supraprofessional clarity, that traditional metaphysics is a game we need not play. For we are under no obligation to accept the metaphysician's faith that, whatever we may think is true, there is a truth apart from thought—a reality waiting, with the patience of the eternal, for the mind powerful enough to give it its true description. "Truth," says Rorty,

> cannot be out there—cannot exist independently of the human mind—because sentences cannot so exist, or be out there. The world is out there, but descriptions of the world are not. Only descriptions of the world can be true or false. The world— unaided by the describing activities of human beings—cannot.[14]

There is no true world for the metaphysician to represent truly. Or, nothing in the world provides a sturdy platform on which to build a secure structure of metaphysical truth. In his introduction to *Empiricism and the Philosophy of Mind* (1956) by Wilfred Sellars, Rorty notes that

> one of the most quoted sentences in the essay occurs in sect. 38: ". . . empirical knowledge, like its sophisticated extension, science, is rational, not because it has a *foundation* but because it is a self-correcting enterprise which can put *any* claim in jeopardy, though not *all* at once." This sentence suggests that rationality is not a matter of obedience to standards (which epistemologists might hope to codify), but rather of give-and-take participation in a cooperative social project.[15]

Philosophers bent on sustaining the metaphysical enterprise say that if reason can find no secure foundation in the world, the mind cannot be rational. If there is no true world to be represented truly, all our representations—all our accounts of things and people and events—are frivolous and ultimately irrational. Rorty and other pragmatists do not try to prove that they are, after all, rational in some way that matters to metaphysicians. Nor do they try to prove that, appearances to the contrary, the irrational is the province of metaphysics. Instead, they try to contribute to the effort of making ordinary life more humane, in the name of decency, not some moral absolute.

"Convinced that there is no subtle human essence which philosophy might grasp," says Rorty, pragmatists

> do not try to replace superficiality with depth, nor to rise above the particular in order to grasp the universal. Rather, they hope to minimize one difference at a time—the Christians and Muslims in a particular village in Bosnia, the difference between blacks and whites in a particular town in Alabama, the difference between gays and straights in a particular Catholic congregation in Quebec. The hope is to sew such groups together with a thousand little stitches—to invoke a thousand little commonalities between their members, rather than specify one great big one, their common humanity.[16]

An effort of this sort is distinguishable from the theoretical side of fair-minded politics only by the clarity and sophistication of its rationale. This rationale is what makes it philosophical—that is to say, rational—and it may be Rorty's rationality that makes him so unresponsive to contemporary art.

In 1993 an interviewer asked him if new art has any interest for him. "Not very much," said Rorty. "I find myself sort of walking through the contemporary rooms in order to get back to the nineteenth century as quickly as possible." Asked if there is "a pragmatist art criticism," he replied: "Pragmatism I think of as a philosophical doctrine that talks about stuff like truth and knowledge and meaning, and it's just not about art." Claiming no authority as a critic, Rorty says he is attracted to art that provides an "immediately recognizable image of what people or nature are like." He is attracted to it all the more powerfully if its representations of people and nature tell "some story about a social future for which people can work"—not because pictures like these are true, in a metaphysician's sense, but because they might be useful in the pragmatic effort to make peoples' lives better.[17]

Many feel as Rorty does: art should reassure us with its familiarity and encourage us with its promise of usefulness. In modern times, however, certain artists have tried to disentangle art from the viewer's need to be encouraged and reassured. Refusing to make common cause with those who search for truth or struggle for social betterment, they have found ways to make art strange, unsettling, and, above all, impossible to recruit to any productive enterprise. "I think," Robert Smithson declared in 1967, "I agree with Flaubert's idea that art is the pursuit of the useless, and the more vain things are the better I like it."[18]

A year later Smithson said, in praise of Sol LeWitt, that everything he "thinks, writes, or has made is inconsistent and contradictory. The 'original idea' of his art is lost in a mess of drawings, figurings, and other ideas. Nothing is where it seems to be. His concepts are prisons devoid of reason."[19] A year after that, LeWitt wrote, "Irrational thoughts should be followed absolutely and logically."[20] That is, LeWitt would use logic to put art as far as possible beyond the reach of logic. Kosuth wanted logic to oversee the merger of art and philosophy. This was a quixotic program, for the art that Kosuth took seriously is irrational and useless, in contrast to philosophy, which is rational and driven by an exalted purpose.

No one praised Kosuth for sheer silliness, and of course his ambition must have seemed sensible to him. Furthermore, art is difficult to see as irrational and useless, for it is easily burdened with purposes that are moderately rational but not its own. Art can be a financial invest-

ment, a means to social respectability, a source of moral instruction. One can sift through new art for fresh trends in design. Though art can be made to serve a variety of purposes, its own purpose is to have no purpose. The aesthetic is that zone of our culture where one goes to escape the forces that shape and maintain the rest of the culture. Bureaucracy and the marketplace impose strict imperatives. Civil society exerts moral pressures. By their own standards, these institutions are rational. To accept their standards is to become a function of institutional authority. One loses one's autonomy. To regain it, one embraces some form of the irrational—in art, for example, for its irrationality is not dangerous.[21]

As vulnerable as it may be, as fictional as it no doubt is, individual autonomy feels indispensable to most Westerners. Thus art seems indispensable, for we assume that it must always have provided individuality with a refuge against institutional coercion—or an ironic weapon against it. But this is not what art provided in medieval times, nor what it offers non-Western audiences. Art does and is many things, for it has no essence. What we call art is a contingent response to our contingencies, which are complex enough to supply us with endless cross-purposes. In these secular times, presecular impulses survive, not only in religious worship but in the quasireligious art of Kandinsky, Mondrian, and other utopian modernists. The Platonic faith persists even among art writers known for tough-mindedness. See Annette Michelson's awe in the face of "apodictic" form—a feeling she never acknowledged. According to her account, she sees the minimalist object calmly, in the harsh, phenomenological glare of a world unilluminated by metaphysics. Much anti-Platonism is covertly Platonic. See logical positivism, a doctrine of unadmitted essences and absolutes, tired and discredited by the late 1960s, yet still vital enough to breathe life into Joseph Kosuth's art-world ambitions.

In the hope of protecting his philosophical interests from the swamps and rapids of irrationality, Kosuth tried to arrange the merger of art and philosophy on the latter's terms. From that arrangement issued the one interesting question about Kosuth's art. Is it, after all, art? No, because it is rational. Its rationality may be amateurish and derivative. It may be dull—there's not much interest in an earnest deployment of tautologies in the logical positivist manner. Nonetheless, his writings engage philosophical matters in a philosophical style. It cannot, therefore, be art.

But what about Kosuth's career as an artist? This is an awkward question. From the outset, he produced objects in various mediums: illustrative accompaniments to his philosophical borrowings. Occasionally he expands these illustrations to the scale of a museum installation. Mixing decorative appeal with an aura of intellectuality, these objects

and installations have found, over the years, an audience with little sense that Kosuth was right to say, in 1969, that space was "irrelevant" to his work. At any rate, his attempt to merge art and philosophy had no use for space, for this was a maneuver in the fields of theory. It took him beyond objects and further still, beyond the absence of objects, to a place where there is never any question of objects—a magical realm on the far side of the old Cartesian gulf between body and mind, where the air is so pure that nothing but concepts can ever catch a breath.

VITO ACCONCI, *Drifts*, 1970. Activity for photographs. Jones Beach, New York. Detail. Courtesy of the artist.

# FROM BOX TO BEHAVIOR

"Place as end-point: reasons to be there: take possession of, contain, attend to, accommodate, welcome, acquiesce to, be exposed to, meet with something from outside. (I've changed my shape to fit into the place — I change shape again when I take something in when I'm there.)"

*Vito Acconci, 1972*[1]

The mind likes antitheses: true/false, good/bad, us/them. Once a simple opposition gains currency, its usefulness makes it difficult to question. To many in the art world, the contrast between painting and sculpture looks like a fact of nature, all the more so because it leads so directly the more general distinction between two-dimensional and three-dimensional works of art. On one side, painting is the dominant presence in a cluster that includes drawings, photographs, and prints in myriad mediums. The leading figure on the other side is the monumental statue. Around it stand lesser variants, which include the statuette, the figurine, the *objet d'art.* Though a low-relief sculpture may be flatter than a heavily worked painting in oils, it is grouped with the three-dimensional works. This is practical, for low relief is nearly always the work of a sculptor working in stone or bronze or some other traditionally sculptural material.

A collage is considered two-dimensional, even when a thick object protrudes from its surface. An assemblage is a freestanding collage. Its appeal may be more pictorial than sculptural, yet we call it a sculpture because it has left the wall to stand on the floor. As the avant-garde invented new mediums like these, the distinction between two-dimensional and three-dimensional works of art came to look like a machine for creating borderline cases. Yet few of them cause serious problems, either for those who write about art or those who sell it. The painting/sculpture opposition turns out to be as flexible as anyone needs it to be. Perhaps that is why it persists, providing critics, curators, and dealers with a pair of spacious and useful categories, while leaving the minimalist object in the analytical dark, clearly seen but only dimly understood.

Inevitably, a Judd box is called a sculpture, and common sense can find no objection to the label. Nonetheless, it obscures the object's origin, which was in Judd's obsessive need to purge the flat surface of pictorial effects. His boxes are not sculptures so much as monochrome paintings displaced from two dimensions to three. By entering real space, they gained more surfaces and lost the residual allusions to imaginary

space that persist in even the flattest monochrome canvas. To see his objects as sculptures is to miss the point, and a related point is missed when one sees a Morris box as sculptural. For Morris wanted to relieve the three-dimensional artwork of the figurative qualities that cling even to sculpture at its most abstract. By 1969, he was ready to admit that he hadn't succeeded.

In "Beyond Objects," the fourth part of his "Notes on Sculpture," Morris wrote:

> The specific art object of the 1960s is not so much a metaphor for the figure as it is an existence parallel to it. It shares the perpetual response we have toward figures. This is undoubtedly why subliminal, generalized kinesthetic responses are strong in confronting object art. Such responses are often denied or repressed because they seem so patently inappropriate in the face of nonanthropomorphic forms, yet they are there. Even in subtle morphological ways, object-type art is tied to the body. Like the body, it is confined within symmetry of form and homogeneity of material: one form, one material (at the most two) has been pretty much the rule for three-dimensional art for the last few years.[2]

If Morris and the other Minimalists failed to rid the object of all anthropomorphic overtones, they did manage to disengage it from sculpture's heroic and humane ideal of the body. A Morris box is to a traditional sculpture as is a robot to a living person. Or we could see his boxes of the mid-sixties as numb, rendered comatose by his nearly successful attempt to deny them their fictive lives. The vitality of old-fashioned sculpture doesn't inhabit the minimalist object so much as haunt it, filling its hollowness with the aura of morbidity that so troubled Eva Hesse and Paul Thek. A minimalist object can have the presence of a coffin, as Morris admitted in a roundabout way by letting images of skulls and bones and fleshly remains emerge from the smooth surfaces of works he made in the 1980s.[3]

No object is immune from our need to find symbols of ourselves. Any thing of any size, shape, or provenance can serve as an emblem of the body or a body part. That is why Morris's "nonanthropomorphic" policy was bound to fail. Yet he, Judd, Andre, and LeWitt did seem to have immersed the art object in real space, where painting's allusions to fictive space could not survive. And by deadening whatever reminders of the body they could not eradicate, they dispelled the fictive space that surrounds traditional sculpture: the imaginary three-dimensions where a sculptor's image of the human figure, abstract or representational, comes to life. So the minimalist object is not a kind of sculpture standing in opposition to painting. Acknowledging only real space, it stands opposed to painting and sculpture alike. By 1965 or '66, the art

world had seen enough to make it clear that the old dualism, painting/ sculpture, needed to be replaced by a new one: painting and sculpture/ minimalist object.

This replacement did not occur. The old dualism was and is too useful to jettison, and the new one required too drastic an adjustment of focus. We approach works of art primed for reassuring fictions: spatial, gestural, narrative, what have you. How does one focus on their absence? Those who did hardly paused to note what they saw. As the reinvention of art accelerated, the minimalist box receded to the status of a starting point for artists and a few writers bent on escaping the real space of the gallery for the somehow realer space of the city, the countryside, the realm of concept. By 1970, Jack Burnham was arguing that conceptual artists had so thoroughly integrated the experience of art with "nonart habits of perception" that there was no need to revise the old categories of medium and style. There was no need to oppose art to life. The two were one.[4]

Burnham was a visionary who saw the future as a place where the mind would have no difficulty understanding its resemblance to a computer, and artists would see that "at a basic level" they are

> similar to programs and subroutines. They prepare new codes and analyze data in making works of art. These activities are supervised by metaprograms which consist of instructions, descriptions, and the organizational structures of programs. Metaprograms include art movements, significant stylistic trends, and the business, promotional, and archival structures of the art world.

Traditional philosophers argue that behind the veil of mere appearances lies a true and abiding Reality. Having read a great deal of nontraditional philosophy—systems analysis and technoprophesy by Ludwig van Bertalanffy and Marshall McLuhan—Burnham was convinced that if we were to scrape away centuries of encrusted sentiment, we would see that our values are just "information processing structures."[5] Thus his description of artists as computer "programs" was not metaphorical. Fittingly, the show he organized for the Jewish Museum in 1970 was called *Software*.

Les Levine had planned to show the real-time activities of his studio on monitors installed at the museum. This proved technologically impossible, so he showed tapes recorded earlier.[6] David Antin asked visitors to record a story based on a word supplied by him. Each story became an episode in the ever-lengthening saga patched together from visitors' successive additions. John Baldessari's contribution to the show began with the cremation of all the paintings he had ever made. He then filled an urn with their ashes and sealed it into a wall at the museum. Robert Barry's *Ultrasonic Wave Piece* (1968) was known only through its

THE ARCHITECTURE MACHINE GROUP, MIT. *Seek*, 1969-70. Glass enclosure with block, 5 x 8 feet; computerized pressure-sensing devices; gerbils.

description: "Ultrasonic waves (40KHz) reflected off interior surfaces, filling selected area with invisible, changing patterns and forms."

Nicholas Negroponte and the Architecture Machine Group designed a habitat for gerbils. Beside the usual accoutrements of a cage for small pets, it included stacks of wooden blocks and *Seek*,

> a 5 x 8 foot superstructure supporting a carriage which has three dimensions of freedom. Its extremity is composed of an electro-magnet, several micro-switches, and pressure-sensing devices. This elementary prosthesis is guided by the blind and handless computer to pick up or deposit its payload of a single two-inch cube. The nucleus of the system is an Interdata Model 3 Computer with 65536 single (yes/no) bits of memory which are shared by instructions and data.[7]

Moving about in this rectilinear environment, the gerbils pushed blocks here and there and sometimes knocked over an entire stack. Guided by its memory of the original configuration, *Seek* tried to accommodate these changes.

This feedback process would provide information helpful to city planners—at least, this hope gave the piece its rationale, which shared Burnham's assumption that systems analysis reveals the equivalence of all activity by whatever sort of agent, animal, human, or cybernetic. From the interaction of gerbils and computers one could extrapolate the city of the future. And in the present it was asked: is this art? Elsewhere in the show, visitors weren't always aware that the question had been raised.

Imagine yourself at the *Software* show, looking at one work after

the next, hoping to get some sense of where art is heading in 1970. Slowly or, as it may happen, suddenly, you are aware of a mute presence nearby—a person with long hair, wearing a fatigue jacket and blue jeans, and much too close for comfort. Is he mad or merely rude? Discretion being the better part of getting through a day in Manhattan, you go on to the next work of art, unaware that you have just been forced to participate in one: Vito Acconci's *Proximity Piece* (1970), an improvisation controlled by strict specifications.

> Every day, for the entire day, I'm present at the exhibition area, going randomly from room to room; at various points, I choose a person standing at one of the exhibits: I stand beside him or behind him, closer than the expected distance, crowding him—I can stand near him until he moves away.[8]

The responses Acconci induced counted as feedback, of sorts, so his *Proximity Piece* did what a work of art in a group exhibition is supposed to do: it illustrated the prevailing theme. Yet Acconci's intrusive body was an atavistic presence in the galleries devoted to *Software*. The show celebrated the conceptual patterns that were moving into the foreground as the minimalist object stayed behind, immobilized by a clarity achieved in 1965. For *Proximity Piece*, Acconci impersonated that object in all its stubborn impersonality. As best he could, he became a nonfigurative figure, sheer matter claiming the focus of attention for itself. Most museum goers discomfited by his performance no doubt saw him as further proof of the truism that the city is a haven for odd people. For the artist, this work was a decisive step in his remarkably coherent transition from the page filled with words to space inhabited by bodies.

Looking at a black painting by Frank Stella or a box by Donald Judd, what you see is what you see—or so they hoped. Acconci was brought to the verge of art by poems that offer themselves not as webs of imagery but as words on a page: what you read is what you read. He wanted to literalize language, and as his poetry readings turned into performances, the things he did always pointed back to the words—or letters—on the page:

> . . . Orient Coffee House, November 1968—I distributed among the tables, at random, 8½ × 11 sheets of paper, each containing a letter of the alphabet—then I picked up each letter in alphabetical order, saying, at each table, an adverbial or prepositional phrase beginning with that particular letter ('along the way,' 'back a little,' 'crossing over').

He later wrote that performances like these "were not so much ways off the page as ways to stay on, ways to constrict outside space into page space." Carefully managed, constriction provides control.

To perform *Fall* (1969), Acconci fell forward, camera in hand. When he hit the ground, he snapped the shutter. Images replace words. Furthermore, "rather than move toward a point (the page), I can be the point (the landscape is seen in relation to me); rather than move in one direction (toward the page), I can move freely (the landscape adjusts to me)." Leaving poetry for art, Acconci has more freedom. But he loses none of his control. Early in 1971, he made a Super-8 film of himself facing the camera,

> extending my arm forward, full-length, in front of me; passing my hand up and down, and back and forth, in front of my face. Gradually pulling in my arm, repeating the up-and-down, back-and-forth motion, until my hand pushes into skin.

As the planes of a minimalist box define its presence, so Acconci's repetitive, inexpressive gestures define his. And so he defines his relation to us. To watch this film, *Passes*, is to watch the artist's hand "withdraw from you," while he watches it advance toward him:

> you watch me losing room, while I watch myself gaining space, bringing it to me; you lose my touch while I take my touch, feel myself. (I make a boundary—I take a boundary—I make my limits—I make myself.)

Rather, he tried to remake himself as an object in real space, stripped of personality's aura, just as a minimalist object is stripped of the aura that endows a traditional sculpture with imaginary life.

Of course Acconci failed to reduce himself to an object. Radiating the charisma of an artist fanatically determined to owe nothing to charisma, he was a mesmerizing performer, as the photographic evidence shows. In 1970, he presented *Rubbing Piece* on a Saturday afternoon at Max's Kansas City: "Sitting alone in a booth, during the ordinary activity at the restaurant. With my right hand, rubbing my left arm, gradually producing a sore." For *Trademarks* (1970), he was naked with no audience but a photographer: "Biting myself: biting as much of my body as I can reach. Applying printer's ink to the bites; stamping bite-prints on various surfaces." In these works, Acconci the physical being was material for Acconci the artist.

As Acconci noted, to execute *Trademarks* he had to "move into myself—move around myself—move in order to close a system." *Rubbing Piece* employed the same material, Acconci's flesh, to close another system: "Performer as producer (I give myself the sore)—performer as a consumer (I receive the sore)—performance as circulation."[9] Minimalist objects take their shapes from symmetries and modular repetitions that

could be repeated to infinity but, in fact, turn in on themselves. For a film called *Hand and Mouth* (1970), the artist pushed his hand into his mouth until he choked. Then he did it again, and again, for as long as the camera ran: three minutes, in the black and white version, seven minutes in color.

As Carl Andre describes it, sculpture is "a direct physical hefting of matter."[10] Suspending his sense of self, Acconci became the physical matter he hefted, marked, manipulated. When the results were not boring, they were painful, yet those in sympathy with Acconci's art felt no need to sympathize with him. Rather, they felt the need not to sympathize, for Acconci did not intend his behavior to be expressive. During all his performances, his face remained deader than deadpan. Presenting himself as an object with a certain form, he offered his boredom and pain as phenomena with forms of their own.

*Second Hand* (1971) required him to keep an eye on the second hand of a clock and, as it turned, turn in an analogous circle. In this piece, he later wrote, "I'm faceless, I've turned my back on the viewer, I disappear into the clock." Dennis Oppenheim and Terry Fox were performing nearby. "In becoming the clock," said Acconci, "I can time the other performances—be a measure for the other performances (disperse myself —becoming time—providing, confirming, the ground for the other performances)."[11] Here Acconci the object labors to become Acconci the gallery, the spatio-temporal setting for other works of art. He fails, for the attempt to become something other than oneself is driven by the desire for that ultimate escape, and the desire can only be one's own: a sign that one's self persists. The harder Acconci tried to erase signs of his individuality, the more distinctive his presence became, as he must have known that it would.

The Minimalists had dispensed with the usual means of expressing individual emotions, attitudes, and motives, yet their works were hardly interchangeable. One would not mistake a Judd box for a Morris cube, much less an Andre carpet for a LeWitt lattice. As generic as its premises may be, a minimalist object is specific to the point of quirkiness. Still, it displays none of the signs of personality that had become so familiar—and so shopworn—in much art of the 1950s. Though Minimalism could not be impersonal, it yearned for impersonality, and this made it credible in the eyes of Acconci and his generation. Here, in the uninflected objects of Judd and the others, was the blunt factuality that had saved art from the hyperactive emptiness of abstract expressionist cliché.

In his early performances, Acconci adjusted his person to the impersonality of minimalist forms and patterns. From the awkwardness

VITO ACCONCI, *Trademarks*, 1970. Activity/Photopiece/Inkprints. Detail. Courtesy of the artist.

of the fit he emerged naked—not expressed, as by a traditional work of art, but stripped down to a blunt, almost presocial state of being. For Acconci, the minimalist object was a presence so powerful that he could stand up to it only by usurping its premises and letting them drive him to an emergency version of himself: the Vito Acconci, desperate and numb, who survived the dehumanizing procedures he inflicted on himself with obsessive precision.

Early in 1970, he presented *Room Piece* at Gain Ground Gallery:

> Each weekend, the moveable contents of my apartment
> (Christopher Street) are relocated at the gallery (West 80th
> Street). Whenever I need something that has been relocated at
> the gallery, I go there to get it; anything taken out of the gallery is
> returned when I have finished using it.

To use any of his possessions—a toothbrush, a book—Acconci had to travel eighty blocks, from his Greenwich Village apartment to the Upper West Side, and then back, to replace the object he had used. Like an art object, Acconci was function of the gallery.

*Service Area* (1970), his contribution to the Modern's *Information* show, made him a function of museum space:

During the exhibition, my mail is forwarded by the post office to
the museum: my space in the museum functions as a mail box.

   The museum's guard's normal services are used now, as a
matter of course, to guard my mail: he guards against a federal
offense.

   The piece is performed unawares by the postal service and
by the senders of the mail; I perform the piece, intentionally, by
going to the museum to pick up my mail.[12]

   Yet the rules governing the artist's actions permit him no inten-
tional leeway whatsoever. *Following Piece* (1969) entailed

choosing a person at random, in the street, any location; following
him wherever he goes, however long or far he travels (the activity
ends when he enters a private place—his home, office, etc.).

   Once he was led through the city for nine hours. Another time,
the exercise lasted for just two minutes. In keeping track of another per-
son, he sometimes lost track of himself. "I am almost not 'I' anymore,"
he noted. "I put myself at the service of a scheme."[13]

   In giving a linear form to *Following Piece*, Acconci gave himself
no control over the length or the shape of the lines he followed. Line
was more predictable in *Room Piece* and *Service Area*, for he nearly always
took the most direct route from apartment to gallery, from apartment to
museum. *Rubbing Piece* and *Proximity Piece* exchange line for point—a spot
on the artist's body or a spot on the floor where he had decided that his
body ought to be placed. *Drifts* (1970) brought him to Jones Beach, on
the shore of Long Island, where he lay at the water's edge and performed
three activities:

1. Rolling toward the waves as the waves roll toward me; rolling
away from the waves as the waves roll away from me.
2. Lying on the beach, in one spot, as the waves come up to dif-
ferent places around me.
3. Making use of my wet body: shifting around on the sand, and
letting the sand cling to my wet body.[14]

   Lying still, he marks a spot. Shifting around on the sand, he draws
eccentric lines. Rolling toward and away from the waves, he measures off a
series of planes. Though Acconci could not make his body as objectlike as
a minimalist box, his performances brought at least a memory of the box
and its blankness into contact with forces far greater than any it had to
confront when locked inside the white cube of evenly-lit gallery space.

*    *    *

   In 1970, Charles Simonds buried himself in the earth. A film
called *Birth* records his reemergence. The minimalist object offered itself

as *sui generis*, born of itself from a nonpast into an absolute present. Invoking the Scriptural usage that equates human flesh with clay, Simonds claimed minimalist self-generation for himself. Filmed the following year, *Landscape-Body-Dwelling* shows the artist's supine form smeared with clay, which he molds into the forms of a miniature pueblo. In 1974, Simonds told Lucy Lippard,

> I'm interested in the earth and myself, or my body and the earth, and what happens when they become entangled with each other and all the things they include emblematically or metaphorically; like my body being everyone's body and the earth being where everybody lives.[15]

When Acconci substituted his body for the minimalist object, he tried to strip away its—so to speak—figurative meanings. Simonds did the opposite. Treating his body as if it were an object, he renewed its metaphorical energies. In his aesthetic, clay is flesh is city is civilization. Ideally, the sense of self flows through the entire equation, making each of us as vividly alive to others as we are to ourselves. During the 1970s, Simonds built a number of miniature cities from clay, mostly in the vacant and despoiled lots of Manhattan's Lower East Side. These were the dwelling places of the imaginary people who lived at the heart of the artist's "personal mythology," a fantasy about salvaging the earth from environmental abuse. Simonds hoped that, by building his works in city neighborhoods, fantasy would become reality, as people took an interest in his mythology and saw its implications for the future. Thus performance art evolved into ecological activism.

CHARLES SIMONDS. *Landscape-Body-Dwelling*. 1971. Artist's body, clay. Courtesy of the artist.

LES LEVINE, *Disposables*, 1962. Polyexpandable styrene, 12 x 12 x 12 inches each.

# BEHAVIOR CONTINUED

The largest problem anyone has is to describe what's
there. By coming up with non-sentimental objects that
obviously were what they were, Minimalism solved that
problem. It was quite radical. It also had a repugnant,
pedantic aspect, because the Minimalist sculpture is
finally just that: a piece of sculpture involved with all
the old sculptural questions about form and of course
scale—size in relation to the body—and gravity—form in
relation to the ground. By making the criteria of sculp-
ture so clear and overusing them with such academic thor-
oughness, the Minimalist box quickly became a historical
object, like the *Mona Lisa*. People confront the box in
historical time. I wanted to make works of art that you
confront in their own time—objects that are more concep-
tual than object-like. Consciousness is not static, it
wants to move on. My works give it permission to do that,
to detach itself from the past and move into its own
present.

*Les Levine, 2000*[1]

**H**oping to make it easier to see—or to believe—that art is a product of inward experience, Robert Barry cleared objects out of the way. Les Levine considered that unnecessary. One could make objects or not, as one chose: art is intangible. "Many serious artists," wrote Levine, "are for the most part involved in making art systems. The works themselves are not to be considered art, rather systems for the production of art."[1] In 1969, he directed assistants to pour fifty gallons of house paint on a gallery floor. The process was art, or was it in the framed color photographs that recorded the process at regular intervals?

And what of Levine's *Disposables* (1966), the small sheets of plastic with vacuum-formed indentations, which he offered for sale by the thousands at $1.25 each? Was art to be found in these mass-produced forms or in the process of mass production? Perhaps art was in the distribution process. Or did art occur each time a member of the audience joined Levine's game and bought one of these objects? Then, again, it may have been enough to get the idea—or, if you like, the joke.

Toward the end of March 1969, Levine bought shares in the Cassette Cartridge Corporation. Eight months later, he sold them for a profit. If he had taken a loss, the value of the work—*Profit Systems I*—would have been no different. Jack Burnham admired Levine's willingness to engage real-world systems of the kind that art usually offers to transcend. He was impressed by the bland extremism of Levine's doctrine on "Choice and taste." In 1969, Levine declared:

> I've never seen a work of art I didn't like. Good and bad are irrelevant in terms of process. On a process level being totally excited is of no more value than being totally bored. If you run around your backyard and make a good painting, it's just the same as running around in your backyard and making a bad painting. Running around is running around.[2]

That year he decided to run a restaurant. Burnham approved:

ALLEN RUPPERSBERG, from *Al's Café*, 1969. Small Dish of Pine Cones and Cookies. Installation, Los Angeles. Detail. Photograph courtesy of Gorney, Bravin & Lee, New York.

> *Levine's Restaurant* at 19th Street and Park Avenue South is a Levine; which is to say, it is refractory, plastic, and the ultimate real time artwork devised to date. The restaurant is process in all its vicissitudes. For my taste, his closed-circuit television and color scheme leave much to be desired, but the food is very reasonable.[3]

Disinclined to fuss about taste or flaunt his singularity, Levine described the art world as a "locked-in system," a set of feedback loops so predictable that "from now on you don't have to make art because art will make itself."[4] Burnham, who liked to see artists as bits of software seamlessly grafted onto larger programs, made Levine his favorite example of a systems artist. Focus on flatness and the minimalist box is an arrangement of planes. Focus on the edges formed when planes meet, and the box becomes a set of lines. See Levine not as a function of a "megaprogram" but as the source of the processes he set in motion and he becomes a performance artist. Vito Acconci impersonated the minimalist object. Levine played the role of restaurateur, investor, surveillance expert, and more.

In 1971 Gordon Matta-Clark and Caroline Gooden, a photographer and choreographer, converted a SoHo luncheonette into Food, a restaurant that doubled as a performance space of sorts. During the week, a menu of mostly organic food was on offer. For the weekends, Matta-Clark organized the Saturday Night Guest Chef Dinners. Robert Rauschenberg, Donald Judd, Keith Sonnier, and other luminaries are said to have starred in these events, though little evidence remains. By contrast, Allen Ruppersberg conceived of *Al's Café* (1969) as work that would live chiefly in the afterlife of documentation.

Ruppersberg installed the café in a storefront on West Sixth Street in downtown Los Angeles. There was a diner-style counter, with matching stools. On the walls were advertising placards, pennants, and calendar art. Among the specialities of the menu was a "Patti Melt"—"A Patti Page photo (or reasonable facsimile) covered with toasted marshmallow"—for two dollars. The "Angeles National Forest Special," at three dollars, was a blend of tree bark, pine cone, twigs, and rocks. "I thought of myself as a sculptor," Ruppersberg says. "And I was particularly impressed by the idea of place that derived from Minimalism. The café is based on that idea, it was all about location, in a way, but of course it took the idea in another direction."[5] Open for nearly half a year, *Al's Café* became a meeting place for artists in the Los Angeles area.

*Al's Grand Hotel* opened in a house on Sunset Boulevard early in May 1971. During its six weeks of operation, the hotel offered weekend accommodations in a variety of decors. The Al Room featured a ceiling festooned with party streamers and seven life-size cutouts of the artist, his left hand raised in the peace gesture. In the Jesus Room, motel furniture shared the space with a large wooden cross. The Ultra Violet Room, named after the Warhol superstar, was decorated with sheets of notebook paper, each bearing the title of a film in which Ultra Violet had appeared. The sheets were framed and signed by the superstar herself. At half price—fifteen dollars a night—one could stay in the "B" Room, where *Life* magazine covers filled the walls and the mattress lay on the floor, beside a picnic basket and its contents. Downscale but comfortable, the "B" Room was perfect for B-list parties. There were seven rooms in all, each with a complement of objects and images that functioned as décor and as works of art for sale.

Terry Allen and others presented musical pieces in the bar on Saturday evenings. On Sunday mornings, a Continental Breakfast for Hangovers was available. As promised by its brochure, *Al's Grand Hotel* was "a small, modern, convenient, comfortable and friendly hotel which offers the finest accommodations at the most reasonable rates."[6] It was, as well, an elaborately staged performance piece that required the artist to be permanently on call in the role of proprietor. Presence became absence in *Where's Al* (1972), a set of one hundred and sixty color photographs interspersed, gridwise, with one hundred and ten index cards. The cards bear neatly typewritten speculations about the artist's whereabouts. The snapshots picture the places he might be. The mystery is never solved, though one suspects that Al is hiding behind the camera, in the role of photographer.

\*   \*   \*

ALLEN RUPPERSBERG, *Al's Grand Hotel, The B-Room*, 1971. Hollywood, California.
Courtesy Gorney, Bravin & Lee, New York.

The Minimalists—Robert Morris and Sol LeWitt, especially—
gave their objects the aura of concepts materialized, made palpable, with-
out the intervention of the hand. If the hand is unnecessary, why bother
with the object? Let the work be the concept of the work, as LeWitt sug-
gested.[7] Or let the object persist in the person of the artist. "Performance
artist" was coined for those who took this option, and the label hovers
around others who kept the object in play by dismantling, ironizing, and
otherwise transforming it.

Fred Sandback stretches his lengths of yarn then gets out of the
way. His presence is no part of his art, yet each work is a concise record
of time spent in a particular space, taking its measure and looking for
ways to revise it. Musing in 1975 on the impossibility of knowing in
advance what a site will demand, Sandback wrote, "More and more,
working seems to be like a performance; not in the sense of presenting a
process, but in the conditions required to complete a piece."[8] Questioned
about *Splitting* (1974), the work of bisecting a house in Englewood, New
Jersey, Gordon Matta-Clark called it "hardhat performance, producing a
clean-lined brutality."[9]

Jackie Winsor winding hemp, Barry Le Va slamming into a wall

or improvising a "distribution" piece, Michael Heizer scattering dye into the desert air, Rosemarie Castoro dripping paint from the buckets lashed to her bicycle, Peter Hutchinson diving beneath the sea to fasten a length of rope to a bed of coral or climbing the slope of a volcano to arrange loaves of bread just inside the crater's edge—all can be seen as performance artists. Richard Long's hikes from point to point and in concentric circles were no less performances than Bruce Nauman's *Slow Angle Walk (Beckett Walk)* (1968). The minimalist box was generic. The bodies that took its place performed actions of astonishing variety—all the more so because not all the bodies were human. Bill Beckley wove the behavior of birds and turtles into his work. William Wegman collaborated on performance pieces with his dog, Man Ray.

As a critic, John Perreault reported on performance for *The Village Voice*. As a poet, he followed Vito Acconci off the page, into real space. His *Alphabet* (1971) was first of all a slide show of minimalist aridity: the letters A to Z projected in the usual order on a sheet of transparent plastic. Each letter prompted an action. In response to E, Perreault rolled an egg across the floor with his nose. For F, he extracted a long red ribbon from his fly. U sent him under a sheet, where he removed his underpants. "The term 'performance,'" he told an interviewer from *Avalanche*,

> is now being used for things that are closer to sculpture than my own works, but it is still neutral enough to be useful. . . . Think of an equilateral triangle in which point A represents theater (leading off to or out of poetry), point B, dance; and point C, sculpture. Point P stands for my performances and it is at the center of the triangle where the perpendiculars bisecting all three sides meet. I have been presenting aspects of the theater in isolation or in simple formal combinations. I am interested in my body as a moving, space-defining sculpture, so my performances are also related to dance and sculpture.[10]

As the 1960s turned into the '70s, it seemed that performance could be related to nearly anything, from process to historical pantomime. Having spent a day drawing a line across a wheat field, Bill Beckley decided to spend an hour drawing one across a river. He chose the Delaware for its width. Strapping a can of paint to his belt, he walked into the water, dripping paint from a brush as he went. Partway across, he stepped into a hole and felt himself being pulled under water. Unbuckling his belt, he let the current carry paint can away. Pulling himself up onto the far back of the river, he noticed a plaque: it was here that George Washington and his troops crossed the Delaware to elude the British in 1776. "I had no idea this is where it happened," Beckley recently recalled,

I mean, I was familiar with the painting of Washington crossing the Delaware, because it's reproduced so much, but it was a complete shock to see that plaque. It gave me an idea for a series of pieces. You're always hearing that Washington slept here, for example, so I spent a night at the George Washington Motor Lodge, on the Pennsylvania Turnpike. This was in the spring of 1971. That summer, I chopped down a cherry tree, which is something he is supposed to have done but didn't actually do. A few days after that, I made myself up to look as much as possible like Washington—the Washington you see in the Gilbert Stuart portrait—and took a picture of myself.[11]

Early the next year, Beckley presented *Song for a Chin-Up* at 98 Greene Street. The text was a single word, "are," to be sung in a rising tone as the performer rose toward the chin-up bar, and in a descending tone as the performer descended. Performed twice, first by a soprano and then by a tenor, the piece transposed the rigidity of the minimalist object into strict patterns of action. Nearby, at 112 Greene Street, Beckley showed sculptures that invited the audience to improvise a performance. For *Silent Ping-Pong* (1971), four tables and eight paddles were muffled with a layer of white Styrofoam. "The idea," says Beckley, "was to take language out of Ping-Pong, which is named for the sound the ball makes. If everything is padded and you can't hear the ball, the focus is on the action. Somehow, everything is much clearer."

*See-Saw* (1971) was an immense beam on a fulcrum. To one end, the artist attached a variant on the minimalist box: a video monitor showing a bird in flight. The other end was empty, an invitation to the viewer to climb on and weigh his or her presence against an image of unfettered freedom. Beckley is among the few artists of the period who gave gallery-goers a role to play. The participation of others erodes the artist's control, as Bruce Nauman pointed out whenever interviewers raised the topic. Granting the audience little freedom of action—there are not many ways to squeeze through his narrow corridors—Nauman's performances granted him even less, though early on a degree of playfulness carried over from his puns. The series of *Eleven Color Photographs* (1966–67) that shows the artist waxing the letters "H," "O," and "T," includes *Self-Portrait as a Fountain*, an antic image of the artist spurting water from his mouth.

By the late 1960s, the sharp focus and bright palette of his color photography had given way to the dull blur of video images, and his behavior had settled into tightly regulated ritual. From the title of a wall drawing by LeWitt, one gathers precisely the nature of the work. Likewise, the titles of Nauman's early video and film pieces tell one exactly what the artist will be doing on screen: *Stamping in the Studio* (1968), for example. Performances of this sort induce no performance

anxiety. Yet only a slight increase in complexity brings the threat of chaos. *Bouncing Two Balls Between the Floor and Ceiling with Changing Rhythms* (1967–68) went fairly well at first, as the artist told Willoughby Sharp:

> At a certain point I had two balls going and I was running around all the time trying to catch them. Sometimes they would hit something on the floor or the ceiling and go off into the corner and hit together. Finally, I lost track of them both. I picked up one of the balls and just threw it against the wall. I was really mad.

When Sharp asked him why, Nauman said:

> Because I was losing control of the game. I was trying to keep the rhythm going, to have the balls bounce once on the floor and once on the ceiling and then catch them, or twice on the floor and once on the ceiling. There was a rhythm going and when I lost it that ended the film.[12]

*Dance or Exercise on the Perimeter of a Square* (1967–68) shows a square marked on the studio floor in white. Nauman is dressed in black. Placing his bare feet at corners and midpoints, he takes up a series of positions in respect to the four lines that form the square: with both feet at the midpoint of one line, he bisects that side of the square; with one foot on the midpoint of one line and the other foot on the midpoint of an adjacent line, he straddles a corner; and so on. In *Manipulating a Fluorescent Tube*, a videotape from 1969, Nauman aligns his body in various ways to the linear form of the fixture. Inverting the camera, he produced *Pacing Upside Down* (1968); *Revolving Upside Down* (1968); and *Bouncing in the Corner, No. 2: Upside Down* (1969).

The actions in these videos are stubbornly ordinary. Strangeness—but not virtuosity—appears in *Walk with Contrapposto* (1968), which shows Nauman moving along one of his claustrophobic corridors. At each step, he swings his hips to one side or the other in an exaggerated manner, as if to measure the width of the space he has allowed himself. Stranger still is Nauman's posture in *Slow Angle Walk (Beckett Walk)* (1968). Legs stiff, hands clasped behind his back, bending double at every other step, the artist walks—or slowly staggers—in eccentric but carefully repeated circles. The clue to Nauman's model for this performance is in his allusion to Samuel Beckett, whose character Molloy has a stiff leg and a crutch. "Some days," Molloy says, "I advanced no more than thirty or forty paces."[13]

By invoking a hapless character from a Beckett novel, *Slow Angle Walk* brings into focus other stars in the constellation of Nauman's heroes: Marcel Duchamp, Man Ray, Vladimir Nabokov, and Jasper Johns.

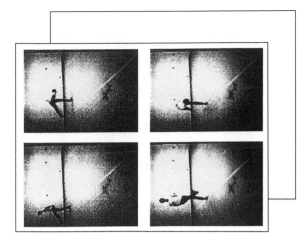

BRUCE NAUMAN. *Slow Angle Walk (Beckett Walk)*, 1968. Still from videotape. Castelli Gallery, New York.

These are jokesters with a weakness for puns and enough sophistication to give an edge of elegance to even the silliest play on words. Admiration for their subtleties pervades Nauman's oeuvre, yet the clearest reference of *Slow Angle Walk* is not to the sensibility of a predecessor but to the form of an object: the minimalist box, which the artist does his best to imitate with a rigidly angular gait. Like Acconci, he tries to embody the box, though they have disparate notions of embodiment.

Acconci's performances take their shapes from the elements of the minimalist object: point, line, plane. In *Proximity Piece*, he centers himself on a certain point. *Following Piece* draws a line. Giving himself over to the waves, in *Drifts*, he lets his body mark off a plane. *Second Hand* turns him in a circle—a variant on the rectangle he paces off in *A Situation Using Streets, Walking, Glancing* (1969). Though Acconci traced the forms that constitute the box, he never tried to assume its form, as Nauman did, with his leaner, more angular body.

Nauman appears to have found the minimalist object more companionable, therefore more vulnerable, if only to the projection of anxiety. In 1969, he tuned the strings of a violin to D, E, A, and D, then played the four notes in succession, as fast as he could. "I don't know how to play the violin, so it was hard," he said. "I had ten minutes of film and ran about seven minutes of it before I got tired and had to stop and rest a little bit and then finish it."[14] No matter how tiresome they are, repetitious forms cannot get tired. In *Violin Tuned D E A D* (1969), and his more strenuous walking and jumping pieces, Nauman forced himself to feel the fatigue that repetition could not feel for itself. Compulsively moving, he enacted the frustrations of stasis. The more tedious a performance, the more fully he took on Minimalism's burden of boredom and futility.

Jumping up and down, revolving around a single point, doing the "Beckett Walk," he seems to be dramatizing a critical perception: no reductive style, not even one as severe as Minimalism, can prevent itself from being read as a bleak sort of Expressionism. With his grimly tuned violin, he played up a suspicion that minimalist solutions were more oppressive than the problems they offered to solve. As unconvincing as traditionally expressive forms of art may be, or eventually become, a programmatic denial of expression can feel deadly from the outset.

Cameras were firmly mounted in Dan Graham's installations. In his performances, they were hand-held. *Roll* (1970) shrinks the minimalist object to the size of a Super-8 camera on the gallery floor. The viewer of the object, played by the artist, lies on the floor with a second camera at the ready. Then,

> with both cameras filming, the performer with camera to his eye rolls slowly toward the right framing edge of the other camera's view, with the aim of continuously orienting his eye/camera's view to center on the other camera's position (and image).[15]

The film made by the performer shows his legs slowly rotating in extreme foreshortening, as the other camera sits isolated in the middle distance. What one sees of Graham's body seems weightless, an effect sharply countered by the other film, which shows the artist in full, straining against gravity as he labors to keep the other camera in view.

*Two Correlated Rotations* (1969) puts cameras in the hands of a pair of performers. As the performance begins, they stand close to one another, cameras running, each with the other's lens in his viewfinder. One follows a spiral track inward, the other spirals outward, as they try to maintain the filmic equivalent of eye contact. Their paths are simple in concept: a spiral is among the more obvious variants on a straight line. In the event, however, it was not easy for the two performers to stay visually connected and on track. Each needed the guidance of "feedback" gathered from the moving image of the other, as it appeared in his viewfinder.[16] The performers of *Body Press* (1970–72) are dependent on even more fugitive patterns of feedback.

*Body Press* takes place inside a cylinder large enough to contain two people. Its inner surface is reflective—in effect, a wraparound mirror—and the performers, a man and a woman, are naked. Each presses a 16mm movie camera against his or her flesh, lens outward, with the film running. Starting near their feet, they rotate their cameras from front to back, moving upward, slowly, until their cameras' spiraling paths have reached their eyes. Then the spirals are reversed, and cameras return, just as slowly, to their original positions. "The rotations are at correlated

DAN GRAHAM, *Roll*, 1970. Still from Super-8 film. Courtesy of the artist.

speed," Graham wrote. "When each camera is rotated to each body's rear it is then facing and filming the other, where they are exchanged so that the camera's 'identity' 'changes hands,' each performer handling a new camera."[17] Projected simultaneously, the two films show two bodies as separate, then merging, then separating, but never decisively. From the literalist recording of flesh come reflections on the ambiguities of selves.

Graham's early performances substituted not the body but an image of the body for the minimalist object. At first glance, this has the look of a dehumanizing tactic: manipulable thing becomes manipulable image, a transition facilitated by the photomechanical workings of the camera. Yet, in a note to his note on *Body Press*, he says that "the camera may or may not be read as an extension of the body's identity."[18] Though Graham had displaced minimalist symmetry and seriality from objects to performers, he didn't want the results to be absolutely impersonal. He later recalled that, despite the "literalized, philosophical-phenomenological" tone of his early work, it required "the live audience bring an interest in 'self-improvement' to it. This work involved the perceivers' perception of their own perceptual process."[19]

As we've seen, Graham often designed his video installations to delay the transmission of images from camera to monitor by eight seconds. This quick feedback, he hoped, would give members of the audience a vivid sense of their place in real time. He wanted the feedback loops generated by his performance pieces to have a similar effect. Illuminated by the spectacle of performers learning to see themselves seeing, the audience would see in its turn that "the 'self' is not an atom-

istic entity, but is imminent in the network of interrelationships or the environmental structure."[20] By crucial contrast, Vito Acconci aspired to the solipsism of the minimalist object.

Acconci's goal—desperately ironic because so obviously impossible—was to control his actions as absolutely as the Minimalists controlled the forms and settings of their works. Graham preferred the flexible, improvisational control provided by feedback patterns. Acconci's early performances were quixotic attempts to suppress the self-consciousness that Graham tried to enlarge with his. *Performance/Audience/Mirror* (1977) placed Graham on a stage in front of an audience, with a mirror behind him. Facing one way, then the other, he described himself, then the audience. "First," the artist noted,

> a person in the audience sees himself "objectively" ("subjectively") perceived by himself; next, he hears himself described "objectively" ("subjectively") in terms of the performer's perception. The slightly delayed verbal description by the performer overlaps/undercuts the present (fully present) mirror view an audience member has of himself and of the collective audience.[21]

Making their way through this maze of points of view and modes of image-making, members of Graham's audience were to arrive at a redemptive self-awareness. His transformation of the minimalist aesthetic was utopian. Acconci's was contradictory. He embodied the minimalist object both to defy its power and to claim it. Resolving nothing, he may have hoped only to intensify his immediate sense of himself. In documentary photographs of his performance pieces, Acconci seems to have driven himself beyond boredom to a silent form of hysteria. In the role of a minimalist object, Bruce Nauman suffers a boredom tinged with sadness. He pantomimes the object's awareness that it has arrived at a dead end and persists only through habit. At times, though, his solemnity gives empty repetition the look of a vocation, and mere sadness turns into a bleakly exalted melancholy.

WALTER DE MARIA, *Beds of Spikes*, 1968-69. Stainless steel. Five parts, each 2 1/2 x 78 1/2 x 41 1/2 inches. Detail.

# DANGER

"There will be blood."

*Robert Smithson, on performance art, late 1960s*[1]

One day in March 1970, Terry Fox poured a bit of gunpowder into an ashtray on a café table in Berkeley, California. Then he lit it. As Willoughby Sharp remarked, "The explosion which gave him a third-degree burn on his right hand could almost have been one of his works, whose use of violent physical and chemical changes often involve a significant element of danger."[2] Not long before, at the opening of an exhibition at the University Art Museum, in Berkeley, Fox had used a flame-thrower to destroy a rectangular patch of jasmine blossoms. He entitled the performance *Defoliation*, so that his outrage at the American military's destruction of the environment of Vietnam would not be missed. Though Fox's art was usually not so pointedly political, nor so violent, he often invoked death.

Diagnosed with Hodgkin's Disease at the age of seventeen, he was eventually cured, after years of painful procedures. "My concern for the body has grown out of real experiences," he said in 1971. "So many operations have been performed on me, I've been the object of action so many times, that I became material. I was a piece of meat that people were acting upon."[3] For an installation called *Hospital* (1971), Fox evoked his medical history with an array of objects: a stretcher; two wooden poles wrapped in bread; a heat lamp hung close to the floor and, heated by the lamp, a basin, soap, and a red towel; a blackboard where the hospital charges had been written and partially erased. A tangle of wires like veins led to a pair of tape players, which broadcast the sound of his breathing and, occasionally, his voice chanting the phrases, "Needles pierced my arm" and "Many times."

Horror relived is horror allayed, if one can choose the means of recollection—or so Fox hoped. He intended *Hospital* to be "uplifting, exhilarating," though many viewers found it depressing.[4] By pushing symbol to the verge of literalism, the artist forced himself into a direct and liberating confrontation with his fears. Invited to follow his example, his audience found it too difficult. *Pisces*, another work from 1971, began

CHRIS BURDEN, *Through the Night Softly*, 1973. Performance piece, Los Angeles.

with Fox buying two live fish in San Francisco's Chinatown. Then, as Tom Marioni recalled, Fox placed them

> on the floor of the Museum of Conceptual Art and tied strings to their tails. While they were still struggling to breathe, the other ends of the strings were tied to the tongue and penis of Fox. As the fish flipped and jerked, they tugged on the artist's body until they died. This direct action created in his mind an extremely graphic image of death.[5]

The dangers that evolved from minimalist literalism were mostly imaginary. Then the imaginary became appallingly real in the art of Chris Burden.

For five days in April 1971, Burden lay in a storage locker at the University of California, Irvine. He drank from a tube connected to a five-gallon container of water in the locker above. He urinated into a tube connected to a second container in the locker below. Impersonating a piece of left luggage, he put himself at risk of severe claustrophobia— the locker was two by two by three feet in size. He increased the risk late the next year with a piece called *Deadman* (1972). Stretching out on La Cienega Boulevard in Los Angeles, Burden covered himself with a tarpaulin. Near his head and feet stood two fifteen-minute flares, to deflect traffic. No car struck him, but the police took notice, and arrested him for "causing a false emergency to be reported."[6]

During the first half of the 1970s, Burden made a career of putting himself in harm's way. He had a friend shoot him with a 22-caliber rifle through the flesh of his left arm—*Shoot* (1971). Holding his hands behind his back, he wriggled his way nearly naked across fifty feet of pavement strewn with broken glass—*Through the Night Softly* (1973). He thrust two live electrical wires into his chest until they crossed, closing

the circuit and causing a burn—*Doorway to Heaven* (1973). He had himself nailed through the palms, in cruciform position, to the back of a Volkswagen—*Trans-fixed* (1974). He inhaled water from a sink—*Velvet Water* (1974). In 1975, Burden built a platform ten feet above the floor of the Ronald Feldman Gallery in New York. The artist lay there, out of sight, for three weeks. In contact with no one, he ate and drank only the minimum necessary to prevent permanent bodily damage. The work was called *White Light/White Heat.*

Musing on this exercise in invisibility a few days before it began, Burden said that it would be a "refinement" on *Bed Piece* (1972), which confined him to a bed that stood at the far end of a gallery in Venice, California. "I stayed there for twenty-two days," he said. "I didn't talk to anyone. There was a portable toilet for me at the front desk and I'd run up there after gallery hours, but most of the time was spent in bed." The gallery would leave food for the artist, but, he added, "a lot of times I didn't get fed because in their minds I had become an object." For *White Light/White Heat,* Burden reduced the bed of the earlier work to a stark form directly descended from Robert Morris's slablike *Cloud* (1962). He would become an object in the company of an object, as defined by Minimalism's aesthetic of deprivation.

Not all of Burden's performance pieces required him to starve or run the risk of severe injury or death. In 1973, he fired a pistol at a passing airliner. This piece, *747*, drew the attention of the FBI, which dropped its investigation when it became clear that Burden had fired at the plane from too great a distance to do it any harm. Yet this piece's resemblance to an act of terrorism was unmistakable, not just to the FBI but to art critics, and it was difficult not to see Burden's *Trans-fixed* as an allusion to Christ's agony on the cross. *Bed Piece* and *White Light/White Heat* recall Franz Kafka's story "The Hunger Artist." *Velvet Water* seems to have reenacted scenes of torture from war and movies of war. Inevitably, Burden has been understood as an artist desperate to communicate some deep fear, some dreadful knowledge, some frantic warning about horrors that we ought to know and fear.

Perhaps he is driven by that desperation. Yet he didn't need to harm himself so literally, or expose himself to the risk of death, to warn us of the world's dangers. Further, the literalism of his performances may undermine whatever warning we might suppose he is trying to deliver. How can we trust the humanity of his concerns if he is so inhumane to himself first of all? Hume's argument that beauty is not inherent in things applies to all qualities and meanings. We are free to ascribe to Burden's performance whatever significance we wish. Yet his willingness to treat himself as an object—more precisely, as an art object of a pro-

CHRIS BURDEN, *Trans-fixed*, 1974. Performance piece, Venice, California.

grammatically inexpressive kind—suggests that it would be willful to read deep feelings into his art.

Most commentators do so, nonetheless, on the way to literary and Scriptural interpretations of an edifying sort. The alternative is to see him as monstrously blank, an artist who reenacted the most painful part of Christ's Passion to show that it could be endured without passion. This, it seems, is what Burden wanted it to show. As he described his reenactment of the Crucifixion,

> Nails were driven into my palms into the roof of the car. The garage door was opened and the car was pushed halfway out into Speedway [an avenue in Venice, California]. Screaming for me, the engine was run at full speed for two minutes. After two minutes, the engine was turned off and the car pushed back into the garage. The door was closed.[7]

In the realm of Burden's early work, bodies display no signs of pain. Screams of anguish come only from machines. *Jaizu* (1972), the least dangerous of his early works, was in a way the most disquieting. At the far end of a gallery of the Newport Harbor Art Museum, Burden spent two days sitting in a director's chair. Dressed in white, his eyes hidden by sunglasses, he tried to remain absolutely motionless. Visitors were permitted, one by one, to sit on a cushion at the other end of the gallery and look at him. He could not look back because a coat of black paint covered the insides of his already dark lenses. When he put himself in

harm's way, Burden acknowledged in himself at least a residual human-ity—a fleshly vulnerability. With *Jaizu* he argued mutely that not even this residue need remain.

<div align="center">*    *    *</div>

When bodies took the place of objects, the audience felt an electrifying uneasiness. To prolong that feeling, artists exposed them-selves to danger, and no one employed this tactic with more flair than Gordon Matta-Clark. To execute *Splitting* (1974), he drew a line with a chain saw in a medium that threatened at every moment to collapse. After all, to cut a house in half is to destroy its structural integrity. In 1975, he made another chain saw drawing, this time in an abandoned pier on the lower West Side of Manhattan. As the summer ended, he wrote a friend,

> During the months of July and August . . . I devoted myself to a working vacation by the water on the Hudson. My "studio retreat" consisted of appropriating a nearly perfectly intact turn-of-the-century wharf building of steel truss construction having virtually basilical light and proportions. A beautiful shape for such an industrial "hanger." Once [I] had secur[ed] the space from intruders . . . I . . . spent the next two months working out—that is cutting and working out section of sock 10–18" thick, roof, and walls and heavy steel trusswork.[8]

In the dock that served as the building's floor, Matta-Clark made a cut nine feet wide and seventy feet long. A section removed from the roof marked one extreme of a vertical panorama, from the sky above to the river below. The artist made another opening to the water, and in the west wall of the building he cut an immense almond-shaped hole. Focusing on its form, he called it a "cat-eye." Shifting his attention to its function, he compared it to the "rose window" of a cathedral, for it became the building's main source of illumination.[9]

Early in the afternoon, only a thin, nearly vertical wedge of light could enter. As the sun descended through the western sky, the light increased, and sunset would fill the abandoned building with pink and orange radiance. Any architectural interior has at least a distant relation-ship to the emptiness of the minimalist box. Matta-Clark filled this one with a scenic effect crucial to those nineteenth-century landscape painters—Frederick Edwin Church, Albert Bierstadt—who gave the American sublime its early definition. Moreover, he worked at the scale of landscape itself. Here was the fact, not the image, of sunset enclosed by a work of art. Matta-Clark had literalized the sublime. He called the

GORDON MATTA-CLARK, *Day's End*, 1974. Pier 52, New York.

work *Day's End* (1975). Visitors were awed—and apprehensive, as the aesthetic of the sublime requires.[10]

Matta-Clark and his assistants had risked injury to produce *Day's End*. And it posed risks to others. Nearly a decade later the artist's dealer, Holly Solomon, recalled that when she saw the work for the first time,

> it reminded me of the first moments of seeing a Michelangelo, of being in a cathedral with flying buttresses and light-stained glass. Yet I was also afraid. I was afraid to cross the cut he had made in the floor; I'm afraid of height. He made a small handrope for me and other people who were fearful.[11]

The artist Joel Shapiro remembered the site as

> a mysterious, decrepit place—a huge space—and the cuts had a certain scale. It was frightening. I recalled thinking, whose building is this? It is dangerous. . . . To go to an abandoned place and chop it up—I don't know what I thought about that. The destructive aspect, I mean. . . . The willful aspect, I don't know. The piece was dangerous to the viewer. It was large; it had scale. He was creating some kind of edge—flirting with some sort of abyss.[12]

Matta-Clark was also flirting with the law. Pier 52 had fallen under the authority of the New York City Economic Development

Administration. Tipped off by a city employee, officials from the EDA appeared at the inauguration of the piece and chased the artist and his guests off the pier. Matta-Clark was threatened with litigation, and when he left New York for Paris in September 1975 he learned from his lawyer that the agency was on the verge of listing him as a fugitive.[13] The threat of legal action faded quickly, and may never have been entirely serious. Nonetheless, an aura of lawlessness tinges *Day's End*. In the realm of the aesthetic, threats need not be real to be significant.

In the late 1960s, Richard Serra made "prop pieces" from slabs and bars of lead and steel. Nothing holds the elements of these works in place, and it is easy to imagine them crashing to the floor with disastrous results. This never happened and no one reasonably expected that it would. By arranging his materials with extreme care, Serra persuaded gravity to give these works all the stability they needed. Nonetheless, they looked precarious. More to the point, they insinuated a reminder of risk into configurations of plane and the line—forms the Minimalist had rendered all too safe and solid.

As the minimalist object came into hypersharp focus, Serra and Robert Smithson grew impatient with their immediate elders. As Serra told an interviewer in 1980, he and Smithson felt that the Minimalists

> were purporting to represent in their work and theory a system of construction that was not only definitive but closed. There was a presumption of didacticism, of authority. We felt that it left no room for doubt, no room for anxiety, no room for anything that would not substantiate a general proposition. We thought that closed systems were doomed to fail. Smithson and I shared a general empathy, he for my splashed lead pieces and the notion of collapse, I for his notion of site and entropy.[14]

Among Smithson's favorite sites was the lost continent of Atlantis, which made an early and dignified appearance in Plato's Timaeus and declined, over the centuries, into the stuff of sci-fi films and superhero comic books.[15] To celebrate this entropic decay of a powerful fantasy, Smithson made a map of Atlantis from sheets of plate glass. Smashing the glass sheets not quite to smithereens, he shoveled their jagged fragments into a casual heap which would have posed a danger to passersby, had there been any. *The Map of Glass (Atlantis)* (1969), appeared in a vacant lot on a quasi-derelict island off the North Jersey shore. Once photographed, it was cleared away.

Made not to be seen but to be documented, this work was chiefly the occasion for a rhapsody to disintegration:

> Outside in the open air the glass map under the cycles of the sun

radiates brightness without electric technology. . . . It is a shimmering mass of decreased sharpness, poised on broken points showing the degrees of reflected incandescence. . . . The cracked transparency of the glass heaps diffuses the daylight of the actual color source—nothing is fused or connected. The light of exploding magma on the sun is cast onto Atlantis, and ends in a cold luminosity. The heat of the solar rays collides with the spheres of gases that enclose the Earth. Like the glass, the rays are shattered, broken bits of energy, no stronger than moonbeams. A luciferous incest of light particles flashes into a brittle mass. A stagnant blaze sinks into the glassy map of a non-existent island. The sheets of glass leaning against each allow the sunny flickers to slide down into hidden fractures of splintered shadow. The map is a series of "upheavals" and "collapses"—a strata of unstable fragments is arrested by the friction of stability.[16]

Opaque to eye, the minimalist object was transparent to the mind: what you understand is what there is to be understood, and in that equation was the beginning and end of the object's significance. Exasperated by this pretension to transparency, Smithson smashed sheets of glass into a heap of debris, glittering but opaque. Calling it a map, he launched a series of metaphors that reached from Platonic myth to the surface of the sun, yet revealed little but Smithson's indifference to literal fact—or his liking for dark snarls of ambiguity. In his universe, light entrances but does not illuminate. What you see is what you flee, into zones of the imaginary.

In Barry Le Va's *Shots from the End of a Glass Line* (1969), broken glass marks a long, snaking path across the floor. At eye level, a pipe about a foot-and-half long is set into the gallery wall at a right angle. Below the point where the pipe ends, the line of glass begins and continues over the floor to a second point, where the pipe looks like a point drawn on a flat surface, not a line reaching into the room. "It was about locating yourself in space," the artist says. "Being aware of the ways things change as you move around. And starting to see various relationships between the different ways things look, formally." From the far end of the *Glass Line*, five bullets were fired at the end of the pipe. Inevitably, they missed, leaving five bullet holes in the wall. One is invited to wonder if a sixth vanished in to the pipe. "The piece is almost cinematic," Le Va adds. "Because you put it together from the pieces it gives you."[17]

What you saw was a montage of sorts, a set of juxtapositions that proposed certain meanings. The shards of glass could be read as ruins of the transparent planes the bullets had traversed on their way to the opacity of the wall. In the meandering line of jagged glass, viewers might see a reminder of their ruminative paths through "the white cube" of gallery space. The lines drawn by the bullets were fast, and the bullet that found its target—in supposition if not in fact—established a right angle with perfect exactitude. By demonstrating geometric form with a firearm,

Le Va evoked the power of a simple idea suddenly understood. Because guns are dangerous, precautions were taken when these *Six Shots* were fired. Offering no real threat to viewers, the *Glass Line* was an emblem of meandering contemplation, and properly tenuous, for it served just as well as a reminder of all that is shattered by geometric certainty.

For the Whitney's *Anti-Illusion* show, Le Va flung meat cleavers at an empty wall. He aimed the first dozen at the wall's upper edge, the second at its lower edge. "There seem to be associations with danger in a lot of your work," Liza Béar and Willoughby Sharp noted when they interviewed Le Va for *Avalanche* in 1971. "I'm never aware of the possible danger," he replied, though he acknowledged that attending to wobbly cleavers with a row of twelve more above one's head did feel a bit risky.

> It was also quite dangerous for the audience if they got too close. But I wanted people to have a real physical confrontation with the piece. That's why I didn't like those ropes they put in front of it at the Whitney. Apart from physically confronting the cleavers, which was very important, you could trace the relationship between the top and bottom row, figure out from which angle they were thrown. To me a cleaver doesn't necessarily have to be viewed as something going into a wall, but more as a point at the end of a line or arc.[18]

The trajectories of the cleavers were paths of escape. To confront them physically, with their blades buried in a museum wall, was to feel the urgency of the need to get out of the box.

With his drawings of the maze as a prison—*In the Realm of the Carceral* (1978)—Robert Morris argues that there is no exit from the box: whether they define an object or a space, lines and planes and simple curves are escape-proof mechanisms. With *Observatory* (1971–77), his largest outdoor work, Morris makes a counterargument: to get out of the box, one needs only decide to do so. And there is a counter-counterargument in *Observatory*'s alignment with the motions of the solar system: one can leave the gallery for the desert or the edge of the sea but simple patterns of line and plane preserve their confining force. None of these arguments is convincing unless one chooses to be convinced. In the realm of the aesthetic, all is optional, despite the historical and formal necessities that art writers like to invoke. Necessities are what one deems to be necessary. The "security walls" and "hot and cold pools of persuasion" in Morris's *Carceral* realm have no power to coerce. At most, they can persuade us to embrace the idea of coercion, to choose to believe that the aesthetic is a game of inevitabilities.

His *Labyrinth* (1973–74), is somewhat baffling but not indecipherable. Its complexities cannot incarcerate you. Bruce Nauman's corri-

dors are claustrophobic but easy enough to escape. Stephen Kaltenbach's *Room Cube* (1969) was a touch frightening to some, but put no one at real risk. Rather than threaten danger, these artists alluded to it and thus to the ordinary world, where blood is shed. Sometimes the allusion was shockingly direct. In a conversation with Cindy Nemser, Kaltenbach told her of a motorcycle accident that led to the amputation of a toe.

> It turned out that a premed student friend, who was in my ceramics class, did the cleanup for the operation, and I asked him to save the toe for me. Since I was stuck in the hospital for two months after the operation, I asked him to put it in an unfired pot and cremate it for me. When I got out of the hospital, I mixed the ashes from my toe into a Japanese ash glaze, and put it on a small pot.

Later, Kaltenbach devised a new way to produce works on paper: "Every time I'd cut myself, I would make a monoprint by pressing paper onto the wound. It's a record of what happened to me, and I have those things dated and in a filing cabinet."[19]

When Walter De Maria first showed his *Beds of Spikes* (1968–69), at the Dwan Gallery, one could enter the premises only after signing a form that released the artist and his dealer from any liability for injury. This procedure was a nuisance but sensible enough. The spikes certainly looked dangerous. Years later Virginia Dwan remembered wondering, as the first day of De Maria's exhibition ended, just how sharp they really were. With the front entrance to the gallery locked, she tested a row of the spikes with the palm of her hand. They were, she found, terrifyingly sharp.[20] Minimalism had threatened to bore the audience, to baffle it with blankness. With their minimalist clarity, the *Spikes* made it clear that the threat had been escalated. These forms could inflict grievous bodily harm.

With remarkable speed, the shocking literalism of the minimalist object had become a respectably aesthetic quality, routinely analyzed by critics and just as routinely praised by curators and collectors who considered objects of this sort worthy of being collected. Everything the art world considers serious eventually becomes collectable, even a photocopy of a conceptualist's typewritten text. De Maria's *Beds of Spikes* now belong to the far from adventurous Kunstmuseum of Basel, Switzerland. Yet when they were new, these objects defied appreciation, as Robert Morris's cubes had done only a few seasons earlier. For a time, the threat of literal danger revived the feeling that literalism itself is dangerous.

VITO ACCONCI, *Seedbed*, 1972. Wooden ramp, 10 x 60 x 22 feet, with loudspeaker.
Performance piece, Sonnabend Gallery, New York.

# BEYOND DANGER

The personal plays the role of the concrete, immediate, and specific. I want to give concreteness to my work in order to blast the simplistic categories that we impose on people. I use my own experience—my own selfhood—when it seems strategically the best way to make concrete those thoughts, statements, or beliefs that might be dismissed as being too theoretical or abstract.

*Adrian Piper, 1990*[1]

During April 1971, the John Gibson Gallery presented a Vito Acconci exhibition entitled "Ongoing Activities and Situations." Reviewing the show for the *Village Voice*, John Perreault described a variation on the minimalist object:

> a wooden box with small holes drilled into it, inside of which there is supposedly a cat. The box is locked and only Acconci has the key and can care for the cat. How and when will he do this? Those of us who know Acconci know he will act with utmost responsibility. What is interesting is that although the cat is enclosed and controlled, the control box and the situation is actually controlling Acconci's own movements and the schedule of his private life. He must periodically return to the gallery to take care of the cat. Controlling is to be controlled.[1]

In his "Notes on Sculpture," Robert Morris had said, "Control is necessary if the variables of object, light, space, body, are to function."[2] Control itself is a variable. To demonstrate absolute control over control, one must, on occasion, lose it. One must choose to let the cat out of the box, so to speak, as Acconci did with *Untitled Performance for Pier 17* (1971). Perreault called it "a danger piece."[3]

On the wall of the Gibson Gallery, Acconci posted a description of the work:

> From March 27 to April 24, 1971, 1 A.M. each night, I will be at Pier 17, an abandoned pier at West Street and Park Place in New York; I will be alone, and will wait at the far end of the pier for one hour.
> To anyone coming to meet me, I will attempt to reveal something I would normally keep concealed: censurable occurrences and habits, fears, jealousies—something that has not been exposed before and that would be disturbing for me to make public.

As Acconci noted, this work might supply a participant with "material for blackmail." A more immediate risk was assault from a denizen of the piers. However, the artist completed the piece physically

unscathed and unvictimized by blackmailers. He had, he said, "Not enough secrets that I find hard to reveal."[4] It was enough to reveal that secrets were an issue. Like the box at the Gibson Gallery, with its imprisoned cat, Acconci-the-art-object had an inner life.

Traditionally, artists have not merely admitted their inwardness. They have flaunted it. Since the Romantic era it has been easy to assume that art simply is self-expression, the more revelatory the better. Minimalism questioned that assumption, and in its aftermath artists invented means of concealment. In 1967, Bruce Nauman launched a series of *Art Make-Up* films, which show him applying white, then red, then green, then black makeup to his face. At every stage the image of his face grew flatter, until, as he said, "The flatness itself became a kind of mask"—a blank plane. Questioned by Joan Simon about his knack for "simultaneously presenting and denying a self," Nauman replied:

> To present yourself through your work is obviously part of being an artist. If you don't want people to see that self, you put on makeup. But artists are always interested in some level of communication. Some artists need lots, some don't. You spend all this time in the studio and then when you do present the work, there is a kind of self-exposure that is threatening.[5]

With the puns and ironic platitudes of his early work, Nauman kept that threat well under control. His films and videotapes make him literally visible, of course, yet the lugubrious dignity of his performance style reveals little more than a reluctance to reveal very much. Even in his most tightly controlled performances Acconci was more fully present as a personality—his anxieties about control appeared to be uncontrollable—and with *Seedbed* (1971), he made a ritual of self-exposure.

At the Sonnabend Gallery, Acconci built a ramp with a resemblance to Robert Morris slanted forms: *Untitled (Corner Piece)* (1964), and *Untitled (Wall/Floor Slab)* (1964). Twice a week, for six hours a day, Acconci would lie beneath the ramp and listen for gallery-goers' footsteps on the boards above him. From those sounds, he generated fantasies and told them to a microphone. As speakers filled the gallery with his mutterings, he masturbated—spread his seed on the floor. Quizzed by Liza Béar, Acconci said that, in principle, visitors "were completely compromised as they walked into the gallery, onto the ramp—they were implicated." That, said Béar, is

> a peculiar kind of intimacy. They're put in the position, by coming into the gallery, of hearing you perform what is normally a private activity for which they may provide the stimulus. They're not there as voyeurs. So they're being more compromised than you are.

*Vito Acconci*: No, I'm being equally compromised as soon as the audience is aware that I'm carrying on this normally private act, as you said, in a public place—something that is supposed to bring about shame, degradation, whatever. Though they couldn't be so aware of the situation as to detach themselves from it, since any viewer was potentially part of the activity.

*Liza Béar*: But that wasn't your experience of the piece, was it?

*Vito Acconci*: No, it wasn't. I had literally built myself into a position where I would have to be concerned with that. However conscious I might be that people knew what I was up to, I was still hidden—though I didn't really think, I'm invisible, therefore it's not so bad. I'm not sure how much it affected me at the end of the day when I left the ramp and the people who were still around would look at me very strangely, draw back, obviously . . . what can you possibly say to a masturbator?[6]

Nothing, presumably, and that is what one has to say to a minimalist object. Enclosed in its self-sufficiency, the object demands only to be seen. The initiated viewer replies to its blankness by remaining as mute and emotionally blank as the object appears to be. And when Acconci's body art exposed an uneasiness just beneath the surface, the response remained the same. Self-exposure is not self-expression. The latter is a claim to an exalted humanity and a bid for empathy. The former is the first step toward reduction to a thing.

At Pier 17, in the hours after midnight, Acconci exposed himself to danger—as Gordon Matta-Clark had done on another pier and Chris Burden routinely did for half a decade. None of these artists suffered permanent injury, yet the dangers they faced were real enough to revitalize the literalism they had learned from the minimalist object. Treating his body as his material, Burden used it as the contents of a small box, as a target for a bullet, as a means of closing an electrical circuit. Dehumanizing his flesh, he left his inwardness untouched—neither expressed nor exposed. It was possible that, somewhere beyond the reach of physical danger, he and other extremists among the performance artists were preserving their expressive options. With *Seedbed*, Acconci nullified that possibility, at least for himself.

Self-expression of the usual sort may be painful, yet it is nearly always respectable. We expect it, after all, to help us define and improve ourselves. Self-expression is progressive. By contrast, masturbatory fantasies are regressive. To broadcast them in a gallery is to expose the static regions of the self, zones of the personality as turned in on themselves as the symmetries of a minimalist object. For *Seedbed*, Acconci had converted the most embarrassingly inert residue of his psyche to the material of a performance piece—as Robert Morris had turned debris into works of process art. Beyond the risks run by bodies when artists treat them as objects is the chagrin they suffer when they reveal not only their obses-

sions but their willingness to reduce every aspect of themselves to the stuff of art. Those who drew back when Acconci emerged from his hiding place were not morally repelled. SoHo in the early 1970s was not a censorious place. Rather, they withdrew from one who was no longer a person in any familiar, approachable way.

\* \* \*

At its most powerful, art doesn't merely focus the gaze. It changes the nature of our seeing, often so thoroughly that we can't remember how art and the world looked before the change took place. That is why the artists who were the most deeply affected by Minimalism have had the least to say about its impact. Coming across the minimalist object for the first time, they saw it as utterly, absolutely realized and themselves as the opposite: formless, yet all of a sudden ready to be born, to become whoever they would be as artists. Transformed, they have neither the motive nor the ability to recall the transforming confrontation. Among the exceptions is Mel Bochner, whose review of *Primary Structures* calmly records his shock at seeing how decisively the simplicities of the minimalist object stood apart from that exhibition's overload of involuted geometries.[7] And in 1992, Adrian Piper recalled with precision the "brilliance" of Sol LeWitt's *46 Variations on Three Different Kinds of Cube* (1967), which she had when it was new.

"What he did," said Piper,

> was to take the cube, a very basic idea, and then stack it in rows, three cubes per stack, and vary the sides of the cubes that were open or closed, so that each column of cubes looked slightly different depending on where the openings were. And then they line up, and they fill basically an entire room. Looking at that piece was the visual equivalent of listening to Bach's "Art of the Fugue." It was just amazing.[8]

Like Acconci and Dan Graham, Piper found ways to transpose fuguelike variations from three dimensions to the flatness of the page. After a few seasons of making art from words, she returned to inhabitable space by impersonating the minimalist object. Like Acconci and Graham, she became a performance artist.

In Acconci's performances, uneasiness was a by-product of the restrictions he imposed on himself. His body had no objection but he did, for the self—even that of an artist willingly formed by minimalist precedent—cannot be content to play the part of a point or a line or a plane. Piper, too, was an uneasy performer. Yet, because she never cast herself in roles as narrow as Acconci's, Piper's uneasiness had no conven-

ient explanation. Her clothes pungent with vinegar and cod liver oil, she would browse in a bookstore or ride the subway. Bearing a sign that read "WET PAINT," she walked through the streets of Manhattan, her shirt in fact wet with a coat of white paint.

Part of the *Catalysis* series (1970), these performances were attempts to provoke reactions—to be catalytic. Piper wanted to be a disquieting presence, a tear in the fabric of the ordinary. Once she walked through the lobby of the Plaza Hotel with helium balloons attached to her hair, nose, and front teeth. However uneasy she felt, she hoped that others would feel even more so. Beyond the possibility of physical harm is the risk of exposing oneself as strange, unpleasant, the possessor of shameful thoughts. Beyond this danger to one's inwardness, one's self-esteem, is the awkwardness of raising difficult social and political issues. It was to risks of this more public kind that Piper's *Catalysis* pieces were bringing her.

Asked in 1993 if he thought art should have a moral or social agenda, Sol LeWitt said, no, and went on to make a sharp distinction between art and politics. Recalling the protest and turmoil of the late 1960s, he said that the art of the time "represented more of an aesthetic than a political upheaval." Artists could be politicized, but not art.[9] Despite her admiration for LeWitt, Piper disagreed. With the approval of LeWitt himself she had found a place among the conceptualists and performance artists of downtown Manhattan. Yet, as a black woman, she felt the limits built into the acceptance she had received. Like the larger world, the art was biased against females and members of racial minorities. Piper saw, moreover, that if art is defined as apolitical it could provide no grip on these matters. In 1972, she donned an Afro wig and launched her *Mythic Being* performances.

Her outfit completed with moustache and sunglasses, a cigarillo and street clothes, Piper impersonated a stereotypical black male— *Everything You Most Hate and Fear*, to quote the subtitle of a *Mythic Being* performance from 1975. On videotape and in photographic narratives, the artist's alter ego ogled white women, committed a mugging—in short, behaved according to the dictates of prejudiced expectation. Piper's hope was that, by holding a mirror up to prejudice, it would recognize itself. Her later works addressed racial conflict more directly, often mixing personal reminiscence with family history and documents of black life in the United States. Because Piper is light skinned, some whites see her as white and thus receptive to racist remarks. In 1986, she prepared herself for jokes and slurs with a card announcing that she is black. When there was occasion to present it, she has said, "the person looked at it, did a double take, and then completely withdrew from me . . . not once did I

ADRIAN PIPER, *Catalysis III*, 1970. 2 black and white photographs mounted on page with text; page, 8 1/2 x 11 inches, each photograph, 5 x 5 inches. Courtesy of Thomas Erben Gallery, New York.

have any sort of dialogue or confrontation with who got the card."[10] Nonetheless, Piper still tries to start a dialogue or, at the very least, stage a confrontation.

Autonomy is always contested. The moment writers defined art as independent of any practical concerns, their definitions were challenged by moralists determined to uphold the perennial doctrine that an agent as powerful as art cannot be allowed to stand idle. It must be recruited to useful purposes. This conflict can divide a sensibility as well as a generation. John Keats was among the earliest to argue that the aesthetic stands apart from all else. Yet he also said that surely "not all those melodies sung into the world's ear are useless." On occasion, a "poet is a sage, a humanist, a physician."[11] Works of the imagination have healing work to do.

By this second Keatsian standard, Piper's later work counts as art of a particularly elevated kind, for its purpose is to heal our society's deepest wounds—the ones inflicted by racism. Her method is to illuminate suffering and rage with illustrations as trenchant as she can make them. The disquiet, even panic, caused by her art is proof of its power. Yet it is precisely their social and political acuity that banishes Piper's works from the realm of the aesthetic as it is understood in the vicinity of the minimalist object, the purely aesthetic presence isolated in its autonomy—or, in Mel Bochner's word, its "solipsism."[12] Illustrating nothing, demonstrating only its self-sufficiency, the art object exists in, as, and for itself. Any other mode of existence would disqualify it as a work

of art. And so, after she moved beyond her LeWittian legacy, Piper found herself disqualified—not entirely, of course, for she still figures in histories of Minimalism and its aftermath. Yet she has been ushered to the margins, not only because she is black and a woman but because she has made her race and gender the substance of her art.

The art world has never insisted absolutely on the absolute autonomy of the artwork. Even in the late 1960s, at the height of the conflict between the two formalisms, Greenbergian and minimalist, attention was paid to decorative art, expressive art, art animated by political outrage. Yet this attention has usually been cursory, for the center of aesthetic gravity always was and still is occupied by works of art that surround themselves with an aura of unqualified self-sufficiency. The art object of this sort is privileged. The sex object is not. In 1973, Ana Mendieta merged the two terms in a performance piece called *Rape Scene*.

For the occasion, the artist turned her apartment into an exhibition space. Naked from the waist down, she had herself bound to a table by her wrists. Her exposed flesh was spattered with blood. More blood stained the floor and its array of broken crockery. That year, she spilled blood on the sidewalk outside her apartment and photographed those who stopped to look at it. Though imaginary, the violence of Mendieta's art is vivid enough to be taken as a prophesy about her life, which ended in a fall—under suspicious circumstances—from a window in the apartment where she lived with Carl Andre, then her husband. But interpretations of this sort are sheer melodrama. Mendieta invoked violence to protest it, not to invite it.

Like works of art, women have traditionally been accorded a transcendent value. *Rape Scene* presented this privilege as vulnerability in a thin disguise. Like Adrian Piper's work, Mendieta's is respected for the power of its protest. Yet that respect tends to segregate their work in the category of "political art" or, still more dismissively, "politically correct art." Their points about violence and privilege are understood as applying only to the larger world, not within the zone of the aesthetic. If the concerns of "political art" were permitted to intrude on the isolation of the autonomous artwork, its privileged status might begin to look dubious—a state of dependency rather than power.

In fact, this intrusion often occurs. As a professor of philosophy at Wellesley College, Piper questions the ideal of aesthetic autonomy as pointedly as she does as an artist. Critiques of the privileged work of art arrive from every point of the intellectual compass. Yet the institutions of the art world deflect them all, and in the realm of the purely aesthetic the veneration felt in the presence of Minimalism's apodictic objects is

still intelligible. Nonetheless, apodicticity had begun to look a bit tired by the end of 1960s. Rather than abandon it, certain younger artists chose to embody it. To test the objecthood of their bodies, they subjected themselves to physical danger—and then to psychic danger. Beyond the reduction of body and soul to the state of an object there was nothing, no credible variation on the ideal of autonomy. An endpoint had been reached and became crowded, as thing-like selves proliferated.

In 1972, the British artists Gilbert and George inaugurated the Sonnabend Gallery in SoHo with a performance of *Underneath the Arches*. Dressed in identical suits, their hands and faces covered with metallic makeup, they stood together on a narrow platform. As a phonograph played a recording of the music-hall song that gave this work its name, Gilbert and George mouthed its lyrics. When the record was over, one of them would descend, restart the record, step back onto the platform, and the pantomime would resume until, once more, the song was done. Now the other stepped down to replay the record, step up to platform, and so on, all day, every day, for the duration of the show. Gilbert and George had made themselves into mechanical men: autonomous objects as automatons, as in Scott Burton's performance tableaux, with their "robot lovers."

During the late sixties, Patrick Ireland wrote a series of ten "structural" plays. "They deal with words," he said,

> and movement in terms of symmetry . . . all kinds of symmetry. I take a grid with one or two people on that grid. I do not want a personality with blue or red hair or anything. There's just an intelligence that can move and talk . . . a person that is limited to two functions, that is, moving and saying something, or three functions, standing still, or four functions, saying nothing.

Ireland insisted that his performers would not be automatons,[13] yet people reduced to definable functions cannot be anything else. Performance art filled the art world with bodies mechanized not in fact but in fantasy. Because the prevailing literalism discouraged the imagination, this make-believe metamorphosis of the flesh went unacknowledged. Secretly, it generated an atmosphere of weirdness, as if the air were full of spells and sinister enchantments. Weirdest of all was the sorcery, whatever it may have been, that gave birth to Dennis Oppenheim's marionettes.

\* \* \*

To preserve the power of the minimalist object, Oppenheim had dismantled it and enlarged its constituent parts. Conceiving of the earth

as a plane, he inscribed it with lines—but only tentatively. His lines erased themselves, and the land, too, vanished as his attention shifted. Not long ago, he was asked how this happened. Having heard this question before, he replied:

> I always say that when I was walking around on the land, I suddenly became aware of my body. I'm not sure how true this is. Land Art seemed to be silently and secretively taking over my body, a bit like the Body Snatchers. The body loomed as a vital area of fertile possibility, and it was easy for me to give in to it.[14]

By putting his body in place of the landscape, Oppenheim gave his art the cohesion he feared had been lost in the far reaches of his outdoor projects. He was reconstituting, on his own terms, the unity of the minimalist object.

Filmed by Robert Fiore, *Wire and Arm* (1969) shows Oppenheim's forearm in extreme close-up, as it repeatedly rolls over a length of electrical cord bent into a U. "Basically," said the artist, the work makes "no distinction between the material and the tool. The impressions produced by the expenditure of downward pressure are returned to their source and registered on the material that expends the energy." End and means are caught in a closed circuit, the performance artist's equivalent to a Minimalist's reversible series. *Backtrack* (1969), is a film of the tracks left in sand as Oppenheim performed various maneuvers on his back. As he later said, "I was trying to get as close as possible to the material that was supporting me"—that is, the sand—"to interact directly with it instead of vicariously activating an ego-system"—in other words, projecting an intention into the landscape, as he did with the ice drawings and *Cancelled Crop*.

*Backtrack* was shot at Jones Beach, where Vito Acconci would perform *Drifts*, and his *Rubbing Piece* is a concise variation on Oppenheim's *Wire and Arm*. In Acconci's version, flesh injures flesh, without the intervention of inanimate material. For a year or two, Acconci and Oppenheim developed along parallel tracks, both of them inching ever closer to the risk of serious physical injury. Oppenheim's *Reading Position for Second-Degree Burn* (1970), produced two color photographs. The first shows the artist lying on his back, in the sand, with a book entitled *Tactics* resting open on his chest. In the second, he is sunburned and the book has vanished. In its place is a rectangle of unburned skin.

Defining his body as "an exposed plane," Oppenheim impersonated the canvas—and the pigment—of a monochromist:

> I allowed myself to be painted, my skin became pigment. Not only would my skin tones change, but its change registered on a

sensory level as well—I could feel the act of becoming red. I was tattooed by the sun. You simply lie down and something takes over. It's like plugging into the solar system, communicating with an element.

And it was like becoming elemental oneself: an aesthetic substance functioning "as the sole vehicle of the art, the distributor, initiator, and receiver simultaneously." Serving now as "both subject and object," Oppenheim's body could shift with ease "from the position of instigator to victim."[15]

*Rocked Circle—Fear* (1971), required Oppenheim to stand at the center of a five-foot circle as collaborators threw rocks at him. For half an hour he stood there, as still as possible, while a video camera recorded his features. This work exposed him to injury, and to a further, less tangible danger. For the idea of the work was to reduce facial expression to a malleable sort of material, like the sand in *Backtrack*. To realize this idea would be to dehumanize himself utterly. Oppenheim stopped performing in 1971. Three years later, he built a set of stand-ins for himself: marionettes, a foot and half tall, dressed in dark suits. Their faces were grim caricatures of his own.

In *Attempt to Raise Hell* (1974), one puppet lay on the floor. At regular intervals he would sit up, bringing his forehead into sharp contact with the edge of a bell. The resulting clang was an exceedingly unpleasant variant on the sound, already unpleasant enough, of a skull meeting a blunt instrument. *Theme for a Major Hit* (1974), set a puppet endlessly dancing at the end of his strings, while a tape loop played a rock song with an insistent chorus: "It ain't what you make, it's what makes you do it." Oppenheim had raised the perennial question of the artist's motive and, by implication, the matter of art's purpose.

Behind expression, which Minimalism suppressed, lies motive, which Minimalism ignored: apodictic form simply is, unmotivated. As they turned him away from the minimalist legacy, Oppenheim's marionettes were luring him down well-trodden path toward old-fashioned concerns. *Search for Clues* (1974), alluded to Aladdin by raising a large oriental carpet several feet above the gallery floor. In a corner, a puppet lay with a knife in his back. Nearby, a monitor played a tape of a knife being stuck, repeatedly, in a revolving surface. On the soundtrack this time was the voice of a young girl—the artist's daughter—talking of life and death, knives and her father's fate. She always knew, she says, that he would arrive at his limits—would reach the edge of art, which is symbolized by the edge of the carpet and, finally, by the edge of the knife that has murdered his effigy.

Oppenheim made puppets as a boy. Now he was making them again. He has always talked of them gingerly, as if embarrassed. Toward

DENNIS OPPENHEIM, *Theme for a Major Hit*, 1974. Motor-driven marionette, 24 inches high. Courtesy of the artist.

the end of the seventies, he called them "retrograde."[16] Puppets launch the narrative imagination. Worse, they are uncannily expressive. "On the Marionette Theater," a dialogue by Heinrich von Kleist, leads to the conclusion that the consciousness which makes us human deprives us of innocence and thus of grace. We are not always hopelessly clumsy, yet "grace appears purest in that human form which has either no consciousness or an infinite one, that is, in a puppet or in a god."[17] In the light of this argument, Oppenheim's puppets were all too human. Jittery, awkward, compulsively repetitious, they invited sympathy and encouraged fear. These puppets stand at a border no inheritor of the minimalist legacy would ever choose to cross.

JAMES COLLINS, *A Domestic Dialogue (Red)*, 1977. 3 color photographs, 27 x 13 inches each.

# FACT TO FICTION

*Willoughby Sharp:* What would you say about the relation-
ship between your work and photography?
*Robert Smithson:* Photographs steal away the spirit of the
work.
*Dennis Oppenheim:* One day the photograph is going to
become even more important than it is now—there'll be a
heightened respect for photographers. Let's assume that
art has moved away from its manual phase and that now
it's concerned with the location of material and with
speculation. So the work of art now has to be visited or
abstracted from a photograph, rather than made. I don't
think the photograph could have had the same richness of
meaning in the past as it has now. But I'm not particu-
larly an advocate of the photograph.
*1970*[1]

From the stability of the minimalist object followed works of deliberate instability. Performance pieces vanished as they were seen. Lines drawn on the desert floor disappeared more slowly, yet they too made the argument that works of art need not be permanent. It's enough for them to survive in their documentation, and sometimes a piece did not come fully into being until a record of it went on view. Dennis Oppenheim's *Gallery Transplants*, for example, were unintelligible in the landscapes where they took place. They made sense only as juxtapositions of map and captioned photograph, matted and framed and hung on a gallery wall. Douglas Huebler's texts often end with the declaration that the other elements of a piece—photographs, schedules, maps—"join with this statement to constitute the form of this work." Documentation is primary: the work itself, not a reference to work elsewhere.

Minimalism form had the weight of self-evident fact. Huebler wanted to give equal weight to facts of casual observation: clouds in the sky, pigeons in a park, people in city streets. At first, he allowed facts to present themselves. In 1970, he began to generate them. Rather than stand to the side and photograph pedestrians as they passed by, ignorant of his intention, he approached certain individuals and took their pictures a moment after saying, "You have a beautiful face." The result, more often than not, was a smile—abashed yet pleased. James Collins employed a similar method to different ends.

Spotting an attractive woman in the New York streets, he would introduce himself and try to persuade her to sit for his camera. "The choice of a girl is what it is about," he once said. "An adventure, socially authorized in the sense that I'm an artist."[2] A "girl" willing to be chosen would appear in a photograph with the artist. Nearly always, she looks out at us while he looks at her. As Walter Robinson pointed out in 1975, it is difficult to tell if these images of women being seen as objects are about sexism or simply sexist. Very possibly the latter, Robinson implies, though he doesn't feel that Collins needs to be severely condemned for

his, after all, helplessly worshipful attitude. Nor need we object because his art is so unapologetically in sync with the zone of "commercial culture" defined by "*Vogue, Cosmo* and other fashion magazines." Collins's models, said Robinson,

> have that fab-career look, because it is a career to look that good; what you see are "models" for a certain kind of success in life. The aesthetic lies in the makeup and in the care of the appearance—which may not be Art but is certainly aesthetic.[3]

Collins redeems the aesthetic of high urban style by enmeshing his models—or their images—in the devices of sixties abstraction. *A Domestic Dialogue (Red)* (1977), shows the face of a red-headed woman against a red wall. She appears in the lower right-hand corner of the picture. In the upper right-hand corner hangs a framed photograph of a cherry tree in bloom: a spray of pink. The artist appears in the lower left, his eyes on the woman. A photograph of an oak tree with rusty foliage occupies the corner above his head. Thus the four corners of a rectangular format are emphatically marked, with pictures within the picture reinforcing the flatness of the image. Running parallel to the artist's gaze, the straight line of a red shelf bisects the image horizontally. On the shelf stand vases of flowers in further shades of red and pink, the middle one marking the midpoint of the image.

"I'm a painter," Collins once said, and "a closet formalist. . . . I use devices like tables and shelves because they're metaphors for the picture plane."[4] The all-red, yellow, and blue backgrounds of the *Domestic Dialogues* have an obvious resemblance to monochrome canvases, yet it is odd to hear Collins call himself a painter after he has so decisively dispensed with the paints and brushes of his student days. Explanations appear here and there in the art criticism he published throughout his career. In 1973, for instance, he described John Baldessari as "a painter who happens to use photographs. Painting in only a simple sense deals with canvas, paints, and easels." Jasper Johns, says Collins, "showed this years ago." In Collins's private dictionary, "painting" is the name for any art that establishes "some sort of rule structure linked to the visual world."[5] So he is hardly a "closet formalist." His formalism is flagrant, in his critical commentary and in his meticulously structured images.

To call oneself a formalist in the mid-1970s was to invoke the criticism of Clement Greenberg and Michael Fried, and their brand of formalism must have helped Collins focus his ideas about the flatness of the picture plane and visual structure generally. Yet his symmetrical, ingeniously gridded portraits of himself looking at women are flat in a manner more minimalist than Greenbergian. Projected on two screens,

sometimes three, his film loops adapt minimalist seriality to the demands of his voyeurism. Usually, the subjects of his movie camera stare into the lens. Occasionally they undress. In *Watching and Imagining*, the left-hand screen shows artist looking at a woman who faces us. On the right-hand screen, she appears behind him, still facing forward but invisible to the artist. Unable to watch, he must imagine her.

Like minimalist forms, Collins's are precisely placed and neatly separated—by distance in his photographs, and in his works on film, by the gaps between screens. As he once said, "I'm conscious of the woman being isolated; I'm isolated; and the objects are isolated. Nothing touches anything else."[6] In the realm of his obsessions, his tight control—his rigid administration—of visual form turns Collins into the sheerest of images. He gives himself the autonomy of a minimalist object. The targets of his gaze show the same self-sufficiency, despite clear signs that they are aware of Collins's attention. Or these women may feel all the more self-sufficient, all the more securely enclosed by their "fab-career" images, precisely because his stare puts him at such a decisive distance.

With nothing touching anything else, no narrative can be launched. Collins's obsession leads nowhere—or, anyway, he gives us no reason to suppose that it does. In this universe, everything begins and ends as an image of the artist gazing at image-conscious women. Repetition turns the uneasy voyeurism of his art into narcissism, as, slowly, his formalist obsessions crowd everything else out of the picture and he acquires the look of an allegorical figure of looking—not of a person looking at another person or even at a work of art, but of a work of art defining itself through self-contemplation. Collins the voyeur becomes an impersonation of the modernist art object seeking purity through a reflection on its ideal self. Endlessly in need of someone new to play the part of himself purified, perfected, transcendent, he would roam the streets, an eye out for a woman with just the right look.

In Greenbergian formalism, the promise of perfection through self-reflection is explicit. In minimalist formalism, it is only implied. By converting both kinds of formalism to his own purposes, Collins illuminates their compatibility. During the 1960s, Greenberg and other critics devoted to color-field painting engaged in a permanent skirmish with the theorists of Minimalism. The bitterness of the conflict made it difficult to see that the two camps shared a set of formalist premises, and even now it is not usually recognized that minimalist theory was a kind of formalism. Nearly always, critics reserve the word for the Greenbergian kind. Collins helps us see how thoroughly the formalist yearning for absolute autonomy pervades the upper regions of the art world, and the flatlands of "commercial culture," too.

JAMES COLLINS, *A Domestic Dialogue (Yellow)*, 1977. 3 color photographs, 27 x 13 inches each.

Collins's staged photographs made him a prominent figure in a small group of artists who had released documentary art from its bondage to fact. Late in 1974, he wrote in the review pages of *New York Magazine*,

> "Story Art" is just one of the newer games around, and you can see a good example of it in Peter Hutchinson's current show at the John Gibson Gallery. Briefly, the "Story" label comes from a group show of that name in New York last year, and covers a wide range of artists who *welcome* rather than reject a story element in their art, be it visual or verbal.[7]

In his Gibson exhibition, Hutchinson's "story elements" were handwritten anecdotes—extended captions appended to photographs mounted on the wall beneath capital letters rendered in various materials. Under an "E" made of earth and standing for eggs, the artist noted that "walking on eggs is like skating on ice and requires a good deal of tact." He then went on to tell of visiting his friends Horace and Holly with another friend, Angelo:

> Angelo was sitting with his legs crossed & Horace could see only one of his feet. Horace kept saying how great Angelo's 7" heels were (heels were just coming into style). Holly and I kept trying to signal to Horace to stop and it was only later that Horace realized that Angelo was crippled in one leg and had to wear an orthopedic heel.

Between this text and the earthen "E" is a photograph of bare feet walking on eggs and breaking them.

Under an aluminum "A" for artichoke, Hutchinson tells of sleeping in an Italian artichoke field on his way to meet Horace and Holly. He is awakened by a strange rustling in the night—a toad, possi-

PETER HUTCHINSON, *Walking on Eggs — the letter "E" from the Alphabet series*,
1974. From Alphabet Series, artist's book, John Gibson Gallery, New York.
Detail.

bly, or a snake. Unable to find the creature, whatever it may have been,
he moves his sleeping bag a yard or two from its original location, crawls
in, and goes back to sleep. In his review of Hutchinson's *Alphabet Series*,
Collins said, "The written stories under the stories condition the way you
look at them. Stories also suggest what abstract artists try so hard to
avoid: a real-life context with a possible past, present, and future."[8] The
photograph captioned by the story of a night in an artichoke field shows a
wooden chair. On its seat sits an artichoke and a bowl containing an
apple. "A" is for apple as well as artichoke, and perhaps for ambiguity,
too. In Hutchinson's art, contexts are elusive and so, therefore, is his
sense of "real life."

A wooden "O" smeared with oil paint is accompanied by a pho-
tograph of a small panel covered with more messy paint. The text recalls
a difficult moment in art school. Struggling to complete a painting
required for the completion of a course, he found his colors turning "a

sickly shade of green." As the deadline approached,

> I couldn't help noticing that my palette, a simple square of
> primed masonite, looked better than my painting. In
> desperation . . . I gave it a couple of swipes with my brush and
> handed it in. They never discovered the deception. I received a
> grade of C–, barely passing but much better than I would have
> received for my 'real' painting.[9]

Early on, the reality—or, perhaps, the realness—of painting was
a vexed matter for Hutchinson.

Born in London, he moved to the United States when he was
twenty-three. After studying art at the University of Illinois, he moved to
New York in 1961, and by the mid-1960s was known for the quirky ele-
gance of his abstract paintings. Baffled by the "withdrawn" nature of the
canvases Hutchinson showed in 1966, an *Artnews* reviewer praised them,
faintly, for their "wryly individual quality."[10] Geometric but displaying no
readily grasped pattern or principle, Hutchinson's early works were of the
kind that Mel Bochner dismissed as mannerist, in contrast to the starkly
simple objects of the Minimalists.[11] Hutchinson could have objected to
Bochner's dismissal but not to the label, for he believed that in the 1960s
art could only be mannerist—and he saw the idiosyncrasies of the
period's inevitable mannerism in works by Dan Flavin and Robert
Smithson, artists Bochner praised for their unadorned severity.

In an essay called "Mannerism in the Abstract" (1968),
Hutchinson gathers the art of the utopian modernists—Mondrian and his
colleagues de Stijl, Kandinsky, and other "form masters" at the
Bauhaus—under the heading of "purist abstract painting." Abstraction of
this sort is clear and confident. It has grandeur, for it transcends individ-
ual peculiarities. In Hutchinson's view of the modern period, "purist
abstract painting" plays the part of classicism in full-scale surveys of
Western culture. Like classical art, it is serene and understandably so, for
it rests securely on the foundation of solid knowledge built by science.

But, Hutchinson asks, how can abstract painting avoid a decline
into mannerism "when science itself is undergoing a mannerist
dilemma"? We have come to "view the universe as based on probabili-
ties, contingencies, chances, and cosmic breakdowns. Scientific discover-
ies only uncover larger gaps in knowledge." With nothing certain, what
wonder is it that the legacy of "purist abstract painting" has fallen prey
to signs of mannerist hysteria: excessive elegance, ostentatiously refined
technique, melodramatically inventive form, garish color, and the self-
conscious recycling of cliché.

Hutchinson sees these faults in the art of Larry Poons, Richard
Anuszkiewicz, Charles Hinman, and others, including himself, presum-

ably. Yet he lays no blame, for he sees mannerism as an inevitable response to an uncertainty too deep, too pervasive, to be alleviated. Upheavals in sixteenth-century Italian life prompted the mannerist art of Bronzino and Rosso Fiorentino. Now artists face a crisis subtler than war or political turmoil: "Where once art was the only useless thing, now everything has lost meaning. If the artist himself feels he is losing meaning, no wonder he reacts with hysteria."[12]

There are gaps in Hutchinson's picture of history. What, for example, of medieval times, which were plagued by uncertainty but produced no art that could be called mannerist? What of the serenely neoclassical effigies that emerged from the violence of eighteenth-century revolution, first in the United States and then in France? However, these objections are beside the point of the remarkably interesting idea of art that hides in the tangles of Hutchinson's comment on uselessness. To disentangle this idea, it helps to note that he distinguishes between art and nonart on the traditional grounds of utility.

In the course of a friendly commentary on a show of Dennis Oppenheim's models for earthworks, Hutchinson observed that

> Artists today . . . are taking their cues from meteoritic craters and volcanic pits as well as dams, burial mounds, aqueducts, fortifications, and moats, to build works that change the surface of the earth. These latest works, however, differ from what went before in that their intent is abstract and intentionally artistic. They have no function as useful earthworks (i.e., dams, forts, etc.), nor are they signs of catastrophic events (craters, glacial deposits, earthquakes).[13]

Neither natural nor useful, they are simply—or purely—works of art. Their uselessness is admirable. If they couldn't maintain it, they would no longer qualify as artworks. Yet uselessness is, so to speak, useless when everything loses its meaning.

Hutchinson treats "useless" and "meaningless" as synonymous, or nearly so. For this to make sense, he needs to be understood as having employed the word "meaning" rather narrowly, to refer to meanings that can be put to practical use: utilitarian rather than aesthetic. If we bear this narrowness in mind, his apocalyptic proclamation—"Where once art was the only useless thing, now everything has lost meaning"—becomes a bit clearer. To have "lost meaning" is to have been deprived of practical significance. Unanchored by any utilitarian purpose, things drift into the condition of art. When this happens to everything, as Hutchinson fears it has, the results are disastrous. Art is valuable in contrast to nonart. If all is art, there is no contrast: nothing is art. Artists had meaning (or were useful) because they produced the meaningless (or useless) things

called works of art. Now that everything, hence nothing, has aesthetic value, the artist "reacts with hysteria." And hysteria breeds mannerism.

Hutchinson was alone in his fear that the things of ordinary life had acquired the nonutilitarian freedom of art. It was more usual for artists and critics to worry that art was losing itself in the mundane practicality of life. Dennis Oppenheim recently recalled the anxiety he felt when he realized that the execution of *Cancelled Crop* (1969), had burdened him with agricultural expertise. "There was a need to stay in contact with the art," he says,

> and a fear that the contact might be broken. To complete the projects proposed in the late '60s, it was necessary for the artist to engage systems much larger and in many ways more complex than the art system. The problem, at a certain point, was how to keep from being absorbed by those systems, how to enter them and then find a way back out—a way back to the art world.[14]

Faced with the architectural fragments Gordon Matta-Clark exhibited at 112 Greene Street, in 1972, an *Artforum* reviewer wondered if the artist was "not working too naturalistically for his products to be discernable as art." How can one take an aesthetic interest in "dirty lath, crumbling plaster, old wallpaper, linoleum, worn floor boards, and rotten beams"? The answer arrives as the reviewer's focus shifts and this detritus becomes evidence that Matta-Clark is "involved with Process"—not practical work of any sort, but an aesthetic activity with implications of "sabotage, subversiveness, and danger."[15] Of course Matta-Clark never doubted that even his most decrepit objects were objects of art, nor was Oppenheim ever in danger of misplacing his aesthetic compass. Hutchinson, by contrast, felt lost. Every direction led him to art—or its absence, which could be overcome only by the dubious tactics of mannerist hysteria.

In 1968, Hutchinson abandoned paint and canvas for photo-collages of unrealizable outdoor pieces. One of them shows huge, transparent tubes ascending from the surface of an iceberg. Inside the tubes are crystals and decomposing carbohydrates. As the iceberg drifts southward, temperatures rise and the crystals begin to grow, then dissolve, then grow again. In the tubes containing rotten vegetable matter, fungus comes alive, taking in air and giving off carbon dioxide. When the iceberg melts away, the tubes fall into the sea. The one containing organic matter sinks. The other floats, possibly, its contents going through endless cycles of crystallization and dissolution.

As the painter and critic Anthony Robbins suggested, the containers "filled with crystals . . . are like perpetual motion machines (it is possible to think of our earth's motion this way), which once set up will

function until some external (cosmic) event destroys the structures."
With this proposal, Hutchinson seems to acknowledge that art is
enmeshed in natural processes. Yet there is nothing natural about tubes
inserted in an iceberg. The photo-collages transposed his aesthetic of
mannerist quirks from painting to fictional earth—and sea—works. When
he found a way to realize his imaginary volcano project, Hutchinson
transposed his aesthetic once again, this time to performance art.

He had played the role of a performance artist not long before,
donning scuba gear to execute *Threaded Calabash* (1969). That piece took
the form of an underwater line, punctuated by spheres and arcing toward
the surface of the ocean. *Beach Line* (1969), repeated the form at water's
edge. At low tide, Hutchinson spread a streak of calcium carbonate. High
tide carried the material out to sea, where it marked an increasingly wavy
line on the surface of the water, as it slowly vanished. For *Paricutin
Volcano* (1970), he

> laid a 100 yard line of bread along faults at the crater edge. The
> piece was made to be large enough to be visible in photos taken
> later from the air. This bread was used to grow mould in the six
> days that the project lasted and this growth is shown in large photo-
> graphs by a change from white to orange. I wrote a text on my
> experiences which was made available at the showing, but not inte-
> grated into the work as exhibited. . . . Text eventually was to
> become as important a part of the work as the visual/photo aspect.[16]

Nearby, Hutchinson arranged a six-foot triangle of yellow crab
apples on a field of black lava dust at the foot of the volcano.

Collins wrote of Hutchinson's *Alphabet Series* that his "three-part
arrangement for each letter shows Minimalism's influence, yet there's
none of its abstraction."[17] Of course, the alphabetical sequence is itself a
non-abstract variant on seriality. With his lines and triangles, his triads
and serial patterns, Hutchinson acknowledged that the most convincingly
art-like forms to be had were of Minimalist origin. Perhaps all things
were useless, meaningless, and incipiently esthetic, yet the devices of
Minimalism were the most obviously useless—the most blatantly "irra-
tional," to use Sol LeWitt's word. So they were the most useful to
Hutchinson, who still wanted to be an artist, despite his qualms about
the very possibility of art.

*Horseshoe Piece* (1970) is a set of photographic prints in a sym-
metrical arrangement. The rectangular outlines of the prints themselves
form an awkward arch. The arch formed by their images of flowers is ele-
gant: a smooth curve of blossoming color. Because each photograph was
taken in a different location, *Horseshoe Piece* is, in the artist's words,
"purely photographic." Its symmetries "cannot exist in nature."[18] To test

PETER HUTCHINSON, *Paricutin Volcano Project*, 1971. Color photograph, 39 x 79 inches.

his own ability to exist in nature, Hutchinson spent six days in the summer of 1971 backpacking through the Snowmass Wilderness of Colorado with an assistant named Jonathan. This effort produced three forms of documentation: a lengthy journal; photographs, which accompanied the journal when it appeared in Art in America; and several strips of film. One of these shows the title of the piece, Foraging, written in rocks:

> I find a snowbank. . . . It is a good location. The snow overhangs a violent torrent, and on this ledge to the right side of the stream we set to work. I point out the place for F and the O and throw Jonathan some rocks. He makes these letters perfectly, but the RAGING starts to go askew. From the other bank, I see what corrections are needed, and we finish it together. I film it with Jonathan in the foreground for scale.

At the conclusion of their foraging, the artist and his assistant collaborate on the project of arranging strawberries in a final image. "They smell great," according to Hutchinson's journal.

> The sun increases its warmth on my back. The garter snakes are disturbed and slide off.
> I complete the T and begin the H. Soon I have THE END written in wild strawberries. The early rays of the sun strike the letters, giving them a small row of shadows, a sort of scripted depth. It is ready. The end is ready. Jonathan brings the Super-8.
> I stand exactly five feet away, zoom in, and begin to shoot. As planned, after ten seconds, Jonathan's brown hand enters the screen and takes a strawberry from the T. He takes another. The T is gone. Then the H is attacked. "Destroy it all," I say.
> The END is destroyed. Time is renewed.[19]

Later that summer, Hutchinson traveled to Amsterdam where he made a film called *The End of Letters* (1971). It shows each letter of

"The End" going up in flames, being buried in the earth or drowned in water. Made of bread crumbs, "T" is eaten by pigeons. "Although some people took this as a criticism of writing," Hutchinson noted,

> I didn't feel that way. After all, the words had taken over the film. To rectify somewhat this interpretation I transferred the three-minute film to video and then had it played in reverse so that the words are recreated and the pigeons regurgitate the letter "T".[20]

"The End" in reverse returns to the beginning. This temporal symmetry echoes the spatial symmetry, equally artificial, of *Horseshoe Piece*. Of all the devices Hutchinson learned from Minimalism, the reversible pattern was his favorite. *God Saw I Was Dog*, a work from 1976, whose title is a palindrome, is a photograph of a Dalmatian standing beside a white sedan. Flipped, it becomes a photograph of a white dog standing beside a sedan with Dalmatian spots.

Hutchinson endowed symmetry and other minimalist devices with "real-life" content, as Collins said. Yet his images of real life are so artificial—so irrational in the LeWittian sense—that they are intelligible only as works of art. His fear that art was being absorbed by life was needless. Feeling that fear, nonetheless, he assuaged it with an array of mannerist idiosyncrasies—minimalist devices revamped with off-hand strangeness. To Minimalism's legacy Hutchinson owed his tentative faith in art. Minimalism owed him nothing in return. From within Hutchinson's vision of the real, a minimalist fact looks utterly fictional—an artifice as contrived as the integrity of the Greenbergian "picture plane" or, for that matter, the coherence of a traditional novel's story line.

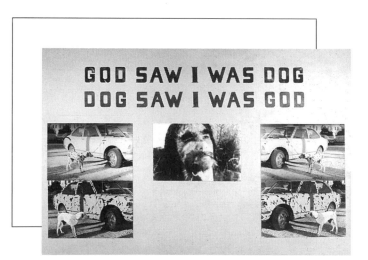

PETER HUTCHINSON, *God Saw I Was Dog*, 1976. Photo-montage, 60 x 90 inches. Courtesy of the artist.

BILL BECKLEY, *Rising Turtles Watching the Setting Sun*, 1974. Cibachrome and black and white photographs, 59 1/2 x 39 1/2 inches overall. Courtesy of the artist.

# FICTION CONTINUED

"I'm interested in the way people construct meanings with things. I don't think of the story at all. The story's a loose thread. I think more of the kind of logic. It seems to me that once you start thinking of meanings and the way objects are in cross-reference to each other, narrative probably occurs whether you want it or not."

*Mac Adams, 1977*[1]

The minimalist object generated an effect of factuality, of plain realities so obviously, self-evidently real that no questions need be asked. One need only admire the clarity of an artwork that had managed to disentangle itself from dubious pretensions to expressiveness, revelation, transcendence, and all the rest of it. Yet questions can always be asked. For instance, is any human artifact entirely inexpressive? The minimalist object proposed a simple dichotomy: expressive/nonexpressive. But what if the contrast were between familiar and unfamiliar, between the tired old "hullabaloo" of Abstract Expressionism, as Frank Stella called it, and the new expressionism of the Minimalists—the expressionism of emotions denied?

If meanings are not apodictic—if apodicticity itself is no longer accepted as the meaning of art—then meanings have to be pieced together from ambiguous evidence. Mystery fiction provides a useful model, as Barry Le Va implied when he said that it was not enough for viewers simply to register the look of *Cleavers* (1969). He wanted them to see it as an array of clues and—"like detectives"—work their way from uncertainty to some plausible hypothesis.[2] Invited to exhibit new work in a group show of printmakers, John Baldessari handed a porcelain bowl to the curator, dusted it for fingerprints, then offered it as his contribution. In defense of this pun on the word "print," Baldessari could have invoked minimalist literalism, which also justifies his use of a forensic definition of personal identity. Allan Ruppersberg's *Where's Al* (1972) adapts minimalist modularity to the routines of a missing-person case. In Dennis Oppenheim's *Search for Clues* (1974), the clues, if found, will lead to a murderer, and in his *Lecture Piece #1* (1975), murder is multiple: seriality becomes the sequence of bodies left by a serial killer.

For an installation piece called *Hearing* (1972), Robert Morris redesigned the minimalist box just enough to produce a table, a chair, and a bed with a slablike pillow. Clustered on a platform, lit harshly from above, these objects evoked an interrogation cell. From loudspeakers

came the voices of an investigator, a witness, and his counsel. Their involuted exchanges did not make it clear what charges, if any, were being brought. One gathered that the investigator, under cover of innocent inquiry, was trying to ensnare the witness in damning admissions. Yet the investigator's evidence was fragmentary and the clues he extracted from it tended to be bizarre, or at least hopelessly tendentious. Definitions of art were at stake, it seemed, though aesthetic matters had a way of turning political. Visually stark, *Hearing* was mazelike to the ear and, of course, far more baffling than Morris's *Labyrinth* (1973–74).

Any hint of a maze leads eventually to the idea of mystery and the yearning for a solution. With his installation pieces of the mid-1970s, Mac Adams made the confrontation with mystery immediate. In *The Bathroom* (1977), a real bathtub sat on real tiles. Soap suds floated on the bath water. Scattered cosmetics made it clear that the scene's recently departed occupant was a woman. Everything else was in doubt. Lit in the manner of *film noir*, this tableau crawled with sinister possibilities. What happened? This inevitable question has no answer, for even if it employs the devices of a crime thriller, a work of art is not a puzzle to be solved. It is an opportunity to invent meaning. As Adams has said, "I think all you can do is offer the spectator something and he is on his own to deal with it whatever way he can."[3]

When Adams came from Wales to Manhattan in the late 1960s, he made sculpture of pliable materials.[4] Next he made his body his material, but not in the manner of a performance artist. Measuring parts of his anatomy, he would mark his measurements on a string, with knots. To link his body to space, he would stretch the string from one gallery wall to another. Recalling this time, Adams said that he and James Collins "used to talk about the idea of making works all about ourselves as opposed to dealing with minimal art, with abstract theory, or with object." Yet he and Collins took the impersonal premises of Minimalism as their own. The difficulty was in finding a way to make them entirely their own: to personalize the impersonal, without sacrificing its power.

From "antiform" and body measurement, Adams turned to furniture—chairs, in particular, which he used as surrogates for those who sit in them. The body as object was to become the person as social being. In 1974, he staged and photographed a series of *Domestic Devastations*: tables and chairs in disarray. From the aftermath of an event, one was to deduce its details, possibly its cause. The artist appeared in none of these pictures. He wasn't trying to obscure his presence so much as disperse it through a world of his own invention. The *Domestic Devastations* had a knock-about, slapstick air. *The Motorcycle*, an installation presented for the first time in 1977, is more sinister.

In a dark space, a motorcycle stands in a pool of light. Its head-light is lit but illuminates nothing. Nearby, a girl's backpack has spilled its contents: clothes, mostly, and a few snapshots. Is the owner of the backpack the girl in the photographs? Is the motorcycle hers or was she a passenger? Or was she never present? In which case her possessions must have been brought here by the motorcycle's absent owner. Who, precisely, is missing from this doom-laden scene? These questions turn the scattering of objects and images into clues, which add up to a spectacle of indeterminability. "You see," Adams told the critic Kim Levin in 1978,

> I'm not really interested in mysteries. I'm interested in the whole semantics of information, where you look at something and you pose questions of how do you know what you know. . . . There are other levels, other kinds of language . . . that's what I'm interested in—objects, gestures, expressions, multiple coded ways of transmitting information. The mystery is strictly a vehicle for me.[5]

Adams's installation pieces of the 1970s were like three-dimensional movie stills. His two-paneled photographic pieces from the period have the impact of movies drastically condensed. In the left-hand panel of *Port Authority* (1975), a hand offers a marijuana cigarette to a young woman. The right-hand panel shows us that the hand is that of a young man in blue jeans and a plaid shirt. He kneels before an open coin locker—at the Port Authority bus terminal, presumably—and stuffs into a valise what appears to be the patterned dress the woman was wearing in the first panel. There's a mystery here, no doubt. Violence may well have been committed. Then again, there may be some perfectly innocent explanation—as investigators sometimes say in mystery stories. We can't know. The point lies in the play of gestures, postures, expression, and style that knits the two panels together. Finally, the point is in the experience of that complexity: how we construe it, what we make of what we have wrought from the clues provided, and how we come to terms with unyielding ambiguity.

Adams recently said that he admired the serial patterns, the orderly permutations of minimalism. But he could not "do Sol LeWitt"—could not, that is, be content with a repertory of lines and curves. He wanted his art to be "accessible" to audiences, not versed in abstract art.[6] Thus he opened his work to ordinary life, its realities and its fictions alike. *The Mystery of Two Triangles* (1977) tells an old story: two men, one woman; eventually, someone ends up dead. At any rate, that is the implication of the tarpaulin on the beach, in the second image. Having heard Adams say that he wanted his art to reflect "social phenomena," Kim Levin replied, "It's interesting that you've chosen the subject of criminality, which is antisocial." "Social and antisocial are inseparable," said the artist.[7]

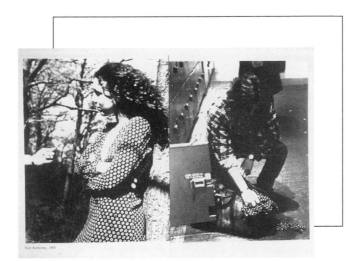

MAC ADAMS, *Port Authority*, 1976. Two black and white photographs, 40 x 60 inches overall. Courtesy of the artist.

A crime emerges from a backdrop of social norms. A word or visual detail is intelligible as a figure against a ground of encoded meanings. Adams catches the attention with a word or an image, then encourages it to shift from word to language, from an image to the code that turns it into a clue—though never a key to the puzzle. In *The Mystery of Two Triangles*, he once said,

> I was interested in the earthwork/bodywork reference. And the inverted triangles are also male/female signs. The male points up, the female down. It's also an elemental sign. Fire and water. Once you can understand the implications of those triangles, the situation these people are in becomes logical. It's not arbitrary. A man is against the wall (water). He's lighting a cigarette (fire). He has a tattoo and he's looking at a male/female person in an embrace. You don't know who is underneath the covers. You really have to scan, study, think, and work it out.[8]

When offered by the minimalist object, a dualism—horizontal/vertical, open/closed—is to be taken as understood: to perceive the pattern is not only to grasp its meaning but to exhaust it. The patterns of Adams's dualisms—fire/water, male/female, before/after—are just as clear as those of Minimalism. Yet their meanings are endlessly elusive. "What you see is not what you're getting," the artist has said. "You're getting a whole lot more."[9] But only if you seek it: what you get is what you generate from speculation. Of course, the notion that "what you see is what you see" was no less the product of a speculative flight—a leap into a realm of fiction where pure, apodictic facts can be perceived with perfect clarity, unsullied by interpretation. In the shifting light of Adams's art, the fictiveness of such facts is obvious.

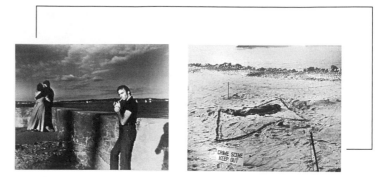

MAC ADAMS, *Mystery of Two Triangles*, 1978. Two black and white photographs, 28 1/2 x 33 inches each. Courtesy of the artist.

\* \* \*

Late in 1970, a disquieting tableau appeared in a room at the Chelsea Hotel on 23rd Street. An apartment door, painted black, stood upright against a wall. On the doormat stood a carton of fat-free cottage cheese and a bottle of fat-free milk. From the lock hung a bunch of keys. This was *Lynn Traiger*, one of *Eight Portraits of New York Women*, by Eleanor Antin. Certain implications were fairly clear. As the artist said, "You don't leave your keys in the door all night in New York unless you want to be raped or murdered and they must have been there all night because the milk wasn't taken in." This was, she added, "an image of vulnerability."[10] Antin's portrait of *Hannah Weiner* was a trio of chairs and a table designed for a summer terrace. Amid the plates and glasses of the three place settings, lay a hammer. Here was a clue as obscure as it was menacing.

Among Antin's eight New York women was the art critic Amy Goldin, who described her portrait as "a pale narrow bed with a kerosene lamp above it (a nice touch; I've always felt inadequately illuminated) with a pair of tiny pearl button earrings on the coverlet (one earring would have been more realistic, I think . . .)." As Goldin saw these portraits, they

> projected implications of renunciation, rejection, or submerged yearning. I remember arguing with Antin about it. Our argument, as I recall it, was not about art but about heroism (I thought it was misplaced). Still, the artist's interpretations of a subject are an art material among others, and you can no more fault an artist for his or her ideas than you can protest the use of a particular brand of paint.[11]

Only in the wake of Minimalism would a critic call interpretation a material and compare it to paint, for only the authority of minimal-

ist literalism made the comparison intelligible. By the early 1970s, of course, that authority had faltered. Yet it persisted, sustained by irony: minimalist fact had generated powerful varieties of fiction. Though objects still had the presence the Minimalists had given them, they had recovered their old malleability. Thus Antin was able to charge them with the burden of portraiture.

Her *100 Boots* look like one hundred objects. They form lines, mark off planes, heap themselves into "antiform" pieces. She saw them as a unity: the hero of a picaresque novel. Not long after their adventures ended, she cast herself as the King of Solana Beach, a beach town near Del Mar, California, where she and her husband, David Antin, had settled in the late 1960s. To become kinglike, she would apply a moustache and goatee to her face. Then, wearing a cape, high leather boots, and a broad-brimmed hat, she would stroll through Solana Beach, greeting her "subjects."

When she learned that developers were planning to despoil a stand of rare pine trees on a stretch of coast nearby, Antin provided the king with a monologue, *The Battle of the Bluffs*. First delivered in 1975, it is a reflection on environmental politics, the uses of power, and the risks of rebellion. The king, Antin has said, "is my political self." Her "grand, beautiful, female self" is represented by a ballerina, who has undergone several transformations over the years. Her other personae include a nurse and a movie star. Though these intricately elaborated characters have taken her far beyond the stark premises of Minimalism, Antin recently said,

> I used to tear them down, the Minimalists, and later I came to realize that in a sense they were my teachers. I didn't know it then, but I was having my art education right there, going to those Minimalists' shows, because they taught me one thing—it was one of the greatest lessons, and I didn't even know they were doing it—they taught me how to make a show, because they were so *theatrical*.[12]

Of Minimalism's inventors, only Robert Morris ever played any overtly theatrical roles. For a work called *21.3* (1964), he cast himself as an art historian. To perform a process piece about money, at the Whitney's Anti-Illusion show, he dressed up in the white, double-breasted suit and sunglasses of a shady financier. On the poster for *Voice* (1974), he appeared naked except for the chains and helmet of an S&M fetishist. Three years earlier, he had published an essay on three "extra-visual artists" who turned out not to exist—or to exist only as projections of his wish to abandon visual form.[13]

Adrian Piper's "Mythic Being" was of course fictional, as were

the *Streetworks* Stephen Kaltenbach did not perform in 1969 but described to John Perreault as if he had. Perreault reported them in the Village Voice, with accounts of *Streetworks* that had, in fact, been executed by other artists. "The idea," says Kaltenbach, "was to make something out of nothing—to see how little I could do and still make an art work. To make works from lies seemed to be the minimum. The purest that art could be."[14] With these imaginary works, Kaltenbach converted the fictive purity of the minimalist object to the fact of sheer, willful fiction. A year later, in his contribution to *Art in the Mind*, Eduardo Costa would recommend outright forgery. If one wants to become a conceptual artist, he said, simply replicate a work by an established conceptualist, advance the date a few years, and sign it.[15]

\*   \*   \*

Bill Beckley's *See-Saw* (1971), substituted a video monitor for the minimalist box. In an installation called *Short Stories for Popsicles* (1971), the surrogate box became a small white refrigerator. It stood on a shelf and the popsicles, of course, were inside. On each of their wrappers a story was printed—rather, that's where the story began. To finish it, one had to eat the popsicles and expose the finale, which was printed on the stick. For his exhibition at the John Gibson Gallery in 1973, Beckley remodeled the box as a series of listening booths where visitors sat and heard, through headphones, recitations of the texts drawn from works that hung on the wall before them. *An Avoidance of Ann* (1973), juxtaposes photograph of a woman silhouetted in a doorway with a panel bearing the story of trying to avoid her. Because her name is Ann, avoidance can be complete only if, in the telling, the narrator avoids the word "an," as well.

This literalist equation of "Ann" and "an" has roots in Minimalism. The absurdity of the equation was a sign of impatience. "The moment I saw the works of Sol LeWitt and Judd, their importance was obvious," Beckley recently said.

> Minimalist systems, minimalist progressions—these were extremely powerful. They provided starting points. Without that sort of structural clarity there are too many options. You lose coherence. But the problem was that, once you get into a system like that, it's hard to get out. It's hard to do anything but turn into a second-generation Minimalist, which I definitely didn't want to do. Artists like Vito Acconci and Michael Heizer avoided that trap, but their work created another problem, because it depended so much on documentation. In other words, it depended on your believing that what you saw in a photograph of a performance piece or an earthwork was actually true. It wasn't a problem of doubt. I mean,

I wasn't like those people who say the moon landing never hap-
pened, the NASA photos were rigged. I never doubted that
Michael Heizer made those huge cuts in the desert. And I knew
that Vito had bitten himself, because I photographed him doing it.
The problem was in the reference to something else. The primary
thing was elsewhere, and the photograph could only be secondary.
But I wanted it to be primary.[16]

No matter how believable, a documentary image can be only
half-heartedly present, for it is imbued by the absence of the docu-
mented fact. It occurred to Beckley that an image could be fully pres-
ent—as indubitably here as a minimalist object—only if it were fictional.

*The Origin of And* (1972), is a sequence of three black and white
photographs interrupted by a panel covered with a handwritten story
which begins at a dinner party given by an Englishman living in the
United States. Oddly enough, there is nothing to eat but a reminder of
American pop art—the can of Campbell's soup that appears in the first
photographic panel. The second shows a wrapped object, possibly a per-
son, being raised by a pulley to what is evidently a very high ledge. This
is a detail from the story within the story, which is told by the narrator's
host. Near his village in England, it seems, there is a monastery with liv-
ing and sleeping quarters at the top a cliff. Midway down is a cave where
scribes work, and at the bottom of the cliff are the gardens. Food is
drawn up by pulley, accompanied by the monk who serves as cook.

One day, upon reaching the upper level, the cook noticed that
the rope had worn thin. "Give me a hand," he said to a monk standing
nearby. Just then the rope broke. The cook fell to his death, accompa-
nied by fruits and vegetables. As he passed the scribes in their cave, they
heard only "the vowel and final consonants" of his last word. Seeing, at
the same time, a torrent of objects, they ever after "associated this word,
'and,' with the concept of multiplicity."[17] The third photograph shows
produce tumbling past a rectangular opening.

Recasting the psychology of John Locke in the style of Rube
Goldberg, the story prompts many questions. For instance, how did the
scribes manage to inscribe anything before this association of ideas was
formed? An indispensable word doesn't suddenly appear, like a new
gadget one doesn't know how one did without. Words are immersed in
languages, which are in turn immersed in the mostly forgotten pasts of
selves, societies, and cultures. From those histories come the meanings of
words. With his story about the origin of "and," Beckley chides the mini-
malist notion that meaning can occur all at once in an isolated *now*. Yet
the chiding is friendly, for he respects this notion. It was useful to him
and to all the artists of his generation. Thus he respects the forms that
conveyed the notion—symmetry and modular repetition, in particular.

BILL BECKLEY, *Drop and Bucket*, 1974. Three Cibachrome photographs, one 48 x 16 1/8 inches and two 29 1/2 x 60 1/2 inches. Courtesy of the artist.

In the aftermath of Minimalism, art tended to be black and white and gray. Those were the tonalities of Beckley's work until 1974, when he discovered a brand-new technology called Cibachrome. Suddenly his art was aglow with lush color. "I think I was the first artist to use Cibachrome," he says. "It wasn't just the richness of the color that was so great. The pristine quality of the surface was equally important. It was delicate; you had to watch out for fingerprints. The image had this powerful materiality, this physical presence, like an object."[18] As black and white gave way to color, typesetting replaced handwriting. Beckley was giving his art an industrial finish.

As surfaces became more glossily impersonal—more reminiscent of Minimalism at its most elegant—narratives became more revealing. Yet Beckley did not become an autobiographer. From glimpses of himself and his obsessions he assembled enigmas. The point was not in his fragmentary revelations but in their juxtaposition. His ruminations on catch phrases lead to further thoughts about language. His reminiscences about far-off places recall the pleasures lurking in very idea of distance, and each image of flesh or food or neon light hints at the full spectrum of sensuality. Beckley has a knack for setting the imagination adrift. Still,

attention focuses in the present on the point—or line—where disparities meet.

*Rising Turtles Watching the Setting Sun* (1974) is a diptych. The evening sky is above, in glowing Cibachrome. Below are six turtles enclosed by the compartments of a six-unit grid. Photographed in black and white, they are dark blotches emerging from some white liquid—milk, probably, though it doesn't matter. The point is in the sharp contrast of light and dark, and in the further contrast between this sharpness and the smoothly gorgeous modulations of the upper panel. The turtles are not, of course, watching the sunset, nor could they. It's not in their space. Nonetheless, they all seem to be looking in its direction. With their necks craned upward, their heads look phallic, and disc of the sun becomes an emblem of penetrability. This sexual implication is pure artifact, the product of a relationship between images that looks arbitrary until one gives it this meaning. Minimalist symmetry has evolved into an image of sexual reciprocity.

Symmetry extended is modularity. In Beckley's art, modular form and its permutations sometimes read as the story of a sexual relationship or as a bafflingly involuted image of sexuality itself. Sometimes his themes are as plain as those of process art. *Drop and Bucket* (1974) is a three-panel work. Vertically aligned, a square, a triangle, and another square show, respectively, a faucet, a drop of water, and a bucket. Each image establishes its own point of view. Clearly, these images do not document a process that occurred in the past. Rather, they inspire the process of working out—in the present—a relationship between the three of them. One reads the story of a drop of water falling from a faucet to a bucket. The interest, obviously, is not in the narrative, but in the clarity of apprehension. As in a face-off with the facts of a minimalist object, one enters real time. Only now, the entry is by way of a fiction flaunting its fictiveness. In place of a static pretense to the Real is the quicksilver sense one makes of the work, in the immediacy of the present.

Above: DENNIS OPPENHEIM, *Protection*, 1971. 12 trained attack dogs; 12 five-foot steel poles; 12 six-foot chains; land area: 32 x 64 feet. Courtesy of the artist.

Below: DENNIS OPPENHEIM, diagram for *Protection*, 1971. Black line print, 16 x 20 inches. Courtesy of the artist.

# THE REINVENTION OF ART

"One way to end a story is to give it a surprise ending."

*Bill Beckley, 1974*[1]

After the minimalist object came into focus, many in the American art world found it difficult to remember how it felt to plunge with empathy into the surging crosscurrents of abstract expressionist paint. Minimalism, it seemed, had changed the nature of the aesthetic. In fact, it changed much, but it didn't change the point of art. Rather, the Minimalists preserved that point and clarified it. Then, in their struggle to get out of the box, Minimalism's heirs clarified it further. So the story ends with a surprise: by reinventing art, these artists kept it precisely the same. A question arises: the same as what? There is, after all, no agreement about the nature of art. All its definitions are contested endlessly. What, then, do I mean by "art"? In this book, I've used the word to refer to works that make a claim to autonomy. But what do I mean by "autonomy"?

My explanation begins with a look at something Carl Andre said in 1967: "Art is what we do. Culture is what is done to us."[2] This remark runs counter to our assumption that art is intertwined with culture—or that art defines culture's upper levels. In Andre's view, they are separate and opposed. When artists are free they make art; then they must watch passively as the culture imposes its interests and purposes on them and their work. Thus art and culture sponsor incompatible ways of being. In the art zone, individuals realize themselves through the exercise of their powers. As members of their culture, they are in a sense nonexistent, for they have no powers to exercise. They are functions of forces they cannot resist. Andre's picture is as stark as one might expect from a Minimalist, yet it is not original. Its premises were codified long before, in the doctrine of "l'art pour l'art"— art for art's sake—which Gustave Flaubert claimed, in 1850, to have defended "against a Utilitarian."[3]

This is the creed to which Robert Smithson pledged allegiance more than a century later, by announcing his agreement "with Flaubert's idea that art is the pursuit of the useless."[4] Though Flaubert and Smithson are not kindred spirits, exactly, their stubborn insistence on the

autonomy of art—on its independence from the world of practical interests and purposes—places them in a line of succession that could be traced to the beginning of the eighteenth century. By Flaubert's time, claims for the autonomy of art had become received wisdom and suitable targets for the irony of Charles Baudelaire, who argued for the moral necessity of a disinterested view of painting. After all, he asked, what other attitude is decent when one looks at a picture of a martyr being flayed or a naked woman in the depths of a swoon? Those who cannot admire an image of the body *in extremis* for "the pattern it describes in space" must be sadists or incapable of distinguishing art from pornography. The pleasure of color and line, he said, are "absolutely independent" of subject matter. Here Baudelaire strikes the pose of a hard-line formalist. Elsewhere, he acknowledges that a painter's subject, too, can be an object of aesthetic delight.[5]

In 1911, Kenyon Cox described James McNeill Whistler as a "pure painter, caring only for the material beauty of his production, and despising any literary implication."[6] Cox, a militant traditionalist, didn't like Whistler's art or the idea of pure form. Yet he couldn't dismiss it. After the mid-nineteenth century, the idea pervaded the atmosphere of modern life. So we feel that we know what Kandinsky and Mondrian mean when they call themselves "pure" painters.[7] Purity is transparent. With his eye for ambiguity, Willem de Kooning is among the few to have seen patches of opacity in the ideals of purity and freedom promulgated by these utopian modernists.

Mondrian and the rest of them were "bothered by their apparent uselessness," said de Kooning, yet they wanted to preserve the ideal of autonomy. To have it both ways, they played with definitions:

> In spite of all their talk of freeing art, they didn't really mean it
> that way. Freedom to them meant to be useful in society. And
> that is really a wonderful idea. To achieve that, they
> didn't need *things* like tables and chairs or a horse. They needed
> ideas, social ideas, to make their objects with, their construc-
> tions—their "pure plastic phenomena"—which they use to illus
> trate their convictions.[8]

For the utopians, art was at once pure and illustrative, autonomous and useful, disinterested and a means for perfecting the world.

From these contradictions we might conclude that modernity has generated at least two traditions of art, one that insists on the ideal of autonomy and another that rejects it in favor of doing good. This is plausible, given all the politically correct art that has appeared in the last few decades. But a question lingers. What if, despite de Kooning's skepticism, Mondrian did manage to have it both ways? I mean, what if the practical

purpose of his "pure plastic phenomena" was to generate a new world, a utopia, where everyone's experience was perfectly attuned to the impractical ideal of autonomous beauty? After all, Mondrian equated formal harmony with social justice.[9] Finally, his mix of disparate purities is too vaporous to be pinned down. However I construe it, his doctrine remains vexed, and, in any case, the greatest difficulty for my thesis is presented by de Kooning himself—by the entire generation of Abstract Expressionists.

In place of abstract expressionist agitation and ambiguity, the Minimalists put calm and clarity. Didn't they also put their version of pure, autonomous art in place of an art directed toward a goal—for don't we call these artists Abstract Expressionists because they had something to express, and isn't expression an activity with a purpose? Yes, it is, and I believe that certain artists in de Kooning's vicinity sincerely wished to communicate something about themselves and the world as they saw it. Nonetheless, I don't believe that the major Abstract Expressionists thought of art as a means of sending messages.

Granted, de Kooning, Jackson Pollock, and other leading figures have been praised for confessing their anguish, baring their fears, evoking the existential plight of humanity in the aftermath of war, and so on. Furthermore, certain artists in de Kooning's milieu praised themselves for doing all that. Critics joined in, filling the pages of the art magazines with the crisis-ridden commentary Frank Stella called "the hullabaloo . . . the romance of Abstract Expressionism . . . which was the idea of the artist as a terrifically sensitive, ever-changing . . . person" and art as a record of this person's sublimely volatile "sensibility." After letting this rhetoric mesmerize him for a few seasons, Stella "began to see through it."[10] And he rejected it, which is not the same as rejecting Abstract Expressionism—though, at the time, his rejection seemed total. For morally concerned admirers of the Abstract Expressionists, Stella's stripes were the pictorial equivalent of a slap in the face.

They felt that way because they had confused art with "the hullabaloo" it inspired. Perhaps Stella blurred them a bit, as well, in the late 1950s. In retrospect, it appears that he didn't so much reject Abstract Expressionism as borrow from the stripes of Jasper Johns's *Flags* a device that would muffle the high-pitched commentary that had saddled the art of the 1950s with moral purposes and denied its autonomy. As the years went by, Stella allowed painterly painting in the New York manner to reappear in his art. Some of his later works are as messy as the messiest canvases by de Kooning. Yet we're never tempted to read his splashy colors and brushy textures as self-expression. They look sufficient in and as themselves. That's all very well, one might say, but what does this have to do with Willem de Kooning?

Judd and Morris described the poured paintings of Jackson Pollock as exercises in literalism. Clement Greenberg and the Greenbergian formalists offered these canvases as examples of "pure opticality." Narrow as those accounts may be, they help us see Pollock's art as autonomous. But nothing helps us when we turn to the art of de Kooning, which is still lost in the swirling clouds of "the hullabaloo." I can't even begin, here, to extricate his refined and sometimes dandified art from those who have a use for it—biographers, psychologizers, social historians. Instead, I'll just note that de Kooning's highest praise went not to a visionary modernist or an Expressionist but to Marcel Duchamp, whose work, he said, "implies that each artist can do what he thinks he ought to do—a movement for each person."[11]

For each artist, an art movement defined solely by that artist—aesthetic autonomy cannot be invoked with more concision. Or with a better example. And for those who can't get past the feeling that de Kooning's disheveled brushwork means that he must have some frantic message to deliver, I'll quote an off-hand remark he made in 1960, as he sat before a movie camera musing about "the real world." That world, he says, is "just something you put up with, like everybody else." This is the realm of ordinary life, with its causes and effects, its shifting interests and inexorable necessities—the world where, according to Carl Andre, "culture" is imposed on art and the artist. Painting goes well, says de Kooning, only when he gets "a little bit out of this world."[12] Leaving "the real world," he enters the zone of art, where Andre, too, prefers to be.

Now, de Kooning and Andre occupy the art zone in different styles. So do. Smithson and Flaubert. Autonomy generates singularity. Free to become himself, de Kooning feels free to admire Duchamp—just as the Romantic Delacroix admired the classicizing Racine, despite the naïve assumption, mocked by Baudelaire, that all artists have an interest in narrow stylistic allegiances.[13] In modern times, artists become major by having no narrow interests, or *any* interests that ordinary sensibilities can comprehend. Nothing prevented Donald Judd from admiring de Kooning—or at least admitting, in 1965, "I'm not against Abstract Expressionism. I think it's just as difficult and just as good as other forms have been. As usual, it has a superfluous number of followers."[14]

The chief problem with Abstract Expressionism was its tendency to inspire "the hullabaloo." Even the best of de Kooning's work tends to disappear into a buzzing haze of earnestly right-minded interpretation. To discourage that sort of thing, the Minimalists made their art blank and turned themselves into imperious nitpickers. In 1967, a curator invited Dan Flavin to submit a proposal for an installation of fluorescent

lights, which he did. Having received the curator's response, Flavin wrote back, "I do not like the term 'environment' associated with my proposal. It seems to me to imply living conditions and perhaps an invitation to comfortable residence. Such a usage would deny a sense of direct and difficult visual artifice"—would deny, that is, the exclusively aesthetic nature of Flavin's art.

Not that anyone would think for a moment of settling into a gallery occupied by his fluorescent tubes. In shaping a space, his light claims it for itself, leaving no room for any other sensibility to take up "comfortable residence." You can feel comfortable in his installations only for as long as it takes to get the point: in this zone, the artist's sensibility reigns. "I intend rapid comprehensions," wrote Flavin. "Get in and get out situations."[15] We may insist on loitering, with intent to take pleasure in his lighting effects. He is concerned only to give us a sense that, in its place, his artifice is sovereign.

The artifice of Frank Stella is equally sovereign in the place it makes for itself, and it is just as intent on giving us to understand how absolutely it holds sway in its own realm. We may want his paintings to give us more, but whatever we get in addition is of our own taking. So it made sense for Carl Andre to say, in 1959, "Art excludes the unnecessary. Frank Stella has found it necessary to paint stripes. There is nothing else in his painting." To discourage the thought that Stella's "nothing" is ironic, a shadowy veil over a secretly generous something, Andre went on to say that "symbols are counters passed among people. Frank Stella's painting is not symbolic. His stripes are the paths of brush on canvas. These paths lead only into painting."[16]

By talking of "counters," Andre makes a disdainful comparison between the exchange of symbols for meanings and the exchange of goods for money.[17] Like William Wordsworth, Andre believes that "The world is too much with us,"[18] not only the world of the marketplace but the world in the fullness of its mundane, practical concerns—including the political interests that Andre would not allow to be read into his works.[19] His paths of brick and steel lead only into the zone of his art, and when he juxtaposes these orderly lines, he expands art paths to an art place isolated from the culture. In that place, he and his art remain independent of all the purposes that audiences and institutions would like it to serve.

Like just about every commentator before him, Robert Taplin wants the art of Eva Hesse to serve the purpose of communication. So his first move is to see the forms of her sculptures as "generalized body parts" aglow with "an uncanny, fragile vitality." Next, he says that her works make "a direct appeal to the sensual life of the viewer."[20] Alive to

that appeal, Taplin reports mission accomplished: message sent and received. But remember what Hesse said about her method: "It's only the abstract qualities that I'm really working with, which is to say the material, the form it's going to take, the size, the scale, the positioning or where it comes from in my room—if it hangs on the ceiling or lies on the floor." Where does that leave Taplin's talk of "vitality"?

Not entirely stranded, for Hesse went on to say that each of her works is "a total image that has to do with me and my life . . . it is inevitable that it is my life, my feelings, my thoughts."[21] "Vitality," it seems, is just the right word to apply to her art, if we're willing to grant that she realized her stated intentions. So the question becomes: what are we to do with her formalist talk of working with "abstract qualities"? Let's say that Hesse's art is formalist from one angle, expressive from another, and the angle is your choice.

Andre wants us to see his art from a single angle, the one that strips it of all associations. Yet Hesse could not see his grids without thinking of "the concentration camp . . . the showers where they put in the gas."[22] Though Andre might resist this reading, he has no legitimate objection to it. Just as we are all free to define art as we wish, so we are free to project any meaning whatsoever onto works of art—and artists have no business expecting us take their statements of intention as law, a point so very obvious that it has animated a body of anti-intentionalist theory for the past half century or so.[23]

W. K. Wimsatt and others who warn us against the Intentional Fallacy have a point. We can't substitute an artist's claims about a work of art for our experience of the work itself. But sometimes those claims deserve to be included in the artist's oeuvre, especially in modern times, when the aesthetic is so vigorously contested that we would often be lost if innovators gave us no clue to their intentions. Like certain passages in his poems, certain passages in Keats's letters speculate about the nature of poetry. The latter count as literary works no less than the former, and it may be that Morris's "Notes on Sculpture" are more significant, as works of art, than any of the boxes he built. It is certain that Robert Smithson's writings, which are available to read, are a more important part of his oeuvre than his earthworks, which hardly anyone has seen. There is no sweeping principle to be formulated here. We must decide the status of an artist's writings and statements case by case, bearing in mind that if artists and poets hadn't been talking for years of autonomy and art for art's sake it might not be credible that an object could be made for the purpose of displaying its lack of a purpose.

But do we really need this notion of autonomy? Doesn't it run counter to our tendency—perhaps our need—to read everything as sym-

bolic or expressive? A deserted desert highway expresses this, a politician's decision not to wear a tie symbolizes that. A work of art, of all things, cannot refuse absolutely to make itself useful by conveying some meaning or other, as Eva Hesse's reaction to Carl Andre's sculpture shows. Needs aside, let's grant that it is *possible* to see certain artworks as autonomous—to see them in and for themselves, disengaged from any purpose or interest, including our own. Fine, one might object, but couldn't one take this disinterested, aesthetic view of anything: a sunset or an orchid or anything at all, even a crumpled piece of paper? So where does this leave us? Things that are and things that are not works of art can be seen as autonomous or not, as each of us chooses, from moment to moment. True, but not very interesting.

Interest returns when we acknowledge, with encouragement from artists' statements, that they *intend* their works to be seen as autonomous. Thus they separate their art from the world of sunsets and all the other unintended things that we can, if we like, turn into targets of the aesthetic gaze. But we must proceed with care, for it is easy to see as autonomous an artwork intended to represent autonomy or to display its virtues—as an abstraction by Mondrian does, to recall for a moment his labyrinthine utopianism. To represent, to illustrate, symbolize, to express—all these are purposes, and they entangle art in practical questions about truth and falsity. A work of art becomes autonomous only when an artist denies that it has these or any other purposes, and we find reason to agree with the claim, not once for all, perhaps, but in the light of a certain moment, when our mood is in accord with the artist's willful disengagement. At that moment, we have joined the artist in the art zone.

To enter that zone, Barry Le Va and others followed paths marked by the Minimalists, whose blank, "hullabaloo"-resistant works seemed to dominate the zone simply by being so self-evidently what they are. Performing no tasks, minimalist objects met only the need for works of art independent of any need. When Le Va said that he "was impressed by the rigorous structure of minimalist thinking," he asserted his taste for modular repetition and serial progression. Adding that he had no wish "to emulate a minimalist gestalt," he registered a certain wariness.[24] In the clarity of its "gestalt," the minimalist box was too obviously, too assertively what it was. Permitting the audience next to no latitude, it was acquiring an authoritarian aura. Similarly uneasy, Dan Graham saw Minimalism as a new formalism.[25]

Soon after it had its first impact, the minimalist object began to look like the representation of an ideal. The Minimalists, it seemed, had developed an interest in demonstrating the one way that art ought to be.

Those who nominated themselves as their inheritors wondered, as the 1960s ended, if the Minimalists had betrayed their earlier selves and were now protecting a Platonic interest in the Truth. This suspicion fell most often on Robert Morris, least often on Sol LeWitt, who seemed to have a reliable knack for the "irrationality" that protects art from serving any purpose beyond the display of its nonpurposiveness.

There were, it appeared, metaphysical liabilities in Minimalism's supposedly antimetaphysical virtues of blankness and impersonality. To rescue the virtues and avoid the liabilities, Le Va, Smithson, and others of their generation contrived to get art out of the box—to release it first from the confines of the minimalist object, and then from the white cube of gallery space. Once they had escaped, line and plane and modular form could retrieve their singularity, their arbitrariness, their contingency. Art could once more be manifestly autonomous. It could not, of course, defend itself against latter-day versions of "the hullabaloo." Our relentlessly utilitarian culture insists on assigning useful tasks to everything. LeWitt has been praised for performing the philosophical task of revealing "the structure of thought," and, among the younger artists, everyone from Richard Tuttle to Vito Acconci has been praised for performing expressionist tasks.

Art is defenseless because, if it were not, it would not be art. It would be functional. It would have purposes, including that of self-defense. A work of art can only be what it is in the art zone, this non-place where the work needs no defense because we agree to see it in its singularity, without imposing meanings of the kind that put it at the service of something other than itself. Of course artists are often the only ones who can see their work that way, and that is why they have so much to say. They want to help us look past our usual, practical concerns.

In 1968 Mel Bochner began a series of measurement pieces. The first of them marked off angles with string and nails: forty-five degrees, ninety degrees. Others employed tape and stick-on numbers to indicate lengths: two feet, three inches from floor to window sill; five feet, one inch, from one side of the window to the other. Continuing into the 1970s, Bochner's measuring turned into counting. These are activities with an air of practicality about them, yet there was no practical use to be made of Bochner's efforts. To execute *Room Series: Eye-level Cross-section (Estimated and Measured)* (1971), he drew a line "all around a room at my eye level." Not so much to explain the work as to complete it, he wrote, "My intention is to change the work of art's function for the viewer. Art would go from being the record of someone else's perception to becoming the recognition of one's own."[26]

Just a moment, you might want to say, this statement certainly

sounds like an explanation of a purpose. Yes, it has that sound. But does it explain anything that we don't already know? Ever since Kant published the *Critique of Judgment*, is has not been news that aesthetic contemplation encourages "the recognition of one's own" perception. Rather than explain anything, Bochner's statement points to that familiar "recognition" as if to say, that's all there is. I've left you alone with your perception of my line, which may lead you around the room, back to your starting place, but nowhere else, except ever deeper into a sense of your isolation in yourself.

For *Measurement Five* (1969–71), Bochner placed five stones at the meeting of wall and floor. Then he wrote a "1" on the floor beside each stone, and a "5" on the wall just above the stones. In place of a purpose this piece put an opportunity to see the useful activity of counting unburdened by purpose. One could, if one liked, impose a purpose on *Measurement Five*—make it serve, for example, as the starting point for ruminations on the one and the many, the principles of mathematics, or any topic having to do with numbers. But no one really needs it to serve in that way. With counting for counting's sake, Bochner revamped art for art's sake and claimed for himself a chamber in the art zone where the larger world's points and purposes, causes and effects, have no force.

To claim her portion of the art zone, Dorthea Rockburne used drawing paper. She may have stuck with this traditional material, for a few seasons, anyway, because its persistent invitation to represent something, to make a picture, forced to her formulate a crucial question: "How could a drawing be about itself and not about something else?" Having launched a dialogue with herself, she answered, "Construct an investigation of drawing which is based on information contained within the paper and not on anything else." From the shape of the paper generate a series of folds; from the lines produced by folding generate a rationale for drawing a set of lines. As the mind follows the process, "Thought acts upon itself."[27]

It does this not for the sake of knowledge, not to arrive at Truth, but to assert its sovereignty in the realm it has constructed for, by, and of itself. Will Insley's *ONECITY* is his answer to the question: how could an imaginary metropolis be about itself and not be a utopia, the expression of a hope, or a dystopia, the elaboration of a warning? With his photographic pieces, Mac Adams answers a variant of the same question: how can a mystery story be about itself and not lead to a solution? How, Bill Beckley asked himself, can a story line lead not to a finale but ever deeper into its own ambiguities?

In 1977, Michael Heizer was asked how we are to "relate" to his art. He replied,

You don't have to relate to it. It's not a requirement. All you have
to do is just be there. It doesn't matter what you think when you
see it. The point is, it's the work of an artist. I'm an artist. That's
my business. That's what I do all the time. So, what you're look-
ing at is a work of art.[28]

Of course, many artists do hope to induce us to "relate" to their
work, and thus they assign themselves and their art a purpose. And it's
worth repeating that, however sternly we are warned off by Heizer and
artists like him, we can always define their work as purposeful: expres-
sive, inspiring, relaxing, a window on the hidden truth of its moment.
For autonomy is an incoherent ideal. Nothing exists—or it is better to
say, nothing has any meaning—in complete isolation from everything
else. Surely artists as intelligent as ones I've discussed are aware of this,
because who isn't? Nonetheless, I've argued, they try to make their
works autonomous. More than that, they claim autonomy for themselves,
as artists with the power to create and occupy what I've called the art
zone.

An ideal needn't be coherent to be entrancing. The point of
autonomy is not in the possibility of it but in the yearning for it—for the
feeling of independence from whatever forces define us as functions of
their power. In this defiance of necessity is the origin of the modern self,
or, at least, the modern self in its more willfully self-conscious states.
And, of course, the self is all the more willful in the face of arguments,
some quite persuasive, that selfhood is, after all, a mirage. So, finally,
there is a use for uselessness. It opens a space in the tight mesh of neces-
sity, a space with room only for your most reassuring idea of yourself.

To play an oblique joke on minimalist literalism, Dennis
Oppenheim once designated a patch of terrain as his art zone. He called
it *Protection* (1971). With twelve steel poles, each five-feet high, he
marked off an area thirty-two feet wide and sixty-four feet long on the
grounds of the Boston Museum of Fine Arts. To each pole he leashed a
trained attack dog. For forty-eight hours, the dogs guarded the area. Only
the artist knew how to slip past them. Only he had any reason to try, for
this enclosed area had its meaning as an emblem of the virtual place
where he goes to exercise his autonomy. It was fitting that the guard dogs
had nothing to guard. As Mel Bochner said in his essay on *Primary
Structures*, "Art is, after all, Nothing"—nothing in the world of ordinary
interests, so that it can be everything in the realm it creates for itself.[29]

# notes

out of the box
1  Liza Béar and Willoughby Sharp, ". . . a continuous flow of fairly aimless movement," inter-
   view with Barry Le Va, *Avalanche* (Fall 1971), 66.
2  Le Va added this subtitle to the work when he made a second version of it, *Velocity # 2: Impact*
   *Run, Energy Drain, for Projections: Anti-Materialism,* an exhibition on view at the La Jolla
   Museum of Art, La Jolla, California, 1970.
3  Liza Béar and Willoughby Sharp, interview with Barry Le Va, 65.
4  Liza Béar and Willoughby Sharp, interview with Barry Le Va, 64.
5  Barry Le Va, conversation with the author. February 2, 2000, New York.

chapter 1
1  Mel Bochner, "Primary Structures," *Arts Magazine* (June 1966), 32–33.
2  Annette Michelson, "Robert Morris—An Aesthetics of Transgression," *Robert Morris,* exhibi-
   tion catalog (Washington, D.C.: Corcoran Gallery of Art, 1969), 13.
3  Irving Sandler, *American Art of the 1960s* (New York: Harper & Row, 1988), 6–8.
4  Carl Andre, "Preface to Stripe Painting," *Sixteen Americans,* exhibition catalog, ed. Dorothy
   Miller (New York: The Museum of Modern Art, 1959), 76.
5  Alan Solomon, interview with Frank Stella, "U.S.A. Artists," National Educational Television,
   1966. Quoted in William Rubin, *Frank Stella,* exhibition catalog (New York: The
   Museum of Modern Art, 1970), 13.
6  Frank Stella, in Bruce Glaser, "Questions to Stella and Judd" (1966), *Minimal Art: A Critical*
   *Anthology,* ed. Gregory Battcock (New York: E. P. Dutton & Company, 1968),158. See
   also Dan Flavin on his art: "What it is is what it is," in Michael Gibson, "The Strange
   Case of the Fluorescent Tube," *Art International* (Autumn 1987), 150.
7  Donald Judd in Bruce Glaser, "Questions to Stella and Judd" (1966), *Minimal Art: A Critical*
   *Anthology,* 150, 156, 162.
8  Donald Judd, "Black, White and Gray" (1964), *Complete Writings 1959–1975* (Halifax: The
   Press of the Nova Scotia College of Art and Design, 1975), 117.
9  Donald Judd, "Specific Objects" (1965), *Complete Writings 1959–1975,* 184.
10 Carl Andre (1968), in Kenneth Baker, *Minimalism: Art of Circumstance* (New York: Abbeville
   Press, 1988), 138.
11 Robert Morris, "Notes on Sculpture, Part 2" (1966), *Continuous Project Altered Daily: The*
   *Writings of Robert Morris* (Cambridge, Massachusetts: The MIT Press, 1993), 17.
12 Michael Fried, "Art and Objecthood" (1967), *Art and Objecthood: Essays and Reviews* (Chicago:
   The University of Chicago Press, 1998), 167–68, 146, 147. For "purely optical" pictorial
   effects, see Clement Greenberg, "Louis and Noland" (1960), *The Collected Essays and*
   *Criticism,* 4 vols., ed. John O'Brian (Chicago: University of Chicago Press, 1993),
   4:95–97.
13 Plotinus, *The Enneads,* trans. Stephen MacKenna, ed. John Dillon (London: Penguin Books,
   1991), 5.8.1:410–11.
14 Michael Fried, "Art and Objecthood" (1967), 164–68.
15 Clement Greenberg, "Louis and Noland" (1960), *The Collected Essays and Criticism* 4:95–97. See
   also Clement Greenberg, "Introduction to Jules Olitski at the Venice Biennale" (1966),
   *The Collected Essays and Criticism,* 4:228–30. For the essay that lays the foundation of
   American formalism's metaphysical program, see Clement Greenberg, (1965), *The*
   *Collected Essays and Criticism,* 4:85–93.
16 Plato, *Phaedrus,* 248a–248b, trans. R. Hackforth, *The Collected Dialogues,* ed. Edith Hamilton and
   Huntington Cairns (Princeton, New Jersey: Princeton University Press, Bollingen
   Series LXXI, 1963), 494–95.
17 Marcia Tucker, *Robert Morris,* exhibition catalog, (New York: The Whitney Museum of

American Art, 1970), 21, 25.

18  Robert Morris, "Notes on Sculpture, Part 2" (1966), *Continuous Project Altered Daily*, 17.

19  Marcia Tucker, *Robert Morris*, 25.

20  Donald Judd, "Specific Objects" (1965), *Complete Writings 1959–1975*, 183.

21  John Elderfield, "Grids," *Artforum* (May 1972), 56.

## chapter 2

1  Donald Judd, statement (1967), *Donald Judd: Early Fabricated Work*, exhibition catalog (New York: PaceWildenstein, 1998), 8.

2  Bill Bollinger, statement, *Art in Process IV*, ed. Elayne H. Varian (New York: Finch College Museum of Art, 1969), n.p.

3  *Ibid.*

4  Wade Saunders, "Not Lost, Not Found: Bill Bollinger," *Art in America* (March 2000), 114–15.

5  James Monte, "Anti-Illusion: Procedures/Materials," *Anti-Illusion: Procedures/Materials*, exhibition catalog (New York: The Whitney Museum of American Art, 1969), 9.

6  Scott Burton, "Notes on the New," *Live in Your Head: When Attitudes Become Form*, exhibition catalog (Berne: Kunsthalle Bern, 1969), n.p.

7  Ellen Lubell, "Wire/Pencil/Shadow: Elements of Richard Tuttle" (1972), *The New Sculpture 1965–75: Between Geometry and Gesture*, exhibition catalog, ed. Richard Armstrong and Richard Marsall (New York: The Whitney Museum of American Art, 1990), 266.

8  Tom Marioni, statement, *Tom Marioni: Sculpture and Installation 1969–1997*, exhibition catalog, (San Francisco: Gallery Paule Anglim; New York: Margarete Roeder Gallery, 1997), 4.

9  Tom Marioni, quoted in *Tom Marioni: Trees and Birds, 1969–1999*, exhibition catalog, (Oakland, California: Mills College Art Museum, 1999), 19.

## chapter 3

1  Fred Sandback, interview by Stephen Prokopoff, *The Art of Fred Sandback: A Survey* (Champaign-Urbana, Illinois: Krannert Art Museum, University of Illinois, 1985), 21.

2  Donald Judd, "Nationwide Reports: Hartford; *Black, White and Gray*" (1964), *Complete Writings 1959–1975* (Halifax: The Press of the Nova Scotia College of Art and Design; New York: New York University Press, 1975), 119.

3  Mel Bochner, conversation with the author. March 20, 2000, New York.

4  To Walter Darby Bannard's suggestion that artists need not reject pictorial conventions inherited from Europe, including the ones that generate imaginary space, Donald Judd replied, "It is a question of credibility and what you believe. I can't believe any of it." "Is Easel Painting Dead?" symposium moderated by Barbara Rose, with Walter Darby Bannard, Donald Judd, Larry Poons, and Robert Rauschenberg, November, 1966. Archives of American Art, the Smithsonian Institution, New York, typescript, 31. Judd does not argue against the value or credibility of effects of pictorial space, nor does he try to show that European tradition is somehow wrong. He simply declares that he no longer believes in "any of it." In his style of argument, he resembles the American philosophers known as pragmatists, who, rather than try to disprove the truth of European metaphysics, simply declare that it no longer compels their belief. See, for example, Richard Rorty, "Is Truth a Goal of Inquiry? Donald Davidson Versus Crispin Wright," *Truth and Progress* (Cambridge: Cambridge University Press, 1998), 19–42. Rorty's argument that "there is no Way the World Is," 25, hence no foundation for the metaphysicians's hope of representing it truly, implies agreement with the pragmatist William James's remark, "The truth of an idea is not a stagnant property inherent in it. Truth *happens* to an idea. It *becomes* true, is *made* true by events. Its verity is, in fact, an event, a process." See William James, "The Notion of Truth," *Pragmatism* (1907; New York: Longmans, Green and Company, 1931), 201. For James, John Dewey, and latter-day pragmatists, "truth happens to an idea" only when it has gained the acceptance of a competent community. By contrast, Judd concluded on his own, in isolation, that claims for the aesthetic value of pictorial illusion are no longer "credible," and that the European tradition which evolved that sort of illusion is likewise unworthy of belief.

Thus he displays the willfulness of a modern artist, in contrast with the respect for a community of inquirers which pragmatists, properly so called, characteristically display. There is, of course, a sharper contrast between the lone-wolf pragmatism of Judd and what might be called the studio Platonism of Walter Darby Bannard, who, as an artist and as a critic, defends pictorial tradition by appealing to such metaphysical entities as the essence of painting and the transcendent necessities of the historical moment. In making this appeal, Bannard borrows from the jumble of Platonic, Kantian, and Hegelian-Marxian ideas that supplied so much glamor to the formalism of Clement Greenberg and Michael Fried.

5  Sol LeWitt, "Sentences on Conceptual Art" (1969), *Sol LeWitt: A Retrospective*, exhibition catalog, ed. Gary Garrels (San Francisco: San Francisco Museum of Modern Art, 2000), 371–72.

6  Patrick Ireland, statement (1985), quoted in *Patrick Ireland: Drawings 1965–1985*, with an introduction by Elizabeth Broun, exhibition catalog (Washington, D.C.: The National Museum of American Art, 1986), 52.

7  Fred Sandback, interview with Doris von Drathen. Sandback Archive, New York.

8  Fred Sandback, "Remarks on my Sculpture 1966–1986," *Fred Sandback: Sculpture 1966–1989*, exhibition catalog (Mannheim, Germany: Städtische Kunsthalle Mannheim), 12.

9  Fred Sandback, statement, *Fred Sandback*, exhibition catalog (Munich: Kunstraum München, 1975), n.p. By contrast, Sol LeWitt says, "Once the idea of the piece is established in the artist's mind and the final form is decided, the process is carried out blindly." See LeWitt, "Sentences on Conceptual Art" (1969), *Sol LeWitt: A Retrospective*, 372.

10  Fred Sandback, "Remarks on my Sculpture 1966–1986," 13.

11  Fred Sandback, statement (1998), *Here and Now: Fred Sandback*, exhibition brochure (Leeds, England: Henry Moore Institute, 1999), n.p.

12  Fred Sandback, "Remarks on my Sculpture 1966–1986," *Fred Sandback: Sculpture 1966–1989*, 12–13.

13  Robert Barry, "Four Interviews with Barry, Huebler, Kosuth, Weiner" (1969), reprinted in *Arts Magazine* (February 1989), 44.

14  See Conceptual Art, ed. Ursula Meyer (New York: E. P. Dutton & Company, 1972), 41. Barry repeated this work at the Eugenia Butler Gallery, in Los Angeles, in March 1970. See *Lucy Lippard, Six Years: The Dematerialization of the Art Object from 1966 to 1972* (New York: New York: Praeger Publishers 1973), 133.

15  Barbara Reise, "Sol LeWitt Drawings 1968–69," *Studio International*, (December 1969), 223.

16  Mary Miss, statement (1971), in Lucy R. Lippard, "Mary Miss: An Extremely Clear Situation," *Art in America* (March/April 1974), 76.

17  Mary Miss, "Mary Miss: An Extremely Clear Situation," 77.

## chapter 4

1  Richard Long, "Five, six, pick up sticks, seven, eight, lay them straight" (1980), *Land Art and Environmental Art*, ed. Jeffrey Kastner and Brian Wallis (London: Phaidon, 1998), 241.

2  Carl Andre, quoted in David Bourdon, "Carl Andre's Razed Sites" (1966), *Minimal Art: A Critical Anthology*, ed. Gregory Battcock (New York: E. P. Dutton & Company, 1968), 104.

3  Peter Hutchinson, conversation with the author. June 15, 2000, New York.

4  Eleanor Antin, "Remembering 100 Boots," *100 Boots* (Philadelphia: Running Press, 1999), n.p.

5  Tom Marioni, in Robin White, *View 1* (October 1978), 8.

## chapter 5

1  Robert Smithson, in "Discussions with Heizer, Oppenheim, Smithson" (1970), *Robert Smithson: The Collected Writings*, ed. Jack Flam (Berkeley: University of California Press, 1996), 249.

2  Nicholas Slawny, interview with Dennis Oppenheim. June 2, 1998, New York. Oppenheim archives.

3  Dennis Oppenheim, statement, *Op Losse Schroeven*, exhibition catalog (Amsterdam: Stedelijk

Museum, 1969), 21.

4  Michael Heizer, "The Art of Michael Heizer," *Artforum* (December 1969): 34.

5  For Robert Morris's comments on the sculpture of David Smith and the way the minimal-
   ist object dispenses with scale and references to the human figure, see "Notes on
   Sculpture, Part 1" (1966) and "Notes on Sculpture, Part 2" (1966), *Continuous
   Project Altered Daily: The Writings of Robert Morris* (Cambridge, Massachusetts: The
   MIT Press, 1993), 3–4, 11–16. For the minimalist object's oblique reference to the
   body by way of its resemblance to a coffin, see chapter 18. Thus the body invoked
   by the minimalist object is the body as an object—a corpse. This is the secret sym-
   bolism of the minimalist object, which Paul Thek literalized with his wax effigy of
   his dead self; see chapter 13. For the formalist argument that the hollowness of
   minimalist object, real or imaginary, gives it something like a bodily presence, see
   Michael Fried, "Art and Objecthood" (1967), *Art and Objecthood: Essays and Reviews*
   (Chicago: The University of Chicago Press, 1998), 155–57.

6  Michael Heizer, "The Art of Michael Heizer," *Artforum* (December 1969), 32.

7  Michael Heizer, "Interview with Julia Brown," *Michael Heizer: Sculpture in Reverse, ed. Julia
   Brown*, exhibition catalog (Los Angeles: The Museum of Contemporary Art, 1984),
   28.

8  Lawrence Weiner, statement (1969). See Lucy R. Lippard, *Six Years: The Dematerialization
   of the Art Object from 1966 to 1972* (New York: Praeger Publishers, 1973), 73–74. The
   addition was Weiner's contribution to *Art in the Mind*, exhibition catalog (Oberlin,
   Ohio: Allen Art Museum, Oberlin College, 1970), n.p.

9  Robert Smithson, in Robert Hobbs, *Robert Smithson: Sculpture*, exhibition catalog (Ithaca,
   New York: Cornell University Press, 1981),112.

10 Robert Smithson, in "Discussions with Heizer, Oppenheim, Smithson," *Robert Smithson:
   Collected Writings*, 249.

11 Virginia Dwan, interview with Charles Stuckey (1984), The Archives of American Art, The
   Smithsonian Institution, typescript, 36.

12 Mary Livingston Beebe, "Tell Me, Is It Flat or Is It Round?" *Art Journal* (Summer 1981),
   69–70.

13 Nancy Holt, "Sun Tunnels" (1977), reprinted in *Land and Environmental Art*, ed. Jeffrey
   Kastner and Brian Wallis (London: Phaidon Press, 1998), 228.

## chapter 6

1  Amy Golden, "Patterns, Grids, and Painting," *Artforum* (September 1975), 51.

2  Andrea Gould, "Dialogues with Carl Andre," *Arts Magazine* (May 1974), 27. See also
   "Time: A Panel Discussion," ed. Lucy R. Lippard, with Seth Siegelaub, moderator,
   and Carl Andre, Michael Cain, Douglas Huebler, Ian Wilson. *Art International*
   (November 1969), 23, 39.

3  Sol LeWitt, in Lucy Lippard, "Top to Bottom, Left to Right," *Grids Grids Grids Grids
   Grids Grids Grids Grids*, exhibition catalog (Philadelphia: Institute of Contemporary
   Art, University of Pennsylvania, 1972), n.p.

4  Wassily Kandinsky, "Point and Line to Plane" (1926), *Kandinsky: Complete Writings on Art*,
   ed. Kenneth C. Lindsay and Peter Vergo (New York: Da Capo Press, 1994), 650–53.

5  Wassily Kandinsky, "Little Articles on Big Questions" (1919), *Kandinsky: Complete Writings
   on Art*, 427.

6  Wassily Kandinsky, "Painting as Pure Art" (1913), *Kandinsky: Complete Writings on Art*,
   351–52.

7  Wassily Kandinsky, "Content and Form" (1910–11), *Kandinsky: Complete Writings on Art*, 90.

8  Barbara Rose, "The Politics of Art" (1969), *Autocritique: Essays on Art and Anti-Art
   1963–1987* (New York: Weidenfeld & Nicolson, 1988), 236.

9  Carl Andre, "Carl Andre: Artworker" (1970), interview, in Jeanne Siegel, *Artwords:
   Discourse on the 60s and 70s* (Ann Arbor: UMI Research Press, 1985), 135.

10 See *Arts Magazine* (May 1969), 22..

11   Sol LeWitt, in Lucy Lippard, "Top to Bottom, Left to Right," *Grids Grids Grids Grids Grids Grids Grids Grids*, n.p.

12   John Elderfield, "Grids," *Artforum* (May 1972), 56.

13   Ed Ruscha, *Thirtyfour Parking Lots in Los Angeles*, 1967. No publisher listed.

14   Stéphane Mallarmé, "Brise Marine" (1887), *Mallarmé*, ed. Anthony Hartley (Baltimore: Penguin Books, 1965), 29.

15   Donald Judd, in Bruce Glaser, "Questions to Stella and Judd" (1964), *Minimal Art: A Critical Anthology*, ed. Gregory Battcock (New York: E. P. Dutton & Company, 1969), 150.

16   Carl Andre, interview with Paul Cummins, *Artists in Their Own Words* (New York: St. Martin's Press, 1979), 185.

17   John Perreault, "Art: Transmissions," *The Village Voice* (April 16, 1970), 14.

18   John Perreault, "Scramble," *0 TO 9* (January 1969), 63.

19   Vito Acconci, "In the first place," *0 TO 9* (January 1969), 35.

20   Vito Acconci, "READ THIS WORD," *Extensions* (no. 2, 1969), 71.

21   Adrian Piper, untitled work, *0 TO 9* (January 1969), 50–52.

22   Sol LeWitt, "Paragraphs on Conceptual Art" (1967), *Sol LeWitt: A Retrospective*, exhibition catalog, ed. Gary Garrels (San Francisco: San Francisco Museum of Modern Art, 2000), 369–71. Though the first publication of LeWitt's "Sentences on Conceptual Art" is usually given as Art-Language (May 1969), 11–13, its first appearance was in *0 TO 9* (January 1969), 3–5. This is the issue of the magazine that contains Piper's grid spirals. See endnote 21.

23   Adrian Piper, "On Conceptual Art" (1988), *Adrian Piper: Out of Order, Out of Sight, vol. 1: Selected Writings in Meta-Art, 1968–1992* (Cambridge, Massachusetts: MIT Press, 1996), 241.

## chapter 7

1   Dan Graham, "Homes for America" (1966), *Dan Graham*, exhibition catalog, ed. Gloria Moure (Barcelona: Fundació Antoni Tàpies, 1998), p. 78

2   Dan Graham, "My Works for Magazine Pages: 'A History of Conceptual Art'" (1985), *Two-Way Mirror Power: Selected Writings by Dan Graham on His Art*, ed. Alexander Alberro (Cambridge, Massachusetts: The MIT Press, 1999), 10.

3   Dan Graham, "My Works for Magazine Pages: 'A History of Conceptual Art'" (1985), *Two-Way Mirror Power: Selected Writings by Dan Graham on His Art*, 11.

4   John Gruen, "Jackie Winsor," *The Artist Observed: 28 Interviews with Contemporary Artists* (Pennington, New Jersey: A Cappella Books, 1991), 39,42.

5   See the sonnets by Michelangelo reprinted in Elizabeth Holt, *A Documentary History of Art* (Garden City, New York: Doubleday Anchor Books, 1958), 2:21–22.

6   Carol Gooden, interview with Joan Simon, *Gordon Matta-Clark: A Retrospective*, exhibition catalog (Chicago: Museum of Contemporary Art, 1985), 25.

7   Gordon Matta-Clark, "Jacks," *Avalanche* (Fall 1971): 24–29.

8   Walter De Maria, *Beds of Spikes*, 1968–69.

9   Mary Livingston Beebe, "Tell Me, Is It Flat or Is It Round?" *Art Journal* (Summer 1981), 170.

## chapter 8

1   Will Insley, statement, *Abstract Painting: 1960–69*, ed. Donald Droll and Jane Nicol (New York: The Institute for Art and Urban Resources, 1983), n.p.

2   Mel Bochner, "Serial Art, Systems, Solipsism" (1967), *Minimal Art: A Critical Anthology*, ed. Gregory Battcock (New York: E. P. Dutton & Company, 1968), 92–102.

3   Mel Bochner, conversation with the author. March 20, 2000, New York.

4   Mel Bochner, "*Alphaville*, Godard's Apocalypse" (1968), in Richard S. Field, *Mel Bochner: Thought Made Visible 1966–1973*, exhibition catalog (New Haven: Yale University Art Gallery, 1995), 143.

5   Mel Bochner, "Out of Context," *Tema Celeste* (July–September 1989): 62.

6   Mel Bochner, "Excerpts from Speculation" (1967–70), *Conceptual Art*, ed. Ursula Meyer (New York: E. P. Dutton & Company, 1972), 57.

7   Mel Bochner, notes, reproduced in *Art in Process IV*, ed. Elayne H. Varian, exhibition catalog (New York: Finch College Museum of Art, 1969), n.p.

8   Bruce Boice, *"The Axiom of Indifference"* (1973), in *Mel Bochner: Thought Made Visible 1966–1973*, exhibition catalog (New Haven: Yale University Art Gallery, 1995), 284.

9   Robert Morris, "Notes on Sculpture, Part 2" (1966), *Continuous Project Altered Daily: The Writings of Robert Morris* (Cambridge, Massachusetts: The MIT Press, 1993), 17.

10  Dore Ashton, "New York Commentary," *Studio International* (March 1970): 118.

11  Jennifer Licht, introduction, *Spaces*, exhibition catalog (New York: The Museum of Modern Art, 1969), n.p.

12  Philip Leider, "New York," *Artforum* (February 1970), 69.

13  See, for example, Birgit Pelzer, note on Michael Asher, in Kynaston McShine, *The Museum as Muse: Artists Reflect*, exhibition catalog (New York: The Museum of Modern Art, 1999), 157.

14  See Edmund Burke, *A Philosophical Enquiry into the Origin of Our Ideas of the Sublime and the Beautiful*, second edition (1759), ed. J. T. Boulton (Notre Dame, Indiana: University of Notre Dame Press, 1968), Part 2, sections [4], 8–11, 14–19; Part 3, section 27; Part 3, sections 11–13, 15–16.

15  Jean Louis Bourgeois, "Stephen Kaltenbach," *Artforum* (January 1970), 71.

16  Stephen Kaltenbach, interview with Patricia Ann Norvell (1969), in Lucy R. Lippard, *Six Years: The Dematerialization of the Art Object from 1966 to 1972* (New York: Praeger, 1973), 84.

17  Cindy Nemser, "Stephen J. Kaltenbach," *Arts Magazine* (December 1969–January 1970), 56.

18  John Fitz Gibbon, "Sacramento!" *Art in America* (November 1971), 81.

19  Rosemarie Castoro, conversation with the author. March 26, 2000, New York.

20  Joan Simon, "Breaking the Silence: An Interview with Bruce Nauman," *Art in America* (September 1988), 147.

21  Willoughby Sharp, "Bruce Nauman," interview, *Avalanche* (Winter 1971), 28.

22  Willoughby Sharp, "Nauman Interview," *Arts Magazine* (March 1970), 23.

23  Robert Morris, "Notes on Sculpture, Part 2" (1966), *Continuous Project Altered Daily*, 17.

24  Dore Ashton, "New York Commentary," *Studio International* (March 1970), 118.

25  Chris Burden, in Robert Horvitz, "Chris Burden," *Artforum* (May 1976), 26.

chapter 9

1   Robert Morris, "Robert Morris Replies to Roger Denson (Or Is That a Mouse in My Paragone?), *Continuous Project Altered Daily: The Writings of Robert Morris* (Cambridge, Massachusetts: MIT Press, 1993), p. 301

2   Brian O'Doherty, "The Gallery as a Gesture," *Artforum* (December 1981), 21. This essay is a coda to the "white cube" essays that appeared in 1976.

3   Dorthea Rockburne, conversation with the author. July 3, 2000, New York. See also, Mel Bochner, "A Note on Dorthea Rockburne"; Dorthea Rockburne, "Works and Statements"; Jennifer Licht, "An Interview with Dorthea Rockburne," *Artforum* (March 1972), 28–36.

4   Dorthea Rockburne, "On Completion of the Work Neighborhood," statement (March 1973). Artist's file, Library of the Museum of Art, New York.

5   See the conversation between Dorthea Rockburne, Amy Sandback, and Rolf Steiner, typescript, 1999. Dorthea Rockburne Archive, New York.

6   Jean Louis Bourgeois, "Stephen Kaltenbach," *Artforum* (January 1970): 71.

7   Willoughby Sharp, "Bruce Nauman," interview, *Avalanche* (Winter 1971), 30.

8   See Robert Morris, "Notes on Sculpture, Part 2" (1966), *Continuous Project Altered Daily: The Writings of Robert Morris* (Cambridge, Massachusetts: The MIT Press, 1993), 17. See also Annette Michelson, "Robert Morris: An Aesthetics of Transgression," *Robert Morris*, exhibition catalog (Washington, D.C.: Corcoran Gallery of Art, 1969), 23: The "comprehension" of Morris's art "not only demands time; it elicits the acknowledgment of that temporality as the condition or medium of human cognition and aesthetic experience." In 1969 Jack Burnham wrote, "Making, promoting, and buying art are real time activities. That is to say, they happen within the day-to-day flow of normal experience. Only

Art Appreciation happens in ideal, nonexistential time." See Burnham, "Real Time Systems" (1960), *Great Western Salt Works: Essays on the Meaning of Post-Formalist Art* (New York: George Braziller, 1974), 28.

9   Phyllis Tuchman, "An Interview with Carl Andre," *Artforum* (June 1970) 57.

10  Leonardo da Vinci, in Katherine Everett Gilbert and Helmut Kuhn, *A History of Esthetics* (New York: Dover Publications, 1972), 164.

11  Giovanni Pietro Bellori, *The Lives of the Modern Painters, Sculptors, and Architects* (1672), in *A Documentary History of Art: Michelangelo and the Mannerists, the Baroque, and the Eighteenth Century*, ed. Elizabeth G. Holt (Garden City, New York: Anchor Books, 1958), 94–106.

12  Piet Mondrian, "Plastic Art and Pure Plastic Art" (1936), *The New Art—The New Life: The Collected Writings of Piet Mondrian*, ed. and trans. Harry Holtzman and Martin S. James (Boston: G. K. Hall, 1986), 299–300.

13  Robert Morris, "Notes on Sculpture, Part 2" (1966), *Continuous Project Altered Daily*, 16.

14  Robert Morris, "Notes on Sculpture, Part 1" (1966), *Continuous Project Altered Daily*, 6.

15  Robert Morris, "Notes on Sculpture, Part 2," *Continuous Project Altered Daily*, 17.

16  Max Kozloff, "Review," *Artforum* (June 1974), 65–66.

17  See Morris's comments the modernist effort "to free sculpture from representation and establish it as an autonomous form," in "Notes on Sculpture, Part 1," *Continuous Project Altered Daily*, 3. For Andre's claims that "there is no symbolic content to my work," see chapter 2, endnote 10.

18  Kimberly Plaice, "Catalogue," *Robert Morris: The Mind/Body Problem*, exhibition catalog (New York: The Solomon R. Guggenheim Museum, 1994), 262.

19  Dan Graham, "Essay on Video, Architecture, and Television" (1979), *Two-Way Mirror Power: Selected Writings by Dan Graham on His Art*, ed. Alexander Alberro (Cambridge, Massachusetts: The MIT Press, 1999), 56.

20  Apolonija Sustersic, "One Morning Talking with Dan Graham," *Dan Graham*, exhibition catalog, ed. Gloria Moure (Barcelona: Fundació Antoni Tàpies, 1998), 34.

21  Dan Graham, *"Present Continuous Pasts(s), 1974,"* *Dan Graham*, exhibition catalog, ed. Gloria Moure (Barcelona: Fundació Antoni Tàpies, 1998), 103.

22  Apolonija Sustersic, "One Morning Talking with Dan Graham," *Dan Graham*, 34.

23  Dan Graham, "Essay on Video, Architecture, and Television" (1979), *Two-Way Mirror Power: Selected Writings by Dan Graham on His Art*, 56.

24  Sol LeWitt, *Serial Project No. 1*, 1966, *Aspen Magazine* (Section 17, 5–6, 1966), n.p.

25  Robert Smithson, "Sol LeWitt: Dwan Gallery Press Release" (1966), *Robert Smithson: The Collected Writings*, ed. Jack Flam (Berkeley: University of California Press, 1996), 335.

26  Robert Smithson, "Incidents of Mirror-Travel in the Yucatan" (1969), *The Collected Writings*, 120–21.

27  Ibid., 124.

28  Robert Smithson, "A Tour of the Monuments of Passaic, New Jersey" (1967), *The Collected Writings*, 72.

29  Robert Smithson, "A Cinematic Atopia" (1971), *The Collected Writings*, 139, 141.

30  "What Is a Museum: A Dialogue between Allan Kaprow and Robert Smithson" (1967), *The Collected Writings*, 48.

31  Robert Smithson, "Ultramoderne" (1967), *The Collected Writings*, 62, 63.

32  Robert Smithson, "Incidents of Mirror-Travel in the Yucatan" (1969), 129–30.

## chapter 10

1   Frank Stella, in Bruce Glaser, "Questions to Stella and Judd" (1966), *Minimal Art: A Critical Anthology*, ed. Gregory Battcock (New York: E. P. Dutton & Company, 1968), 158.

2   Robert Morris, in an unpublished interview with Jack Burnham, November 1975. Quoted in Maurice Berger, *Labyrinths: Robert Morris, Minimalism, and the 1960s* (New York: Harper & Row, 1989), 25.

3   Patrick Ireland, letter to Janet Kardon, September 1975. *Art International* (April–May, 1976), 68.

4   Patrick Ireland, letter to Janet Kardon, September 1975. *Art International* (April–May, 1976), 68.

5   Alice Aycock, *New York City Orientations, TriQuarterly* (Vol. 32, Winter 1975), 21–24.

6   Alice Aycock, *Four 36–38 Exposures, Avalanche* (Lenz 1972), 28–31.

7   Janet Kardon, "Interview with Alice Aycock" (1975), *Art International*, (May 1976), 65.

8   Alice Aycock, "Project for a Simple Network of Underground Wells and Tunnels," *Projects in Nature, Eleven Environmental Works Executed at Merriewold West, Far Hills, New Jersey* (Far Hills, New Jersey: Merriewold West, 1975), n.p.

9   Sol LeWitt, "Sentences on Conceptual Art" (1969), *Sol LeWitt: A Retrospective*, exhibition catalog, ed. Gary Garrels (San Francisco: San Francisco Museum of Modern Art, 2000), 371–72.

10   Allen Ruppersberg, "A Lecture on Houdini" (1973), *Allen Ruppersberg*, exhibition catalog (Grenoble: Centre National d'Art Contemporain, 1996), 69.

11   Janet Kardon, "Interview with Dennis Oppenheim" (1975), *Art International* (April–May, 1976), 66–67.

12   Will Insley, *ONECITY*, 1980, 7.

13   Will Insley, "Abstract/Buildings," *Will Insley: The Opaque Civilization*, exhibition catalog (New York: The Solomon R. Guggenheim Museum, 1984), 10.

14   Will Insley, statement, in Maurice Poirier and Jane Nicol, "The '60s in Abstract Painting: 13 Statements and an Essay," *Art in America* (October 1983), 132.

15   Will Insley, statement, *Will Insley: Ceremonial Space* (New York: The Museum of Modern Art, 1971), n.p.

16   Janet Kardon, interview with Will Insley, *Art International* (April–May 1976), 64.

17   Robert Morris, "Notes on Sculpture, Part 2" (1966), *Continuous Project Altered Daily: The Writings of Robert Morris* (Cambridge, Massachusetts: The MIT Press, 1993), 17.

18   Will Insley, statement (1984), in *Will Insley: The Opaque Civilization*, 14.

19   Linda Shearer, "Interview with Will Insley," *Will Insley: The Opaque Civilization*, 20.

20   Janet Kardon, interview with Will Insley, *Art International*, (April–May 1976), 65.

chapter 11

1   Richard Artschwager, in "Artists in Conversation, II: Richard Artschwager, Vija Celmins, Alex Katz," interview by Carter Ratcliff, *Birth of the Cool: American Painting from Georgia O'Keeffe to Christopher Wool*, exhibition catalog (Zurich: Kunsthaus Zurich, 1997), 119.

2   Donald Judd, "Specific Objects" (1965), *Complete Writings 1959–1975* (Halifax: The Press of the Nova Scotia College of Art and Design, 1975), 184.

3   Barbara Rose, "ABC Art," *Art in America* (October–November 1965), 65.

4   Lucy R. Lippard, "Excerpts" (1966–67), *Changing: Essays in Art Criticism* (New York: E. P. Dutton & Company, 1971), 205.

5   John Perreault, "Burton's Robot Lovers," *The SoHo Weekly News* (March 11, 1976), 16.

6   Wade Saunders, "Not Lost, Not Found: Bill Bollinger," *Art in America* (March 2000), 114.

7   Michael Heizer, in Julia Brown, *Michael Heizer: Sculpture in Reverse*, exhibition catalog (Los Angeles: The Museum of Contemporary Art, 1984), 13.

8   Robert Morris, "Notes on Sculpture," parts 1 and 2 (1966), *Continuous Project Altered Daily: The Writings of Robert Morris* (Cambridge, Massachusetts: The MIT Press, 1993), 6, 17.

9   Bruce Nauman, in "Breaking the Silence," an interview with Joan Simon (1988), *Bruce Nauman*, exhibition catalog (London: Hayward Gallery, 1998), 109.

10   Donald Judd, "Specific Objects" (1965), *Complete Writings 1959–1975*, 183.

11   Bill Beckley, "Rooster, Bed, Lying Piece," *Avalanche* (Fall 1971), 20.

12   Bill Beckley, conversation with the author. March 17, 2000, New York.

chapter 12

1   Paul Thek, interview (1969), in *Paul Thek: Paintings, Works on Paper and Notebooks 1970–1988*, exhibition catalog (Chicago: The Arts Club of Chicago, 1999), 22–23.

2   Alain Parent, interview with Dennis Oppenheim (1977), *Dennis Oppenheim: Retrospective*

*Works 1967–1977* (Montreal: Musée d'Art Contemporain, 1978), 17.

3  Suzann Boettger, interview with Dennis Oppenheim (1995), The Archives of American Art, The Smithsonian Institution, New York, 56.

4  Cindy Nemser, interview with Eva Hesse, *Art Talk: Conversations with 12 Women Artists* (New York: Charles Scribner's Sons, 1975), 223.

5  Ibid., 207.

6  Ibid., 214, 215, 218.

7  Sol LeWitt, "Sentences on Conceptual Art" (1969), *Sol LeWitt: A Retrospective*, exhibition catalog, ed. Gary Garrels (San Francisco: San Francisco Museum of Modern Art, 2000), 371–72.

8  Mel Bochner, "Eccentric Abstraction," *Arts Magazine* (November 1966), 58.

9  Robert Morris, "Anti-Form" (1968), *Continuous Project Altered Daily: The Writings of Robert Morris* (Cambridge, Massachusetts: The MIT Press, 1993), 41.

10  See Robert Morris, *Mirrored Cubes*, 1965, and *Untitled (Battered Cubes)*, 1965.

11  Elizabeth C. Baker, "Artworks on the Land," *Art in America* (January–February 1976), 93–94.

12  Michael Heizer, conversation with the author, by radiotelephone. February 13, 1991.

13  Michael Heizer, in Julia Brown, *Michael Heizer: Sculpture in Reverse*, exhibition catalog (Los Angeles: The Museum of Contemporary Art, 1984), 34.

14  Michael Heizer, interview with Virginia Rutledge, 1994, in Rutledge, "Monuments to Making," *Art in America* (July 1995), 70.

## chapter 13

1  Postcard from Peter Hutchinson to John and Susan Gibson, 1969. John Gibson Gallery Archives. Courtesy John Hendricks.

2  Donald Judd, "Specific Objects," (1965), *Complete Writings 1959–1975* (Halifax: The Press of the Nova Scotia College of Art and Design, 1975), 181–89; Robert Morris, "Notes on Sculpture, Part 1" (1966), "Notes on Sculpture, Part 1" (1966), *Continuous Project Altered Daily: The Writings of Robert Morris*, (Cambridge, Massachusetts: The MIT Press, 1993), 1–9; Sol LeWitt, "Paragraphs on Conceptual Art" (1967), *Sol LeWitt: A Retrospective*, exhibition catalog, ed. Gary Garrels (San Francisco: San Francisco Museum of Modern Art, 2000), 369–71.

3  "Gestalt" holds its own against "object" in Robert Morris, "Notes on Sculpture, Part 2" (1966), *Continuous Project Altered Daily*, 10–21, then vanishes from "Notes on Sculpture, Part 3" (1967), 23–39. In "Anti-Form" (1968), the minimalist object with a strong "gestalt" is described as a work of "object-type art," 41. "Gestalt" appears in Morris's later writings with the aura of a faded memento, a souvenir of a time when a fresh bit of jargon could supply an artist-writer with immense authority.

4  Carl Andre, Windham College Symposium (1968), *Twentieth-Century Artists on Art*, ed. Dore Ashton (New York: Pantheon Books, 1985), 169.

5  Carl Andre, Windham College Symposium (1968), in Lucy R. Lippard, *Six Years: The Dematerialization of the Art Object from 1966 to 1972* (New York: Praeger Publishers, 1973), 47.

6  Barry Le Va, conversation with the author. February 2, 2000, New York.

7  Liza Béar and Willoughby Sharp, ". . . a continuous flow of fairly aimless movement," an interview with Barry Le Va, *Avalanche* (Fall 1971), 66.

8  Fidel A. Danieli, "Some New Los Angeles Artists," *Artforum* 6 (March 1968), 45.

9  Barry Le Va, conversation with the author. February 2, 2000, New York.

10  Barry Le Va, "Fictional Excerpts," *Art in the Mind*, exhibition catalog (Oberlin, Ohio: Allen Art Museum, Oberlin College, 1970), n.p.

11  Scott Burton, "Time on Their Hands," *Artnews* (Summer 1969), 42.

12  Lynda Benglis, conversation with the author. September 27, 1994, New York.

13  Lucy R. Lippard and John Chandler, "The Dematerialization of Art" (1968), in Lucy R. Lippard, *Changing: Essays in Art Criticism* (New York: E. P. Dutton & Company, 1971), 261.

14  Robert Morris, "Notes on Sculpture, Part 1" (1966), "Anti-Form" (1968), *Continuous Project Altered Daily*, 7, 42, 43.

15  Robert Morris, "Notes on Sculpture, Part 2" (1966), *Continuous Project Altered Daily*, 17.

16  Robert Morris, "Some Notes on the Phenomenology of Making: The Search for the Motivated" (1970), *Continuous Project Altered Daily*, 91.

17  Robert Morris, "Anti-Form," *Continuous Project Altered Daily*, 46.

18  Robert Morris, "Notes on Sculpture, Part 1" (1966), *Continuous Project Altered Daily*, 6.

19  Barry Le Va, quoted in Robert Pincus-Witten, "Barry Le Va: The Invisibility of Content" (1975), *The New Sculpture 1965–75: Between Geometry and Gesture*, ed. Richard Armstrong and Richard Marshall (New York: The Whitney Museum of American Art, 1990), 321.

20  Robert Morris, "Three Folds in the Fabric and Four Autobiographical Asides as Allegories (or Interruptions)" (1989), *Continuous Project Altered Daily*, 262–63.

## chapter 14

1  Dennis Oppenheim, conversation with the author. March 16, 2000, New York.

2  Claes Oldenburg, quoted in Barbara Haskell, *Claes Oldenburg: Object into Monument*, exhibition catalog (Pasadena, California: Pasadena Art Museum; Los Angeles: The Ward Ritchie Press), 60–62. The work is called *Placid Civil Monument*, 1967.

3  See Sol LeWitt, Box in the Hole (1968), illustrated in Robert Smithson, "Aerial Art" (1969), *Robert Smithson: The Collected Writings*, ed. Jack Flam (Berkeley: University of California Press, 1996), 118. See also Sol LeWitt, "Proposal for Earth Project," for the Fort Worth-Dallas airport: "Encase a 6-inch wooden cube containing something in an 18-inch cement cube and bury it someplace on The Tract. The precise spot would not be designated—but only that it is some within the area and 3 feet underground," in Robert Smithson, "Proposal for Earthworks and Landmarks to Be Built on the Fringes of the Fort Worth-Dallas Regional Air Terminal Site" (1966–67), *Robert Smithson: The Collected Writings*, ed. Jack Flam (Berkeley: University of California Press, 1996), 355. For cubes within cubes, in works intended for exhibition in galleries, see Sol LeWitt, "Cubes with Hidden Cubes," 1968, ink on paper, in *Sol LeWitt: A Retrospective*, ed. Gary Garrels (San Francisco: San Francisco Museum of Modern Art, 2000), 144. This work was fabricated in aluminum in 1977.

4  Lawrence Weiner, *Statements* (New York: Seth Siegelaub, Louis Kellner Foundation, 1968), n.p.

5  See chapter 6, note 8.

6  Sol LeWitt, "Sentences on Conceptual Art" (1969), *Sol LeWitt: A Retrospective*, 371–72.

7  Bruce Nauman, *Art in the Mind*, exhibition catalog (Oberlin, Ohio: Allen Art Museum, Oberlin College, 1970), n.p.

8  Carl Andre, Bradford Junior College symposium, 1968, in Lucy R. Lippard, *Six Years: The Dematerialization of the Art Object from 1966 to 1972* (New York: Prager Publishers, 1973), 40.

9  Dennis Oppenheim, conversation with the author. March 16, 2000, New York.

10  Dennis Oppenheim, "Discussions with Heizer, Oppenheim, Smithson," in *Six Years: The Dematerialization of the Art Object from 1966 to 1972*, 183–84.

11  Robert Smithson, "Incidents of Mirror-Travel in the Yucatan" (1969), *Robert Smithson: The Collected Writings*, ed. Jack Flam (Berkeley: University of California Press, 1996), 126.

12  *What Is a Museum?* (1967), a dialogue between Allan Kaprow and Robert Smithson, *Robert Smithson: The Collected Writings*, 48–49.

13  *What Is a Museum?* (1967), a dialogue between Allan Kaprow and Robert Smithson, *Robert Smithson: The Collected Writings*, 44.

14  James Monte, "Anti-Illusion: Procedures/Materials," *Anti-Illusion: Procedures/Materials*, exhibition catalog (New York: The Whitney Museum of American Art, 1969), 11.

15  Michael Heizer, statement, in Germano Celant, *Michael Heizer* (Milan: Fondazione Prada,

1997), 533.

16  Michael Heizer, in Julia Brown, *Michael Heizer: Sculpture in Reverse*, exhibition catalog (Los
      Angeles: The Los Angeles Museum of Contemporary Art, 1984), 16.

17  Virginia Dwan, interview with Charles Stuckey (1984), The Archives of American Art, The
      Smithsonian Institution, typescript, 20.

18  Michael Heizer, in *Michael Heizer: Sculpture in Reverse*, 36.

## chapter 15

1   Lawrence Weiner, "I Am Not Content," interview with David Batchelor (1989), *Art
      Recollections: Artists' Interviews and Statement in the Nineties*, ed. Gabrielle Detterer
      (Florence: Danilo Montanari & Exit & Zona Archives, 1997), 252.

2   Charles Harrison, "On Exhibitions and the World at Large: A Conversation with Seth
      Siegelaub (1969), *Idea Art*, ed. Gregory Battcock (New York: E. P. Dutton &
      Company, 1973), 165.

3   "Art without Space," a symposium moderated by Seth Siegelaub, with Lawrence Weiner,
      Robert Barry, Douglas Huebler, and Joseph Kosuth, in *Lawrence Weiner* (London:
      Phaidon Press, 1998), 94.

4   *Douglas Huebler, statement (1966), in Origin and Destination: Alighiero e Boetti and Douglas
      Huebler*, ed. Marianne Van Leeuw and Anne Pontégnie (Brussels: Societé des
      Expositions du Palais des Beaux-Arts de Bruxelles, 1997), 125.

5   Douglas Huebler, *Location Piece #1 New York—Los Angeles* (1969), in *Origin and Destination*,
      152–53.

6   Douglas Huebler, "Art without Space," a symposium moderated by Seth Siegelaub, with
      Lawrence Weiner, Robert Barry, Douglas Huebler, and Joseph Kosuth, in Lucy R.
      Lippard, *Six Years: The Dematerialization of the Art Object from 1966 to 1972* (New
      York: Praeger Publishers, 1973), 127.

7   Robert Barry, "Art without Space," *Six Years*, 127.

8   Robert Barry, interview, in *Prospect 69*, exhibition catalog (Düsseldorf: Städtische
      Kunsthalle, 1969), 121.

9   Robert Barry, *Telepathic Piece*, 1969. See *Six Years*, 98.

10  Athena T. Spear, "Introduction," *Art in the Mind*, exhibition catalog (Oberlin, Ohio: Allen
      Art Museum, Oberlin College, 1970), n.p. Sol LeWitt, "Sentences on Conceptual
      Art" (1969), *Sol LeWitt: A Retrospective*, exhibition catalog, ed. Gary Garrels (San
      Francisco: San Francisco Museum of Modern Art, 2000), 371–72. Ian Burn,
      "Dialogue," *Art Press* (July 1969), 5.

11  Robert Barry, *Art in the Mind*, n.p.

12  Scott Burton, *Art in the Mind*, n.p.

13  Eduardo Costa, *Art in the Mind*, n.p.

14  Ian Wilson, in *Six Years*, 162.

15  Ian Wilson and Robert Barry on Oral Communication, July 1970, in Six Years, 179–83.

16  David Hume, "Of the Standard of Taste" (1757), *Essays and Treatises on Several Subjects*
      (1758), reprinted in *Essays Moral, Political, and Literary*, ed. Eugene F. Miller
      (Indianapolis: Liberty Classics, 1985), 230.

17  Immanuel Kant, *Critique of Judgment* (1790), trans. James Creed Meredith (Oxford: Oxford
      University Press, 1952), 41–42, 50–51.

18  Douglas Huebler, "Art without Space," *Six Years*, 127.

19  Wassily Kandinsky, "Painting as Pure Art" (1913), *Kandinsky: Complete Writings on Art*, ed.
      Kenneth C. Lindsay and Peter Vergo (New York: Da Capo Press, 1994), 353.

20  Lawrence Weiner, "Intervention, (1997), *Lawrence Weiner*, 140.

21  Joseph Kosuth, "Art without Space," *Six Years*, 128.

22  A. J. Ayer, *Language Truth and Logic*, rev ed. (1942; New York: Dover Publications, 1952),
      35.

23  John Keats, "Ode to a Nightingale" (1819), line 35; William Shakespeare, *Henry V* (1599),
      act 4, scene 1, line 145.

24  A. J. Ayer, *Language Truth and Logic*, 35.

25  Joseph Kosuth, "Art After Philosophy, I and II" (1969), *Idea Art*, ed. Gregory Battcock (New York: E. P. Dutton & Company, 1973), 83.

chapter 16
 1  Joseph Kosuth, "Art after Philosophy, I and II" (1969), *Idea Art*, ed. Gregory Battcock (New York: E. P. Dutton & Company, 1973), 75.
 2  A. J. Ayer, *Language Truth and Logic* (1936) revised ed. (1946; New York: Dover Publications, 1952), 8, 9.
 3  Donald Judd, statement, *Primary Structures: Younger American and British Sculptors*, exhibition catalog (New York: The Jewish Museum, 1966), 121.
 4  Joseph Kosuth, "Art after Philosophy, I and II" (1969), 83. For Ayer's comment on analytic and synthetic statements, see Ayer, *Language Truth and Logic*, 78.
 5  Joseph Kosuth, "Art without Space," a symposium moderated by Seth Siegelaub, with Lawrence Weiner, Robert Barry, Douglas Huebler, and Joseph Kosuth, in Lucy R. Lippard, *Six Years: The Dematerialization of the Art Object from 1966 to 1972* (New York: Praeger Publishers, 1973), 127–28.
 6  Donald Judd, "Specific Objects" (1965), *Complete Writings 1959–1975* (Halifax: The Press of the Nova Scotia College of Art and Design, 1975), 184.
 7  Kosuth's tautologies invite comparison to Frank Stella's remark, "What you see is what you see," and variations by Robert Morris, Patrick Ireland, and others. For Kosuth, the tautology is a logical form to be deployed in an earnestly logical—that is, philosophical—manner. By contrast, Stella's quip employs the form of a tautology for polemical purposes, and with extreme rhetorical sophistication.
 8  For two of many essays objecting to the strategy of making meaning dependent on verification, see Isaiah Berlin, "Verification" (1939), *Categories and Concepts: Philosophical Essays* (London: Penguin Books, 1981), 12–31; and Friedrich Waismann, "Verifiability" (1945), *Logic and Language*, ed. Anthony Flew (Garden City, New York: Anchor Books, 1965), 123–51. Note that there is a distinction to be made between "the criterion of verifiability," as presented by A. J. Ayer in *Language Truth and Logic* (1936) revised ed. (1946; New York: Dover Publications, 1952), 35, and "the verification principle," as promulgated in the writings of the Vienna Circle—in, for instance, Rudolph Carnap, "The Elimination of Metaphysics" (1932), trans. Arthur Pap, *Logical Positivism*, ed. A. J. Ayer (New York: The Free Press, 1966), 61–65. Neither the criterion nor the principle managed to meet its own standard of verifiability.
 9  Willard V. Quine, "Two Dogmas of Empiricism" (1951), *From a Logical Point of View* (Cambridge, Massachusetts: Harvard University Press, 1980), 20–37.
10  Kynaston McShine, "La Vie en Rose," *Marcel Duchamp*, ed. Anne d'Harnoncourt and Kynaston McShine (Philadelphia: Philadelphia Museum of Art; New York: The Museum of Modern Art, 1973), 126. Pierre Cabanne, *Dialogues with Marcel Duchamp*, trans. Ron Padgett (New York: The Viking Press, 1971), 43, 93.
11  Moritz Schlick, "Positivism and Realism" (1932), trans. David Rynin, *Logical Positivism*, ed. A. J. Ayer (New York: The Free Press, 1966), 86.
12  Baruch Spinoza, *On the Improvement of the Understanding*, trans. Joseph Katz (New York: The Liberal Arts Press, 1958), 11. It is not known when Spinoza wrote this treatise. It was discovered and first published late in the eighteenth century.
13  In the "Introduction" to *Nature* (1836), Emerson asked, "Why should we not have a poetry and philosophy of insight and not of tradition?" For him, "insight" was willful and formative, not the discovery of previously existing realities, as traditional metaphysics claims it to be. Thus "Nature is not fixed but fluid. Spirit alters, molds, makes it." See Ralph Waldo Emerson, *Essays and Lectures* (New York: The Library of America, 1983), 7, 48. Transposed into the language of contemporary pragmatism, Emerson is claiming that reality or whatever we agree to accept as real is "shaped rather than found." See Richard Rorty, "Pragmatism, Relativism, Irrationalism" (1980), *Consequences of Pragmatism* (Minneapolis: University of Minnesota Press, 1982), 166. Of course Emerson has a far more poetic, hence willful, notion of our shaping powers than any advanced by Rorty and his academic colleagues. More willful, even, than Emerson,

Thoreau insists that truth is not "something independent of you." Rather, emerging from relations between oneself and other things, truth tends "to be fabulous or symbolical." See *H. D. Thoreau: A Writer's Journal*, ed. Laurence Stapleton (New York: Dover Publications, 1960), 96, 170.

14  Richard Rorty, "The Contingency of Language," *Contingency, Irony, and Solidarity* (Cambridge: Cambridge University Press, 1989), 5.

15  Richard Rorty, "Introduction," in Wilfred Sellars, *Empiricism and the Philosophy of Mind* (1956; Cambridge, Massachusetts: Harvard University Press, 1997), 5–6.

16  Richard Rorty, "Ethics Without Principles" (1994), *Philosophy and Social Hope* (Penguin Books, 1999), 87.

17  Josefina Ayerza, "Richard Rorty: Philosopher," *Flash Art* (November/December 1993), 72, 73.

18  "What Is a Museum? (1967), a dialogue between Allan Kaprow and Robert Smithson," *Robert Smithson: The Collected Writings*, ed. Jack Flam (Berkeley: University of California Press, 1996), 47. For a sign of Flaubert's devotion to "vain" endeavors, see his ruminations on the project that became *Madame Bovary*, 1856: "What seems beautiful to me, what I should like to write, is a book about nothing, a book dependent on nothing external, which would be held together by the internal strength of its style." Letter to Louise Colet, January 16, 1852, *The Letters of Gustave Flaubert: 1830–1857*, ed. Francis Steegmuller (Cambridge, Massachusetts: Harvard University Press, 1980), 154.

19  Robert Smithson, "A Museum of Language in the Vicinity of Art" (1968), *Robert Smithson: The Collected Writings*, 80.

20  Sol LeWitt, "Sentences on Conceptual Art" (1969), *Sol LeWitt: A Retrospective*, exhibition catalog, ed. Gary Garrels (San Francisco: San Francisco Museum of Modern Art, 2000), 371–72.

21  See Carter Ratcliff, "Dandyism and Abstraction in a Universe Defined by Newton" (1988), *Dandies: Fashion and Finesse in Art and Culture*, ed. Susan Fillin-Yeh (New York: New York University Press, 2000).

chapter 17

1  Vito Acconci, "Notes on Performing a Space," *Avalanche* (Fall 1972), 3.

2  Robert Morris, "Notes on Sculpture, Part 4: Beyond Objects" (1969), *Continuous Project Altered Daily: The Writings of Robert Morris* (Cambridge, Massachusetts: The MIT Press, 1993), 54.

3  Carter Ratcliff, "Robert Morris: A Saint Jerome for Our Times," *Artforum* (April 1985), 60–63.

4  Jack Burnham, "Alice's Head: Reflections on Conceptual Art" (1970), *Great Western Salt Works: Reflections on Post-Formalist Art* (New York: George Braziller, 1974), 48.

5  Jack Burnham, "Real Time Systems" (1969), *Great Western Salt Works*, 27.

6  Les Levine, A.I.R (1968–70), *Software*, exhibition catalog (New York: The Jewish Museum, 1970), 62.

7  The Architecture Machine Group, M.I.T. *Seek* (1969–70), Software, 23.

8  Vito Acconci, notes on *Proximity Piece* (1970), *Avalanche* (Fall 1972), 46.

9  Vito Acconci, notes on performance pieces, *Avalanche* (Fall 1972), 3, 5, 7, 8, 9, 11, 46.

10  Jeanne Siegel, "Carl Andre: Artworker," interview (1970), *Artwords: Discourse on the 60s and 70s* (Ann Arbor: UMI Research Press, 1985), 135.

11  Vito Acconci, notes on *Second Hand* (1971), *Avalanche* (Fall 1972), 35.

12  Vito Acconci, notes on performance pieces, *Avalanche* (Fall 1972), 16, 17.

13  Vito Acconci, in Kate Linker, *Vito Acconci* (New York: Rizzoli, 1994), 20; Vito Acconci, *Following Piece* (1970), *Avalanche* (Fall 1972), 31.

14  Vito Acconci, notes for *Drifts* (1970). Vito Acconci archives.

15  Charles Simonds, "Microcosm to Macrocosm, Fantasy World to Real World," an interview with Lucy R. Lippard, *Artforum* (February 1974), 36.

## chapter 18

1 Les Levine, conversation with the author. November 9, 2000, New York.

2 Les Levine, "For Immediate Release," 47.

3 Jack Burnham, "Real Time Systems" (1969), *Great Western Salt Works: Essays on the Meaning of Post-Formalist Art* (New York: George Braziller, 1974), 37; Les Levine, "For Immediate Release," 47.

4 Les Levine, quoted in Jack Burnham, "Les Levine: Business as Usual" (1970), *Great Western Salt Works*, 44.

5 Allen Ruppersberg, conversation with the author. May 12, 2000.

6 Allen Ruppersberg, brochure for *Al's Grand Hotel* (1971).

7 Sol LeWitt, "Paragraphs on Conceptual Art" (1967), "Sentences on Conceptual Art" (1969), *Sol LeWitt: A Retrospective*, exhibition catalog, ed. Gary Garrels (San Francisco: San Francisco Museum of Modern Art, 2000), 369–72.

8 Fred Sandback, statement (1975), *Sculpture 1966–1986*, exhibition catalog (Munich: Kunsthalle, 1986), n.p.

9 Liza Béar, "Gordon Matta-Clark: Splitting," *Avalanche* (December 1974), 36.

10 John Perreault, in "Rumbles," *Avalanche* (Winter 1971), 4.

11 Bill Beckley, conversation with the author. March 17, 2000, New York.

12 Willoughby Sharp, interview with Bruce Nauman (1971), *Bruce Nauman*, exhibition catalog (London: Hayward Gallery, 1998), 93.

13 Samuel Beckett, Molloy (1956), *The Unnamable: Three Novels by Samuel Beckett* (New York: Everyman's Library, 1997), 91. For a description of Molloy's walk, see pp. 84–86.

14 Willoughby Sharp, interview with Bruce Nauman (1971), *Bruce Nauman*, 92.

15 Dan Graham, notes on *Roll* (1970), in *Two-Way Mirror Power: Selected Writings by Dan Graham on His Art* (Cambridge, Massachusetts: The MIT Press, 1999), 87, 89.

16 Dan Graham, notes on *Two Correlated Rotations* (1969), in *Two-Way Mirror Power*, 87.

17 Dan Graham, notes on *Body Press* (1969), in *Two-Way Mirror Power*, 89.

18 Ibid., 93.

19 Dan Graham, "Performance: End of the '60s" (1989), *Two-Way Mirror Power*, 142; "Dan Graham Interviewed by Ludger Gerdes" (1991), *Two-Way Mirror Power*, 83.

20 Dan Graham, notes on *Two Correlated Rotations* (1969), in *Two-Way Mirror Power*, 87.

21 Dan Graham, *Performance/Audience/Mirror* (1977), in *Two-Way Mirror Power*, 125.

## chapter 19

1 Robert Smithson, late 1960s. Remark attributed to Smithson by Dennis Oppenheim, conversation with the author. March 16, 2000, New York.

2 Willoughby Sharp, "Terry Fox," brochure (San Francisco: Reese Palley Gallery, 1970), n.p.

3 Willoughby Sharp, "I wanted to have my mood affect their looks," interview with Terry Fox, *Avalanche* (Winter 1971), 70.

4 Brenda Richardson, *Terry Fox*, exhibition catalog (Berkeley: University Art Museum, 1973), n.p.

5 Tom Marioni, "Terry Fox: Himself," *Art and Artists* (January 1973), 40.

6 Chris Burden, in Robert Horvitz, *Artforum* (May 1976), 27.

7 Chris Burden, notes on *Trans-fixed* (1974), in Frances Morris, *Chris Burden* (London: Tate Gallery Publishing, 1999), 31.

8 Gordon Matta-Clark, letter to Wolfgang Becker, September 8, 1975, in Pamela M. Lee, *Object to Be Destroyed: The Work of Gordon Matta-Clark* (Cambridge, Massachusetts: The MIT Press, 2000), 121.

9 Gordon Matta-Clark, quoted in Pamela M. Lee, *Object to Be Destroyed: The Work of Gordon Matta-Clark*, 127.

10 See chapter 9, note 14.

11 Holly Solomon, in *Gordon Matta-Clark, A Retrospective*, ed. Mary Jane Jacob (Chicago: Museum of Contemporary Art, 1985), 25.

12 Joel Shapiro, in *Gordon Matta-Clark, A Retrospective*, 142.

13 Pamela M. Lee, *Object to Be Destroyed: The Work of Gordon Matta-Clark*, 257, note 17.

14  Barnard Lamarche-Vadel, interview with Richard Serra (1980), in *Richard Serra: Writings Interviews* (Chicago: The University of Chicago Press, 1994), 112.

15  Plato, *Timaeus*, 24e–25d, trans. Benjamin Jowett, *The Collected Dialogues*, ed. Edith Hamilton and Huntington Cairns (Princeton, New Jersey: Princeton University Press, Bollingen Series LXXI, 1963), 1159–60.

16  Robert Smithson, "Incidents of Mirror-Travel in the Yucatan" (1969), *Robert Smithson: The Collected Writings*, ed. Jack Flam (Berkeley: University of California Press, 1996), 133, note 1.

17  Barry Le Va, conversation with the author. May 17, 2000, New York.

18  Liza Béar and Willoughby Sharp, ". . . a continuous flow of fairly aimless movement," interview with Barry Le Va, *Avalanche* (Fall 1971), 68.

19  Cindy Nemser, "An Interview with Stephen Kaltenbach," *Artforum* (November 1970), 53.

20  Virginia Dwan, interview with Charles Stuckey, 1984, The Archives of American Art, Smithsonian Institution, 4.

## chapter 20

1  Adrian Piper, in Maurice Berger, "The Critique of Pure Racism: An Interview with Adrian Piper" (1990), *Adrian Piper: A Retrospective* (Baltimore: Fine Arts Gallery, University of Maryland, Baltimore County, 1999), p. 97.

2  John Perreault, "Cockroach Art," *The Village Voice* (April 8, 1971), 23.

3  Robert Morris, "Notes on Sculpture, Part 2" (1966), *Continuous Project Altered Daily: The Writings of Robert Morris* (Cambridge, Massachusetts. The MIT Press, 1993), 17.

4  John Perreault, "Cockroach Art."

5  Vito Acconci, notes for *Untitled Project for Pier 17* (1971), *Avalanche* (Fall 1971), 42.

6  Joan Simon, "Breaking the Silence," an interview with Bruce Nauman (1988), *Bruce Nauman*, exhibition catalog (London: Hayward Gallery, 1998), 111.

7  Liza Béar, interview with Vito Acconci, *Avalanche* (Fall 1971), 73.

8  Mel Bochner, "Primary Structures," *Arts Magazine* (June 1966), 32–35.

9  K. Anthony Appiah, "Art Beat," interview with Adrian Piper, *Voice Literary Supplement* (October 1992), 12.

10  Andrew Wilson, "Sol LeWitt Interviewed" (1993), *Art Recollection: Artists' Interviews and Statements in the Nineties*, ed. Gabriele Detterer (Florence, 1997), 159–60.

11  K. Anthony Appiah, "Art Beat," interview with Adrian Piper, *Voice Literary Supplement* (October 1992), 12.

12  John Keats, *The Fall of Hyperion* (1819), Canto I, ll. 187–90.

13  Mel Bochner, "Serial Art Systems: Solipsism" (1967), *Minimal Art: A Critical Anthology*, ed. Gregory Battcock (New York: E. P. Dutton & Company, 1968), 92–102.

14  Elayne Varian, "Interview with Brian O'Doherty" (Patrick Ireland), *Art International* (December 1970), 33.

15  "Conversation between Germano Celant and Dennis Oppenheim," *Dennis Oppenheim* (Milan: Edizioni Charta, 1997), 33.

16  Willoughby Sharp, interview with Dennis Oppenheim, *Studio International* (November 1971), 186, 187, 188.

17  Anne Ramsden, "It ain't what you make, it's what makes you do it," an interview with Dennis Oppenheim, *Parachute* (Winter 1977—78), 11.

18  Heinrich von Kleist, "On the Marionette Theater" (1810), trans. Christian-Albrecht Gollub, *German Romantic Criticism*, ed. A. Leslie Willson (New York: Continuum, 1982), 244.

## chapter 21

1  Liza Béar and Willoughby Sharp, "Discussions with Heizer, Oppenheim, Robert Smithson," *Avalanche* (Fall 1970), xx; reprinted in *Robert Smithson: The Collected Writings*, ed. Jack Flam (Berkeley, University of California Press, 1996), 251.

2  James Collins, in Robert Pincus-Witten, "James Collins: The Erotic and the Didactic," *Arts Magazine* (January 1976), 80.

3  Walter Robinson, "James Collins at Gibson," *Art in America* (November/December 1975), 103.

4 James Collins, in Eric Cameron, an interview with Mac Adams, Bill Beckley, and James Collins, *Mac Adams, Bill Beckley, James Collins*, exhibition catalog (Alberta College of Art, 1977), n.p.

5 James Collins, "Pointing, Hybrids, and Romanticism," *Artforum* (October, 1973), 57.

6 James Collins, in Eric Cameron, an interview with Mac Adams, Bill Beckley, and James Collins, *Mac Adams, Bill Beckley, James Collins*, n.p.

7 James Collins, "Story Art," *New York Magazine* (October 28, 1974), 21.

8 James Collins, "Story Art," 21.

9 Peter Hutchinson, *Alphabet Series* (New York: John Gibson Gallery, 1974), n.p.

10 Lawrence Campbell, "Reviews: Peter Hutchinson," *Artnews* (January 1966), 13.

11 Mel Bochner, "Primary Structures," *Arts Magazine* (June 1966): 32—33.

12 Peter Hutchinson, "Mannerism in the Abstract" (1968), *Minimal Art: A Critical Anthology*, ed. Gregory Battcock (New York: E. P. Dutton & Company, 1968),187–94.

13 Peter Hutchinson, "Earth in Upheaval: Earth Works and Landscapes," *Arts Magazine* (November 1968), 68.

14 Dennis Oppenheim, conversation with the author. March 16, 2000, New York.

15 April Kingsley, "Gordon-Matta Clark at 112 Greene Street," *Artforum* (January 1973), 89.

16 Peter Hutchinson, "Paricutin Volcano," *Selected Works 1968–1977* (New York: John Gibson Gallery, 1977), n.p.

17 James Collins, "Story Art," *New York Magazine* (October 28, 1974), xx.

18 Peter Hutchinson, "Horseshoe Piece"(1970), *Selected Works 1968–1977*, n.p.

19 Peter Hutchinson, "Foraging: Being an Account of a Hike through the Snowmass Wilderness as a Work of Art" (1971), *Art in America* (January–February 1972), 60, 67.

20 Peter Hutchinson, "Foraging" (1971), *Selected Works 1968–1977*, n.p.

chapter 22

1 Mac Adams, interview with Mac Adams, Bill Beckley, and James Collins, by Eric Cameron, *Mac Adams, Bill Beckley, James Collins*, exhibition catalog (Alberta College of Art Gallery, 1977), n.p.

2 Liza Béar and Willoughby Sharp, ". . . a continuous flow of fairly aimless motion," an interview with Barry Le Va, *Avalanche* (Fall 1971), 68.

3 "Mac Adams Talks to Kim Levin," *Mac Adams: Mysteries* (Cardiff: Welsh Arts Council, 1979), 28.

4 Mac Adams, in Judith Vivell, interview with Mac Adams and James Collins, WBAI, 1976, 3.

5 Mac Adams, in Kim Levin, "Mac Adams: Circumstantial Evidence," *Arts Magazine* (April 1978), 126.

6 Mac Adams, conversation with the author. April 14, 2000, New York.

7 "Mac Adams Talks to Kim Levin," *Mac Adams: Mysteries*, 24.

8 Mac Adams, in *Mac Adams, Bill Beckley, James Collins*, n.p.

9 Mac Adams, in *Mac Adams Mysteries*, 25.

10 Eleanor Antin in Amy Goldin, "The Post-Perceptual Portrait," *Art in America* (January 1975), 82.

11 Amy Goldin, "The Post-Perceptual Portrait," *Art in America* (January 1975), 82.

12 Howard N. Fox, "A Dialogue with Eleanor Antin," *Eleanor Antin*, exhibition catalog (Los Angeles: Los Angeles County Museum of Art, 1999), 200.

13 Robert Morris, "The Art of Existence. Three Extra-Visual Artists: Work in Progress," *Continuous Project Altered Daily: The Writings of Robert Morris* (Cambridge, Massachusetts: The MIT Press, 1994), 100–17.

14 Stephen Kaltenbach, conversation with the author. April 17, 2000.

15 See chapter 16, note 13.

16 Bill Beckley, conversation with the author. March 17, 2000, New York.

17 Bill Beckley, *The Origin of And* (1972), black and white photographs and ink on paper.

18 Bill Beckley, conversation with the author. March 17, 2000, New York.

chapter 23

1  Bill Beckley, *Surprise Ending* (1974).

2  Carl Andre, in Barbara Rose and Irving Sandler, "Sensibility of the Sixties," *Art in America* (January/February 1967), 45.

3  Gustave Flaubert, letter to Louis Bouilhet, June 27, 1850, *Flaubert in Egypt; A Sensibility on Tour*, ed. and trans. Francis Steegmuller (Boston: Little, Brown and Company, 1972), 212. Though the doctrine of art for art's sake has roots in the eighteenth-century discussion codified in Kant's *Critique of Judgment*, 1790, it is routinely said to have been enunciated first by the poet Théophile Gautier, who declared, in 1834, "There is nothing really beautiful but that which is useless. Everything useful is ugly, for it is the expression of some want." See Gautier, "Preface to *Mademoiselle de Maupin*" (1834), trans. anon., *Strangeness and Beauty: An Antilogy of Aesthetic Criticism 1840–1910*, 2 vols., ed. Eric Warner and Graham Hough (Cambridge: Cambridge University Press, 1983), 1,163.

4  "*What Is a Museum?* (1967), a dialogue between Allan Kaprow and Robert Smithson," *Robert Smithson: The Collected Writings*, ed. Jack Flam (Berkeley: University of California Press, 1996), 47.

5  Charles Baudelaire, "The Life and Work of Eugène Delacroix" (1863), *Baudelaire: Selected Writings on Art and Artists*, trans. P. E. Charvet (Cambridge: Cambridge University Press, 1981), 370.

6  Kenyon Cox, *The Classic Point of View* (1911; New York: W. W. Norton, 1980), 17.

7  Wassily Kandinsky, "Painting as Pure Art" (1913), *Kandinsky: Complete Writings on Art*, ed. Kenneth C. Lindsay and Peter Vergo (New York: Da Capo Press, 1994), 348; Piet Mondrian, "Purely Abstract Art" (1926), *The New Art—The New Life: The Collected Writings of Piet Mondrian*, ed. and trans. Harry Holtzman and Martin S. James (Boston: G. K. Hall, 1986), 198.

8  Willem de Kooning, "What Abstract Art Means to Me" (1951), in Clifford Ross, *Abstract Expressionism: Creators and Critics: An Anthology* (New York: Harry N. Abrams, 1990), 38.

9  Piet Mondrian, "A Dialogue on Neoplasticism" (1919), trans. Martin S. James and Harry Holtzman, in Hans L. C. Jaffe, *De Stijl* (New York: Harry N. Abrams, 1971), 121, 123. See also Carter Ratcliff, "Dandyism and Abstraction in a Universe Defined by Newton" (1988), *Dandyism: Fashion and Finesse*, ed. Susan Fillin-Yeh (New York: New York University Press, 2000).

10  Alan Solomon, interview with Frank Stella, "U. S. A. Artists," National Educational Television, 1966. Quoted in William Rubin, *Frank Stella*, exhibition catalog (New York: The Museum of Modern Art, 1970), 13.

11  Willem de Kooning, "What Abstract Art Means to Me" (1951), in Clifford Ross, *Abstract Expressionism: Creators and Critics: An Anthology* (New York: Harry N. Abrams, 1990), 42.

12  Willem de Kooning, statement, in *Sketchbook No. 1: Three Americans* (1960), a film by Robert Snyder, Clifford Ross, *Abstract Expressionism: Creators and Critics* (New York: Harry N. Abrams, 1990), 43.

13  Charles Baudelaire, "The Life and Work of Eugène Delacroix" (1863), 371.

14  Bruce Hooten, interview with Donald Judd, February 3, 1965. Archives of American Art, Smithsonian Institution, New York, 2.

15  Dan Flavin, letter to Jan van der Marck, June 17, 1967, in "some other comments . . . more pages from a spleenish journal," *Artforum* (December 1967), 23.

16  Carl Andre, "Preface to Stripe Painting," *Sixteen Americans*, exhibition catalog, ed. Dorothy Miller (New York: The Museum of Modern Art, 1959), 76.

17  Andre's metaphor seems to suggest that, as a merchant offers goods in exchange for money, so artists of the wrong sort offer symbols in exchange for the imputation of meanings to their art. Moreover, such exchanges involve only meanings of the wrong sort—that is, meanings which are paraphrasable, hence detachable, hence available for further dubious exchanges in the interests of what Andre takes to be culture's oppressive forces. This metaphor not entirely clear. Perhaps no metaphor is. For the suggestion that the point of metaphor is a certain, tactically powerful incoherence, see Donald Davidson, "What Metaphors Mean" (1978), *Inquiries into Truth and Interpretation* (Oxford: Oxford University Press, 1984), 245–64.

18  William Wordsworth, "The world is too much with us; late and soon" (1807).

19  For Andre's refusal to allow political symbolism to be extracted form his art, see chapter 7, note 9. For his rejection of all attempts to supply his art with "associations" of any kind, see chapter 2, note 10.

20  Robert Taplin, "Vital Parts," *Art in America* (February 1993), 74.

21  Cindy Nemser, interview with Eva Hesse, *Art Talk: Conversations with 12 Women Artists* (New York: Charles Scribner's Sons, 1975), 207.

22  Cindy Nemser, interview with Eva Hesse, *Art Talk*, 223. See also Anna C. Chave, "Minimalism and the Rhetoric of Power," *Arts Magazine* (January 1990), 44–63.

23  W. K. Wimsatt and Monroe Beardsley, "The Intentional Fallacy" (1946), *The Verbal Icon: Studies in the Meaning of Poetry* (Lexington, Kentucky: The University Press of Kentucky, 1954), 3–18. See also E. D. Hirsch, Jr., *Validity in Interpretation* (New Haven: Yale University Press, 1967), 11–23; *Against Theory: Literary Studies and the New Pragmatism* (Chicago: The University of Chicago Press, 1985); and Denis Dutton, "Why Intentionalism Won't Go Away," *Literature and the Question of Philosophy*, ed. Anthony J. Cascardi (Baltimore: Johns Hopkins University Press, 1987), 194–209.

24  Liza Béar and Willoughby Sharp, ". . . a continuous flow of fairly aimless movement," an interview with Barry Le Va, *Avalanche* (Fall 1971), 66.

25  See chapter 10, note 20.

26  Elayne Varian, interview with Mel Bochner, March 1969, typescript, Archives of American Art, Smithsonian Institution, 5.

27  Dorthea Rockburne, "Notes to Myself on Drawing," statement, March 1973. Artist's file, Library of the Museum of Modern Art, New York.

28  Michael Heizer, in John Gruen, "Michael Heizer" (1977), *The Artist Observed: 28 Interviews with Contemporary Artists* (Pennington, New Jersey: A Cappella Books, 1991), 178.

29  Mel Bochner, "Primary Structures," *Arts Magazine* (June 1966), 35.

# index

 Books from Allworth Press

Redeeming Art: Critical Reveries *by Donald Kuspit*
(softcover with flaps, 6 × 9, 352 pages, $24.95)

The Dialectic of Decadence *by Donald Kuspit*
(softcover with flaps, 6 × 9, 128 pages, $18.95)

Beauty and the Contemporary Sublime *by Jeremy Gilbert-Rolfe*
(softcover with flaps, 6 × 9, 208 pages, $18.95)

Uncontrollable Beauty: Toward a New Aesthetics
*edited by Bill Beckley with David Shapiro* (hardcover, 6 × 9, 448 pages, $24.95)

Sculpture in the Age of Doubt *by Thomas McEvilley*
(softcover with flaps, 6½ × 9½, 448 pages, $24.95)

The End of the Art World *by Robert C. Morgan*
(softcover with flaps, 6 × 9, 256 pages, $18.95)

Sticky Sublime *edited by Bill Beckley*
(hardcover, 6½ × 9½, 256 pages, $24.95)

Imaginary Portraits *by Walter Pater, Introduction by Bill Beckley*
(softcover, 6 × 9, 240 pages, $18.95)

Lectures on Art *by John Ruskin, Introduction by Bill Beckley*
(softcover, 6 × 9, 264 pages, $18.95)

The Laws of Fésole: Principles of Drawing and Painting from the Tuscan Masters
*by John Ruskin, Introduction by Bill Beckley* (softcover, 6 × 9, 224 pages, $18.95)

Looking Closer 3: Classic Writings on Graphic Design *edited by Michael Bierut, Jessi*
*Helfand, Steven Heller, and Rick Poynor* (softcover, 6¾ × 10, 304 pages, $18.95)

Education of a Graphic Designer *edited by Steven Heller*
(softcover, 6¾ × 10, 288 pages, $18.95)

Education of an Illustrator *edited by Steven Heller and Marshall Arisman*
(softcover, 6¾ × 10, 288 pages, $19.95)